A Key

to

the Louvre

Michel Laclotte

A Key
to
the Louvre

Memoirs
of
a Curator

Translated from the French by
Mark Polizzotti

ABBEVILLE PRESS PUBLISHERS

NEW YORK LONDON

For their help and friendship, the author wishes to thank
Laurence Bertrand-Dorléac, Geneviève Bresc-Bautier, Geneviève Bouflet,
Marie-Anne Dupuy-Vachey, Caroline Mathieu, Claudie Ressort,
Paul Salmona, and Philippe Sénéchal.

Editions Scala particularly wishes to thank Mijo Thomas and Jean Clay.

This text is based on interviews conducted by François Legrand,
as rewritten by Michel Laclotte in collaboration with Anne Sefrioui.

———

First published in the United States of America in 2004 by Abbeville Press,
116 West 23rd Street, New York, NY 10011.

First published in France in 2003 by Éditions Scala, Passage L'homme,
26 rue de Charonne, 75011 Paris, France.
Copyright © Éditions Scala, 2003

Photography Credits
Réunion des Musées Nationaux, Paris / Art Resource, New York:
inserted pages, Georges de La Tour, *The Cheat* (photo: Gerard Blot);
Giovanni Bellini, *The Drunkenness of Noah* (photo: Hervé Lewandowski);
and Jean-Honoré Fragonard, *The Bolt* (photo: Daniel Arnaudet)

First edition
2 4 6 8 10 9 7 5 3 1

Library of Congress Cataloging-in-Publication Data
Laclotte, Michel.
[Histoires de museés. English]
A Key to the Louvre : memoirs of a curator / Michel Laclotte ;
translated from the French by Mark Polizzotti.
p. cm.
Translation of: Histoires de museés.
Includes index.
ISBN 0-7892-0820-2 (hc) — ISBN 0-7892-0821-0 (pbk.)
(alk. paper)
1. Laclotte, Michel. 2. Museum curators—France—Biography. 3. Musée du Louvre.
4. Museums—France—History—20th century. I. Title.
N2030.L17413 2004
708.4'361—dc22 2004052817

Editor: Christopher Lyon · Designer: Misha Beletsky · Compositor: Angela Taormina
Set in HTF Requiem
Printed and bound in the United States of America.

For

Jean Coural

Contents

Foreword

Any narrative written in the first person, unless it is fiction or the musings of a confirmed flagellant, contains a share of self-congratulation. I have tried to keep this to a minimum by relating what I personally observed in museums and in the field of art history in France over the last fifty years.

In many respects, my story is the rather banal reflection of what many Frenchmen of my generation experienced in the milieus in which I worked. At the same time, I cannot let it be forgotten that throughout my long career, I benefited from a rare opportunity: having been promoted in my youth through the generosity of an exceptional boss and after that being involved at the right time in undertakings such as are rarely seen in the history of museums.

It is not my intent in this memoir to speak as a professional historian. This book was written from interviews that draw upon personal recollections, with limited recourse to documentary sources in verifying dates, titles, or quotations. In other words, it presents an inevitably partial viewpoint. Many facts relating to these stories have therefore remained unspoken, generally because I didn't know, remember, or correctly interpret them. On top of which, needless to say, I was not able to mention everyone I've encountered during the past half-century. My hope is that those who could not be cited here will forgive me.

I

Learning the Trade

Fifty years of my life have been devoted to art history and museums, and it would be natural to expect a detailed accounting of those decades. But for me to provide one, I would have to adopt the approach of a professional historian, which I am not, on top of which I lack the necessary perspective. Were you to ask my contemporaries about events in our field over the past half-century, their accounts would certainly differ from mine. Rather, what I hope to do in this book is to recreate a sense of the times and to spotlight both the high points in the history of museums (their resurgence after World War II, for instance, or the "boom" in large-scale construction projects) and the low points—around 1970 and perhaps today. And also (though here again my own view is partial and even a bit biased), I hope to highlight the efforts made, after the gray and timid period that followed the war, to revive art history and scholarship in France, the battles won and lost, and finally the vitality of a discipline that not everyone looks upon favorably.

A Key to the Louvre

I was born in 1929 in Saint-Malo and, like any good native of that city, was naively proud of my hometown. The fact that so many Malouins have lent their names to streets, hospitals, islands, and even a commercial temple of information technology* "is not bad for a place whose area," as Chateaubriand put it in his *Mémoires d'outre-tombe*, "does not even rival that of the Tuileries." I have always retained my attachment to the city, so much so that I recently bought an apartment there, within the walls, to enjoy the sea air from time to time.

My family left Saint-Malo after my father was killed in 1940, and the following year we settled in Paris. Filtered as they are through our family's mourning, my memories of the Occupation are naturally rather dark: Germans everywhere, soldiers in the metro stinking of leather and heavy wool . . . My secondary school was the Lycée Pasteur in Neuilly. One teacher who stood out in particular was Henri Petiot, better known as the writer Daniel-Rops, who would soon become famous as the author of *Jesus and His Times*. When teaching history, he made frequent reference to the history of art, which was ignored or neglected in schools at the time (is it very different today?), and he took us to Notre Dame cathedral to help us understand the Middle Ages.

Like all children, I read avidly in those years, starting with bland scouting books and adventure stories, comics featuring the "disastrous housemaid" Bécassine (another Breton contribution), as well as *The Jungle Book*, Jules Verne, Dumas, and many other titles in the white Collection Nelson editions — the paperbacks of that period — which I found in the family library. And, like anyone else, I studied the classics in school: Balzac, Stendhal, Flaubert, the Russians, and so on.

Paris during the Occupation was extraordinarily rich when it came to shows. I'd had little experience with theater before the war, though I do remember *L'Heure espagnole* at the

*Surcouf, named after the famous Malouin corsair Robert Surcouf.

Théâtre de Rennes, where, of course, I was more taken with the heroine's burlesque misadventures than I was with Ravel's music. In Paris, while visiting my grandmother, I'd seen *Around the World in Eighty Days* at the Châtelet and — prophetically — a ballet by Lifar at the Opera, *Entre deux rondes*, in which statues in the Louvre came to life at night.

I spent a lot of time at the theater in Paris with my mother or some friends. It was there I saw Henry de Montherlant's *La Reine morte* and *Le Soulier de satin* by Paul Claudel at the Comédie Française; *Renaud et Armide*, beautifully staged by Bérard but based on a rather weak play by Jean Cocteau; and many classics, including Raimu in Molière's *Le Bourgeois gentilhomme* and *Le Malade imaginaire*. I still remember *Antigone*, the resistor, by Jean Anouilh and also *Andromaque* directed by Cocteau, starring Jean Marais and Annie Ducaux, which caused quite an uproar.

There were also movies. We didn't go to see German films, although there were two in color — something extremely rare outside of American cinema — that were very enticing: *Baron Münchausen* and *La Ville dorée*, about Prague — a German city, as everyone knew... We had no idea that *Les Inconnus dans la maison* or *Le Corbeau* were produced by Germans. Of the films of the period, I especially remember faces: Edwige Feuillère in *La Duchesse de Langeais*, Pierre Fresnay as Inspector Wens, Michel Simon as Vautrin, American-style comedies with Raymond Rouleau and Annie Ducaux, *Falbalas* by Jacques Becker, *Le Baron fantôme*... I also remember two absolutely spectacular films, which at the time were considered "Resistance" movies: Marcel Carné's *Les Visiteurs du soir* — in which Jules Berry as the Devil snickers about "the heart that keeps beating" — and *Pontcarral*. We were frustrated by the unavailability of American films, our interest having been whetted by a friend who had seen some in Switzerland, especially *Fantasia* and *Gone with the Wind*.

It was also difficult to see much art, since most of the museums were closed. Still, I was able to view the monumental sculptures at the Louvre, which they hadn't been able to evacuate, notably the winged bulls from Khorsabad. I also have another "artistic" memory, from what must have been the summer of 1942, at the Bellou manor in Normandy. I was at a Boy Scout camp in the country, and we were visiting the castle that served as a storage repository for Maurice-Quentin de la Tour's pastels from the Saint-Quentin museum. Some of them were hung in the rooms. I clearly recall the roguishness of *Mademoiselle Fels* (which today I find a bit irritating) and the smile of *Abbé Huber* reading by candlelight. But I didn't come away with an irresistible attraction to the eighteenth century.

Nonetheless, a few memories from those years suggest that I was beginning to grow out of my childhood. I can still recall — I must have been thirteen or fourteen at the time — standing in front of a billboard kiosk in Place Saint-Ferdinand-des-Ternes, excited at the prospect of going to see Gounod's *Faust*, the national opera par excellence, until an older friend said, "That's all well and good, but the real *Faust* is the one by Berlioz." I suddenly understood that not all art was of equal value. In a similar vein, I remember our French teacher's dismayed expression when, having asked us to recite a work of poetry, he found that several of us (myself included) had chosen a tirade from Rostand's *Cyrano* or *L'Aiglon*...

I also remember another epiphany, somewhat more significant and inspired by a sense of shame that I can still feel today. It was during the holidays of 1942 or 1943, which I spent in Laval at my paternal uncle's, a doctor who was in the Resistance — which I didn't know at the time. "And what do they think about the Resistance in your school?" he asked me one day. To which I airily replied, "Oh, we're not really interested in politics . . . " Arrogant brat!

At the same time, we knew that some of our teachers at Lycée Pasteur (Sartre taught there, though not in my grade) had links to the Resistance—notably our English teacher, Georges Magnane, who had gone back to teaching because he didn't want to publish under the Occupation. Most of our teachers didn't spare us their more or less concealed allusions to the war, England, and the Germans, though I don't recall anyone particularly extolling the virtues of the Vichy regime. I recently came across some class photos from those years: rows of awkward boys, all vaguely cross-eyed or pimply. In the first year (1941–42), I see among the pupils a boy who was one of my best friends, Weys. In the second year (1942–43), Weys is more or less in the same place, but wearing a yellow star on his smock. In the third-year photo (1943–44), he doesn't appear at all.

I remember the liberation of Paris all the more clearly in that we experienced it from up close (we lived not far from the Arc de Triomphe, which was visible from our balcony): the arrest of a young neighbor, who, as we learned a few days later, was among the hostages shot at the Cascade in the Bois de Boulogne; the arrival of Leclerc's tanks on Place de l'Etoile; the delirious joy; the sniper shots from "bastards" hidden on the rooftops of the adjoining avenue. Needless to say, our joy was tempered by the fact that my father would not be among those coming home and further dampened by the news of the destruction of Saint-Malo. We went there in September 1944 to find the ruins still smoking, a sight made more horrible in that the bombardments were of no military use. They said at the time that the Germans had set fire to the city as they were leaving after placing explosives in the cellars of the oldest houses. Today we know that it was in fact an Allied mistake. Saint-Malo was rebuilt "in the style of," stone by stone and facade by facade, especially the largest houses around Porte Saint-Vincent.

In the 1950s the minister in charge of reconstruction was Eugène Claudius-Petit, and my mother was in his cabinet: a remarkable man, a true modernist who supported Le Corbusier and the most innovative French architects of the period, who were rare. It was thanks to him, for example, that the "Maison du Fada" in Marseilles was built by Le Corbusier, against all odds. He would have preferred Louis Arretche's reconstruction scheme for Saint-Malo to be more radically contemporary — though perhaps he was mistaken in this, for apart from some cheaply made buildings on the ramparts, the urban planning, style, integration of surviving architectural elements, and use of granite are overall quite successful.

I have been asked what I think of Louis Hautecoeur, who was general secretary for fine arts under Vichy. My opinion, of course, is retrospective, as I was only fourteen when Paris was liberated! I met Hautecoeur many years later, when he was already retired and finishing his monumental *History of French Classical Architecture*, and I found him to be an utterly decent man. Hautecoeur belonged, as did the classical scholar Jérôme Carcopino, to a handful of intellectuals who had sided with the Vichy government. Research is now being done to provide a better understanding of the role each of these men played and his share of responsibility. Hautecoeur had to leave France for a time and took over the Musée de Genève; his name was cleared fairly soon after the war. The fact remains that he had been in charge of the arts under Vichy, and as such he paved the way for the reforms that were put into practice beginning in 1945.

I became aware of all this only later, in 1949–50, when I started frequenting university and museum circles. My sense today is that among the larger components of the state, the museums, headed by Jacques Jaujard, were relatively "well behaved" vis-à-vis the occupying forces. A small number of curators were no doubt attracted by Vichy without necessar-

ily becoming active collaborators. Their main concern was to save the collections, moving them to offsite locations to protect them from air raids or from being carried away in German trucks. And they were concerned with saving people. Charles Sterling had managed to reach the United States, but most of the Jewish curators remained in France and were sheltered as much as possible. To my knowledge, not one was deported. The curator Suzanne Kahn, whose parents were deported and never returned, owes her survival in June 1944 to her husband's broken leg, which kept them from getting on the train that would have taken them to Germany. She later told me what it felt like when, for an exhibition of masterpieces from Berlin and Munich at the Petit Palais, she had to welcome some colleagues from Germany and treat them cordially.

I cannot say precisely when I first recognized my museum "calling." What I do know is that at first (this would be 1945), I wanted to be an architect. But to be accepted in the architecture program at the Ecole des Beaux-Arts, which at the time was the only one available, you had to be good in math — unfortunately not one of my strong suits. And so I opted instead for a career in museums, studying for the liberal arts baccalaureate and then for the exams to become a curator. I had been encouraged in this by Jean Adhémar, whom my mother had known during the war when she worked as an archivist for the Ministry for Overseas Territories, where he was engaged in a cataloguing project. A paleographer with an original mind, he had attended the Warburg Institute in London before the war. He advised me that if I wanted to get a job in museums, I should become a paleographer as well. I was especially influenced by the example of Sylvie Béguin, who was several years older than I. Our families had been neighbors in Saint-Malo; we had met up again in Paris, and

she told me of her own career path—liberal arts, then art history and museum studies.

One thing is certain: from early on, I was interested in the collections and exhibitions in provincial museums. On my vacations in Colmar, Angers, Laval, Strasbourg, Toulouse, Nancy, and Montpellier, I began visiting all the local museums that had been reopened to the public. I still have the notes in which I completely reorganized the Musée Fabre at Montpellier—a tad presumptuous, to say the least! Why this lifelong interest? This need to index every painting I've ever seen, to inventory others I found in every book I could lay my hands on? To itemize all the Rembrandts or Fragonards in French collections? No doubt an adolescent passion for classification. And alongside this went a profound interest in the national patrimony. The result of my family's traditional patriotism? Perhaps.

From my first serious readings in art history, before my studies made them more systematic, I've retained a keen memory of Henri Focillon's *The Life of Forms* and Salomon Reinach's *Apollo*—an admirable little pocket guide, the equivalent of which I would love to find today—as well as of several "coffee table" books. During the war, the publisher Pierre Tisné had continued to produce lavish books with color plates, which was rare in those years. He had published Germain Bazin's *Corot*, which I still have, in a collection edited by René Huyghe. It was my first purchase immediately after the war, along with Charles Sterling's book on the French primitives, a true masterpiece from 1942. Soon afterward I read Bernard Berenson, and for my own inventories used his "lists" from 1932, a repertory of Italian Renaissance paintings. I also bought, for their illustrations, the volumes in the precious Collection des Maîtres published by Braun.

In the spring of 1946 in Brussels, after having gone to Bruges with my mother to visit my father's grave, I saw an extraor-

dinary exhibition of masterpieces from Dutch museums, including Vermeer's *View of Delft* and *The Letter, The Governors of the Almshouse* and *Lady Governors of the Almshouse* by Frans Hals, and Rembrandt's *The Syndics of the Drapers' Guild*, all of which have remained indelibly etched in my memory. It was the first time I truly saw great paintings up close: the Louvre had reopened, but only partially. From that moment on, this stopped being a simple adolescent pastime. I now wanted to see as many works as possible, of all kinds; to read, to travel— in short, to make it my work.

Having decided to follow the museum path, I entered the Lycée Henri IV in 1947 to prepare my entrance exams to the Ecole des Chartes, the school for the training of archivists and paleographers. I stayed there for two years. At the time, to become a curator in a national museum, one had to hold a degree from the advanced section of the Ecole du Louvre. This was one of the reforms begun before the war as part of a large-scale reorganization of museums planned by Henri Verne and Jacques Jaujard and put into practice during the Occupation. The Ecole du Louvre had established a section of its educational program that accepted five or six students a year on the basis of a qualifying examination. The system has taken other forms since, but the number of students remains about the same. Students at the Ecole des Chartes and at certain universities were exempt from this exam.

Since I was fairly young and did not have all the requisite training, especially in Latin—to my shame, as my grandfather taught it—I washed out in my first year at the Ecole des Chartes. Meanwhile, the rules had changed: the administration abolished the exemption that ensured paleographers admittance into the advanced section of the Ecole du Louvre. At that point, I had two choices: either continue studying to be an archivist or take the qualifying exam for the Louvre, which is what I decided to do. Despite my failure at the Ecole

des Chartes — in any case, what I learned there helped me pass the Louvre exam in 1950 — I have good memories of Henri IV. I met several future *chartistes*, as graduates of the school are called, whom I continued to frequent later on, especially Jean Coural, who would become my best friend for life.

Like many of my classmates, I followed two courses of study simultaneously: one at the Institut d'Art et d'Archéologie on Rue Michelet, and the other at the Ecole du Louvre. At the Institut d'Art (this was in 1948–50), you had to earn four diplomas to get your degree. One diploma was in aesthetics, which I took with Etienne Souriau, though without stellar results: my lack of interest in abstraction and pure ideas is one of the weaknesses in my intellectual makeup. The other three were more specifically in art history. The great prewar Hellenist Charles Picard, who was then at the end of his career, was giving his course on Delos, where he had excavated. I clearly recall not only his teachings but also his appearance, like a Notable under the Third Republic, quite different from our image of a field archeologist. Neither of the other two professors, Elie Lambert and Pierre Lavedan, offered courses on painting. Lambert, who taught monastic architecture, made us study floor plans, to the point where I can still tell (though it hardly takes a genius) where the refectory, chapter house, and dormitories would be when entering a monastery. Lavedan, who wrote several excellent books, taught a course on the notion of Baroque, reviving interest in what had been a great subject of intellectual debate before the war. The definitions by Eugenio d'Ors and Heinrich Wölfflin and remarks made during various symposia on the Baroque — which at the time was differentiated from Classicism, and not applied to all artistic creation of the seventeenth and eighteenth centuries as it is today — provided a change from strict scholasticism and helped illuminate the general history of creative styles and methods. These men were excellent art

historians and good teachers, but looking back, I would say they lacked the cross-cultural breadth of a Focillon, who had been one of the school's great masters before the war, or the richness of information and method that one could find at the Courtauld Institute in London. In that regard, France after the Liberation shut in on itself with a certain smugness. The revitalizing energy brought by a number of Focillon's former students had not yet penetrated the university.

There were many of us at the Institut d'Art, and I didn't mix much with my classmates there. At the Louvre school, on the other hand, there were only six or seven of us in each year, with only three years of study separating the oldest and the youngest, and we spent a lot of time together. We organized study trips and led a traditional "student" life, with annual balls, contests, and so on, which made our little group a kind of intellectual — or at least social — fraternity within that huge school.

The teaching we received was also different from the university. On the one hand, we followed a general program of art history over three years taught by the Louvre's leading minds at the time. André Parrot, for instance, taught the ancient Far East. Like the best specialists, he had an excellent general knowledge and proposed simple and convincing syntheses. This was also the case with Jean Charbonneaux, the most sensitive and elegant of them all, for Greek art. In the third year we had museum studies — a new discipline, and very well taught — with Germain Bazin. At the same time, we took two "organic" courses, our specialization over three years. I had Michel Florisoone, a curator in the Paintings Department, who lectured on Venetian painting from the late sixteenth and seventeenth centuries, and Bernard Dorival, who taught French painting of the seventeenth century. The Louvre school has an excellent tradition of teaching with the works themselves, of basing any historical and critical analysis

on direct contact with these works. I've kept good memories of Florisoone's teachings about the Bassanos and the early seventeenth century; since this was still a rare subject of study, it made our work less banal and less rehashed. As for Dorival, he was especially known for his work as a curator for the Musée National d'Art Moderne. As a teacher, he was extremely methodical, and his courses provided excellent training. He made frequent reference to the works, of course, but also to source materials and the great writings of the period. Here again, the artists he discussed, such as Champaigne, Jouvenet, or La Fosse, were less studied at the time than we might now imagine.

This was also the period when André Malraux's *Museum without Walls* and *The Voices of Silence* appeared. I admired Malraux as a writer and belonged to the generation for whom *Man's Fate* and *Man's Hope* were cult novels, as we would say today. I still regret having lost my beautiful edition of *The Walnut Trees of Altenburg*, which I bought on publication—a book that Malraux had rewritten from memory after the original manuscript was lost. I eagerly went to see the film of *Man's Hope* (in 1947, I believe) at the Gaumont Palace, where it was introduced by Malraux himself. I can still recall the great funereal descent from the Sierra de Teruel, clearly inspired as much by Tintoretto as by Eisenstein, or the vibration of the crates at the airport and, of course, the famous shot of the machine gun aiming straight at the camera. Malraux's conversion to Gaullism surprised us. When his *Psychology of Art* came out, I was curious to read it. The first edition is admirable: Malraux was famous for his attention to layout and reproduction quality.

You might wonder how an art historian with little taste for lyrical flights of fancy might react to Malraux's juxtaposition of works from disparate places and time periods, not to mention his unapologetic subjectivity. Although this was not at all

my own approach, I found it extremely interesting: why else would I have acquired such expensive books? When you read through them, you realize that these great encounters across the centuries hinge primarily on images. But it works! In the margins of the author's contrasts and comparisons, certain works stand out on their own terms, owing to the magic of the light thrown on them, the intelligence with which certain details are underscored. Kenneth Clark had paved the way with two magnificent volumes of reproductions from his museum, the National Gallery in London, showing details that often constitute little riddles. Here's a single example from Malraux: the small young man showing the tip of his nose in the doorway in Signorelli's *The Birth of Saint John* in the Louvre — a detail that makes the entire painting.

As for exhibitions, after the Liberation I passionately followed everything that was happening in museums, the progressive reopening of their galleries, new acquisitions, shows — I absorbed it all like a sponge. In particular, there were exhibitions at the Orangerie, either major loan shows or scholarly exhibitions based on original research — such as *The Golden Age of Toulouse Painting* in 1946 or *Philippe de Champaigne* in 1952 — and at the Petit Palais, where the director, André Chamson, put great emphasis on display. After a show of French masterpiece paintings from the Louvre, there was a remarkable series of exhibits from museums in Vienna, Berlin, and Munich, which brought "home" to us, as it were, scores of European master paintings of all kinds. Among the dozens of exhibitions I saw during those years, two stand out in particular: *The Virgin in French Art*—an unfortunate title for an exhibition mounted with taste and skill by Jacques Dupont, which included the major French primitives — and *Artistic Treasures of Medieval Italy* in 1952, with masterpieces by the Florentine and Sienese painters whom I was beginning to study. Those were blissfully ignorant years, when we didn't

realize how fragile paintings were or that they shouldn't be hauled around too often!

A number of art historians became true mentors for me in those years. One, Emile Mâle, cut an almost mythic figure as a thinker and researcher. We considered him a classic, the basis for any study of the Middle Ages and what is now called the Baroque. Although known as an iconographer, his work extends far beyond the strict study of images. Mâle and Focillon, both great writers, along with Emile Bertaux, dominated art history in France at the beginning of the twentieth century. Another prominent personality, this time in the field of medieval archaeology, was Marcel Aubert, the head sculpture curator at the Louvre. With his long, Rodin-like beard, Aubert had something unctuously Establishment about him, which we viewed with a certain amused condescension. His taste for power, for presiding over symposia, and for fondling his students earned him some rather cutting nicknames.

Focillon wasn't very old when he died in 1943, and I can only wonder what would have happened if he had come back to Paris. We considered him not only a major art historian, but also an enlightened political figure. A man of leftist sympathies, he had numbered among the founders of the Free French school in New York. His main students in France still had relatively marginal status, although one of them, Jurgis Baltrusaïtis, was already acquiring a huge reputation. In the immediate postwar period, he gathered friends every Wednesday at his home, Villa Virginie, with his wife, Hélène Baltrusaïtis, Focillon's step-daughter and student. I myself joined this group belatedly. People told me that you went to Baltu's house to have a drink, discuss art history, or listen to a presentation. Others continued that tradition, such as André Chastel, who received guests certain Sunday afternoons and served tarts made by his wife, Paule-Marie Grand. The

menagerie — dog, cats, parrot — was famous: later, when I partook of family meals at the Chastels', I learned that you had to move quickly if you wanted to eat a bite in peace before the cat got there . . . We brought friends visiting from abroad, and vice versa: it was Enrico Castelnuovo who first took me to Chastel's on Rue de Lübeck. That intellectual generosity fits perfectly into the tradition of Focillon, who dealt directly with his students. We also frequented another group of art historians at the home of Jean Babelon, the father of Jean-Pierre Babelon and son of Ernest Babelon — a real dynasty of art historians. Jean Babelon, a specialist in Spanish art, also received on Sunday afternoons. His passion for Spain attracted various individuals, such as Antonio Bonet Correa, the Spanish art historian, whom I met when he was a young man.

Among Focillon's students, Louis Grodecki and Chastel, the most brilliant of their generation, did not yet hold chaired positions at the university. Chastel taught at the Ecole Pratique des Hautes Etudes, which didn't grant degrees, but everything changed when he was appointed to the Institut d'Art in 1955. His articles in *Le Monde* also went a long way toward broadening his reputation. Grodecki, who worked for the government agency in charge of inspecting historical monuments, was a marvelous fellow, with an invigorating warmth and humor. It is striking to note that among our greatest art historians, were two Poles, Grodecki and Charles Sterling, who both became important French writers.

In 1950 René Huyghe left the Louvre and created the chair in psychology of art at the Collège de France. His departure from the Louvre saddened us: we knew that he had been a great curator, modern and innovative. And I came to appreciate his work at the museum even more when I succeeded him. He supported me on several occasions when I became head of the Paintings Department, even though some of our reorganizations, which modified his, ran counter to his taste.

When he presided over the arts council of the national museum board in the 1970s, I admired the freshness of his approach to the works presented for possible acquisition, his direct contact with them, his way of confirming the singularity and benefit of the objects we proposed. The following anecdote illustrates rather humorously what people already thought of Huyghe before the war. As the executor of Jean Vergnet-Ruiz's estate, I'm in possession of part of his diary. In it, he recounts that in September 1939, the museum board faced the problem not only of evacuating works of art, but also of mobilizing for war. He himself was mobilized as a military doctor; Sterling went into the army, and so on. And then comes this sentence, full of tender malice (for everyone liked Huyghe): "As for Huyghe, he enlisted in *le Génie*—of course."*

Another important art historian, Pierre Francastel, taught at the Ecole des Hautes Etudes. He was a significant figure, but he had less of an influence on me because I belonged to another school. The rivalry between Francastel and Chastel, which was personal as well as professional, only intensified as time went on. Francastel always endeavored to rediscover the social, historical, and intellectual context of creation by drawing on other disciplines in the humanities—which had long been the view of Erwin Panofsky and, in a word, of the Warburg Institute and the Viennese.

If many students at the time neglected iconography and knew almost nothing about iconology, it was mainly because we were used to contemporary art (at the time, this meant non-representational painting) and favored form and style over a painting's subject matter. Maurice Denis's motto seemed self-evident to us: "Remember that a painting, before being a horse in battle, a female nude, or a given anecdote, is essentially a flat surface covered with colors assembled in a

*Untranslatable pun: *le Génie* means both "the Army Engineering Corps" and "genius" (trans.).

certain order." In some cases, the complexity of a religious or secular subject drew our attention sufficiently to make us want to analyze it, try to decipher it. But personally, I didn't quite see how reading and interpreting the images might lead to a deeper understanding of the artist's themes and intentions (even unconscious ones) — and I confess that in this I was mistaken. The iconography of a Virgin with Child on a gilded background, for instance, is usually fairly commonplace, but not always. It is no coincidence that iconographic studies became more widespread in the 1960s and that contemporary art again became representational.

There were also special cases, such as Frederick Antal, who wrote Marxist art history. I read him early on, since he treated a subject that was of particular interest to me: Florence in the fourteenth and fifteenth centuries. The Marxist portion of his analyses was never dogmatic, for he was also a connoisseur. While he very usefully illustrated his research with an excellent analysis of the geographic, sociological, and economic context, he always based his theses on a profound knowledge of the works from a "positivistic" viewpoint.

On the other hand, foreign art historians, such as the Germans living in exile in the United States, were little read in France. The first translations of Panofsky did not appear until the early 1960s. Still, even though I'm glad the great texts have been translated and are widely available, it's not as if they were written in Bantu! A French art historian could read them in the original, if the need or desire was great enough — which is what I did, particularly for Panofsky's writings on the Quattrocento and the Flemish primitives.

Many of the great authors fleeing the Nazis had joined art schools in the United States and Britain. This crossbreeding would yield especially fruitful results in London — at the Warburg, of course, which was transplanted directly from Germany, and also at the Courtauld Institute. The confronta-

tion of cultures at the Courtauld produced a unique mixture, an extraordinary cocktail of ingredients. On the one hand, there was the English tradition of aestheticism, taken from Ruskin and Pater, which heightened the quality of the discourse, as well as the equally British practice of connoisseurship, maintained by a lively art market and active museums. To this was added the scientific rigor and historical imagination brought by the German and Austrian exiles. All of this took place in a locality furnished with masterpieces — when I was at the Courtauld, works from the collection hung in the classrooms — along with the best photo archive available and an excellent library, not to mention conservation studios that allowed us to study artistic techniques directly. This exceptional circumstance gave birth not to a method or ideology, but to a "Courtauld spirit," which recognizes the necessary plurality, and thus the complementary nature, of different approaches and research methods. It is certain that its postwar director, Anthony Blunt, was largely instrumental in this exemplary success.

As soon as Chastel gained the status of mentor, his first concern was to make us travel; he particularly recommended the Courtauld and the German institutes in Italy. What I found at the Courtauld, and especially at the Witt Library, with its formidable image bank, perfectly suited the research that I wanted to do into Italian painting. It was a bit different with the Warburg: the institute leaned more toward interdisciplinary research that fostered interpretive readings of the Renaissance and seventeenth century. Only later did I have reason to work there for specific research projects.

When I first started working for the Louvre in 1951, it was under some rather absurd-sounding job titles, such as "free attaché" and "unemployed intellectual." In fact, "unemployed intellectual" meant that I filled in vacancies, for which I was

paid a modest fee. Even as I continued taking courses at the Ecole du Louvre and the Institut d'Art, I conducted guided tours of the Louvre to make some extra money. My old friend Sylvie Béguin, who was then a young research assistant in the Paintings Department, got me hired as an intern in the Service d'Études et de Documentation. This remarkable office had been created before the war by Huyghe; the other curatorial departments didn't have one. Here, each painting owned by the Louvre was the subject of a large, scholarly documentary file, which was constantly updated. They also maintained a general photo collection on paintings, the beginnings of a photo archive similar to the ones that had been created and then abandoned at the Institut d'Art, and especially to the ones in London, New York, and The Hague. A rather remarkable individual named Edouard Michel, a French industrialist living in Belgium who was a specialist in the Northern schools, had donated his photograph collection and overseen the inauguration of this new office: its purpose was to facilitate cataloguing and research, both within the museum and at large. At the helm was Hélène Adhémar, Jean Adhémar's wife and author of an important book on Watteau. She ran the Service with a team that included Béguin, whose research on Italian Renaissance painting made her the most "modern" of the group. With hindsight, I realize how annoying I must have seemed to those women: in my youthful arrogance, I thought I knew everything!

As part of this job, I was assigned to a highly important project: identifying paintings found in Germany that might have belonged to Jewish collectors despoiled by the Germans. Soon after the Liberation, a number of works had been returned to France and restored to their rightful owners, but quite a few still remained unclaimed. I remember the genuine concern of the Louvre's curators with retracing the provenance of those paintings and finding their owners.

Toward this end, there was a large presentation of works in Compiègne.

Since 1947, I had been conducting research on museums in the provinces, without realizing that there was such a thing as an Inspection Department for provincial museums. I myself had already amassed and catalogued vast quantities of notes, photographs, and postcards. Mme Adhémar suggested I go see Jean Vergnet-Ruiz at the Inspection office, which was in the Louvre, to ask if I could continue my internship as part of his group.

I didn't know Vergnet, but I quickly recognized that he was a most uncommon individual. As inspector general of provincial museums, he ran a huge department and had considerable authority. I made an appointment by telephone, and when the day came, I went directly to his office without ever thinking to stop first at his secretary's desk. I still remember his amazed expression — tinged first with annoyance, then amusement — on seeing this Candide stride as naturally as you please into his office ... He immediately recognized my sincere interest in provincial museums and hired me for his Inspection team. This was in 1952, and an exhibition of Venetian painting was planned for the following year.

This position, needless to say, was unsalaried, though for me this wasn't as problematic as it was for some. I was already on track: as an accepted student, I should have been able to find a position after defending my thesis. Unlike today, interns weren't paid, and we had to find other sources of income to tide us over.

The matter of income brings me back to the way things were done before the war. Charles Sterling once said that, as a young assistant in the Paintings Department in the 1930s, he had been assigned to take the great Berenson, who was seen as God made manifest, on a tour of the Louvre's various holdings. In the Grande Galerie, Berenson suddenly asked him the

fateful question: "Are you independently wealthy?" Sterling, who didn't have a cent to his name (he was living on author's royalties from his catalogues and on a stipend), answered in the negative. Berenson's stinging reply was, "In that case, you had best find another line of work," which shocked Sterling to the core. The tradition of the aristocratic curator has certainly existed, but aristocratic in the academic sense: Paul Jamot was a *normalien* and an *athénien*—that is, a graduate of the Ecole Normale Supérieure and a member of the Ecole Française d'Athènes—even though his family owned a department store, the Belle Jardinière.

I don't honestly know why I chose the Italian primitives as my specialty. At the time, travel was much more difficult than it would be twenty years later, and I didn't yet know Italy. In reality, what interested me was painting in general. In the notes I still have from those years, jotted haphazardly during visits to museums and exhibitions, I find all sorts of observations, from naïve sketches stressing the main lines of a composition to impudent or infantile remarks and occasionally something less idiotic, such as a comparison between the Berlin Crucifixion now attributed to Hans Witz and those of Atonello da Messina. In any case, my appetite was boundless!

Once I began taking an interest in Italian painting, gilded backgrounds, Piero della Francesca, and Bellini, my admiration and readings tended toward Berenson, Roberto Longhi and his first pupils, Richard Offner, and, further back in time, Cavalcaselle, Raimond Van Marle, Adolfo Venturi, and Pietro Toesca. They tended, in other words, toward art history based on the study of a given artist's style with an eye to discovering and defining his particular manner of conceiving and painting a subject, analyzing what differentiated him from other artists, grouping artists from the same family into studios and schools—in short, adhering to notions of inven-

tion, influence, rupture, or tradition in a particular historical and geographical context. If the greatest historians of this type ultimately proposed their own vision of an artist's work, period, or school, all of them first sought to verify the attributions of the works in question, and when necessary, challenged them, suggested new ones, or situated them elsewhere in an artist's opus. In other words, they performed the work of a connoisseur and viewed them through the eyes of an expert. In the field of old paintings, few French historians belonged to that family at the time.

In this regard, Charles Sterling's return from New York, where he had been forced to take refuge during the war, appeared as a sign: he was the missing master, whose conception of art history was what a small but growing circle of young people, myself included, were looking for. Sterling had a huge reputation at the Louvre, where he had been a curator before the war, and his exhibition catalogues — such as *French Realist Painters of the Seventeenth Century* in 1934 or *Rubens and His Times* in 1936 — were milestones. Once back, he reclaimed his former office in the Paintings Department, with first René Huyghe, then Germain Bazin as chief curator.

I myself met him only later. But from the moment I began working with him in 1957 on the exhibition of the Lehman Collection, I never stopped seeing him or benefiting from his advice. I often went to his home on Avenue d'Iéna, a large apartment that had been allocated to him on his return from America in an annex of the Musée Guimet. He had moved his library and photo archives there. After delicious meals served by his wife, who had also been a student of Focillon's, he would show me his latest research. We were watched over by a photo of Focillon, which never left his study. His method was to demonstrate, convince, prove by making stylistic comparisons of images and backing up his statements with written documents and archival sources. As such, he left his mark on

me. He set about drawing artists' works out of oblivion (which for him meant anonymity or false attribution) like, as he said, a hunter in the darkness of the Middle Ages and reintroducing them into the light of history next to works that were already known — which were themselves constantly reexamined. And he succeeded. After his first books in 1938 and 1942 and a series of articles in *L'Oeil*, crowned by two large volumes on Parisian painting at the end of his long life, he recreated what French painting had been in the late fourteenth and fifteenth centuries. A bit like what Berenson and Longhi had done for the Italian primitives, or Chandler R. Post for the Spanish, or Max Friedländer for the Flemish primitives. He played the role of discoverer, but more than this he offered a new, coherent critical and historical vision, from a European perspective, of painterly creation in fifteenth-century France.

Sterling left the Louvre in 1961 to teach several months out of the year in the United States at the Institute of Fine Arts at New York University, just opposite the Metropolitan Museum, where he had been a curator during the war. But he kept his publications, research, and family life in France. I went to visit him in his beautiful country house in Bréval, to ask his advice about an acquisition or attribution, or simply to chat with him, his wife, and his daughter. Ever a friend of the Louvre, Sterling left his library and photo archive to the Paintings Department.

I remember clearly — I was still in *lycée* at the time — the first Salon d'Automne in 1944 after the Liberation. An entire room was devoted to recent works by Picasso. I can still recall the paintings, several of which are now at the Pompidou Center, such as *L'Aubade* (1942). I also recall a classmate telling me in the spring of 1947 that Bonnard had died, which suggests that I was already interested in contemporary painting by then. I have another, very intense, memory from the sum-

mer of that same year: a sense of dazzlement in a gallery of the Palais des Papes in Avignon. On the back wall, black, green, and violet, Picasso's *Night Fishing at Antibes*; and nearby the large *Moroccans* by Matisse (both today in the Museum of Modern Art in New York), as well as dozens of other works by every major living painter. I still have the catalogue of that prodigiously insightful exhibition, which was organized by the Zervoses. This full frontal explosion of painting is surely what triggered my appreciation of modern art. Before that, I had seen at the Louvre works formerly on wartime deposit in Montal or Montauban. René Huyghe, eager to show these paintings as quickly as possible — this must have been toward the end of 1945 — had mounted an extraordinary show in the Daru gallery. Cézanne's *Card Players* hung side-by-side with those of Le Nain, and Gauguin juxtaposed a seventeenth-century Spanish painter. Huyghe excelled at those kinds of association. Very early on, then, I had the sense that there was no difference between old and modern painting. Huyghe was also behind the creation of the Impressionist museum at the Jeu de Paume; I remember its opening in 1947, the way the light from its windows shimmered on these "modern" paintings.

It was also in 1947 that the Musée National d'Art Moderne (MNAM) opened its doors with Jean Cassou as director. Visits there soon became *de rigueur*, and Jean Coural and I went every Sunday morning. We were a bit like the many American artists and students who first learned to look at art at MoMA — although they had more material to absorb. Little by little, we saw the installations at the MNAM change, the collection become richer. Indeed, Cassou endeavored with energy and conviction to increase his holdings or simply to fill in what had been glaring holes before the war. He had gone to see acquaintances such as Picasso, Braque, Bonnard, Léger, Chagall, and Matisse to obtain donations or buy works at the

"friend's discount," and what he did manage to obtain was quite remarkable. Might they have given more? We can always dream. Matisse's *Moroccans* hung at the museum for many years before being returned: might we have kept it? Would Bonnard have given one of his most beautiful canvases, *The Terrace at Vernon*, now in Düsseldorf, if Cassou had been greedier or less tactful?

Nonetheless, the collection continued to grow, and during those years the MNAM took in works by Pevsner, Kupka, Delaunay, and later Kandinsky and Brancusi; but there was no representation of Klee (or very little), nor of Mondrian, the German Expressionists, or the Italian Futurists. The notable absence of Surrealism no doubt reflected the curators' tastes: apart from Max Ernst and Miró, Surrealist painting was generally considered too "literary," especially by Bernard Dorival. No Balthus either, even though he figured in the Avignon collection.

Regarding Cassou himself, I never really knew him until late in his life, when he very kindly said to me (which I found very flattering), "I regret not having met you sooner." I admired him greatly, and Roseline Bacou, who had been his student at the Ecole du Louvre, always spoke of him with respect and affection. On top of which, he had the aura of his legend as a member of the Resistance. Had he wished, he could have been a cabinet minister after the Liberation, but instead he preferred to return quietly to his office at the modern art museum, from which he had been removed by Vichy. Cassou was a warm and lively figure, with eyes full of mischief and wisdom and an uncommon intellectual generosity. His open-mindedness showed not only in his acquisitions, but in his very personal exhibitions, such as *Sources of the Twentieth Century* in 1960 — real milestones, all of them.

Speaking of Dorival, in 1946 he published *Contemporary French Painting*, in which he celebrated the "young painters in

the French tradition" — Bazaine, Le Moal, and Manessier. I bought the book the moment it came out, and I still have it. But we have to keep the dates in mind: the book analyzes the situation up until 1944. The latest movements Dorival discusses had mainly emerged under the Occupation and included the "young painters in the French tradition" whom he had courageously shown at the modern art museum, which reopened in 1942; many of these painters had since become non-representational. By the years 1948–52, when we were visiting dealers' galleries, which at the time were plentiful and very active, another wave had hit with Nicolas de Staël, Hartung, and later Soulages. My own tastes ran more to these latter. I admired some of Manessier's canvases, but his work sometimes had a stained-glass-window aspect that I found less appealing. I preferred the intellectual of the group, Bazaine (especially his gouaches, which I saw at Maeght's), and their elder, Roger Bissière. I later met Bazaine; he showed me sketchbooks containing marvelous drawings from life that demonstrated a remarkable sensitivity to the real world. It was bit different for Tal Coat: with him, I appreciated the way he translated his admiration for Cézanne, especially the watercolors.

There were many other figures in what Charles Estienne called — in 1952, I believe, for a memorable group show at the Babylone gallery — the "New Paris School," notably Singier, Le Moal (who would later create beautiful stained glass windows for the Saint-Malo cathedral), Atlan, Ubac, and Piaubert. I'm leaving aside Lapicque, whom I met at Denise René's. In my notes, I had written, "Average Frenchman, like Victor Boucher." We liked his drawings and black ink sketches, which were very strong and painterly, more than we did his paintings with their (overly?) lush use of color. Still, maybe time is on his side, as it might be for Estève.

Then came the "black" group, with Hartung, Schneider, and

Soulages, who showed with Lydia Conti on Rue d'Argenson —
one of the best gallerists of the time. Gérard Schneider is
unjustly forgotten today. I recently rediscovered his large
canvases from those years, which are resplendent with picto-
rial intensity. I developed a personal rapport with Soulages
early on. He had welcomed our student group from the
Institut d'Art into his studio on Rue Schoelcher and, as one
might expect, had enthralled us. He was always able to speak
of his painting eloquently and simply. We became friends,
and I still admire what he's doing: some of the paintings he
recently showed in Paris, less monumental than his "polyp-
tychs," show yet another exciting evolution in his work.

Conti's little gallery showed a different installation every
month. I bought a Hartung and a Schneider charcoal draw-
ing there. We also paid frequent visits to Denise René's on
Rue La Boétie, where we could see artists such as Vasarely,
Mortensen, Poliakoff (at least at the beginning), and most of
the artists from the New Paris School. It was from that gallery
that I bought a Poliakoff canvas in 1949, which I paid off
in installments over many long months . . . On reflection, it
seems to me that gallery owners were quite generous at the
time, for Coural and I were simple students who hardly
looked like golden boys. I recall us at Pierre Loeb's, who had
been a friend of the Surrealists, in his gallery at the corner of
Rue de Seine and Rue des Beaux-Arts, where Coural bought
a magnificent drawing by Giacometti, a *Studio* from 1940. We
walked out without having to pay for the drawing! Loeb had
never seen us before, but he no doubt sensed our passion and
told us to come back and settle the bill when we could. He
even ran after us in the street to give us a frame for it.

At Denise René's, we also liked Jacobsen. The Danish
sculptor, who assembled pieces of metal like Calder or
González, doesn't have the recognition he deserves. The same
for Gilioli. I was less attracted by the cold, regular, calculating

side of Vasarely and Dewasne, who nonetheless evolved considerably when he adopted large formats. I have good memories of the more discreet Deyrolle, by whom I have a beautiful gouache. But for us, the dominant figure was de Staël. His works could be seen at Dubourg but were unfortunately too expensive for our student budgets. I still remember his tiny panels, precious like Seurat's "*croquetons*" (little sketches). Each one went for fifteen thousand francs at the time — more than Giacometti. There are several of them in the Granville donation in Dijon, which, fifty years later, still hold up admirably.

In pictorial landscapes, there was also the "concrete" tendency, incarnated (in a manner of speaking) by Herbin and the Salon des Réalités Nouvelles. It wasn't entirely our world, and it struck me — and still does — as too hard, too dry, too "enameled," unlike their model Mondrian, who remains a painter's painter. Magnelli, whom I met at Denise René's, was an imposing individual. In my notes, I described him as an "Episcopal Léger": he had some of Léger's massive stature, but was more unctuous. I never met Léger, only glimpsed him once at the Closerie des Lilas; he had the same squarish, tough look as his paintings.

After 1950–51, it seems to me that things hardened a bit. At the Salon de Mai in 1950, if I remember correctly, positions became more entrenched: concrete art and geometric abstraction on one side, lyrical abstractionists on the other.

Not surprisingly, this gave rise to a number of disputes, notably among Léon Degand, Charles Estienne, and Michel Tapié. I read Estienne's articles in *Combat*. He was an excellent critic, somewhat reticent vis-à-vis geometric abstraction, and was the inspiration behind a gallery located on Rue de Beaune, run by Suzanne de Coninck. I don't believe she had any artists under contract, but made arrangements with them as needed. I saw Poliakoff gouaches there, as well as lesser-known artists such as Istrati or Yves Klein's mother, Marie

Raymond, by whom I own a small gouache — not exactly a work of genius, but indicative of the times. The role de Coninck played has not been sufficiently underscored in recent histories of the period. She published the first French edition of Kandinsky's *Concerning the Spiritual in Art*, and in 1950 she launched a collection of short monographs — Signes, edited by Roger van Gindertael — on modern artists such as Kandinsky, Villon, and de Staël, with others planned on Arp, González, Hartung, and so on. It cost her her fortune, moreover.

There was also Vieira da Silva, whom I met at Dora Vallier's; I admired her works enormously, but could never buy any of them. Other names I could cite are Zao Wou-Ki, who would become a friend; Degottex, whose work has aged beautifully; and Chapoval, a gifted Russian whom they found one day dead in his bed. He used to exhibit at Denise René and at Jeanne Bucher, where Bissière also showed. On Boulevard du Montparnasse, Bucher was run by Jean-François Jaeger.

In fact, our tastes were not much different from a Dora Vallier or Geneviève Bonnefoi or Gildas Fardel, a modest collector who left his collection and document files to the Nantes museum. Bonnefoi, who still champions the Paris of those years with great conviction despite its current neglect by official Parisian circles, organized an exhibition of those artists last summer in her abbey in Beaulieu. It moved me to see it — though sadly I wasn't able to share my emotion with Jean Coural, who had passed away the year before — and, plainly put, I felt no embarrassment over what we had loved in our youth.

Two other figures, independent and unclassifiable, caused a sensation at René Drouin's shortly after the war: Jean Fautrier and Jean Dubuffet. During the Occupation, Fautrier had painted politically committed works, his *Hostages* series, which were frankly affecting. Like the tragic Wols, he was

greatly admired by the writers associated with the *Nouvelle Revue française*, such as Malraux and Jean Paulhan. As for Dubuffet, I don't really remember him from those years, having seen and admired his work only later. On the other hand, I have a clear memory of the Kandinsky exhibition at Drouin on Place Vendôme, I believe in 1947. At the time, there was only one painting by him, and not a very good one, at the modern art museum.

Around the Saint-Placide gallery, people were also talking a lot about "miserabilism," notably in the works of Gruber; Bernard Buffet, who at first had something truly strong and original to say when he painted on bedsheets; Lorjou, an artificial explosion of paint; and the sad Minaux. The tendency didn't last long.

Another important development in art history at the time was the emergence of the new American painting. I wish I could say that I saw the Pollock exhibition at the Facchetti gallery, or *Vehemence Confronted* in 1951, but it isn't the case. I knew Tobey, who was more like the Parisians. I became a less active observer of the galleries as of 1953–54, absorbed as I was in my work for the Louvre and my trips to the provinces. I was no longer a student by then and had a full-time job. But I never lost my interest in recent works, in following the progress of the artists I had loved as a student, or in seeing others of the same family emerge, such as Olivier Debré, Tàpies, Geneviève Asse, Hantaï, and the great Americans: Rothko and Barnett Newman, then Jasper Johns (it's no surprise, given my inveterate taste for painterly painting, that I preferred him over the other Pop artists) and Sam Francis. But I'm getting ahead of myself.

Even as I was discovering new artists, I never lost my interest in films and literature — though what I can say about them could be said by many of my generation, who experienced

the same jolts of passion and today have the same nostalgia ... From early on, I began frequenting Henri Langlois's Cinemathèque Française, which at the time was on Avenue de Messine, not far from Louis Carré's gallery (where one could see Dufy, Villon—highly admired at the time, but today fallen into a scandalous purgatory—and Lanskoy) and the Maeght gallery, which carried Braque, Chagall, Miró, and Calder, the great men of the house. At Maeght, I saw with jubilation the Surrealist exhibition of 1947, entering under curtains of rain, the tennis players sitting on pool tables ...

In a tiny room, Langlois sometimes projected real oddities, such as prints of American films subtitled in Danish, or Russian films in English. It was there that I discovered Dreyer, Eisenstein, German Expressionist cinema, Murnau's *Sunrise*, with its incredible tracking shot, Flaherty, von Stroheim, and many others. As of 1947, when I started at Lycée Henri IV, my friends and I went to the movies sometimes twice a day, especially to the Champollion. We absorbed everything: Carné's films from before the war, *Drôle de drame*, *Rules of the Game* by Renoir—which remains one of my favorite films—Pagnol, Feyder's *La Kermesse héroïque*, the Marx Brothers seen over and over again, *Hellzapoppin*, any western, Cukor and MacLaren and Lubitsch, and, of course, Orson Welles. And then came Ray (*Johnny Guitar*), Aldrich (*Kiss Me Deadly*), *The Barefoot Contessa*, and *Lola Montes*, discovered enthusiastically on its opening day, despite the public's chilly reception. And the Italians: Rossellini, De Sica, Visconti. In a word, I loved the cinema.

As for literature, for my generation there were Sartre's novels and plays, of course, but we liked Camus even more. I also remember very well the news of André Gide's death spreading through the Latin Quarter in 1951. He still exerted an extremely strong power of seduction over young people. For us, Gide was the *Nouvelle Revue française*, *Lafcadio's Adventures*, the

Journal, the correspondence, *Marshlands*, which I read and re-read . . . When they staged *Lafcadio* at the Comédie-Française, we rushed to see it. It wasn't a very good adaptation, but I've heard that Gide was delighted. It featured a very young Jeanne Moreau in the role of Carola Venitequa, and Lafcadio was played by Roland Alexandre, who died shortly afterward.

Our great references at the time were Malraux, as I've said, Aragon for his novels, François Mauriac, and Jean Giraudoux. I particularly liked Roger Martin du Gard, and I've developed more of a fondness for him since the publication of his diaries. Proust, of course, read straight through, like *War and Peace*. And then Conrad, and Americans such as Hemingway, Dos Passos, especially Faulkner, and also Henry Miller. As I said, nothing very original here, other than an enormous appetite, a taste — which still persists — for literary history: literature that tells its own story, if I may put it that way. I'm among those who devoured the memoirs of Gide's confidante Maria Van Rysselberghe and who are still waiting for the last volume of the unexpurgated edition of Flaubert's correspondence to come out. All of this without "politically correct" prejudices: I read Jules Vallès just as well as Gobineau's *Les Pléïades*, Aragon's *Aurélien* as well as Drieu la Rochelle's *Gilles, La Négresse blonde* as well as American detective stories.

On the other hand, I didn't have much of a taste for philosophy, though it happened that I met Martin Heidegger. Jean Beauffret, who was a friend of Jean Vergnet-Ruiz and a professor at the Ecole Normale Supérieure, had introduced Heidegger in France. During one of the German philosopher's visits to Paris, Beauffret had asked me to show him around town, and had asked Gérald van der Kemp and Jean Coural to do the same in Versailles. But no spark passed between us. He spoke little, and looking every inch the middle-class German, he walked around with the low-level curiosity of an average tourist. At the time, no one mentioned

his stances during the Nazi period: it was enough that Beauffret, who had been in the Resistance, vouched for him.

I still went to the theater quite often. My memories of those years include, in no particular order, all the shows staged by Jouvet, lit by the genius of Christian Bérard (*The School for Women, Don Juan*, Jouvet and Moreno in *The Madwoman of Chaillot*); Roland Petit's ballets at the Champs-Elysées, such as *Le Jeune Homme et la mort* with Babilée and *Les Forains*; *Waiting for Godot*; the Théâtre National de Paris, of course; Claudel's *Break of Noon*, which remains one of my best memories. It was standing room only at the Marigny theater, and Brasseur and Feuillère were in white on the bridge at noon . . . And we also loved the Grenier-Hussenot company, Bobino, the Frères Jacques, Edith Piaf, and Yves Montand. And also the variety shows at the Casino de Paris and the Folies-Bergère, which delighted us with their popular naïveté: Josephine Baker as Mary Stuart, singing Schubert's *Ave Maria* surrounded by bare-breasted women holding candles, is not something you forget easily! Or else — but in this case, the comedy was voluntary — the very fat black American singer June Richmond as Gilda, crowned with blond locks, in the quartet from *Rigoletto*, which made us laugh so hard that we went back again with a group of future *chartistes*.

To stay in the so-called cultural domain, I read *Arts, Combat* (for Charles Estienne's articles), and *Le Monde*, notably for Chastel's articles. I also checked the family copy of *Le Figaro* to find out what plays I absolutely had to see. As a rule, if Jean-Jacques Gautier's review was bad, you could be sure that the play would be good.

As for music, I still remember an exceptional performance of *The Magic Flute* by the Vienna Opera in Paris, directed by von Karajan, with what at the time was a dream cast: Seefried, Dermota, Lipp, Kunz . . . It might have been this *Flute*, to which I had been dragged by a friend, that triggered my love

of opera. Needless to say, I also take great pleasure in chamber music: Ravel's Trio was one of my first records.

I also remember a miraculous *Così fan tutte* in Versailles, in the small Théâtre de la Reine at the Trianon. In 1956 Coural was a curator at the chateau and got us in to see the dress rehearsal of a performance that preceded the Aix production with Nan Merriman (Teresa Berganza would succeed her in Aix), the wonderful Teresa Stich-Randall, and Marcello Cortis, directed by Rosbaud. There was also another *Così*, from Aix but this time restaged in Paris in 1963 at the Opéra Comique, with sets painted by Balthus (where are they today?) and sung by Schwarzkopf. In the early 1960s, Jean and Chantal Coural and I traveled regularly to Aix-en-Provence during the grand festival season, back when Gabriel Dussurget was musical director.

When it came to music, I also learned a lot from Jean Vergnet-Ruiz, who was quite knowledgeable, particularly about vocal music; his record collection was legendary. As I frequently traveled abroad, he often asked me to buy him records that couldn't be found in France, by this or that singer from the beginning of the century: Pol Plançon, Claire Croizat, or Litvine. He had no prejudice or snobbery in that regard. He was one of those people, for instance, who couldn't abide Callas. Perhaps he would eventually have changed his mind if he'd listened to her more carefully, but he could never understand my enthusiasm.

True opera lovers love everything at once: Offenbach and Monteverdi, *The Barber of Seville* and *Wozzeck*, *La Traviata* and *Carmen*. In the 1950s bel canto was not yet fashionable, nor was Baroque opera, and purists recognized only *Otello* and *Falstaff* among Verdi's works. Music lovers, notably Wagnerians, and even more so some lovers of twentieth-century music (not all: I knew a few dissidents), considered Puccini and Verdi mere popular music. But Vergnet loved everything. He didn't

care too much about the staging, so long as it was sung well. He and I saw a *Trovatore* at Covent Garden, with Zinka Milanov and Fedora Barbieri, the great cast of the time, although the lead (was it Björling?) didn't show because of illness. But the performance wasn't canceled, and instead they brought on a tenor who had almost no voice left and who had not been onstage in many years, a tall thin fellow who sang in English, his score in hand. With its corny sets, that production had an utterly eccentric side to it that I found delightful.

Before Rolf Liebermann's arrival in 1973, many performances at the Paris Opera were still sung in French, and the general appraisal was that the musical level was woefully subpar. There were a few exceptions, among which I fondly remember *Les Indes galantes* and *Oberon* in the time of Maurice Lehmann; *Carmen* and *Don Carlos* with sets by the great Lila de Nobili; several sumptuous appearances by Crespin in Wagner, Glück, or Verdi; the admirable *Wozzeck*, directed by Boulez and staged by Barrault, with sets by André Masson; an unforgettable evening from the time of Auric; and Callas's belated, celebrated appearances in *Tosca* and *Norma*.

Preceded by an admirable *Femme sans ombre*, the arrival of Liebermann, invited by Jacques Duhamel and urged to accept by Dominique Ponnau in Hamburg, marked a true revolution. And since we're talking about opera, let me jump ahead in time to stay with the subject. I had great admiration for Liebermann; he was a true leader, who dexterously blended humor with authority. In 1975 he asked me to come up with a large exhibition at the Grand Palais to celebrate the centennial of the Opera house. With Martine Kahane's assistance, I created a true synopsis. In the first room, to prime the audience, we planned to project the famous scene of the Bohemian chorus from the Marx Brothers film *A Night at the Opera*. Then came a series of spaces featuring mock-ups of stage sets, costumes, paintings, and documents that evoked

the history of staging and choreography, from the Royal Academy to the present: the great musical productions, Romantic ballet, Meyerbeer, Wagner, Verdi in Paris, Degas at the Opera, the Ballets Russes, Jacques Rouché, and so on; plus the great myths (*The Phantom of the Opera*) and the social scene (prominent subscribers, *Les Petites Cardinal*). We also planned to intersperse serious sequences with humorous interludes (Wagnerian fripperies and mountains of stage jewelry; the swan from *Lohengrin*, sold as a wind-up toy at the Opera exit, and so on). And in a side aisle of the Grand Palais we wanted to recreate beautiful sets commissioned from painters (Utrillo, Max Ernst, Léger, Masson). In short, it was a serious and entertaining project, but no doubt too costly, and it never went beyond the planning stage. Too bad.

In Bayreuth, I attended the famous *Ring* by Boulez and Chéreau, which remains one of my great experiences of performance, as do Mnouchkine's *1789* and Ronconi's *Orlando Furioso* at the old Les Halles. I had seen most of Chéreau's shows, beginning with his *Richard II* at the Odéon — an unforgettable overture in total darkness and Callas's voice singing "Don fatale" from Verdi's *Don Carlos*—with sets by Richard Peduzzi, who would work with me on Orsay and the Louvre and become a dear friend. And I often went to Covent Garden, which was then indisputably one of the world's great opera houses, during a period when I was often in England to see dealers.

Like many opera lovers, I could devote many pages to my opera memories, full of remarkable evenings and delightful oddities, such as an overheated *Semiramis* by Rossini with Sutherland and Horne in Chicago. In Philadelphia, a stodgy *Traviata* with Caballé, who rarely sang it onstage (easy to see why), and a young Carreras. Another *Traviata* at the Met, with Beverly Sills at the end of her career, but affecting for that very reason. An open-air *Tosca* in Naples, with the very un-

Roman bay as background—just as *William Tell* did not look very Swiss in the thermal baths of Caracalla—and another *Tosca* at the San Carlo, where our ambassador discovered that the second act took place in his office. And yet another *Tosca* in Paris, where an insufficiently built chair could not stand up to the amorous superimposition of Pavarotti and Hildegard Behrens. A *Carmen* sung in Hungarian, Italian, and French in Budapest. A particularly tense *Samson and Delilah* at La Scala— for at the preceding performance, the final fall of the temple had caused someone's death. The appearance, in a Vienna performance of *Flute*, of a bewigged and doddering elderly gentleman in the role of Tamino, who to my astonishment was hailed by the audience at the end of his first aria. He turned out to be Anton Dermota, who had come out of retirement for one special performance, and who, despite his age and the decline of his voice, was still a fine musician. I had seen him thirty-five years earlier in the same role— which is as good a way as any of bringing us back full circle.

2

An Inspector of
Provincial Museums

Let me come back to the structural reforms that affected the museum world after 1945. The overall plan, partly conceived during the war by Louis Hautecoeur and Jacques Jaujard, entailed state control over all French museums. A system was created that included the national museums — essentially those in greater Paris, plus the larger chateaux: Versailles, Compiègne, Fontainebleau, and a few others, such as Pau in the provinces; the classified museums, in other words the thirty or so museums in France's other major cities, whose curators had the same qualifications as in the national museums; and finally "controlled" museums.* A newly created bureau, the General Inspection of Provincial Museums, employed a corps of inspectors to help it exercise its functions. This reinforcement

*Public museums, generally associated with political entities (towns, *départements*, regions), whose collections have been designated an inalienable part of the national patrimony (trans.).

of the state's role after the war was entirely justified, as the aim was to implement a comprehensive policy of modernizing or rebuilding museums, restoring and studying the collections, and opening the doors to more work by living artists. The project, which would receive government funding, necessarily involved initiating a dialogue between Paris and the provinces.

During the Occupation, the main figure in the museum world had been Jaujard, director of the Musées Nationaux, who deserves credit for keeping the national collections on home soil. He also did everything in his power to prevent threatened Jewish collections from being removed — in vain, unfortunately, apart from a few exceptions. His subtle and risky strategy managed to prevent the loss of Boucher's *Diana* and to keep the Basel Altarpiece in the Cluny museum from being repossessed as German property. He played a major organizational role in preparing for the postwar period. After the Liberation, he was appointed general secretary of the Ministry of Arts and Letters.

The new position of director of the Musées de France, instead of director of Musées Nationaux, which also entailed administrative supervision over provincial museums, was given to Georges Salles. A specialist in Asian art, as well as a collector and art lover in his own right, Salles also had personal contacts with contemporary artists, notably Picasso, and so very quickly the tone was set. It was he who commissioned Braque to paint a ceiling in the Louvre, which I saw being executed in the Flore Wing. He was a remarkably charming and seductive man, who knew how to use his aristocratically nonchalant manner to advantage. He would no doubt have preferred the modernization process to be faster and more complete. Given his taste for contemporary architecture, he regretted that certain displays were anything but. Shortly after its reopening, Jean Coural and I, two young

assistants at the time, visited the Cluny. We suddenly saw the director of the Musées de France walk up to us and, with a grand gesture toward the newly installed yet old-fashioned display, proclaim, "There you have it: this is the exact opposite of what I like."

The return of Jean Cassou as head of MNAM, Salles's appointment as director, and the arrival in the larger provincial museums of young curators, some of whom were passionate about contemporary art, combined to provide — independently of the structural reforms — the openness that had so sorely been lacking in those museums before the war. Jaujard, as general director of the Ministry of Arts and Letters, enjoyed an authority that extended well beyond the museum sphere, since he was also responsible for theater and music. Even he probably didn't realize how much of an appetite for contemporary art was spreading throughout France. He had several truly remarkable individuals around him, especially Jeanne Laurent, who did so much for "public" theater with the TNP, the extensive campaign to open new theaters in the provinces, and so on. But we still felt that the state was taking a rather timid approach to artistic creation and public commissions — nothing comparable to what was being done in the domain of sacred art, at Assy, Audincourt, or at Vence with the Matisse chapel.

Jean Vergnet-Ruiz took over as Inspector General of Provincial Museums in 1946. He had a very particular background, having done advanced studies in art history after completing a medical thesis on Cosmas and Damian, the patron saints of his profession. As a young man, he had been a close friend of the writer Louis Aragon, but this relationship had cooled (as had so many other friendships of Aragon's) after Aragon married Elsa Triolet, who made sure to clear the ground around her handsome Louis. His personal tastes corresponded precisely to what was needed in Inspection: a

broad-ranging historical and literary education, knowledge of highly varied fields of art history, and a refreshing lack of pedantry. Before the war, he had worked in Versailles under Gaston Brière, a great scholar who had endeavored to restore certain rooms of the castle (which had been utterly despoiled during the French Revolution and "modernized" under Louis-Philippe) to their original eighteenth-century appearance. Vergnet had been trained in that tradition before joining the Paintings Department of the Louvre, which was then run by Paul Jamot, the very model of an old-style department head. It was there that he came to know the curators or attachés who would become his friends, Jacques Dupont, Charles Sterling, and Marie Delaroche-Vernet.

Jamot left a strong imprint on the Paintings Department, and those who worked there were devoted to him. He had written on the three Le Nain brothers, offering the first hypothesis of how to attribute their individual paintings, and was one of the first to recognize the importance of Georges de La Tour. In declining health, he finally handed over responsibility for the 1934 exhibition *French Realist Painters of the Seventeenth Century* to Charles Sterling, who made a great success of it. Also in that department was the young and brilliant René Huyghe. This remarkable team partly dispersed when Jamot retired in 1937 and Huyghe succeeded him. By then, Vergnet had left the department to run the recently established research laboratory: they figured that since he'd been a doctor, he knew all about X-rays and ultraviolet! He didn't stay there long, and afterward became curator of the chateau in Compiègne, where he set about refurbishing the place, following on the example of Versailles. Subsequently, the renovation effort was furthered by the fundamental work of Pierre Verlet, reinforced by his systematic study of the archives.

Faced with the task of defining a general program for

provincial museums, Vergnet began by establishing that a museum, whatever its status, should not try to become a miniature Louvre, but rather should have its own character, determined by its particular history and standing collections. The Condé museum in Chantilly, for instance, was formed by the will of the Duc d'Aumale and should remain basically untouched. Conversely, most other museums are expected to keep pace with the times by expanding their holdings and updating their displays.

Not only did Vergnet have a specialist's erudition, especially in eighteenth-century painting, but he also had the broad curiosity of the people of that century, which allowed him to sense the important element in each museum, whatever its specialty. The man's generosity, humor, simplicity, and dynamism had allowed him to create a network of friends throughout the country, which was essential if one wanted to create a common mind-set. We gathered in the Inspection offices at five o'clock over a quick cup of tea, which allowed visiting colleagues to meet and discuss matters of mutual interest. Vergnet also welcomed colleagues to his home, where they were well received—he was quite a gourmand. This "conviviality," which today goes with the job, seemed to come quite naturally to him.

In the years around 1945, as later in the 1980s, the emphasis was on complete renewal. The first matter at hand was meeting the material needs of the postwar period: the museums in Brest, Douai, Beauvais, Caen, Orléans, and elsewhere had been destroyed, along with parts of their collections. Since the 1930s, museum layouts had become somewhat codified, as architecture in countries like the United States, the Netherlands, and Switzerland became more rational: they weren't content merely to fix up old buildings, but rather built entirely new ones to modern standards. In France the postwar period accelerated the need for these widespread

recastings and rethinkings of how works were exhibited. The basic mission of Vergnet and his colleagues at Inspection was to back the curators and to encourage town authorities to give their local museums the requisite funding. Actively supported by the state through government grants, this policy had a clear-cut objective: to restore and study the collections, reopen the museums, and modernize them following a cogently defined program.

Paris's intervention in this regard was favorably received, even highly desired. The museums had everything to gain from it. Not that it was an idyllic arrangement in every case. But when Vergnet and his inspectors went to work, they brought with them intellectual and scholarly resources to support the curators, as well as financial resources to help the municipalities. Nor could the undertaking have worked without the new generation of curators who came on the scene, often better trained than their predecessors, enthusiastic, and eager to open their museums to new audiences and new forms of art. I got to know most of them fairly well. They were faced with an exciting challenge: starting with ruins or with their holdings packed away in crates, they had to put the national heritage back on display and recapture the public's interest. Some of them already had experience, like Pierre Quarré in Dijon, Hans Haug in Strasbourg, Jean Claparède in Montpellier, Luc Benoist in Nantes, René Jullian in Lyon, Boris Lossky in Tours, or Maurice Allemand in Saint-Etienne. There were also younger ones, who often held degrees that their elders didn't, such as Georges de Loÿe in Avignon, Jean Leblanc in Ajaccio, and a certain number of women, such as Marie Berhaut in Rennes, Olga Popovitch in Reims and then Rouen, Marie-Lucie Cornillot in Besançon, Gilberte Martin-Méry in Bordeaux, Françoise Debaisieux in Pau, and Jacqueline Pruvost in Orléans.

When I started working for him in 1952, Vergnet was con-

stantly on the road to negotiate with local mayors, define projects with curators, see architects, or obtain grants. But the goal was not to create a standardized museum model; rather, the mission of each museum was to underscore its own particular qualities. For example, since the painter Hyacinthe Rigaud, a native of Perpignan, placed great value on his provincial origins, increasing the Rigaud holdings at the Perpignan museum seemed self-evident. It was important to honor the area's native sons and daughters — Ingres in Montauban, Joseph Vernet in Avignon, the Alsacians in Strasbourg — or to bring them back home, as with Max Jacob in Quimper or Henri Gaudier-Brzeska in Orléans. In the case of a museum like Grenoble, which already had a rich collection of modern art, it made sense to continue in that direction. The Lille museum owned a number of Flemish and Dutch works; it therefore seemed appropriate to keep building the Northern holdings rather than stop up gaps with one or two more Italian paintings. The Musée Goya in Castres was a typical case of a museum that owed its riches to chance: the painter Briguiboul, a native of that city, had bequeathed it a number of major works by Goya. Through a series of exchanges with other museums, it has become the great French repository for Spanish painting, from the primitives to the twentieth century. Just as in Bordeaux, a small section of English paintings from the eighteenth and nineteenth centuries was created to reflect the city's long-standing Anglophilia. And many other examples could be cited. There was also strong encouragement to create departments devoted to folk arts and traditions, local history, or a given region's particular specialty: clock-making in Besançon, for instance.

We also helped foster donations, such as the one by Georges Grammont. I saw his magnificent collection of modern paintings in his apartment on Ile Saint-Louis: Seurat,

Signac, Bonnard, Van Dongen, Vuillard, the most beautiful Fauvist painting by Matisse in France, *Gypsy*, which is now housed at the Annonciade museum in Saint-Tropez... Vergnet had two sentimental and familial attachments: the Oise, where he was born and died, and the Franche-Comté. He bequeathed a portion of his library to Chantilly in testament to his passion for everything having to do with the history of the Oise region. He was a close friend of another Franche-Comtois, George Besson, an extraordinary individual whom I knew well, an unrepentant old Communist from before the war, who worked as a pipe manufacturer and art critic. He had become friendly with a number of artists who were then considered avant-garde; his portrait had been done by Bonnard and Matisse, and his wife's by Van Dongen. In his apartment on Quai de Grenelle, he had integrated into the woodwork two large compositions by Bonnard — *Place Clichy* and *Café "Au Petit Poucet"* — which the painter sometimes touched up when he visited his old friend, also making the necessary touch-ups when the radiators or wood trim got chipped. Besson had been one of the great critics before and after World War II, responsible for several series of books on the history of painting, notably the precious Collection des Maîtres that he edited for Braun, small-format books, each with sixty black-and-white illustrations. He wrote for the Communist newspaper *Les Lettres françaises* out of political loyalty, but I can vouch for the fact that he was no Stalinist. Despising abstract painting, after the war he championed artists like Desnoyer or Walch, who weren't bad, but who couldn't compete in stature with the artists he had defended in his youth. Besson split his collection between the Besançon museum, in his native region, and Bagnols-sur-Cèze, home to his friend the painter Albert André, who after World War I had helped establish a small contemporary art museum. To celebrate the Besson donation, an exhibition was organized

in 1965 at the Louvre in the Mollien gallery, of which I was in charge. The morning of the opening, just when Malraux was supposed to arrive, we learned of the sudden passing of Adèle Besson, as she was preparing for what was to be, for her and her husband, the crowning moment of a lifetime of struggle and generosity. Malraux, ever attentive to signs of fate, had a bouquet of flowers placed beneath Van Dongen's portrait of her.

Beneath his jovial exterior, Vergnet believed in the strict virtues of erudition and the need for scholarly rigor; he demanded that we keep meticulous inventories and encouraged the publication of catalogues raisonnés. He not only made sure that the members of the Inspection team traveled to the provinces to verify attributions, catalogue collections, check the physical conditions of works, and so on—which was our job—but he also brought in the best specialists in Paris. As such, Pierre Verlet, Hubert Landais, Charles Sterling, and many other curators from the national museums went on-site at his request to give their colleagues a hand. Given this, he had little patience for curators who didn't share his enthusiasm or his concern with scholarly exactitude. He has been reproached for his excessive, and sometimes unjust, divisions between "good" and "bad" curators, which earned him some powerful enemies, notably mayors Gaston Defferre in Marseilles and Jacques Chaban-Delmas in Bordeaux. I'm certainly no stranger to tensions in the Inspection offices, as the confidence he placed in me—I was appointed assistant curator in 1954—naturally aroused some jealousy and rancor. And you could add to this the petty administrative harassments fomented by the head offices of the Musées de France. When he took his retirement in 1961, I hope he was comforted by the fervent loyalty he commanded throughout the country. We weren't about to forget his generosity, his singular personality and culture, or the enormous effort he had

made to once again turn French museums into centers of intellectual and social life. History should not underestimate the fundamental importance of his work. After that, he settled in Senlis, where I often went to see him. He continued to help us as we pursued the series he had inaugurated on masterworks from provincial museums, as well as an exhibition of Spanish works, and, especially, another one on Dutch painting, organized in 1970 by Jacques Foucart and Jean Lacambre, which he sponsored and for which he even conducted research throughout the provinces.

In the early days, my main job in the Inspection Department was to provide general assistance to the inspectors, depending on the needs of a given museum or Vergnet's requests. This might mean overseeing reinstallations, restorations, or cataloguing projects, helping determine attributions, and so on. For this, we had to make frequent trips outside of Paris, and as such I had a chance to visit many larger and smaller museums, taking notes and examining the works in storage. In addition, I was assigned to prepare the regrouping of Italian primitives in the Campana collection, to which I'll return later.

My thesis at the Ecole du Louvre focused on the Florentine and Sienese primitives housed in French provincial museums, and my research therefore benefited from the trips I took for Inspection. As I said earlier, I couldn't say why I became interested in the Italian primitives as opposed to other schools, but this interest has never waned. I wrote my thesis under the direction of Michel Florisoone, who, though not a specialist in Tuscan painting, was perfectly capable of guiding me. My work, then, consisted in cataloguing the Tuscan primitive works housed in French museums outside of Paris by studying each painting, its history, its precise attribution, and its place in the corpus of the artist's work.

As part of this research, I spent several weeks in Florence

at the end of 1953. The previous spring, I had made a large tour of northern Italy with Jean Coural and Jean-Pierre Babelon, led by our friend Alain Dufour, and we would make similar visits over the next several years to the rest of Italy. After examining the works themselves, reading everything that had been written about them, and gathering the necessary photos, I had to study them and form my own opinion before consulting the great specialists. I mainly worked at the German Institute in Florence, which had the best photo archive and the best library on Italian art, as well as all the related journals published in the world. I still have a fond memory of the time I spent working in that incomparable place, then located near Santo Spirito. I also had friendly relations with several young curators there, notably Luisa Marcucci. It was she who pushed me to contact Roberto Longhi, which I hadn't dared do up until then, to request an appointment. He unhesitatingly invited me to come over, and that meeting had a profound impact on my life.

When he first saw this young, somewhat disheveled Frenchman show up with his hundreds of photos, he realized that I wasn't completely out of it. He immediately gave me an extraordinary amount of help, providing me with numerous indications and paths to follow (with, if I may say so, no benefit to himself: someone else might easily, as has often been the case, have taken what I showed him and published it as his own research). Once you gained his trust, Longhi could be extremely generous. After this, I often sought his advice and to see him, and when I was in Florence, I stayed at his home on Via Benedetto Fortini. He did me the honor of inviting me to join the editorial board of his journal *Paragone*.

I had done a lot of reading before going to meet him. I had been lucky enough to find at a bookseller's near Santa Felicità all the back issues of *Paragone*, the periodical in which he published his findings and those of his students. Longhi's work

fell into several periods. His *Piero della Francesca*, for example, was written in almost too flowery a style, "a little ornate," as he would say. After that, Longhi's writing became simpler, without losing any of its richness or his talent for using language evocatively. Fromentin was one of his main references, along with Fénéon, Focillon, and a few other French critics. Moreover, he possessed a remarkable knowledge of French literature in general: he regretted, for instance, not yet having been able to find the works that Balzac had published under a pseudonym. He loved French poetry and songs, especially by Raymond Queneau and Georges Brassens, and the way one could play with words.

Who today would dare script, as he did, imaginary dialogues between Mantegna and Bellini, or Masolino and Masaccio? His superbly literary approach was inimitable. At the same time, we mustn't see Longhi's talents as merely literary. His imagination helped him recreate the past, which he reconstructed from new data, or from previously unknown works of art that he reintroduced. A single example: *The Drunkenness of Noah* in Besançon is now a famous painting. Before the war, Longhi had maintained that it was painted late in life by Giovanni Bellini, which at the time was unthinkable—Berenson attributed it to Cariani. But this is what Longhi's intuition told him, and it has since been confirmed by numerous cross-references and attributions of other paintings, which radically changes our view of Bellini at the end of his long career. By crediting the young Bellini with the *Altarpiece of Saint Vincent Ferrer* at San Zanipolo in Venice, which shed light on the artist's beginnings, he laid the cornerstone of a monument to which he also added the final blocks (excuse the metaphor). This was not some brilliant show of erudition, but a creative act that reimagines the work of a great painter in its historical setting. Attribution is not merely about juggling artists' names, but about placing a

given work in a new context that allows us better to understand the artist's language.

Such flashes of brilliance fascinate me. Longhi was able to navigate on many different waters, from the thirteenth to the nineteenth century. He identified Giottos in Chaalis and thousands of Italian paintings throughout the world, as well as — two examples among many — a Velázquez in the Orléans museum and a Ter Brugghen in Le Havre, which no one before him had recognized. To my knowledge, few of his peers could "cover" as many centuries of painting as he. Berenson did not go beyond the fourteenth, fifteenth, and sixteenth centuries; Hermann Voss, a great art historian who is too little known today, did magnificent work on the sixteenth and seventeenth; and Max Friedländer, another great connoisseur, specialized in the fifteenth and sixteenth centuries in Holland and Germany. Only Federico Zeri followed in Longhi's footsteps, at least for Italian painting.

One more word about Longhi, the most important: he truly upended the commonly accepted hierarchies that obtained at the beginning of the century. Of course, some of these challenges seem like blind spots on his part, such as his poor opinion of Tintoretto (on the other hand, he revered Veronese), or like provocations — such as putting Raphael "at the head of his class"; but they always force you to think. He wanted to show that next to the Classically oriented and idealizing inspiration that served as a standardizing model for all of Europe, there existed in Italian painting a freer and no less constant vein, which was based on a realistic vision of nature. It's no coincidence that he loved Caravaggio and his disciples from early on or that he was the first to demonstrate the vivacity of an entire realist tradition in Lombard painting, from Giovanni da Milano in the fourteenth century through Ceruti in the eighteenth. He placed the same accent on the neglected schools of Bologna, Umbria, and Rimini, which

were more popular and naturalistic than those of Florence or Siena in the 1300s. He constantly shed light on the imaginative dissidents — some of them Giotto-esque — who rebelled against the more academic painters like Bernardo Daddi, the "mechanical nightingale." This did not keep him from also defending Guido Reni, the Carracci, and Bolognese painting, which, at the time, were threatened by an overwhelming enthusiasm for the Caravaggesque painters. In short, we owe to him a complete revision of Italian art history, on which we still rely. Isn't this better than quietly working on minor differences in attribution?

After the war, he had hoped to be appointed to a chair at the university of Rome. He had already earned a substantial reputation and trained a first generation of students before the war at the university of Bologna. But they gave the chair to Lionello Venturi, who was returning from his exile in France, and Longhi took it as a personal failure, even though he had regained his aura, his journal, and his prestige in Florence.

In the postwar period, the world of art history in Italy contained a number of competing factions, and Longhi, who smacked of heresy, was sometimes violently critiqued. Not always unjustly, moreover: he had engaged in numerous disputes of his own (some of which were quite humorous) against various colleagues, notably with Mario Salmi. Before the war, Longhi had founded the journal *Critica d'arte* with Carlo Lodovico Ragghianti, an agile and inventive historian, who had notably stressed the importance of cinema. But their personalities were simply too incompatible, and they had fallen out. More ideological tendencies (specifically Marxist) surfaced with Giulio Carlo Argan, Venturi's influential successor in Rome and later the city's mayor. On the other hand, Longhi maintained fairly cordial relations with the major fine arts superintendents, except in Florence. He had more or less

directly inspired several of the great postwar exhibitions in Venice, Milan, Bologna, and Naples.

While working on my thesis, I also met Richard Offner, the greatest American specialist on the Tuscan primitives since Berenson, who divided his time between Florence and New York, where he taught. (Moreover, he played a major role in training many young researchers.) Before the war, he had launched a huge undertaking, which is still ongoing today: a corpus that aimed to publish every known Florentine painting, each one accompanied by a wealth of analysis, bibliography, reproductions, and so on. He had been aided in this mad adventure by some American patrons, the Strausses, who donated their collection (which he had helped form) to the Museum of Fine Arts in Houston. Offner had made a name for himself via several important analytical writings, in particular an article published in 1939 in *Burlington* magazine, "Giotto, Non-Giotto," in which he disputed Giotto's very presence in Assisi. Offner had always been well respected for his rigor and the quality of his analyses; he had a remarkable eye. But according to him, an artist's corpus should be absolutely pure; in other words, anything that couldn't be determined beyond a shadow of a doubt as being entirely by that artist's hand must be considered the work of his studio or a follower. This method, though intellectually impeccable, is clearly too radical: many paintings from that period are collaborative works, in which you cannot deny the creative responsibility of the principal master. Since he didn't admit stylistic deviations within the corpus of a single artist, Offner had created a large number of secondary or ancillary masters. For example, the large *Crucifix* at Santa Maria Novella in Florence is considered one of the young Giotto's masterpieces, similar to certain frescoes in Assisi (*Isaac*), but Offner always excluded it from the master's body of work. Under his influence, the American school unfortunately became

anchored in an excessive prudence. The most famous example remains George Rowley's 1958 book on Ambrogio Lorenzetti, in which the artist's work is attributed to a dozen different masters — the Pompona Master, the Rofeno Master, and so on — which limits it to an absurd degree. It's obvious that the same artist painted all these works, sometimes with the help of his studio. I have to see this as an antithesis to the generosity practiced by Longhi and his students, which some consider equally excessive. Since studios played such a large role in the fourteenth and fifteenth centuries, Longhi — like Berenson — refused to restrict an artist's corpus only to undisputed masterpieces.

My conversations with Offner, when I asked his opinion of a given panel, reflected his prudence and scruples: "Yes, I know this master," but without saying which master he had in mind; or: "No, I do not believe that attribution is correct" — period. It was rather frustrating, to say the least!

In my early days in Inspection, my mission was to help establish the true identity of works in provincial museums, which in most cases was already well known if the collections had been correctly studied and catalogued. But for the smaller museums, or the ones without a competent curator, I had to impose some scientific order without being swayed by the often whimsical or overly optimistic claims of interested parties. In addition, my own work for my thesis also consisted in determining the identity of several hundred paintings, with an introductory essay that would explain my reasons for these attributions.

Nonetheless, it is obvious that "attributionism" (as some have called it) is not a procedure central to art history, but rather a means of knowledge, useful for some periods or schools and not for others, indispensable in certain areas of research (catalogues raisonnés, museum inventories, col-

lection catalogues) and for the art market. It is not an end in itself.

Even as regards the strictly practical function of attributions — assigning an author to an anonymous painting — very few French historians at the time had that capability. There were of course amateur collectors and art dealers, but for old painting (I'm leaving aside prints and drawings, which had reputable experts), there were only a few competent curators in the provinces, such as Hans Haug or Boris Lossky. The tradition of connoisseurship (a much better word than "attributionism"), the kind found in Mariette, Thoré, Chennevières, or Reiset and that continued into the twentieth century with historians like Robert André-Michel, Louis Demonts, and Paul Durrieu, had languished. Which explains our joy at Charles Sterling's return after the war.

Some have likened attributionism to pure guesswork, but there is more method to it than that. Everything rests, first, on extensive visual experience: you have to have seen an enormous number of works. Photos are an excellent mnemonic prompt, assuming you have a particular kind of memory. Some connoisseurs have written about attribution: I'm thinking for example of the beautiful book by Max Friedländer, *On Art and Connoisseurship*, published toward the end of his life. A German Jew, he had managed to survive in Amsterdam during the war. In Germany, along with Wilhelm von Bode, he had incarnated the very figure of the great connoisseur, in charge of the prodigious collection of Flemish painting in Berlin. In his short book, he very simply details some of the fundamental traits of connoisseurship.

This operation, not unlike storing a large number of images on a computer database today, is a very personal mental process of figurative association. It is also crucial to have an appreciation of painterly quality. The ability to differentiate between the hand of a great master and that of a lesser artist

or to tell an original from a copy or studio work depends on one's ability to examine and analyze the painter's "touch."

In the case of primitive works, there is a particular type of attribution. A large number of fourteenth- and fifteenth-century Italian paintings—in fact, up until the Florentine principle of unified composition become widely adopted—are composed of more or less compartmentalized polyptychs. Museums are full of fragments, pieces of predelle, side panels, pinnacles, or pilasters that have lost their accompanying parts. One of the most enjoyable sports practiced by connoisseurs, myself included, is to virtually recompose the bits and pieces of a composite work dispersed throughout the world. But comparisons of specifications—dimensions, similarities in the carved haloes, radiographic confirmation of similar wood backings—and iconographic verisimilitude are not enough to prove that two or more panels belong to the same altarpiece. Nor is it enough to show that they're by the same artist—that's the least of it. You must also sense an artistic identity specific to the grouping in question. It's like attribution to the second degree!

How does one train one's eye and learn how to recognize the ways in which a painter leaves his particular mark on the materials? Cavalcaselle was ingenious: by referring to his drawings, he could recall what information he had stored away. And photos filled in the missing details. Berenson, an absolute genius in the field of attributions, kept a huge photo archive. Longhi also made sketches (not very good ones, truth be told) as memory prompts, but they couldn't really help him with attributions as such. The only one who had a supposedly rational "method" was Giovanni Morelli, who moreover deserves better than his self-ascribed reputation as the "Sherlock Holmes of art history," with its mechanical aura of a detective searching for the criminal. Recent studies have shown that, independent of the "eye-nose-and-throat-man"

theory (an artist can be recognized by his way of drawing ears, noses, and so on), Morelli had a remarkable eye, which led him to make a number of seminal discoveries. In fact, all of this is quite comparable, as has often been noted, to a medical diagnosis. Using the same methods, the same experience, the same studies, a doctor will or won't be a good diagnostician. It comes down to personal talent.

In the end, we can say that a convincing attribution is based on three criteria: style, first and foremost; manner (way of doing); and spirit. Sterling often evoked the "spirit" of a work to discern its particularities. The spirit is the least definable part. It's an element of appreciation that is not governed by reason: the fact that a given work is in the spirit of an artist does not necessarily mean that it is *by* that artist. Friedländer pushed that logic to its extreme point: "If someone told me that he owned a still life by Frans Hals, signed and dated 1650, without having seen a single still life by that painter I would form an idea of what it is like, which will serve as a guide in accepting or rejecting the work's authenticity when I later view it."

For his part, Sterling considered it an injustice to leave a work anonymous, without an artist's name attached. The goal of the connoisseur-hunter is to find works that are hidden away in some little church or museum enclave, or that have erroneously been attributed to another artist. The joy of discovery does not rest only on the pleasure of unmasking the "guilty party," but also on the feeling of having rectified an error of history and of helping expand a field of study. Adding a previously unknown work to an artist's catalogue is already quite something. But the "invention" is still more useful when it helps bring to the fore a hitherto obscure or unknown artist. The connoisseur shows that a seemingly disparate grouping of works, which until then had never been related to each other, is all by the same artist, that it reveals the same spirit,

inspiration, and style. This is how Vermeer and Georges de La Tour were resurrected.

For a large number of primitives, identification is not always accompanied by an actual name. What counts is the artistic singularity of a "master," defined by the stylistic and spiritual coherence of the works attributed to him. The fact that he might be anonymous, that his particulars are unknown, is less important than the fact that his personality cannot be confused with any other. Whether or not the Master of Flémalle was actually named Robert Campin, he was, with Jan van Eyck, the greatest Flemish painter of the early fifteenth century.

So-called "attributionist" art history, which is also called "museum art history," has often been criticized for taking attribution as an end in itself. Longhi, in one of his masterworks, *Officina ferrarese*, began on a note of attributionist philology, but then moved into context and ended with an essay. As I said, it's a matter of goal. When the young inspector Michel Laclotte goes to a provincial museum, finds an anonymous painting, and attributes it to Giordano—the easiest artist to recognize!—he is simply putting a work back in its rightful place. This is the primary task of "museum people": to give the public accurate information about what it is seeing.

Criticizing attribution for being an end in itself is irritating. I consider that art history is and must be pluralistic, as we say today, because it is constantly enriched by successive waves of resources, of keys to analysis and interpretation (in no particular order: sociology, iconology, structuralism, psychoanalysis, or any other humanistic study), as well as by the new areas of research—the commissioning and reception of art works, for instance, or the history of taste or artistic techniques. But all of these must admit the coexistence of different approaches and their relative necessity. One of the merits of the "Courtauld spirit," to come back to that, is this toler-

ance: they understood that one should not disdain any of these approaches, which are often complementary, and especially that certain critics have greater talent for a particular analytical method or means of expression — and so much the better.

Let us therefore be conciliatory toward those, fairly numerous in France and especially in the United States, who sniff at the work of "positivists," by recognizing that this coal mining is done for their benefit, so that they do not have to waste their time with that kind of research and so that they can safely rely on it for their own reflections if they care about staying with "facts" (which isn't always the case). From the most basic research to the most lyrical flight of interpretation: may everyone find his niche!

I shouldn't jeer, as the situation has completely changed in France over the past fifty years. There are many today who can distinguish a youthful Giordano from a Ribera, a copy from a replica, and can even take advantage of the archives while still writing beautiful books. And there are many who are capable of composing vast syntheses, rich in historical, sociological, or psychological insights, who are also excellent "connoisseurs" of painting.

Let me tell one more story about Longhi, to put an end to this discussion of attribution. Longhi took at least two long trips to France every year, and when he visited the Inspection offices, I showed him piles of photos brought back from the provinces or possible acquisitions. In a batch of photos from the Rouen museum — this was in 1959 — was one of a *Flagellation of Christ* that had come in a short time before with differing attributions. He immediately perked up: the image reminded him of another, more or less identical, version in a private collection in Switzerland, which Denis Mahon had published as being by Caravaggio. Longhi shuddered, sensing that he might be looking at an original. He immediately

decided to go see the canvas in Rouen, inviting André Berne-Joffroy, author of an admirable book on Caravaggio, to go with him. He executed a kind of mute dance around the painting, looked at it from different angles, and suddenly, very quickly, we read in his expression that the painting had become an authentic Caravaggio. He explained why he was so sure of his attribution: by looking at the painting in raking light, you could recognize a technical detail that does not lie. Unlike most other artists, Caravaggio did not draw on paper — there are no known drawings by Caravaggio, any more than by Velázquez or by other Caravaggesque painters — and in all likelihood he did not draw on the canvas either. He worked directly on the fresh ground, using the pointed end of the brush handle to incise the outlines of his figures in the ground itself. Without question, we could see these outlines engraved in the layer of paint. In some cases, successive re-mountings and manipulations have flattened the surface and erased these incisions. But here, they still existed. It goes without saying that this technical detail would not have been enough if the painting itself had not shown all the qualitative signs of authenticity. But it was the stigmata that no copy could have contained. So it is that an average painting in a provincial museum suddenly becomes a masterpiece — by a single look.

In 1931 and 1933, the Association des Conservateurs had mounted two exhibitions in Paris on masterworks from provincial museums with selected French paintings from the seventeenth to nineteenth centuries. They weren't based on very extensive research, but they had the merit of suggesting the importance of provincial riches. Vergnet wanted to reprise these exhibitions in a more scholarly fashion. Initially he envisioned a show of Venetian painting, scheduled for 1953, but ultimately he decided on a general exhibition of the

fourteenth and fifteenth centuries in Italy, I think because he knew of my interest in the Tuscans. He put me in charge of it; a second exhibition on Romanesque art was to be organized the following year by Pierre Pradel. My exhibition encompassed all the Italian schools and therefore covered a larger territory. The project gave me my first opportunity to work with André Chastel, whom we invited to write the catalogue preface. His groundbreaking essay marked the beginning of research, which others (notably Giovanni Previtali) have since pursued, into the French taste for primitive art in the nineteenth and twentieth centuries.

I was twenty-six, and already I was enjoying the support of Chastel and Longhi! In my career, I've seen many patrons who legitimately benefited from the work of beginners. It would have been natural for Vergnet, who had conceived of the exhibition and who buttressed it with his authority, to keep me in the background. But instead, he very generously pushed me to the forefront. I owe my career to him.

For the occasion, Chastel had brought Longhi to Paris. The latter gave two lectures at the Institut d'Art et d'Archéologie. The first, given in French from just notes, on problems of attribution, was dazzling; the second, which had been written out beforehand and was therefore stiffer (I had translated it as best I could), concerned the "Stefano case," one of his more famous reconstructions, in which he recreated the artistic personality of an unknown painter, Stefano, and through him illustrated Giotto's influence in Assisi. As it happened, Longhi's identification was erroneous — the painting in question was almost certainly by another pupil of Giotto's, Puccio Cappana — but the reconstruction of the work by simple analysis of style remains masterful.

The small catalogue of the exhibition contained 168 items, all of them reproduced — which was rare at the time. Chastel and Longhi published excellent articles in the press. The

day of the opening, Germain Bazin invited me to join the Paintings Department of the Louvre, a flattering invitation that I naturally declined — it would have been, to say the least, a curious way to thank Vergnet.

One highly discordant note sounded in the midst of this pleasant music: opening the newspaper *Combat* on June 4, 1956, I found an article by George Isarlo bluntly titled "Les Croûtes italiennes de l'Orangerie" [Mediocre Italian Paintings at the Orangerie]." It was a massacre of the exhibition, the choice of works, the attributions, the catalogue, and everything else. I fell from the clouds. Here's one comment among many: "In the guise of a scholarly text, [the catalogue] is a coterie's masterpiece, vibrating with, and inflated by, the intrigues of the Italian clans who completely dominate it. It is the Longhi clan, his students, admirers, and imitators, who triumph in this catalogue . . . Berenson no longer exists, but is here reduced to dust." What bothered me most in this heap of insults was that Isarlo claimed the exhibition and catalogue were all a concerted attack on Berenson.

The truth is that I had gone to Berenson's Villa dei Tatti while preparing the exhibition to work in his library and see his collection, though Berenson himself was away at his summer home in Vallombrosa. By then he was already quite an elderly and somewhat frail gentleman. I had the greatest admiration for his work, especially for what he had found in the provinces, through which he had traveled with his wife, Mary Logan, at the end of the century. I had, of course, made great use of his "lists," which inventoried a large number of the paintings on exhibit. I didn't always agree with his attributions, no more than with any other great specialist when I had a differing opinion or when I'd been convinced otherwise, especially by Longhi. I immediately wrote to Berenson to say that Isarlo's accusation was absurd and that I was extremely sorry, as we all knew full well that he had pioneered

research on Italian paintings in France. He answered with a perfectly cordial note, confirming at my request that he approved the attribution of the Besançon *Noah* to Bellini and ending with the words: "Fifty years ago, I began systematically exploring France to see what I could find in the way of Italian paintings in general, and Campana paintings in particular. I've experienced all the joys of a pioneer and an explorer. I need no other recognition, nor do I ask for any." Which proves, alas, that beneath his elegant understatement, he had been affected by this. Luisa Vertova, Berenson's last assistant, was the heir to his ideas and would put the final touches on all his books and lists after his death. It was she whom *Burlington* magazine had asked to review my exhibition. Because of the controversy, I was terrified when I saw her arrive at the Orangerie. To my relief, her review was attentive, precise in its discussion of attributions, and overall rather positive. She even recommended that the museum authorities give Michel Laclotte "time and money" to further his research. I'm not sure how to take that recommendation . . . In any case, Berenson's followers did not see me as having sinned against the master. What I didn't realize at the time was that this exhibition could be regarded as having been mounted for the exclusive glory of Longhi.

In fact, the 1950s, which were Berenson's last years, saw the rise of a new "boss" of Italian painting, Longhi, just as yet another *padrone* would later succeed Longhi in the person of Federico Zeri. Berenson remained a major figure, but he had already passed into history, embalmed in his legend as an old humanist sage in the Tuscan warmth. Longhi, thanks to *Paragone*, his teaching, his articles in the press, and several spicy polemics, became a public figure, dazzling with verve and invention. His books, especially *Piero della Francesca* and *Officina ferrarese*, and his important research on Caravaggio, Giotto, Masaccio, and Venetian painting were well known; his repu-

tation now extended beyond specialist circles to the general public. And with regard to the Trecento and Quattrocento, he offered a much more multifaceted vision of painterly production, reintroducing artists and schools — the fourteenth-century Bolognese and Umbrians, for example — that had been somewhat neglected by Berenson, as well as by other specialists. Which led to new hierarchies: Florence, Siena, and Venice were no longer the only great capitals of creation. In this regard, the exhibition at the Orangerie could suggest, however inadvertently, that the torch had been passed from Berenson to Longhi.

After a falling-out that lasted forty years, the two men had officially reconciled at the end of Berenson's life. This was not merely academic, as I determined much later. Berenson had been the principal adviser to Joseph Duveen, the greatest art dealer of his time, and had worked in the same capacity for Georges Wildenstein. That the dogma of his infallibility should have holes poked in it was no small matter — all the more so in that Longhi, for his part, had been adviser to one of Wildenstein's great rivals, Alessandro Contini-Bonacossi, who had supplied Samuel Kress with hundreds of Italian paintings that today hang in the National Gallery and dozens of other American museums.

As for Isarlo, he was a Russian émigré who probably arrived in France in the early 1920s and had become a fixture in Montparnasse. Isarlo had a kind of odd genius for documentation and a passion for photos of artworks. With only modest resources he had accumulated, in a hotel room on Rue de Seine, an enormous archive of black-and-white photos and newspaper clippings that were of considerable research value. He was a Douanier Rousseau of documentation, endowed with an indisputable polemical talent. He had created a column in the widely read newspaper *Combat*, "Combat Art," in which he violently denounced anything taking place in Paris,

other than at the Petit Palais, and staunchly praised exhibitions abroad, or sometimes in the provinces, especially Bordeaux. Behind this were certainly personal interests and animosities — most acutely against Vitale Bloch and Charles Sterling — but also an independence of mind perverted by an obvious paranoia.

Isarlo's article on the "Croûtes italiennes" at the Orangerie purported to be a precise accounting of the exhibition, almost object by object. I was never specifically named; rather, he used the term "exhibition organizers." With flagrant bad faith, he disputed a large number of the attributions. He was more knowledgeable about the sixteenth and seventeenth centuries, and sometimes in those areas he hit the nail on the head. Thankfully, I survived the affair, but at the time, this execution, which delighted some (I didn't have only friends), did not exactly please me! In subsequent years, the same character continued to massacre my exhibitions, as he had done for Sterling's and would later do for Jacques Thuillier's. Still, it would be interesting to study his case seriously. In the mass of imprecations and ineptitudes he published, there were a number of insights and references to many little-known works. His document files were eventually acquired by the Wildenstein Foundation.

Isarlo's opinion of Longhi and his influence were shared by others at the time. In a long report addressed to the director of French museums on March 23, 1957, Germain Bazin questioned the scholarly policies of the Inspection office, suggesting that the Paintings Department take over its functions. This is what he wrote about the Orangerie exhibition: "While I had wished, for a time, to have Mr. Laclotte in the Paintings Department, it is partly because a young man of such talent would benefit from contact with the methods of scholarly prudence that I labor to maintain here, the rudiments of which he received from his teacher, Michel

Florisoone . . . In his remarkable exhibition at the Orangerie, he could have spared himself many bitter criticisms had he not let himself be carried away with youthful imprudence by aligning himself too blindly with the views of an eminent Italian critic, whose great erudition, as everyone knows, is not always served by equal discernment, and whose deductions sometimes appear inspired by concerns outside the domain of pure Art History. . . Has Mr. Laclotte noticed that a kind of 'mannerist' crisis is raging in Italian art criticism, which under the name *filologia* makes attribution into a game, an unrestrained intellectual speculation, a high-wire exercise whose success must provoke the spectator's astonishment and admiration by showing the experimenter's nimbleness at making sparks fly between the most distant poles?"

This first experience was the happy occasion for me to enter into contact with the heads of the Réunion des Musées Nationaux.* At the time, the RMN was run by Marie Henraux, *née* Delaroche-Vernet, a descendant of that artistic dynasty. At her home one could see the delightful portrait of Louise Vernet in front of the Villa Medicis by Delaroche, which went to the Louvre after her death. She had been part of Paul Jamot's team and had remained close to Vergnet. Her husband, Adal Henraux, had been one of the great collectors between the wars and had played an active role in the Museum Council, the Amis du Louvre, and the committee for recovering stolen works brought to Germany. Marie's elegance, her "class," and her moral authority make her one of the figures of the Louvre from the old days, the memory of whom should not be allowed to fade. At her side, in the "black

*The Réunion des Musées Nationaux (RMN) was created in 1895 to obtain and administer funds to acquire works of art for the national collections. Today, its role has expanded to include the organization of exhibitions on behalf of thirty-three French museums, the management of museum shops and bookstores, and the editing and production of museum-related publications (trans.).

office" — so called because of the color of its Second Empire woodwork, and which would be my office as museum director — her second in command, Jacqueline Hériard-Dubreuil, who soon became a close friend, managed the RMN with a tiny staff.

In 1956, when I was twenty-seven, I was awarded a Focillon scholarship. Focillon had taught at Yale, where he died in 1943, having made a strong impression, and most of the professors there were his former students. To honor his memory, the French government had decided to award an annual scholarship to a young researcher — as it still does to this day — from either the museum or the university to spend three months at Yale. After the intense preparatory work for my exhibition, three months of intellectual pleasure awaited me. The program was very flexible: research work, visits to museums, participating in campus life, and attending seminars.

I took advantage of my stay to see as many museums as possible. I gorged myself, looking at everything and filling entire books with notes on the Italian primitives in American museums, of which there are many. After the large museums in Washington, New York, Boston, and Philadelphia, I moved on to the smaller ones: Providence, Hartford, Springfield, and so on. I was also able to visit Chicago, Detroit, and Toledo. I saturated myself with America. This type of voyage was much less common back then than it is today, and the discoveries one could make were fresher, less tainted by the feeling of "having seen it all before" that we now get from movies and television. I recall Broadway and Forty-second Street, immersing myself in the paradise of college libraries, the coffee shop on the corner with its bleak atmosphere out of Hopper, the musicals staged like clockwork, the smoky movie parlors, old ladies with purple hair wearing "I love Elvis" pins, the ballet, Balanchine, Martha Graham, walking down a deserted

Wall Street on New Year's Day, Callas in *Lucia* at the Met — all wonderful memories.

I went to see Offner in New York in a charming little apartment in Washington Square and spent a lot of time working at the Frick Reference Library. The Frick Collection is surely the most precious and seductive museum in America. Next to the museum proper, the founder had thought to assemble a photograph archive and library, as at Doucet and Courtauld, to give his compatriots the tools to carry out extensive research in art history. He had created an enormous photo collection, one of the largest in the world at the time, organized by artist. I was lucky enough to be recommended to Miss Frick, the founder's daughter, by an old friend of hers, Clotilde Brière-Misme, the wife of Gaston Brière, who had established the photo archive at the Doucet library. Brière himself was a man of the old school, the kind you barely saw anymore even then, a roguish and articulate Parisian bourgeois. Before I left, he'd said to me, "Young man, I'd like you to do me a huge favor. I'd like you to go to the Rockefeller Foundation. There is a painting in their offices that I haven't seen in some time" — in fact, not since the exhibition of 1889! "It's the portrait of Lavoisier and his wife by David, and I don't quite recall what the colors are." As for Mme Brière, she had sent me to see Miss Frick, asking me to bring her a bottle of I don't know what. But the result was that the latter found me charming and especially allowed me to work, which no one had yet done, directly in the photo archive stacks, where I feasted on Italian painting. I spent entire days there. At the time, I was working without a defined goal or plan for a book; the only thing pushing me was the need to know as much as I could about these two centuries of painting that I had chosen, the fourteenth and fifteenth.

Thanks to André Chastel, I was also able to meet Millard Meiss at the Fogg Museum at Harvard. Meiss represented the

generation after Offner for studies of the Italian primitives. He was then working on subjects that interested me deeply, having just published his capital book *Painting in Florence and Siena after the Black Death*. He could not only tell whether or not a given painting was by Pietro Lorenzetti, but could also place it in a well-informed socioeconomic, religious, and intellectual context. Later, he applied the same care and breadth of views to the study of French painting, mainly illuminations from the early fifteenth century. He was an exquisite man.

At Yale, the professor I knew best was Charles Seymour, Jr., a specialist in Florentine sculpture of the Quattrocento. At the same time, I was amazed to see what they were planning under his direction for Italian primitives at the museum, which owned the oldest and one of the best collections of these paintings in the United States. In the name of truth, they intended to subject them to radical cleanings. I saw the catastrophic effects of this in my later visits: dozens of panels so badly stripped that they could no longer be shown. Courageously, the current museum staff has begun, with the help of the Getty, to repair what can be saved and has taken a lesson from this sad experiment by hosting an international symposium on the problem of restoring primitive works, in which I gladly participated.

In 1957 I met at Yale two or three younger researchers, whom I would again see later on: Colin Eisler; Marcel Röthlisberger, who taught in Geneva and became, among other things, the specialist on Claude Lorrain; and especially Bob Herbert, a young professor at the start of his career, who was working on Seurat and Millet and would become a friend.

Toward the end of my stay in the United States, Charles Sterling invited me to join in a planned exhibition at the Orangerie, devoted to masterworks from the celebrated Robert Lehman collection: he asked me to put together the

catalogue on the Italian primitives. Sylvie Béguin was to write
the entries for the drawings, and Olga Raggio those for the
three-dimensional objects. Originally from Italy, Olga was a
young assistant curator at the Metropolitan; she would later
become head of the Renaissance and Modern Art depart-
ment and actively pursue a policy of reorganizations, acquisi-
tions, and publications. She is my best friend in America. The
project gave me the opportunity during visits to the Lehmans
to glimpse what life must be like for American billionaires.

Among the other figures met during this stay was Wilhelm
Suida, a Viennese from the grand epoch, who had been
forced to flee the Nazis before the war. Mainly a specialist in
Lombard painting, he had been involved in the construction
of the famous Kress Foundation. And speaking of Kress: after
the war, new collectors began appearing in the field of old
painting. Among the most important were the Kress broth-
ers, owners of a chain of discount stores, who had decided to
devote their huge fortune to forming a collection of these
paintings. The "cream" of this collection would become part
of the Mellon and Widener collections at the new National
Gallery. The other works, including many Italian masterpieces,
would be dispersed among dozens of other American muse-
ums. This extraordinary enterprise had been realized through
the purchase of thousands of artworks from the Italian prim-
itives to the nineteenth century. These days, whether you go
to New Orleans, Tucson, or a little Midwestern town, you are
almost guaranteed to come across a room with several beauti-
ful Kress paintings. One of the men responsible for studying
these works, and no doubt for their purchase, had been Suida.
In 1956 I had the good fortune to meet him, along with
Sandrino Contini-Bonacossi, nephew of the great art dealer,
who several years earlier had let me visit his uncle's collection
(which was still intact at the time) in Florence. Suida, a dis-
tinguished and charming elderly gentleman, seemed to have

stepped out of a Lubitsch film; he spoke marvelous French and carried the echo of the great Vienna School. Thanks to him, I had the intense pleasure of examining certain paintings before they were distributed to collections across the United States.

Back in France at the beginning of 1957, I again took up my inspection trips to the provinces and jumped right into a new project. In those years of cordial relations between France and Great Britain, the Association Française d'Action Artistique (AFAA), which at the time had a directive to disseminate French art and the funds to organize large-scale exhibitions abroad, had planned a show for the end of 1958 at the Royal Academy in London on the seventeenth century in France. It would be a chance to show the rich holdings of provincial museums in this domain.

Vergnet put me in charge of it, even though it wasn't my specialty, and so once more I found myself combing our provincial cities to select works. I called on well-known historians like Charles Sterling, and also ones less known, such as Jacques Thuillier, who was just back from the Ecole Française in Rome. He was only a few months older than I, but had already done considerable research into the subject, much of it unpublished. We immediately became thick as thieves, if I may be pardoned the expression, as there was nothing of the thief about him . . .

I prepared the exhibition with Anthony Blunt, the undisputed specialist in the French seventeenth century, who was also artistic adviser to the Royal Academy. I barely knew him, but he closely followed my research and commented on my proposals. This project brought us closer together, and we maintained friendly relations up until his "disappearance," on which I'll have more to say later. He took me to his club in London, the Travellers, where one could see the special stair-

case ramp installed for Talleyrand. A planning lunch was organized at the Royal Academy, a place highly reputed for its French wines, which included Blunt, Vergnet, the president of the Royal Academy, Charles Wheeler, and its warm and active general secretary, Humphrey Brooke. The lunch was held in the large gallery on the first floor, beneath Michelangelo's great *Taddei Tondo*. In that same gallery at the time hung Leonardo da Vinci's cartoon *The Virgin and Child with Saint Anne and Saint John the Baptist*, which was later bought by the National Gallery. It was a memorable meal: first-rate service, delectable wines, and absolutely deplorable food. I remember Blunt asking Vergnet, who was diplomatically taking a little sauce, a kind of blackish gruel, "Would you care for some more camphor?"

Blunt, who wrote the entries on Poussin and a preface that set out the thesis of our exhibition, had assigned the English version of the catalogue and some original entries to his student Brian Sewell, who would himself become a brilliant and feared art critic, as well as one of Blunt's most fervent defenders. The exhibition demanded a huge effort of preparation, which I found fascinating; my task was to present every aspect of that rich and diverse century, which saw the rebirth of an original form of painting in France — mainly via works from provincial museums. This was at the beginning of a great critical reassessment of the French seventeenth century; such now-familiar names as Blanchard or La Hyre were much less known then.

Working with Blunt was easy and stimulating. Here's one example: Working in Ajaccio for the exhibition of the primitives, I had selected from a batch in storage a small painting depicting Midas, obviously Roman, from about 1630. During one of Longhi's visits to Paris, I had shown him photos of the museum where this painting was housed. "You should check into Poussin," he immediately said. And it was indeed by

Poussin. I showed it to Blunt, who identified it via a painting that was known through a document from 1631, bought by Stefano Roccatagliata from the dealer Valguarnera. Establishing a provenance for an unknown work by Poussin is more than simply solving a riddle . . . The exhibition also included many little-known or unknown paintings, such as the large *Christ among the Doctors*, which I had found in a church in Langres, painted by a follower of Caravaggio, perhaps French — the Master of the Judgment of Solomon, whom some identify today as the young Ribera! There was also a grouping of religious paintings by the Le Nain brothers, found by Jacques Thuillier, which enriched the view we had of the art of the three brothers, as well as important but forgotten works by Le Sueur, Le Brun, and Vouet, and many drawings. Jacques Dupont handled the part of the exhibition devoted to decorative arts: grand tapestries evoked the monumental ambitions of the *grand siècle*.

My trips to London gave me the chance to become better acquainted with the Courtauld: so far I knew only the Witt photo library. The Courtauld Institute, of which Blunt was director, was still located in Portman Square, in a delightful little private hotel by Adam. There I had the chance to meet a fair number of English art historians: people such as Anita Brookner, who, before becoming a famous novelist, was working on Prud'hon and David; John Shearman, already an authority on the Renaissance, who later made his career in the United States; Michael Kitson, a specialist on Claude Lorrain, who wrote the Lorrain entries for our catalogue; Michael Hirst, a scholar of the sixteenth-century Florentines and Sebastiano del Piombo; and Hugh Honour, who was working on neoclassicism. I came across George Zarnecky and Johannes Wilde and at the time of the exhibition also made the acquaintance of Francis Haskell, who at the time was working on his book on the arts patrons of Baroque-

era Rome. And I also met Emmanuel de Margerie and his wife on diplomatic assignment to London, who were passionate about the exhibition: he would become director of the Musées de France eighteen years later.

The London exhibition met with unexpected success, so much so that they decided to show it in Paris before returning the works to the provinces. It would have been a shame not to show the French public some of our discoveries, and especially not to display this fairly complete and significant panorama, despite the relative paucity of Poussin's and Lorrain's paintings (they were mainly in the Louvre, which wasn't participating). As the Grand Palais was not yet set up for exhibitions, the Petit Palais was used for shows requiring extensive space—and this one contained over three hundred objects. André Chamson was the head of it, and the charming Suzanne Kahn was his right arm.

Naturally, in the five or six articles of "Combat Art" in which he exposed his vision of the seventeenth century, George Isarlo demolished both the exhibition—as very "mediocre"—and its catalogue, once again the fruit of a plot secretly hatched by "people" who wished to "maintain at any cost the prestige of their official or moral position." Fortunately, the front pages of *Burlington* magazine carried an enthusiastic editorial by Benedict Nicholson that expressed a very different opinion.

Under the slightly crowd-pleasing title *The Splendid Century*—frankly, no better than *The Age of Louis XIV*—a second version of the exhibition was organized in the United States in 1960, in New York, Washington, and Toledo, with notable differences. This time, the Louvre, Versailles, and the Ecole des Beaux-Arts lent some remarkable drawings, as did certain American museums, and we showed some new drawings and paintings, such as important canvases by Le Brun and Vignon discovered by Bernard de Montgolfier. Organiz-

ing the exhibition gave me a happy opportunity to return to the United States. One of my courier trips even took place in now-exotic conditions: five days aboard the *France*, a luxury liner, in first class. The transatlantic companies took great care of their last passengers, who were being lured away by the airlines. Haute cuisine, movies, broth at eleven o'clock served by stewards who made sure that the blanket was covering your legs just right — I found all that terrific, as I did my conversations with the Breton sailors when I went down to the hold to check on my crates.

As I was curating this exhibition, I was also beginning to publish my first writings. I had begun by contributing to several collective works, such as *Les Peintres célèbres* edited by Bernard Dorival (1953), for which I wrote several entries. It was mostly uncredited, but this kind of work is excellent for a beginner. Jean-François Gonthier, an inventive young Swiss publisher in Paris, suggested I do a book on the Avignon School, which came out in 1960. This first book allowed me to stay in my field, since the Avignon School took its inspiration from the Italian fourteenth century, as well as to broach the question of cross-cultural exchange, which was starting to interest me enormously. In my research I was fortunately able to benefit from earlier studies by Enrico Castelnuovo, my oldest Italian friend, who had spent a great deal of time at the Palais des Papes, examining the works, their influence throughout Europe, and the way fourteenth-century artists had been perceived by successive generations of writers and travelers from Avignon. I thus benefited from his generosity, before he himself had even published his 1962 book *An Italian Painter in the Court of Avignon*, which is a masterpiece.

Charles Sterling had studied fifteenth-century Provence in detail in his books of 1937 and 1942; this research didn't stop until the very end of his life, nor did his deepening knowledge

of the Avignon School. For these books, he had already done a considerable amount of situating and weeding out; the second part of his 1942 book excludes a number of works that had been attributed too casually to the fifteenth-century Avignon School (instead, he showed that many of these works were of Catalonian, Valencian, or Germanic origin).

Starting from the research by Castelnuovo and Sterling, I tried to construct and suggest my own image of the Avignon School. I proposed new attributions and revealed, for example, an unknown altarpiece by Enguerrand Quarton, found at the Palais des Papes and today housed at the Petit Palais in Avignon. I later republished the book under the same title, supplemented with a full catalogue raisonné by Dominique Thiébaut, who later became a great specialist in French primitive art.

This small volume, beautifully printed, with full-color images tipped in, was easy to read (or so I hope) and a pleasure to look at. The primary reference on the Provençal painters is the one by L. H. Labande published in 1932, containing some questionable attributions, but filled with archival documents and indispensable annotations. I had only been able to consult this rare work in the library. Shortly after the publication of my book, I walked into Roumanille's in Avignon, the great local bookstore (today replaced by a shop selling regional products), and found the two volumes of Labande's book. Seeing my hesitation because of the price, the owner said, "You know, this is a fundamental work, very rare. It's a bit expensive, but worth the price." He then pointed with disdain to my book displayed on a table and continued, "When you see what they're publishing these days on the same subject!" I bought the Labande, paid for it by check, and ran off before he had a chance to see my name, rejoicing inside and forever cured (or almost) of any temptation to feel smug. The next day, the bookseller—feeling

rather sheepish, from what they tell me — related his gaffe all over Avignon.

In 1960 Jean-François Gonthier invited me to edit a series of books on schools of painting after the publication that same year of the book by Sylvie Béguin on the School of Fontainebleau. Two or three projects were completed for it — a book on the Parma School by the very active superintendent of Parma, Augusta Quintavalle; another on Catalan Gothic painters commissioned from Verrié, the excellent specialist in Catalan art, who was unable to publish in Spain because of his Republican ideas — but unfortunately, not one of them saw the light of day. Later, my friend Francis Bouvet, who at the time was the most intelligent and inventive of all the French publishers of art history, asked me to relaunch the project. He had developed at Flammarion a remarkable series, Les Classiques de l'art, which both translated volumes from Rizzoli's Classici dell'arte series and added some original volumes of its own. For the new series, we wanted to create something more complete, each volume devoted to a single school, containing a long essay accompanied by a complete checklist. We first published a volume on the Avignon School with Dominique Thiébaut; then with Jean-Pierre Cuzin, the co-editor of the series, we commissioned the American specialist Thomas Dacosta Kaufmann for a volume on the Prague School, which appeared in 1985. Apart from one more volume on the Nabis by Claire Frèches and Antoine Terrasse, that was as far as we got. It's too bad: there are so many schools — Pont-Aven, De Stijl, Barbizon, Die Brücke, the Blaue Reiter, Bologna, and Rimini in the fourteenth century — that would have lent themselves so well to a juxtaposition of erudition (the checklist) and historical and critical reflection. Perhaps that will happen someday, but publishing these days is not exactly moving in this direction.

After the book on Avignon, the publisher Cercle d'Art,

which had just brought out two handsome volumes by Charles Sterling and Germain Bazin on the paintings of the Hermitage, asked Jean Vergnet-Ruiz and me to write a book on the riches of French painting in provincial museums. After considerable research, we wrote a cursory text, supplemented by a repertory listing the works housed in them. For Poussin, it was fairly simple, but for other artists, such as Corot, it required a fair amount of work. The repertory was just a first draft, but it's already a useful research tool. I was greatly helped by Hélène Toussaint, who would later assist me in research and exhibitions on the nineteenth century. The book was published in 1962.

In the early 1960s, I was still close to André Chastel. In 1961 he founded the magazine *Art de France*. The great bookseller and publisher Pierre Bérès was the publisher for this project, of which I've retained an excellent memory. The editorial board, headed by Chastel, included Bernard Dorival for the seventeenth and twentieth centuries, the archaeologist Paul-Marie Duval, the medievalist Louis Grodecki, Jacques Guignard, Jacques Thuillier, and myself. The first issue features writing by Willibald Sauerlander, a great friend of Chastel's, Sterling, Denis Mahon, Yves Bottineau, Pierre Verlet, Sylvie Béguin, and others, and even a text by the poet René Char. The magazine included several long essays and many chronicles and notes, in which Thuillier's name and mine appear fairly often. Bérès, a man of great taste, made sure that the publication remained at once scholarly, elegant, and visually pleasing, sometimes with original prints. Unfortunately, the magazine lasted only four years. Chastel wanted to create an independent publication that covered the breadth of international research. This project reached its culmination with the *Revue de l'art* in 1968.

In addition to this, I edited a somewhat general work in 1964, *French Art from 1350 to 1850*, published in London and later

in Paris. Closer to my heart was a book on the French primitives, published in Milan in 1966 and in French that same year, which had been commissioned by Amilcare Pizzi. I'd like to take advantage of it to say a few words about Italian art publishing at the time.

From the late 1950s through the 1970s, Italy underwent a period of extraordinary creativity, in publishing as in many other fields, such as film, fashion, design, and museums. Art publishers, too, were part of this innovative burst. Rizzoli had launched the Classici dell'arte series, and Fabbri the Maestri del colore, which were sold at newsstands. Dino Fabbri had created these titles with the simple idea of publishing albums containing beautiful color images accompanied by a short text. These texts were not commissioned from the usual generalists, but from specialists in the subject, who wrote overviews of the artists in question. As such, it was both popular and scholarly. Each time we traveled to Italy, we brought back the latest batch of volumes to keep our collection complete. And alongside this, Einaudi published the great writings of classical and modern art history.

In France during that same period, Jean-François Revel had convinced the publisher Julliard to let him print certain major works by writers such as Edgar Wind, Erwin Panofsky, Emil Kaufmann, John Golding, Fritz Saxl, Ernst Gombrich, and Anthony Blunt, beginning with Kenneth Clark's *Landscape into Art*; the project would later be taken over by André Fermigier. From 1957 to 1966 in *Connaissance des arts*, then in *L'Oeil*, Revel himself wrote regular columns on art that were clear, lively, and well informed. At the time, he was a good friend of mine. We had a number of friends in common, such as Jacob Bean, a gifted American who was intellectually very attractive, and who was then living in Paris; Fermigier—in strict alternation, for the two friends were often not speaking to each other; the Soulages; and the young Françoise Cachin.

Revel was highly offended, as he wrote in his memoirs, that Chastel had not done more in *Le Monde* to support his efforts to introduce the great foreign authors to France.

In my daily life between exhibitions, I was always on the move, traveling throughout France, looking after restorations and numerous acquisitions for the provincial museums. In 1960, in collaboration with the AFAA, I helped organize an exhibition at the Ny Carlsberg in Copenhagen at the request of Vergnet's friend Haraald Rostrup: a pleasant and fairly conventional selection of French portraits from the seventeenth, eighteenth, and nineteenth centuries. It gave me a wonderful chance to spend time in Copenhagen and to discover the Danish School of the early nineteenth century, the Danish golden age: Eckersberg, Køpke, Jensen, Hansen, and all those refined painters with their singular poetry. Everyone knew Thorvaldsen's sculptures through his museum, but this school of painting remained largely unknown outside of Scandinavia. Much later, I would have the pleasure of showing these paintings in Paris and trying to acquire some of them for the Louvre.

Apart from these exhibitions, I naturally continued to be interested in Italian painting—the work of regrouping the Campana collection had begun—and I was studying relations between Mediterranean artists. I was able to widen my field of interest to Spain when we decided, under the authority of Pierre Quoniam, the new Inspector General of Provincial Museums, to mount an exhibition of Spanish paintings in French museums. I was in charge of the section on the primitives. I had put together a committee for this exhibition, with Jeannine Baticle, a curator in the Paintings Department, and Robert Mesuret, a curator in Toulouse who had played an important role during Vergnet's time. With Paul Mesplé, Mesuret had organized an exhibition on

seventeenth-century Toulouse painting at the Orangerie. For our exhibition, he worked on Goya. The show opened in 1963 at the Musée des Arts Décoratifs, which owned a handsome group of Spanish primitives.

Bear in mind that an unfortunate dispute threatened relations between French and Spanish museums at the time: the famous exchange of September 1940. After the fall of France, the Vichy government had decided to grant a pressing request by Pétain, who had been the French ambassador under Franco. Under its terms, France had delivered to Spain most of the crowns of the Visigoth kings from the Cluny, which had been rescued and purchased by the French, as well as the Dama de Elche at the Louvre, the most important Iberian sculpture discovered by French archaeologists during their excavations, and the great *Assumption of the Virgin* by Murillo, which had been acquired for the Louvre by the French government in 1852 at an astronomical price. These major works were let go in exchange for some drawings by Caron, a painting that is only a replica from Velázquez's studio, and a good portrait by El Greco! The imbalance was unpardonable, and contacts with Spanish museums had more or less ended. Much later, we thought — when Valéry Giscard d'Estaing was elected president, and given that he knew the king of Spain quite well — that an amicable resolution could be worked out to undo this "exchange," but it was too late. For me, still a curator at heart, Spain has always been tainted by this injustice.

Our exhibition did not claim to be exhaustive, although nearly every great master was well represented, even Velázquez with two paintings from Orléans and Rouen. Here again, it gave us the chance to show many little-known works, including medieval altarpieces from churches in the Pyrenees and famous masterpieces such as Goya's *Junta of the Philippines* from Castres and the Zurbaráns from Grenoble. Among the

discoveries in my own section were two paintings from the museum in Lyon, long considered "from the Rhône region." Visiting the archaeological museum in Madrid, I had noticed two paintings that apparently came from the same polyptych, attributed to a Castilian master from the late fifteenth century, a fine Hispano-Flemish artist. Amid a large number of little-known works, we also showed some beautiful Zurbaráns, one of which, *Saint Joseph*, had been discovered by the young Pierre Rosenberg at the church of Saint-Médard in Paris, while the other came from Orléans cathedral.

Malraux, it seems, was content with the exhibition. As usual, his visit gave rise to a prodigious monologue, punctuated with phrases such as "you know as well as I do that . . ." or "I don't need to tell you . . . ," followed by pertinent remarks on specific works. I should add that he was particularly knowledgeable about Spanish painting. This might well have been the moment when he began seeing me as a viable successor to Germain Bazin at the Louvre, and what followed tends to bear this out.

In August 1963 in Versailles, Malraux had asked Jean Coural, who had organized a large Le Brun exhibition with Jacques Thuillier, to show the exhibition to President de Gaulle. Coural had invited me and Roseline Bacou to attend. The president had listened carefully to Thuillier's explanations and Malraux's commentary, lengthily examined the *Battles of Alexander*, and ended his visit with the words, "I am glad to have seen this." After which, Malraux had asked Coural and me to join him and the president, calling us his "two main accomplices" — those were his words. Shortly before this, he had appointed Coural head of the Mobilier National, the office that provides furniture to state-owned buildings, for which he couldn't have made a better choice.

One more word about Malraux, who inaugurated and spent considerable time viewing all of our exhibitions. He

asked me to come see him one day in 1963 with Jean Chatelain to suggest a project that was close to his heart: Grünewald. He then treated us to a speech, which I've never seen reproduced, on the use of color by German artists such as Altdorfer, some other painters of the Danube School, and sometimes the young Cranach (but not Dürer) — those colors that are like luminous flashes, iridescences that celebrate meteorological phenomena or the putrefaction of the flesh. It was dazzling, as was his development on the fantastic and visionary concept of German landscape painting in the same period. It was dazzling and based on specific examples, as always in his criticism — "Naturally, you see what I'm getting at: the rainbow in Stuppach's *Virgin*..." When I tried to explain that it would be difficult to transport the Isenheim altarpiece from Colmar to Paris, he brushed aside the objection: "My men and I carried it from the Haut Koenigsburg to Colmar at the end of the war!" Following this interview, I put together a proposal and made some inquiries to the museums in question, but it simply could not be done, due to the fragile state of the main works. Perhaps we should have tried mounting the exhibition in Colmar...

I have already mentioned Roseline Bacou and Jean Coural. We formed a trio of friends, both of them having helped me with some of my exhibitions, while I kept abreast of their work. On Coural's initiative, we launched a project that reflects rather well the needs and hopes of the time. Before working for the Versailles museum, Coural had briefly been an archivist at the Seine-et-Oise archives, where he had noted the considerable benefits of microfilming during an operation to safeguard the archival documents. Once at Versailles, he had talked with us about the benefits of creating a photographic inventory on microfilm of all the drawings in provincial museums.

Bacou, who at the time was a young curator in the Drawings Department of the Louvre, had organized a notable exhibition in 1957 on Odilon Redon. She was acutely aware of the need to facilitate international research in the field of drawings. This was a banner period for the Drawings Department, which, largely thanks to her, became a fertile center for research for numerous foreign connoisseurs such as Frits Lugt. Among these was Philip Pouncey, the British Museum's great expert on Italian drawings, who examined thousands of drawings in the Louvre and saved many magnificent works from anonymity. Around him gravitated a younger group, including Walter Witzthum, Jacob Bean, and Bacou herself, which was responsible for completely remodeling the Italian collection of the Drawings Department, leading to a number of publications and exhibitions. In addition, research spearheaded by Bacou into the then-unknown provenance of thousands of drawings was getting underway.

My research and cataloguing work in provincial museums also concerned works on paper, while Coural was interested in anything having to do with documentation. His idea was therefore to microfilm drawings throughout the provinces at a small photo studio, which he set up in Versailles. At first, the photography was mainly intended as back-up to preserve works in the case of another world war — people were talking about this at the time — but we then realized that it could be used to aid research and scholarship, which let us to decide to publish the drawings. The project, a "general inventory of drawings in provincial museums," in fact resulted from a decision made informally by three young curators. We convinced our bosses in the Drawings Department and in Inspection to help fund the project, but the publication was privately printed. We also benefited from the interest of a young printer, André Verbiest, and of the Gabrilovitch sisters, who owned a celebrated bookstore, Les Quatre Chemins, on Rue

Marboeuf, which subsequently moved to Place Saint-Sulpice. They not only had the best art bookstore in Paris for European and American publications, but also acted as our distributor.

Our series debuted in 1957 with a first volume devoted to French drawings of the eighteenth century in the Pâris collection in Besançon, written by the museum's curator, Marie-Lucie Cornillot. We also published inventories of drawings in Toulouse by Robert Mesurer and in Montauban by Daniel Ternois. Then in 1960 the Musées de France got a new director, Henri Seyrig, an eminent figure in international art history and archaeology. Before and after the war, he had been head of the Institut Français in Beirut, and was one of the great humanistic archaeologists of his century. In addition to his qualities as a scholar, he had a strong moral personality. He had been one of the founders of the Institut Français de la France Libre in New York, with Henri Focillon and Claude Lévi-Strauss; and, like Georges Salles before him, he was keenly interested in contemporary art. He was, for example, a good friend of Calder's, and owned several of his works. Of his daughter Delphine, a well-known theater and movie actress, Seyrig would say wryly, "For a long time she was my daughter; now I'm her father." While Seyrig had been nominated by Malraux, it is also certain that Gaëtan Picon, who had also been stationed in Lebanon, had a hand in it. In his team was a remarkable man, Raoul Curiel, also an archaeologist of great repute. Seyrig came to the French museums with the intention of picking up where Salles had left off, by opening study centers that we still didn't have.

When we went to see him to present our inventory—feeling quite intimidated at showing the new director our project, which was somewhat naïve—he immediately reacted: "Let's go to Versailles right now." For lack of an available car, we went by train. After visiting the little photo studio that was already copying drawings, he decided that our series

would be taken over and published by the Réunion des Musées Nationaux, the official publisher for the French museums, which would alleviate our need to find funding for the books. And this series, which was expanded to include every artistic technique, lasted for many years.

Seyrig, who was used to a lighter style of management and did not have the resources he would have wished, stayed for only two years. His directness and demands made him many enemies among the barons of the time, the more prominent department heads and principal museum directors. He had a hard time accepting the sterile cumbersomeness of the administration, as the following story demonstrates. Seyrig couldn't stand the interminable meetings; during one of them, he suddenly stood up and, *mezzo voce* but loud enough for some of us to hear, said, "That's enough, I'm bored. I'm going to the movies." And he handed the meeting over to his assistant, Raoul. Obviously, this aristocratic nonchalance was not to everyone's taste. His rather marked preference for a trio of young curators—whom many, of course, considered "consumed by ambition"—also grated on certain nerves at the time. When Seyrig left, his other assistant, Etienne Bauer, warned us, "Kids, you're in for it now." And we indeed felt a certain coldness, but, to be honest, it had little effect on our careers.

Gaëtan Picon, the general director of Arts and Letters under Malraux, played an essential role. Beneath his slightly disheveled appearance—always tired, suffering from head-aches—he hid a strong personality, determination, and definite courage. He had written a book about Malraux and surely contributed toward widening his palette, which, in the domain of contemporary art, remained too influenced by the prevailing tastes at the *Nouvelle Revue française*—in other words, Braque, Fautrier, Dubuffet, and Wols. Picon defended that form of modernism, but his own tastes were much more

catholic. It would be interesting, moreover, to study the influence of Picon on Malraux's ideas in the area of avant-garde literature, as well as of contemporary cinema and theatre . . . This collaboration unfortunately faltered over the artistic genre that Malraux knew least: music. When it came time to appoint a director of Music, for which Pierre Boulez was the obvious choice, Malraux curiously picked Marcel Landowski. At that point, Picon resigned, as did Emile Biasini, who was in charge of theaters and cultural centers. This break was very painful for both Picon and Biasini, as I could see. Subsequently, I often went to visit Picon and especially his wife, Geneviève, an historian.

In the years 1962–63, some began to feel that I should leave Inspections, and that someday I might join the Paintings Department of the Louvre. But they also thought that, given my youth, I was not yet experienced enough, and that I would benefit from running an important provincial museum before becoming director of a department of the Louvre. Picon suggested the Musée de Rouen, which I declined. Being quite happy at Inspections, I was in no hurry to be appointed to the Paintings Department, and I've never regretted this choice.

Jean Vergnet-Ruiz had been forced into retirement at the end of 1961. I briefly acted as interim director until the arrival of his replacement, Pierre Quoniam, an archaeologist specializing in Roman art who had been posted to the Bardo in Tunis, the great museum of archaeology created by the French under the Protectorate. He was a big, friendly fellow, smart and full of energy, with whom I got along very well. We soon launched a large exhibition project on the sixteenth century in Europe in provincial museums, which fit perfectly into the series that I mentioned above. The preparatory work for this exhibition took up most of my time over the next two years.

During those years, I often went to London. Funds had just been released to repair war damage to French museums, and this windfall allowed museums, such as the ones in Caen, Beauvais, Brest, Orléans, and others, to buy works in compensation for the ones the bombardments had destroyed. My job, in collaboration with the curators of those museums, was to lead this exciting quest, which gave me the chance to see many works and learn an enormous amount about schools that were less familiar to me. At the Douai museum, for instance, we decided to follow the tendency of the collections, which were heavily Flemish and Dutch. As such, I was able to buy for this museum some important paintings by Cornelisz van Haarlem, Goltzius, and Hans von Aachen, as well as some beautiful Dutch works of the seventeenth century by Balthasar van der Ast and others. One of the important works that I had Douai acquire, *The Flagellation of Christ* by Ludovico Carracci, was located in Paris at the antiques dealer Jean Néger's. It should have gone to the Louvre, where there is absolutely nothing to compare with it in the sumptuous series of Carraccis, but the department's situation at the time made it difficult. We preferred to give it to Douai rather than see it go abroad. Another example: *The Resurrection of Christ* by Antoine Caron, a major Renaissance painting, that went to Beauvais — a fitting choice, as it was the artist's birthplace.

I put together a small team for the scholarly research and exhibition catalogue. The Flemish and Dutch paintings were studied by Jacques Foucart, most of the Italian paintings by Pierre Rosenberg, and the French works by Sylvie Béguin. Drawings were taken care of by Roseline Bacou with Françoise Viatte and Arlette Sérullez, as well as Carlos van Hasselt, a curator at the Dutch Institute. Jacques Thuillier, who came over from Cambridge, was also involved. At the Petit Palais, Adeline Cacan, with whom I got along very well, replaced André Chamson and Suzanne Kahn.

For myself, I had written some of the Italian entries and worked on the provincial painters in France in the sixteenth century, gathering several objects from Burgundy and Champagne. Research on French painters outside of Fontainebleau was in its infancy. For a young researcher interested in the subject, the field was wide open. The paintings to be identified were generally considered to be German or Flemish. In Burgundy, Bresse, Champagne, or the Lyonnais region, one could find true artists—who were clearly influenced by Flemish art, or copied the clichés of Dürer or Lucas van Leyden, but who had a recognizable manner of their own. Since then, I've found other works attributed to Flemish painters. Very interesting exhibitions have explored the subject in Dijon and Marseilles, and historians such as Henri Zerner have reintegrated these schools—at Paris, at Beauvais, or at Rouen, also known since the studies by Jean Lafond for their stained glass—into the history of *grande peinture*, but much work remains to be done.

Ultimately, this exhibition was quite an ambitious undertaking. We decided to broaden the exhibition to several venues: the Petit Palais would present paintings and drawings from French museums and churches (except for the Louvre, where these paintings were on permanent display); the Louvre would have two exhibitions, one in the Drawings Department under Bacou, for the Louvre's drawings, and the other in the Edmond de Rothschild room for drawings and prints from that magnificent collection; and finally, textiles would be shown at the Mobilier National. In total, the Petit Palais exhibition gathered 364 objects, from famous and well-studied works to little- or unknown works. It ended with three paintings on the same subject: the persecution of Christ. There was the Carracci from Douai, the Caravaggio from Rouen (which Longhi had just rescued from anonymity), and a Rubens from Grasse, a masterpiece from the Flemish

painter's Italian period — three masterworks by three of the greatest European painters of the turn of the seventeenth century.

Critical reception was on the whole very favorable, with a very good review by John Shearman in *Burlington* that contained useful observations and some new suggestions for attributions. André Chastel was also quite favorable — no wonder, people said, since he had written the catalogue preface, but Chastel was quite capable of expressing reservations about a book or exhibition by someone he liked personally. Still, this earned him a nasty salvo from George Isarlo in his — fortunately unpleasant — review of the exhibition.

The attitude expressed in *L'Oeil*, on the other hand, was rather a surprise for us. Most of the exhibition team had written for that excellent magazine and had good relations with the editors (as was my case). The new column devoted to exhibitions expressed more than just reservations and detailed critiques of the Petit Palais show. To deplore the absence of paintings by certain major artists was pure bad faith, as both the exhibition title and my remarks in the catalogue foreword clearly indicated that we were showing only works from French collections with all the limitations that this entailed. To contest the quality and value of the works, restorations, or entries was firmly within their right as critics. On the other hand, we did not feel they should take issue with our attributions, as neither Georges Bernier nor Jean-François Revel, the two reviewers, was an authority in that field. I had true bonds of friendship with Revel — he had often helped me and even commissioned me to write for *France-Observateur*, which had led to several unexceptional articles and put an end to my career as a journalist; we also had a number of friends, antipathies, and convictions in common. For his part, it is clear that he sincerely had some strong personal reservations about the exhibition and felt that, among

friends, one should be able to take criticism without seeing it as a personal ambush.

Looking through the press clippings I still have from the time, I found a note published in *Arts* and signed by its editor-in-chief, André Parinaud. Lapidary and irrevocable. In a mere few words, he demolished the exhibition, concluding: "This is nonetheless a huge effort and a sincere, albeit unfortunate, attempt. No doubt the person responsible was not mature enough to handle such a large undertaking, and his youth is surely a valid excuse." The message couldn't be clearer: to hand the reins of the Paintings Department over to a young man such as myself—deserving, likable, but incompetent—would be an act of folly.

The exhibition greatly pleased Malraux. He decided to show it to President de Gaulle, who had only a moderate interest in art, but wanted to make Malraux happy. The latter was, of course, brilliant, as De Gaulle listened in silence. Before one painting, a large landscape by Sustris — *The Baptism of Christ* from Caen — the president nonetheless ventured, "Don't you think it looks like Poussin?" Malraux's reaction made it clear that this wasn't entirely accurate — although . . . The president considered himself corrected. Toward the end of the exhibition, in front of a canvas then ascribed to Titian (*The Martyrdom of Saint Stephen*, whose attribution is now contested), Malraux waxed laudatory, saying that Titian's final canvases numbered among the most beautiful paintings in the world. To which De Gaulle retorted with a curt "Why is that?" which left Malraux speechless.

3

In the Paintings Department
of
the Louvre

André Malraux had long harbored severe reservations about Germain Bazin, the head of the Paintings Department. On the other hand, he had good relations with other department heads, notably André Parrot, the archaeologist of the Mari excavations, who co-edited the Univers des Formes series with him for Gallimard.

Not being in the inner circle, I wasn't privy until much later to the fact that Malraux was thinking of replacing Bazin with Jean Leymarie. During the war, the well-liked Leymarie had been responsible for looking after museum objects on deposit in the provinces. This very intelligent friend of Picasso, Giacometti, and Balthus was especially known for his work on contemporary art and his directorship of the Grenoble museum. The fact that his name should come up in this context was no surprise, as everyone was aware of his broad-ranging intellect.

The 1965 exhibition on the sixteenth century had apparently shown Malraux that I could work with a team. I will never be able to express enough gratitude to him for appointing me to the Paintings Department, despite the many objections that (as I now know) he received at the time. Meanwhile, Malraux made Bazin head of Conservation, a field in which he demonstrated mastery and great experience. Our relations always remained cordial.

In the spring of 1966, I was named head of the Paintings Department, where I was reunited with certain members of the *Sixteenth Century in Europe* team: Sylvie Béguin, who was in charge of documentation; Pierre Rosenberg and Jacques Foucart, who had just arrived; Jeannine Baticle, with whom I had worked on the Spanish paintings exhibition in 1963. Others chose to resign, such as René Guilly, an ally of Bazin, who very loyally said to me, "I won't be able to get along with the younger members of your staff, so I prefer to leave"; he became head of conservation for provincial museums, where he did remarkable work. For me, the most delicate matter concerned Mme Adhémar. In 1964 and 1965, she had acted as de facto department head as Bazin was being increasingly put "on the sidelines," and was utterly devoted to the department. A Watteau specialist, she had been hugely instrumental in developing the Paintings Study and Documentation service, which had been created by René Huyghe before the war.

In 1966 the head of the Paintings Department, besides being head curator of paintings, also enjoyed, on paper, the titles of head curator of the Drawings Department, of the Edmond de Rothschild collection of engravings, and of the Conservation Laboratories. The director of the Musées de France, Jean Chatelain, asked me to give up all those "colonies," which for all intents and purposes were independent. The Drawings Department, for example, already set its own policies. On the other hand, the small Jeu de Paume

museum, which was used for Impressionism, remained under the authority of the Paintings Department, and Mme Adhémar bravely accepted the offer to run both it and the Orangerie, which hosted temporary exhibitions. It was in my authority to "supervise" her, but I preferred to give her complete autonomy. I later heard from her husband that she had appreciated the gesture.

Could I have been viewed as a careerist? I don't think so, or at least I hope not. With the inevitable arrogance of youth, you believe that everything is owed to you. I had around me people I liked, and I went through a small period of euphoria. After all, the position of head curator for the Paintings Department of the Louvre is without a doubt, in this field, one of the greatest in the world! And it is a wonderful thing to hear someone like Malraux say to you, "I'd like you to completely restructure the Paintings Department, and I look forward to your plan of action." For all of 1966, my team and I completely rebuilt the department on paper. Malraux had given me no specific instructions.

Let me say a few words about earlier plans, which get a bit complicated but are necessary if I'm to explain our projects. Before the war, Huyghe had made a very clear plan, which was unfortunately limited by the absence of the Finance Ministry building and the Pavillon de Flore. The latter, still occupied by the National Lottery (which was under Finance), had legally belonged to us for fifty years, without any of us being able to set foot in it.

Huyghe had begun his great reorganization on the eve of the war. Architecturally, his plan notably aimed at modifying the decor of the Grande Galerie, the Louvre's principal axis; he took his inspiration from paintings made by Hubert Robert at the end of the eighteenth century, which were, in fact, architectural proposals for transforming that interminable space into a paintings gallery. More than a pastiche, it

was the realization of an installation plan dating back 150 years, a realization that was ultimately quite successful.

The second main element of the program involved using the entire second floor of the Cour Carrée. The most rational reorganization of the Paris state museums, initiated before the war by Henri Verne, entailed removing certain collections from the Louvre proper: the Musée Guimet, now the state museum for Asian art, took in the Louvre's Asian collection. Same thing for the collections of the Marine museum, which were transferred to the Palais de Chaillot. This freed up a lot of space, leaving the entire second floor of the Cour Carrée available to our department.

Huyghe had planned to display Italian art in the Grande Galerie and French painting on the second floor, except for oversized nineteenth-century works, which would be installed where they still are today. Dutch and Flemish painting would be less advantageously housed in smaller rooms around the Rubens gallery and in a few subsequent areas of the Flore Wing.

The plan for the Grande Galerie was completed. Huyghe belonged to the great generation of the 1930s who invented a sober new form of museum layout, linked to architectural purism and modernism, advocating light-colored backgrounds. In its first version, the walls of the Grande Galerie were pale gray, accented by the pinks and reds of the marble. The sumptuous and subtle installations, with certain works hanging opposite others, allowed for a confrontation between different schools. Apart from some Venetian works in the Salle des Etats, Italian painting was on view from the Salle des Sept Mètres, with the primitives, down to the end of the gallery, where the panorama ended with the eighteenth century and the Guardis. I've kept a brilliant memory of that immense parade of paintings. In the Salon Carré, where the windows were covered over, they had hung a group of Spanish

paintings. The Salle des Etats, dominated by the *Marriage at Cana*, was architecturally less successful (Huyghe himself had been aware of this), because of the mediocre decor used to replace the one from the nineteenth century, as well as the slightly improbable background color. On the other hand, the Daru and Mollien galleries, devoted to great French paintings of the neoclassical, romantic, and realist schools, on a light-colored background with columns framing the canvases in the center, were magnificent. Then Huyghe left the Louvre in 1950.

Bazin continued the project but modified it significantly with two main directives. First, in the European spirit of the times, he proposed to break the notion of national schools and group the paintings according to cross-cultural movements. In the Salon Carré, he installed a room on Mannerism in several countries. In the Grande Galerie, he grouped Poussin, Carracci, and Domenichino, while putting the followers of Caravaggio elsewhere. French and Flemish primitives shared the small side rooms.

For us, then, the question was, should we return to a presentation by schools? After much thought, our answer was yes. The Louvre is surely one of the two or three richest museums in the world, but certain schools are more completely represented in other institutions. For example, for the fifteenth century in Europe, the Louvre could not show the different schools as perfectly as London does. Moreover, the proportion of French paintings over five centuries is such that this earlier approach, a chronological presentation with all the schools mixed together, would have resulted in a complete imbalance. Finally, to juxtapose works from different countries in the same room is sometimes justified and interesting, but only in certain very specific cases — as Bazin had done with the Caravaggesque painters, Mannerism, and, to some extent, seventeenth-century classicism; more often than not

it is inapplicable or artificial. It would make no sense to permanently confront Vermeer with Zurbarán, or Titian with Clouet. And Poussin loses nothing by being shown near Vouet or Champaigne.

Our views on decoration, on the other hand, were completely different, even diametrically opposed. Strongly influenced by a certain Parisian notion of taste, Bazin had asked some very fashionable interior decorators to work on the museum, such as Jean-Charles Moreux, an architect with a passion for Palladio, and Emilio Terry, who since the 1930s had been associated with prominent collectors like Charles de Beistegui. For Beistegui, Terry had created the very varied decors of Groussay castle, just outside of Paris, and the mills in the park. This style, inventive and refined as it might be, did not correspond to my own taste, nor to that of the people around me. The reconstitution of a "style," pastiches, and artificially recomposed "period rooms," though legitimate and successful in certain American museums that don't have the luxury of old interiors *in situ*, have always struck me as inappropriate to the Louvre.

For the smaller rooms and the Médicis gallery, Bazin had asked Moreux and Terry for designs that tended greatly toward the "reconstruction" of a period. For the Rubenses in the Médicis gallery, Terry had designed large black-and-gold frames, copied from the frames on the altarpieces of Antwerp churches, that struck us (and a number of art viewers) as inappropriate. In the end, the former, neo-baroque decor by Redon was less deceptive. We removed Bazin's presentation. No doubt fifty years from now someone will reproach us for having destroyed an installation characteristic of a particular moment in the history of taste.

Moreux, undoubtedly an artist of great talent, realized for the small rooms some equally questionable decorations. The *Pietà* of Avignon, for instance, rested against a false stone wall,

as in a kind of chapel. In the Mollien rooms, the masterworks from the prestigious Beistegui collection, which had just come to the Louvre, were hung on red velvet easels, held in place by black velvet poles with golden rings. For many viewers, this decor evoked an expensive nightclub. For seventeenth-century Dutch paintings (Metsu, Dou, Ter Borch), some of them bought under Louis XVI, Moreux had created a stylized decor in natural wood of vaguely Louis XV style, evoking collectors of the eighteenth century. It was a kind of reconstruction in the third degree.

Fashion also played a part. For the 1952 exhibition of Leonardo da Vinci in the final span of the Grande Galerie, a very fashionable decorator from Hermès, Mme Baumann, had been hired to design the presentation of the *Mona Lisa*. The star of the show was enthroned on an enormous upright with a huge almond-green velvet drapery. It made an excellent Hermès display window. But we had little appreciation for this kind of theatricality, these touches of Parisian chic.

Malraux had therefore asked me to rethink all this. Our first plan largely reprised the Huyghe project, with several modifications. Except for the large-scale nineteenth-century paintings, which remained where they were, we arranged the French paintings around the four sides of the second floor of the Cour Carrée. Italian painting remained in the Grande Galerie. We would also gain some space to the west by putting the Northern Schools in the Pavillon de Flore, which we had finally been able to reclaim,

Malraux rejected this plan. The minister deemed, correctly, that we could not force the public to climb on foot to the top floor to see French painting. We studied how we might make the floor more easily accessible, but none of the ways allowed us to install an escalator without altering historical areas. So Malraux asked me to come up with an alternative plan, without this creating any ill feeling between us. Jean Chatelain

simply asked me to rework the project with my team; if the new project were rejected, I obviously couldn't stay on any longer, which was understandable.

We therefore devised a new plan; this one was approved by the minister and remained under construction until 1981. French painting would be displayed starting at the landing where the *Victory of Samothrace* stands, with the primitives in the Percier-Fontaine and Duchâtel rooms, then the fifteenth and sixteenth centuries in the Salon Carré. The seventeenth and eighteenth centuries were spread throughout the Grande Galerie up to where the Mollien wing branches off, which one followed for the rest of the eighteenth century, until one came to the nineteenth century in the Mollien and Daru galleries. The French circuit ended in the Salle des Sept Mètres with a selection of small-format works from the nineteenth century. After the break in the Grande Galerie at the Mollien area came Italy with Cimabue, Fra Angelico, and so on. The *Mona Lisa* and the sixteenth century occupied the Van Dyck room, while the *Marriage at Cana* fit nicely in the ex-Médicis gallery, being the right width for the Venetian refectory from San Giorgio. The Italian seventeenth and eighteenth centuries followed. The circuit ended with the Spanish School in the Pavillon de Flore. Flemish and Dutch works would be shown on the second floor of the Cour Carrée; we installed the new Médicis gallery for Rubens, where the large Le Brun canvases hang today. After Rubens came a second circuit of French paintings in the east and south wings of the Cour Carrée.

Among the drawbacks of this plan and the criticisms it drew was the suddenness of the transition in the Grande Galerie from Fragonard to Cimabue. But there were also deeper reservations, based on the sense that the plan Malraux had approved had nationalistic implications. I don't believe this is really justified, and no such indication supports the statement. It will come as no surprise that French painting

from the fourteenth to the nineteenth century is by far the best and most abundantly represented at the Louvre. Is it so odd for a country to publicly display masterworks from its own history?

With Malraux's agreement, construction work began immediately, and the first phase was completed in 1968. Our financial credit allowed us to undertake large-scale construction projects. The worksite was overseen by the head architect of the Buildings department, Olivier Lahalle, who was quite competent in the field of restoration, but not very aware of recent architectural trends, like many other architects of the period.

We, on the other hand, wanted to offer a contemporary museum arrangement. I had great admiration for what had been done in several Italian museums after the war: sober installations that were integrated into the old spaces and decors of the palaces without the slightest hint of pastiche. Every new element necessary to the presentation of works (such as ropes, display cases and shelves, labels, and so on) or to visitors' comfort (seating) should quite naturally be contemporary.

The paintings galleries on the first floor of the Cour Carrée, unlike those in the Musée Charles X, no longer had original furniture. We therefore started from scratch. I benefited from Jean Coural's help in researching interior designers who could meet our needs. As the chief administrator of the Mobilier National since 1963, he had created a research and development studio, whose aim was to put the high-level craftsmanship of the Mobilier at the service of designers, both to design the new furniture for public buildings and to perfect prototypes that might eventually be marketed to a private clientele. He immediately called on makers like Roger Talon, Pierre Paulin, Olivier Mourgue, and several others, the finest of their generation, who could now hold their own with

the Italians and Scandinavians. Knowing the best designers, he wisely advised me to choose three: "If you choose one, you'll be bound to him, like Bazin with Moreux; if you choose two, they'll spend their time fighting; take three." He therefore put together the very effective trio of André Monpoix, Joseph-André Motte, and Paulin. They certainly had some disagreements among them, but the plans they showed us were presented as from a single unit.[1] Their work mainly concerned the Salon Carré, the Grande Galerie, the Flore Wing and the Pavillon de Flore, as well as the curators' offices, which had been moved from the Cour Carrée to the Flore Wing. I got along admirably with them: we spoke the same language; the project interested them, and I could get their prototypes executed at Mobilier National, which made everything go more smoothly. In that period, again thanks to Coural and to others such as François Mathey and his team at Arts Décoratifs, people began to see that French design could work in public spaces.

The trio's interior designs should normally have been executed under direction of a project foreman, who was the chief architect of the Louvre, a system that both sides found frustrating despite the respective courtesy of the partners — and this was true of both Olivier Lahalle and his successor, Marc Saltet. Fortunately, the rules changed with the Grand Louvre, with the project designer acting as foreman.

These reorganizations occupied the lion's share of the department's efforts over several years, since everything was subordinated to it; new hangings had to be preceded and accompanied by conservation work, new framing, and so on. In the Grande Galerie, we needed to design new lighting installations — natural or artificial, depending on the time of day. We managed to obtain fairly satisfactory results, all the more so in that the natural lighting in the gallery is very uneven.[2] When they installed glass roofing there in the nine-

teenth century, the roofs on the south side, facing the Seine, had no openings. Therefore, the glass panels are open only on the north side, which is better for lighting but causes strong shadows that must be compensated for by artificial means. The general public is largely unaware of such considerations.

After that, we had to decide on colors for the Grande Galerie. I wanted a fairly warm tone. The color the decorators proposed, which at first looked dark brown to us, was, in fact, fairly light. At around the same time, Coural found a sample of an old fabric that had been proposed to Napoleon for the last part of the Grande Galerie, on the Tuileries side, which under the Empire was used for paintings reserved for the Court: a fabric the color of dead leaves, almost the same as the one to which we had recently agreed. This reassured us. This choice avoided the overly pale appearance that had predominated in the immediate postwar period, making the paintings appear like flies on milk, or the overly dark shades that had made the works look too somber.

The Salon Carré, which reopened in 1972, posed a difficult problem. How could we adapt this space, which Duban had planned for high-set hangings that were now undesirable, to displays of the French primitives? Huyghe and Bazin had been able to hang a top row of second-string canvases, but we couldn't put up "decorative" paintings from the fifteenth century when such a thing didn't exist! At that point, our decorators made this suggestion, which I persist in finding well founded, to lower the height of the room without clashing with the nineteenth-century decor: the viewer's gaze is interrupted by a kind of outer skin, which doubles the original wall and splits the space in half as one's eye travels upward, so that the empty upper part does not seem intended for hangings.

Despite the demolition of the Moreux decor, it was never our intent to change the Salon Carré or the Salles des Sept

Cheminées. In fact, after the war, only the decor of the Salle des Etats, which was very heavy but historically significant, had been removed and replaced with an extremely poor design.

For the Flore Wing, a narrow gallery had been arranged for seventeenth- and eighteenth-century Italy, then the Spanish School, doubled by the same type of add-on partitions as in the Salon Carré. Today, these rails have disappeared, making way for the library shelves. On the second floor, a series of rooms with good upper lighting allowed us to display works from every school: these were study galleries, which are indispensable to any rich museum, so that interested visitors could view important works that otherwise would be in storage without these works encumbering the main galleries. In the plan for the Grand Louvre, we would again find rooms for this use on the second floor of the Cour Carrée. That was also where the "dossier" exhibitions were shown. At the western end on the first floor, in the Pavillon de Flore proper, we installed the Spanish works, with a decorative drop ceiling to integrate spot lights.

For the benches in the Grande Galerie, a contest was held among our three designers. The Mobilier National made a prototype of each design, and we chose the one by Pierre Paulin, which was close in style to the ones he would create for the Elysée Palace under President Pompidou.

For the Daru and Mollien galleries, we brought in a new architect, Marc Salter, whom I had known when he was at Versailles and with whom I got along very well. After many hesitations (for Huyghe's installation had great style), we eliminated the decorative element of large columns in faux marble framing the busts, which interrupted the hanging rails. As for color, we decided to copy the Pompeii red visible in the arches above the cornices. It was a risk, so I asked Pierre Soulages to help us find the right red. Our aim was, of course, to serve the works by evoking, rather than recreating,

the nineteenth century. When these halls were reopened in 1969, showing David, Gros, Géricault, Delacroix, and others, many people congratulated us on having restored the paintings and brought out their original brilliance—when we hadn't even touched them! Which shows just how well this kind of dense, saturated red background suits the grand paintings of the early nineteenth century. At the time, of course, these red backgrounds were much less visible than they are today, since several rows of paintings covered the hanging rails. It's a fact that what happens in the Louvre threatens to have repercussions elsewhere, and that is indeed what came to pass: as of the 1970s, we saw an excessive tendency to put red everywhere, and more generally a return to strong colors. Certain galleries—the Corcoran in Washington, D.C., for example—put nineteenth-century paintings against cranberry reds in the most awful way. The color doesn't go with everything. When we tried to hang Courbet's lighter canvases, such as *The Cliff at Etretat after the Storm*, it didn't match at all.

For the Van Dyck room at the far end of the Grande Galerie, intended for the *Mona Lisa*, our trio, which until then had been very discreet, suggested something more daring: a fabric of woven or richly colored metal on the walls, which would give a sumptuous bronze effect, and a Soto-style drop ceiling with a forest of vertical metal stems that would admit natural light and form a golden vault. It was brilliant but, I have to admit, a bit risky, and the scale model didn't entirely convince us. In any case, the Grand Louvre operation made the whole thing obsolete.

Then we began work on the second floor of the Cour Carrée. For the nineteenth-century French works, Bazin had already opened a series of rooms in the south wing, not very successful from a design standpoint, with a lot of fake marble, pilasters, empty niches, and so on, but with excellent upper light. Apart from that grouping, which was easy to transform,

and a series of rooms to the east set up before the war for the Caillebotte galleries, everything had to be started from zero in those large, empty halls, some of which didn't have a ceiling. In 1960, at Malraux's express request and to the delight of visitors, seven hundred paintings taken out of storage were hung.

In the 1970s all the efforts were turned toward completing the future Pompidou Center, then the Musée d'Orsay, with the result that work on the Louvre dragged on very slowly. On top of which, Paintings wasn't the only department in the museum that needed attention. Fortunately, other projects came to fruition during that period: the Drawings Room was installed in the Flore Wing, and the display of Greek, Etruscan, and Roman antiquities was largely redesigned and modernized.

Reactions to the new paintings galleries were not uniformly favorable, and some considered them too cold. It reached the point where Raymond Aron (whose daughter was an acquaintance) invited me to defend the project at the Académie des Sciences Morales et Politiques. And opinions were so divided that I felt it indeed had to be defended. I did my best to prove the coherence of our plan, but the reactions were mainly in the order of, "Why change everything? The Louvre isn't a modern museum," and so on.

Malraux was no longer in office. He had inaugurated the Grande Galerie in July 1968, then left the ministry after President de Gaulle's departure in 1969. Michel Guy, who followed Malraux's successor, Jacques Duhamel, was a man of culture, a lover of ancient and modern art. On his arrival at the ministry in 1974, he politely reproached me for the coldness of the Grande Galerie, saying, "I'd like the Louvre to have the same atmosphere as in the Hermitage." This struck me as ill-advised. I told him that in the Hermitage, everything had been designed by Klenze, from the malachite vases to the tables and benches. That kind of decorative ensemble,

the product of a single architect, could not be reproduced in the Louvre, where, for lack of furniture, we would have to resort to an imaginary reconstitution. We compromised by adding some more ancient busts in the spaces between the columns and five or six Roman sculptures in the center, including the bronze *Diana Huntress* from Fontainebleau—which, I admit, gives some rhythm to that interminable space. Some people wanted to add chests of drawers.

When it comes to museum layout, I believe it's better to adopt an empirical approach rather than follow a pre-established doctrine. There are no absolute truths in the field of interior design, which responds to fashion and volatile contemporary taste—bad taste is always someone else's fault! There can be no overarching model, since each museum poses specific problems. In certain museums, especially in the provinces, I recommended a mixture of schools and media—sculptures, paintings, furniture, and so on—because the collections lent themselves to it. But not at the Louvre.

For the redecorations in the Louvre, we had chosen sobriety, and this would again be the case later on with the Grand Louvre. If we refused to recreate older styles—as they did in the nineteenth-century painting galleries at the Metropolitan, for example—it's because behind this choice there was an underlying rationale. As the visitor moves from room to room, the Louvre, both the palace and the museum, offers so many different examples of architecture and interior design—not to mention exterior landscaping, viewed through the countless windows—and so many ornamental elements (including the painting frames), that he becomes unconsciously saturated with them. Hence our desire for formal simplicity. Because what truly matter are the works themselves, unobtrusively installed in well-proportioned spaces, nicely lit, and set against a flattering background.

When I was appointed to the Paintings Department, I was

much younger than the other department heads, and no doubt I incarnated, for some of them, a modernity that they considered out of place at the Louvre.[3] I can't say I felt any enthusiasm in their welcome of me, but neither was there anything particularly unpleasant.

In the days of Germain Bazin, Malraux had apparently asked André Parrot and Pierre Pradel, the head sculpture curator, for a complete plan to reinstall the Paintings Department. He had confidence in them. Pradel had a true talent for museum layout and design. But what they came up with was absurd. Their plan entailed destroying the Grande Galerie by slicing it up like a sausage! Noting that the gallery posed a difficult, even insoluble, challenge for oversized and small-format paintings, they had envisioned showing French painting in the Grande Galerie, but breaking it up to create rooms of varying lengths and heights. Thank God, the plan went no further.

It went better with Parrot, who in the meantime became director of the Louvre in 1968. Before this, the museum's director was in fact the director of the Musées de France, who personally oversaw all administrative and financial matters and arbitration of all kinds. Malraux, who had been, they said, very annoyed by the uncooperativeness of the curators — they were opposed (and frankly, I can't say I blame them) to the idea of lending the fragile *Mona Lisa* to the United States — had finally decided to appoint a director specifically for the Louvre.

But Parrot's role was really that of a dean or spokesman. With no real financial or hierarchic power that he could bring to bear on the other head curators, his function was unclear. Pierre Quoniam, whom I knew well since my days at Inspection, succeeded him in 1972. A specialist in Greece and Rome and interested in everything, he was able to encourage the reorganization of the Greek, Etruscan, and Roman galleries.

But he found himself awkwardly stuck in a job that afforded him no real authority. He left the Louvre in 1979, only to come back later as part of the Grand Louvre team.

During the riots of May '68, the department was completely under construction. The Grande Galerie wasn't open. We were afraid that students from the Ecole des Beaux-Arts or elsewhere would come demonstrate at the Louvre. We therefore shut down the museum for several weeks and moved the most precious works — the *Mona Lisa*, the crown jewels — into storage. We were worried enough to sleep on-site for several nights, fearing a fire or some incident getting out of hand. The students from the Louvre school launched a rather loquacious movement, with meetings and conferences in which we sometimes participated. But there was no disorder.

What is the job of a department head at the Louvre? Must one be authoritarian, or is the work mainly collegial? The answer is both. Everyone exercises authority in his own way, and it's not my place to say whether mine was the best! In any event, one cannot lead a team for any duration other than in a climate of trust and solidarity; my sense is that this was the case in the Paintings Department.

Each department is really a "house," with its own long-standing traditions. These departments formed gradually since the opening of the museum in 1793. First there was the Paintings Department and the Department of Antiquities, which grew out of the royal collections, then the Ancient Egyptian Department created by Champollion, the Ancient Asian Department developed thanks to the great archaeological digs, the Sculpture Department and the Decorative Arts Department, and finally the Drawings Department, which later separated from Paintings and became the Graphic Arts Department. Seven departments, most often headed by fig-

ures renowned in their fields, themselves seconded by cura-
tors who, ideally, cover the other areas represented by that
department.

No chair of the Paintings Department has ever claimed to
be a specialist in every period of western painting. Insofar as
my own interests (I won't say competence) are concerned—
and I apologize for this blatant *apologia pro domo*—I had at
least had the opportunity to organize several exhibitions that
allowed me to touch on the sixteenth century in several coun-
tries, Spanish painting, and the French seventeenth century
and to study (this time as a specialist) Italian and French
painting of the fourteenth and fifteenth centuries. In addi-
tion, for my work as an inspector of provincial museums, I'd
had to "cover" a wide variety of periods and schools. But
there's no mystery about it: to handle that kind of job, you
have to love painting, pure and simple. A true connoisseur,
like a true art lover, takes anything as grist for the mill.

As for collegial relations, they fell into place naturally with a
division of labor based on areas of scholarly competence.[4] You
need a specialist for each of the great schools, who is responsi-
ble for the way his or her particular galleries are installed and
patrolled, acquisitions, restorations, publications, and so on.
At the Louvre, these divisions are less clear-cut than in some
other museums, such as the Hermitage, where traditionally
each curator—and there are many of them, all very learned—
is virtually the exclusive guardian, the "conservator," of a part
of the collection. But since each of these preserves is separate
from the others, it is difficult to have a real exchange. At the
Louvre, each curator is in charge of a group of galleries
devoted to his specialty, but it is not out of the question for
him to oversee other galleries or handle other documents. In
addition, everyone has to fulfill ancillary administrative
responsibilities—loans to exhibitions, relations with photog-
raphers, participation in committees, and so on.

I should also note the significant presence in the Paintings Department of the documentary archives, run by a conservator (successively, Hélène Adhémar, Sylvie Béguin, and, since 1972, Jacques Foucart[5]). The role of the archives is to compile scholarly dossiers on every object in the Louvre, including the thousands of works on external deposit, in preparation for catalogue publications. It also contains general documentation and a slide library pertaining to painting throughout the world. For a long time, the slide library, though useful for the department, could not compare with the great visual archives abroad. In the past thirty years, however, a concerted accumulation of photos and bibliographic documents has made it an indispensable resource for anyone doing research on painting.

Also as regards collegial relations, we decided to hold weekly meetings, as in many companies, to discuss possible exhibitions, acquisitions, loan requests, the progress of the ongoing renovations, and anything else affecting the daily workings of the department. These practical matters are an integral part of a curator's scholarly existence. The two are inseparable — even if, to simplify matters, many of the purely "administrative" tasks were handled by the head office of the Musées de France or in some cases by the director's office of the Louvre.

As a further part of the curator's job, Charles Sterling used to recount how he would sometimes receive ludicrous visits from certain owners of paintings, who came to show their wares to the Louvre's curators. This practice is now a thing of the past. That said, one of the curator's primary roles is to act as expert or connoisseur, who has to give his opinion about works being considered for acquisition or under study. It's true that for several years, Sterling agreed — it was an added chore, but he found it amusing — to see visitors who had come to show him photos or paintings. As he told it, very few important works came to light this way. Even though most of

his visitors were convinced they owned an unknown master-piece, this was never the case, though it did give rise to the customary parade of legends about the canvas found in the attic. We discontinued this service, which involved a certain amount of risk: as investments in art became more common, the boundary between commercial activity and pure scholar-ship began to blur.

Every curator maintains a personal relationship with sev-eral professional bodies within the organization. Relations with the security guards were less direct back then than they have since become. When the directorship of the museum was established, they instituted a much higher level of involve-ment for the curators in matters of security and gallery patrols.

Relations with the facilities crew, who physically install the works, are constant and necessarily based on trust. I have to say that the Louvre's teams are exceptionally competent in this regard — as I was able to gauge when seeing how similar teams worked in certain foreign museums.

The fact of hanging a painting on a wall, the arrangement of works "in a certain order," has always been one of the plea-sures of curatorship. Starting with scale models, which are usually abandoned; finding the right placement after much trial and error; increasing or decreasing the space between paintings to suggest their relative importance; moving them a few inches to the left or right to create rhythms by playing with shapes or colors; suggesting a relation between works that is at once stylistic and formal or iconographic — all this is a real joy. But arranging works in a two-dimensional space undoubtedly requires a certain kind of talent. Hanging is never an innocent act. To juxtapose two canvases means that you are making an intellectual comparison. It's the expres-sion of a sensibility, of a desire to show the public a particular viewpoint; for me, this remains one of the primary roles of our trade, and one of the ones I most relished. When a visitor

enters a gallery, he does not necessarily perceive the desired effect all at once, but is led by the placement of the paintings to walk and gaze in a certain way. He regains his freedom only when he can recognize the display principle, in his perception or his memory. As far as I was concerned, I tried — and my department colleagues were of the same mind — to avoid the purely "decorative" installations that can sometimes be so tempting. By "decorative," I mean the style of installation that we privately called "mantelpiece": a large work in the center, two small and two large ones on each side. In other words, a purely symmetrical effect, often obtained at the expense of historical truth or stylistic coherence, thereby reducing the painting to a purely decorative object that might be appropriate for Lancret or Recco, but not for Caravaggio or Fouquet. Personally, I've always tried to combine (which isn't easy) a harmonious effect — not necessarily symmetrical, but balanced — with an art historical demonstration that appeals to the viewer's sensibilities. Only then can we talk about an authentic dialogue between works.

This is a little like attribution, in that it involves both knowledge and instinct. But it is also subject to evolutions in taste and fashion. Forgive me for sounding like those old men who disapprove of any departure from the way things were done in their day, but the current tendency (and this is not endemic to the Louvre) to install works according to subject matter bothers me a bit. Hanging canvases of uneven quality and varying styles, using iconography as the sole guiding principal, can only be detrimental to the main thing, which is after all the work's pictorial quality. Here's one example: in many museums, seventeenth-century Dutch paintings are grouped by genre — still lifes, landscapes, genre scenes, portraits — which strikes me as both uninteresting and misleading. Jacques Foucart was correct to arrange his presentation of these works in the Richelieu Wing by philosophical affini-

ties or chronology. That is how one creates true encounters of style or sensibility, which extend beyond subject matter, in artists of successive generations.

Obviously, one can allow oneself to do things in the context of a temporary exhibition that one wouldn't do in permanent displays. One can be freer in those cases, and in many instances a "thematic" presentation (historical, for example) is precisely what the exhibition is about. And besides, the effect is short-term: if it doesn't work, you can always redo it, or at least it will be forgotten once the show closes.

Another fundamental problem in installing galleries is how to light the works. A friend of mine, the painter Avigdor Arikha, has put a lot of thought into the problem of lighting. This great artist (who incidentally has not received the recognition he deserves in France) is also a subtle art historian, sensitive to the respect one should give the truth sought by the artist. His writings on the subject denounce the chromatic infidelities wrought by the use of electric light. In the museums under my jurisdiction, I tried as much as possible to use natural light, knowing full well that it wouldn't be bright enough at 5 P.M. in February, and that it is sometimes impossible to create glass roofings that evenly capture the northern light, the kind found in painters' studios. The overuse of spotlighting in American museums has more or less ended. At MoMA, one of the most beautiful museums in the world, most of the galleries were lit artificially, except for two or three large rooms looking out on the courtyard. The recourse to natural lighting is an indispensable part of any museum layout.

Another element that plays into the spectator's view of a painting is the frame. Already before the war, Germain Bazin had done considerable work in this area at the Louvre. They had bought or received collections from the leading frame dealers. Bazin endeavored, as we did in his wake, to replace

mediocre frames with frames contemporary to the paintings or that belonged to the great collectors who had owned these paintings. He was generally quite successful. Obviously, you have to make some allowances. The Dresden museum, for instance, made only one great effort at framing, when the Elector of Saxe bought the Duke of Modena's collection. Those are eighteenth-century frames, uniformly and beautifully designed. One would hesitate to replace them, even if they aren't of the period. In the same way, the Louvre went through several campaigns of frame-making, under Louis XVI and the Empire, producing frames that had very handsome neoclassical borders but that bore no direct relation to the style of the works. In the years following the war, these frames were sometimes eliminated a bit too readily. Today we're seeing a return to these kinds of frames, and rightly so. When they're well designed and for specific paintings, they become part of the work's history.

The suppression of frames in the 1950s reflected the modernist bent of the times, when it became fashionable to show old paintings without borders. In some museums, such as Arles, which has a fine collection of paintings, all the old or nineteenth-century frames have been thrown out to give the canvases a contemporary "look." But a frame serves not only the practical function of holding and supporting the canvas, but also an aesthetic one: it provides a buffer between the colors of the work and the wall on which it's hung. Fortunately, this vogue has passed. The Arles museum even managed to recover some of its old frames.

Another tendency is to adapt "fine" old frames to every school. That fashion started between the wars, when some collectors rejected the original nineteenth-century frames (which were in fact rather heavy) in favor of older frames, generally French from the late seventeenth or eighteenth century. When these paintings left their wealthy homes on Avenue

Georges-Mandel or Park Avenue to join the museum's collection, were we right to keep these anachronistic frames as pieces of the work's history? Probably so. Just as you wouldn't strip paintings by Monet or Degas of the frames that Jacques Doucet had Legrain design for them.

After lighting and framing, there is also the matter of the explanatory labels — on which someone should write a complete history! The series of magnificent title plates from the time of the Napoleon museum was continued into the nineteenth century with handsomely designed type. Sometimes we go looking through storage for those old gilded wooden plates from the 1800s — perfectly visible from afar and very legibly bearing the artist's name and dates and the subject of the painting — and reattach them to their frames.

After the war, good taste (notably when Bazin was reframing the old paintings) dictated that the title plates be merged into the frame, laminated so as not to clash or create a visual disruption. Today, this aestheticizing tendency has given way to a concern for restoring the plate's informative role. This didactic streak reappeared in the 1960s and 1970s, when visitors were given huge amounts of information, much more than the artist's dates and the name of the painting. Certain museums, notably in the United States and England, compose long explanatory wall labels, full of historical or even aesthetic considerations. When I was young, we found that practice somewhat vulgar: didn't those light-colored labels clash with the works? Today, the Paintings Department installs wall labels with an explanatory notice next to the works rather than on the frame. This still begs the question of what should be explained. There are various possibilities: in addition to the necessary identifications, should one talk about the style, or only about the subject matter? I tend to favor the latter. These days, visitors have only a vague knowledge of religious history or mythology. They know little about

the meaning of the Visitation or the fall of Absalom, and still less about the loves of Echo and Narcissus, so it is useful to briefly explain the subject. The origin of the work is also important, with the name of the donor and possibly of the collector, which tells something of the history of taste—and acknowledges our gratitude.

A curator's job also involves issues of restoration. Before the war, René Huyghe had created a studio headed by a painter, Jean-Gabriel Goulinat, an excellent restorer in the nineteenth-century tradition. A team was formed at the end of the 1930s, of whom I was able to meet the last representatives: Goulinat himself, Lucien Aubert, Jacques Roullet, Henri Linard, primarily painters by trade, but also excellent technicians, sensitive and careful in the very delicate matter of stripping off layers of varnish. In addition, the Louvre employed proven practitioners for all the operations related to supports—transpositions, backing, and so on. We mustn't forget that in this domain, France could call upon professional traditions that went back two centuries. These operations were always closely followed by the curators.

In the 1930s the Louvre also created a laboratory to study the works, which could oversee the technical conditions under which restorations were handled. This laboratory would increase in size and efficiency when Magdeleine Hours took over after the war. I witnessed a fairly significant change in practices during the 1950s, when the still unsophisticated approach of the traditional conservation studio was transformed into something more like foreign restoration institutes. The primary model was the Istituto del Restauro in Rome, both a conservation studio and a laboratory, as well as a school that trained several generations of restorers from every country, France included. Succeeding Cesare Brandi, Giovanni Urbani headed it, assisted by outstanding restorers

and teachers such as Paolo and Laura Mora. This institute revived the methods and techniques of a trade workshop, establishing a certain number of basic rules. A practice of restoration was set in place, based on centuries-old experience but reinforced by modern methods of physical and chemical analysis. Germain Bazin and I shared an aversion to the radical varnish stripping practiced by the National Gallery in London after the war, which was all too common in the art market. Obviously, a scrubbed and buffed painting will attract buyers more than a dirty one! Our prudence was based on the progress of physical and chemical studies in the laboratory and had the support of the young curators and the restorers themselves. The Institut Français de Restauration des Oeuvres d'Art (IFROA), created in 1977 by Jean Coural, would train new generations of restorers. By that point, the trade was no longer a sub-responsibility of painters, but a profession unto itself with its own principles and areas of expertise. While restoration entails a preliminary study of physics and chemistry that might seem a bit cold, it mainly depends on experience and talent. The best restorers are rarely those who claim they can handle anything, from frescoes to contemporary paintings, from primitives to masters of the Renaissance or the seventeenth century, not to mention dealing with supports, relining canvases, and so on.

I considered it a great benefit when Bazin took over this service in 1966, given his competence and our shared views on the subject. I was also glad that it was under the directorship of the Musées de France, which would be responsible for the provincial museums in cooperation with the conservation laboratory. The service required constant updates and exchanges of information with similar research centers throughout the world.

As concerns the paintings in the Louvre, in any case, the work is still done under the direct supervision of the depart-

ment curators, and the final decision belongs to the art historian. An approach is decided on between the curator in charge of a given collection and the relevant conservator, under the regular supervision of a committee, with weekly visits to the studio by all the curators. The restorers request and require constant attention from the curator specializing in that domain.

I myself closely followed dozens and dozens of restorations — at the patient's bedside, so to speak — right beside the restorer and in concert with the head of the restoration studios. Together we studied all the questions that might arise during restoration: if a particular attempt at removing old varnish wasn't too extreme; whether or not it was better, in repairing an area where the paint was missing, to try to blend the retouching in or make the repair visible, like the Italians; whether or not an earlier retouching should be preserved, either for historical reasons or because it could not be improved upon; whether or not we should ask the laboratory for new X-rays, pigment analyses, or reflectography; and so on. I've always taken a great interest in following this process of resurrection, which puts you in direct, almost carnal, contact with the very matter of painting. The process sometimes reveals flaws that, depending on the case, one should either show or conceal, but it also brings some miraculous surprises: a better overall condition than presupposed or details that have been inexplicably painted over. I'm thinking of that delightful Lolita with a ponytail who, covered over for some obscure reason with dark stain, suddenly emerged one day amid the donors in *The Resurrection of Lazarus* by Geertgen tot Sint-Jans, a Dutch painting of the fifteenth century.

Obviously, we're dealing here with extremely different cases, beginning with rescues made necessary by the paint layer coming detached, alterations in the varnish, the dangerous fragility of supports, or accidental damage. Such cases

were fairly rare at the Louvre, where the collections have always been carefully attended to. But the great upheaval of reinstallations led us to reexamine each work one by one. Most of them, on display since the war, could be rehung as they were; others needed a simple dusting (what the old restorers used to call the "Tuesday toilette," from the custom of going through the galleries on the day the museum is closed with a dry cloth); still others, a minuscule retouching of the varnish.

The more important operations concerned works disfigured by old retouchings or obscured by yellowed varnish. Since the 1930s, when Goulinat began discreetly stripping some of the varnish on certain Rembrandts, department policy has always been based on great caution. Except when the disastrous state of the paint layer or the support requires a complete removal, the rule is never to strip it down to the original varnish layer. In old collections such as the Louvre's, canvases are covered with several layers of varnish, superimposed over the centuries, which naturally turn yellow with time; in addition to which, many works were covered with artificially tinted varnish to give them the "museum patina" that was so highly prized in the nineteenth century. The restorer's very delicate art, the part that requires the greatest mastery, is the subtle operation of progressively removing layers of varnish. It is tempting, in the name of authenticity, to go all the way down, to strip it all off and rediscover the fresh, dazzling colors of the paint. But we also know that such a practice can lead to disasters. Because of it, many paintings from the sixteenth or seventeenth century have lost or partially lost glazes applied by the painter himself over the first layer of varnish. More frequently, color discordances have emerged — different colors age differently; certain whites or lapis blues retain their brightness, while others fade or darken over time — that had been muted by the slight yellow of the

varnish. How many paintings stripped to the bottom have revealed gaps or worn spots that earlier restorations had opportunely concealed? In such cases, isn't it better, rather than condemning ruined works to remain in storage, to leave in place the bandages that had cauterized them? Naturally, this question is at the heart of any debate about restoration: should the traces that history leaves on a work be erased so that the work can recover its original truth? The Louvre's answer has always been nuanced. There was no question, for example, of restoring to their original dimensions paintings from the royal collections that had been enlarged and supplemented by the king's painters to fit the woodwork at Versailles. At most, when the composition suffered too much because of it, we masked the fake addition under a frame, as in the case of Lotto's *Christ and the Woman Taken in Adultery* or Titian's *Concert Champêtre*.

In the main, and with hindsight, I have the impression, and would have no hesitation in saying, that when it comes to the delicate process of removing retouchings or excess varnish, or of uncovering the true appearance of a painting, taking into account what the patina of time might have added, the Louvre's conservators and restorers, over several generations, have generally obtained excellent results.

In the 1980s, especially following the polemics over the restoration of the Sistine Chapel, explosive debates brought problems of restoration into the public eye. My own point of view, having witnessed the Sistine restoration from up close and on several occasions, is that Michelangelo was not betrayed. Various associations at the time launched violent protests, even in France. There was nothing strange about that — on the contrary, such passions prove the public's interest in the national patrimony. But a number of the arguments advanced struck me as dubious. Is one right to say, "You have no right to touch such-and-such a work, because that's how

Delacroix and Cézanne saw it," when we know for a fact that the painting in question has changed over the last 150 years? Because of this, a rather unhealthy climate hovered over the perfectly realized restoration of Veronese's *Marriage at Cana*. Amid imprecations and contradictions (for many of those hurling imprecations proved their incompetence in this domain), screams and protests, it is not possible to have a calm discussion. Debate, consulting with persons external to the museum, discussing the paintings with restoration committees—all of this is fine, and we have always done it. But nothing is gained from irrational outbursts and unfounded charges of malpractice. All the more so in that the Louvre, of all the museums in the world (and I could name several), is the one that has had the fewest serious accidents. As you see, even I have a hard time keeping my temper when talking about this!

As I noted before, I witnessed a large number of restorations, and each one was different and often fascinating. There is one, however, that kept me particularly breathless: the restoration of Piero della Francesca's *Portrait of Malatesta*. Every day I went to see the restorer, Jeanne Amoore, who, millimeter by millimeter, discovered that the canvas had certainly been repainted, which we knew, but that beneath the retouchings gradually emerged an intact layer of paint—the face and costume—or else empty or worn-out spots, such as in the hair and background.

Naturally, a minute study of the painting had been conducted in the laboratory. One day, during this examination, I received a rather concerned phone call from Hours, who said, "Not very good news, I'm afraid: there are traces of oil in the binders." Actually, she could not have given me better proof of the painting's authenticity. While most Italian panels of the fifteenth century (until 1470, in any case) were painted in tempera, we know that Piero della Francesca introduced oil

into his binding substances beginning with the polyptych *Madonna della Misericordia* in Sansepolcro around 1450. He certainly saw in Ferrara, where he stayed around that time, canvases by Rogier van der Weyden painted in oils and absorbed his example. This explains, in the *Portrait of Malatesta*, painted in Rimini about 1451, the effects of carnal truth engendered by the ductility of oil, which we don't find in the Florentine painters of the time, but which Antonella da Messina would obtain later. It was this luminous material that the restoration slowly revealed, hidden beneath the leaden opacity of the overpainting.

Should a museum continue to acquire, and why? For certain museums, it's a good question. Museums based on a specific collection, such as the Wallace in London, the Jacquemart-André museum in Paris or the Condé in Chantilly, are the expression of a given collector at a given time. Their collections will not grow further, unless someone else decides to augment them with his own donation, as was recently the case when the Jacques Petithory collection was bequeathed to the Musée Bonnat in Bayonne. But the mission of most museums, like libraries, is naturally to increase its holdings, in response to the public's ever-renewed curiosity and demand for knowledge. "A museum that doesn't enrich itself impoverishes itself," as we like to say.

In the case of the Louvre, this is a core mission. From the moment they decided to put the royal paintings collections on public view, an acquisition campaign was waged under the enlightened authority of d'Angiviller, Louis XVI's remarkable superintendent, and of Jean-Baptiste-Marie Pierre, the first Painter to the King, to complete the existing collections. I don't need to mention that this has been, from generation to generation, the constitutive policy of the Revolution, of Vivant-Denon, of the nineteenth century, and on down to

our own time, always conducted in the encyclopedic spirit of its origins.

Visitors today believe that what they are seeing has basically been here forever. Not so. Here's one example: initially, the Musée Napoléon had no Italian primitives. There was Van Eyck, but Italian painting began with Perugino. Anything before that was dismissed as "gothic" painting, which had suffered several centuries of disparagement. Dominique Vivant-Denon, the Musée Napoléon's brilliant director, gets credit for understanding the importance of that painting and bringing it into the museum, thus presenting pictorial art from before Raphael.

Another eternal question: what is the greatest museum in the world for paintings? There are three or four, of which the Louvre is certainly one. In my view, what characterizes it with respect to others when it comes to paintings or drawings is the juxtaposition of, on the one hand, a great historical collection (the royal collection), including Leonardo, Raphael, Poussin, Rubens, the great Venetians, and the Bolognese, corresponding to the values of the Ancien Régime, and on the other, contributions from over the two centuries that followed. For old painting, the Hermitage is comparable to the Louvre in its formation, with Catherine the Great's collection that contains masterworks by Giorgione, Titian, Lorrain, Rubens, Poussin, Rembrandt, and so on — sadly skimmed off by the Soviet sales of the 1930s. But despite some beautiful Flemish works, there are relatively few primitives in the Hermitage; or again, it has one of the most complete collections of seventeenth-century Dutch paintings, but not of Vermeer. We can also see some imbalances in the Prado, which is sumptuous for fifteenth-century Flemish, but thinner for Italian primitives or seventeenth-century Dutch, as the incomparable royal collection was not "brought up to date" in the nineteenth and twentieth centuries. The explana-

tion is, of course, a matter of history. The great royal collections, such as Vienna, the Uffizi, the Prado, Dresden, and the Hermitage, were essentially composed under the Ancien Régime, with a certain vision of art history. The other great museums, such as London, Berlin, and of course the American museums, were constituted during the Industrial Age with great financial resources and great advances in knowledge in the nineteenth and twentieth centuries — which led to a much more open-minded approach to every period and school in the history of painting. The Louvre is the only museum that benefits from these two sources of wealth: the great royal collection and the acquisitions of the nineteenth and twentieth centuries, when France, in full industrial development, had the means and the ambition to effect large purchases, reinforced by important donations. The relative balance of our collections is the result. Moreover, we own more varied examples than anyplace else of every technique and support in painting, from small cabinet paintings and gallery and church canvases to the great oversized works and frescoes.

The history of the Louvre's acquisitions over the past two centuries lies in the way that successive museum authorities have been able to purchase, receive, and also ignore or lose out on thousands of works, with the aim of gradually composing as complete a history of European painting as possible. And this while trying to fill the obvious gaps that have always existed, and keeping in mind (hopefully not too late) the phenomena of rehabilitation or resurrection that constantly bring forgotten figures back into prominence. I should add that a very important part, essential for French painting of the eighteenth and especially nineteenth centuries, of this long process has been made possible by the generosity of the great donors, reflecting the freedom of taste and the instincts of independent art lovers.

At the same time, you can't own everything, and some

would say that the collections are already overfilled. I have long been a member of the Siècle club, which was founded by journalists and is largely populated by prominent business-men. Hardly a dinner went by at this club when, if I mentioned how paltry our acquisition funds were, I didn't hear one of my tablemates, some company president or upper management type, say to me, "But you already have too many paintings as it is, your storage areas are stuffed to the gills! Why don't you sell some off so you can buy others?" I then had to explain that, fortunately, French law forbade this (and may it always be so), and that fluctuations in taste and in the value of works had led every museum, especially American, that had sold off paintings to regret it later on. Hadn't our grandmothers sold off their old Gallé vases for nothing? And hadn't so many "pompier" paintings, at first admired then hidden away for years, eventually found their place in the market?

I'll give one example among many of this kind of historical hiccup, the case of Georges de La Tour, in which, as it happens, the Louvre's curators tried for several generations to make an opportune move. *The Adoration of the Shepherds* had been acquired in 1926, thus well before the 1934 exhibition at the Orangerie, which first revealed the artist to the mainstream public. It is striking that a London collector, Percy Moore Turner, dealer and Francophile, bequeathed La Tour's *Joseph the Carpenter* to the Louvre in 1948, after the National Gallery had decided against buying it before the war. At the time, Georges de La Tour seemed mainly a curiosity. No use mentioning that present-day curators are kicking themselves for this oversight, as they still have no works by the artist.

When I arrived at the department, the Louvre owned three works of great quality by him, *The Adoration, Joseph,* and *Madeleine Terff,* but no diurnal scenes. Sadly, *The Fortune Teller,* which René Huyghe had tried to buy in 1949 (but the house

of Wildenstein had outbid us), had left France for the Metropolitan Museum. So we still didn't have a painting of this type. But one still existed in France, the famous *Cheat*, which belonged to Pierre Landry, a former tennis champion, one of the "musketeers" of the Davis Cup, with Lacoste and Cochet, and a great lover of paintings. Legend has it that one rainy day in 1925 or 1926 he took shelter in an antiques shop on Ile Saint-Louis, where he found *The Cheat*, signed Georges de La Tour. He bought the painting, lent it to the 1934 exhibition, and kept it all his life—it was his pride and joy, and rightly so. The first La Tour exhibition in 1972 gave us a chance to buy the work, and for me it became an obsession: I wanted *The Cheat* for the Louvre. Landry was a very complicated fellow, at once unbearably oversensitive and charming. For him, it obviously wasn't a matter of money; he wanted recognition for his role as a pioneer (which he was) in the rediscovery of La Tour after World War I. It thus became, with the help of several of his friends, a kind of dance around him to get him to accept the idea. And so we insisted that he should appear as one of the organizers of the exhibition, alongside Jacques Thuillier and Pierre Rosenberg. At the close of the exhibition, *The Cheat* entered the Louvre's collections, and Landry made us the gift of a delicate panel from the Avignon School, *The Presentation of the Virgin* by Nicolas Dipre. Several years later, in 1979, thanks to the Amis du Louvre, we were able to acquire the nocturnal *Saint Sebastian* from the church of Bois-Anzeray. Later still, in 1988, on the initiative of Rosenberg, a public subscription brought in a second diurnal painting, *Saint Thomas*.

This rather long tale illustrates how successive department heads are driven by the feeling of a mission to accomplish. But careful: the story I've just told is gratifying and fairly flattering. I could also cite countless cases of past failures, from *The Adoration of the Magi* by Hugo van der Goes, sold by

the convent of Monforte in Spain and bought out from under
the Louvre in 1914 by the Kaiser Friedrich Museum in Berlin,
to all the masterworks by Cézanne, Gauguin, or Seurat that
left France before the war, for lack of legal means of keeping
them here, financial means of buying them, and, at least
before 1930, enough discernment to recognize their impor-
tance. That was the past, but in a moment I'll give you several
examples of failures that happened during my tenure in the
department.

The important thing is that the curators remain driven by
the same appetite, the same assiduousness; that they have this
desire in their blood. On this condition only, Velázquez and
Duccio, Altdorfer and Hogarth, Bermejo and Liss, Paret and
the Master of the Virgo Inter Virgines, Philips Koninck
and Stefan Lochner, Venetsianov and Elsheimer, and even
Grünewald, Campin, and Masaccio, might someday come to
join their fellows at the Louvre.

As head of the Paintings Department, I tried both to estab-
lish a precise acquisitions policy and to respond to opportu-
nities as they arose. We had several means for this at our
disposal. First, the legal provisions of 1945 established that
any work of art scheduled to leave the country through cus-
toms should be examined by the Musées Nationaux, so that,
if need be, it could be preempted. Every Wednesday, the cura-
tors from various departments in the Louvre — since each
department of the museum is to some degree responsible for
its particular "medium" throughout the entire country —
would go to see works that dealers or private owners wished
to export. Ninety-nine percent of the time, they signed an
exit authorization. When a work seemed "museum-worthy,"
we had the right to preempt, as in a public auction, in other
words, to buy it for the price indicated by the exporter. Now,
this control was exercised during a time when the market was

very active and there was considerable international demand, especially from American museums. In Europe at the time, France was second only to England in the number of paintings, drawings, sculptures, and decorative objects it held.

At first, in the 1950s and 1960s, the system wasn't entirely effective. Many crucial works were legally and irrevocably let out of France, much to our subsequent regret. The Musées Nationaux had less money for acquisitions, and some departments were perhaps less aware of the need to acquire. Certain unattributed works eluded the vigilance of our representatives — otherwise, the Louvre would now own the Hugo van der Goes that it's missing! As an example, we can only deplore the fact that an obviously patrimonial painting by the fifteenth-century painter Jacques Iverny, which came from a church in Avignon, left France to go to the National Gallery in Dublin. This was an extremely rare canvas whose rightful place is at the Louvre or the Avignon museum — and the price wasn't even that high. But it was exported legally by Wildenstein, along with a large polyptych by Ugolino da Siena that is now in Williamstown. I have to say that Albert Châtelet, the department's young assistant who handled these customs matters, made me share his regret over such a loss.

Still, thanks to this right of preemption, several important acquisitions were made possible during those years, such as *The Flagellation of Christ* by Jaime Huguet in 1967, Zoppo's *Madonna* in 1980, and Chardin's *The Serinette (The Bird Organ)* in 1985 — up until 1992, when the legislation was changed.

We could also ask the minister to forbid a work's exit from France without buying it, something we did only on very rare occasions. Some dealers and collectors considered this an exercise of royal prerogative (which was indisputable) that compromised the health of the French art market (which was debatable). They might have been right had the practice ever

become commonplace. To my mind, the system worked because it was not definitive. I myself have verified that, as far as paintings are concerned, practically none of these interdictions was maintained without a purchase. For example, Fragonard's magnificent *Gimblette* was submitted to us for export twice in a row; in both instances, we asked the minister to forbid its exportation. Finally, on the third try, we relented. The painting is now in Munich, because in the meantime we had acquired several major Fragonards. Since the painting was thereby less rare, we decided to let it leave France.

This system presented many advantages when it came to the great collectors who had been friends and donors to the museum for generations, such as the Rothschild family or David-Weill. The arrangement we had with the collectors or their heirs was a kind of gentleman's agreement. They knew that certain truly patrimonial objects in their collections could not leave France, and they accepted that. On the other hand, when the matter arose, such as after an inheritance, the departments would let some very important works leave, which they probably wouldn't have recommended in most instances. This happened several times: we authorized the export of Goya, Fragonard, Hals, Rubens, and other greats, with the hope that the collector would keep for himself or his children other works that were essential for the national patrimony and that might one day come to the museum.

This practice is no longer in effect. According to the European regulations, a certificate is required for important works to leave the country. Works that do not obtain this certificate, having been deemed "national treasures," can be acquired within a certain time period. But once this period is over, they are allowed to leave France. It has happened, and not that rarely, that several national treasures have become available in the same year, and we didn't have the funds to buy them all, at which point major works left the country.

Perhaps France shouldn't have adopted this practice, as the Italians and Spanish wisely decided.

The practice of notification, which has its own drawbacks, is the one they continue to use in Italy. You might say they use it to excess. In France, when we apply it (because our system is basically the same as notification), we do not make it definitive, as I said. The Italian practice, on the other hand, entails the risk of freezing the market and encouraging smuggling. I can cite two or three examples concerning Italian museums with which I was involved. The Louvre lacks works by Baschenis, an admirable seventeenth-century painter of still lifes, very rare outside of Italy. We once found one of his beautiful still lifes at a dealer's in Bergamo, and the Amis du Louvre were ready to buy it. When consulted, Franco Russoli, the superintendent of Milan who was in charge of patrimony for Lombardy, said to me, "We have similar works in Bergamo and Milan, so this painting can certainly leave Italy for the Louvre." Unfortunately, the head committee in Rome vetoed his decision. I don't believe it was the right choice.

Another time, we were absolutely set on acquiring paintings by the Macchiaioli, highly original Tuscan painters of the nineteenth century, for the Musée d'Orsay. It was practically impossible to find a Fattori or a Lega. The truly important paintings in Italian private collections were all under notification, and naturally we couldn't become involved in taking paintings out illegally, as someone had suggested. Finally, a Venetian lady offered us a portrait of a woman by Silvestro Lega, a beautiful canvas representative of the artist's final period. The superintendent of Venice refused to let it go, even though Lega is well represented in Italian museums. Was that really fair?

One final example concerns the three paintings I most regret losing: a small panel by a rare artist, the Master of the Knight of Montesa, a fifteenth-century painter from the

school of Valencia. This panel depicted Christ in the tomb with three skulls in the foreground. It was an extraordinary work, not unlike certain Ferrarese canvases of the late fifteenth century. If the painting is indeed by Pablo de San Leocadio, which is likely, then it is of Italian origin. It was offered to us for a hefty but acceptable price by a dealer who claimed that its exit from Italy had already been arranged. I presented the acquisition to the curators' committee, who accepted it. But shortly afterward, the dealer informed me that he still had a few details to finalize. These details turned out to be nothing less than the authorization for the work to leave Italy, which ultimately was refused when I thought the acquisition was final. And the painting was returned to its owner, who moreover has since lost it: it was destroyed by a fire in his apartment! This case is a bit different from the others, in that I understand why the Italians wanted to keep such a work as part of their patrimony. The sad part is that they ended up enjoying it no more than we did.

"Giving in payment" (*dation*) is another major source of acquisitions. This was a remarkable initiative on the government's part, passed into law in December 1968 under Michel Debré and applied under Georges Pompidou, which is the envy of several European nations. Italy adopted the principle, which consists, in the case of export or inheritance, of waiving tax duties for works of art. The heirs who would otherwise have to pay huge sums lose nothing, since the estimated value agreed on by the Finance Ministry is calculated according to the international art market. The price of the work therefore corresponds to what one would obtain at auction in London or New York. Most collectors or heirs were satisfied with this, since many of them preferred to see their works in a French museum rather than abroad to begin with.

Maurice Aicardi played a considerable role in perfecting this

system. He even made it so that an ill-informed family that had already paid inheritance taxes could be "reimbursed" by the Finance Ministry in exchange for a masterpiece! A number of first-rate works — Filippo Lippi, Solario, Fragonard, Goya, Hals, Rubens — entered the Paintings Department this way. Not to mention the Impressionists and modern works, culminating with the Picasso *dation*.

For the Louvre, the greatest work acquired in this way is incontestably *The Astronomer* by Vermeer. I had seen it at the Orangerie in 1946 in the unforgettable exhibition of masterworks from French private collections that had been looted by the Nazis and rediscovered in Germany. It later belonged to Baroness Edouard de Rothschild. If someone had asked me when I started in the Paintings Department which painting from a private collection I dreamed of for the Louvre, I would surely have said this one. The fact that my dream was to become reality was announced to me by Baron Guy de Rothschild himself, who had the tact to invite me to lunch on Rue Laffitte to do so. Hurt by the nationalization of the Rothschild Bank, and despite the hesitations of certain members of his family (notably his wife, Marie-Hélène), who would have preferred to make other financial arrangements with the state, he had insisted on making this gesture, worthy of the great Rothschild tradition, knowing what this painting meant to the Louvre.

Our acquisition funds were and remain insufficient. They have benefited from state subventions to varying degrees and from import duties paid to the Réunion des Musées Nationaux. For example, there are funds derived from the "Canadian foundation." The American-born Princesse de Polignac, one of the great arts patrons between the wars, especially for music, had bequeathed her collection to the Louvre, including famous works by Monet. She had also left monetary funds which generated arrears that long served to

acquire major works, such as *The Pont de Maincy* by Cézanne or the large panels by Sassetta from the Sansepolcro polyptych.

Later, there were also the patrimony funds, which are still in force and which allow museums, libraries, and archives to acquire essential works that might otherwise leave France. Still, all of this is not enough. Some recent, and fortunate, fiscal legislation will allow companies, through important tax incentives, to acquire and donate national treasures.

As for gifts, since French fortunes are no longer what they used to be, the *dation* system probably has taken the place, in many cases, of bequests or outright gifts. But disinterested generosity has not entirely disappeared.

One particularly pleasing example of pure generosity concerns two elderly gentlemen from Strasbourg, Othon Kaufmann and François Schlageter, major collectors of Baroque painting, who bequeathed their collection to the Louvre and the Strasbourg museum. Pierre Rosenberg, who helped engineer this, had learned about a collection of Italian and French paintings in Strasbourg. Paying a visit to the collectors, he had been dazzled by the quality of the works they had assembled, as they had been dazzled by their visitor's knowledge and sensitivity. He became their friend, as subsequently did I. We went to see the gentlemen in Strasbourg, accompanied them to Bayreuth, took them around the collections in Paris, and introduced them to our colleagues in the department. They began buying paintings that were of interest to the Louvre. And finally, the idea of bequeathing us their collection was voiced.

They bought only what they felt like buying, Italian or French paintings from the seventeenth and eighteenth centuries with a predilection for sketches. I met them one day at Christie's in London, rummaging here and there. On my advice, they bought a magnificent portrait by Drolling, a painter from Strasbourg. The painting remained with them

for only a month: they had bought it to make me happy, but without real conviction. As with any true art lover, they were motivated completely by their own taste.

Their future donation was presented to the Louvre in the form of a temporary exhibition in 1984. We saw then that the sureness of their choices would one day bring the Louvre some missing Italian artists such as Borgianni, Cavallino, Creti, or Corrado Giaquinto, or paintings that revealed new aspects of artists already in the collection: Le Sueur, Greuze, Vouet, Boucher, Tiepolo. It would mean the arrival of true "art lovers' paintings," adding a charming complement to the more official portions of our collections. On that occasion, Minister of Culture Jack Lang awarded them the Legion of Honor. It was very touching to see these two old men, who looked like they'd stepped out of a drawing by Hansi — they were both of German origin, but their many years in Strasbourg had given them an Alsatian patina — at once intimidated, terrified, delighted, and astonished by the courtesy of a minister whom they'd expected to see with a knife between his teeth.

Getting back to what I said earlier, I myself never instituted a formal acquisitions policy in the Paintings Department. Many works were discovered, identified, negotiated, or supported by a given curator. We discussed them at department meetings, sometimes taking a vote if there were doubts or dissenting opinions, and, of course, we consulted outside specialists when necessary. It is the department head's job to make the final decision, but we always ended up more or less in common agreement.

Our first task was to penetrate the network of dealers in France and London — with whom I was fairly familiar through my purchases for the provincial museums — as well as in Italy, Switzerland, Germany (which at the time I didn't visit much), and the United States, and to establish trusting

relations with them so that they would know what we were looking for and would think to give the Louvre "first refusal" when important works came onto the market. For example, Otto Wertheimer and his wife, Anne, Germans who had taken refuge in France in the 1930s and become citizens, had found an extremely rare painting by Wolf Huber. Although represented in the Drawings Department and some provincial museums by some beautiful works on paper, the Danube School was not represented in the Paintings Department, and they immediately thought of us. The price was fairly steep, but they could have gotten more by selling it in Germany if they'd wished.

. Still, one isn't always successful. We had good relations with the firm of Agnew in London, which specializes in British painting and from which we had already bought the *Lake Nemi, Sunset* by Joseph Wright of Derby in 1970. They knew that we were looking to increase our British collection and that we would have liked to include Richard Wilson, the great eighteenth-century British landscape artist, heir to Claude Lorrain and "English little brother" to Joseph Vernet. One day, Rodney Merrington from Agnew invited me to view two magnificent canvases, two large views of the Italian countryside that were clearly the Wilsons that should be in the Louvre. But for lack of timely funding, we had to let them go, and I still regret it.

One of the weaknesses of the old Louvre collections was that Mannerism was less well represented than in other princely collections, such as Vienna, Dresden, or the Prado. This is because the French had always preferred classical tendencies: the Bolognese and Romans over Genovese, Neapolitan, or Lombard Baroque; Raphael and Correggio over the Mannerist eccentrics (except for Rosso Fiorentino). But acquisitions of works by Niccolò dell'Abbate (1933), Spranger, and Arcimboldo (1964) had opened the door, and

we had, for example, acquired Dutch masterpieces by Wtewael and Cornelisz van Haarlem. But we were still lacking the greatest of them all, alongside Rosso and Pontormo: Parmigianino. The Louvre has one of the world's greatest collections of drawings by Parmigianino, but no master painting — at least not until 1992, when the delicate *Mystic Marriage of Saint Catherine* entered the collection. It could have been otherwise: twice in London, in 1974 and 1977, superb paintings came up for sale, a portrait and another larger *Mystic Marriage of Saint Catherine*. Both times I had raised the money, and both times the painting had gone to the National Gallery. It's understandable, but still, every time I see them in London, I can't help feeling a certain annoyance.

There have, of course, been successful examples as well. The great prewar Italian dealer Alessandro Contini-Bonacossi had kept the cream of his purchases for himself. He had decided to leave his Florentine villa and the totality of his personal collection to the Italian state. But his heirs contested the donation and legal debates ended in a transaction: a certain number of paintings would be left to the state, and are today in the Uffizi; while a number of other important works would be authorized to leave the country and be sold. We immediately came forward and were able to acquire Giovanni Bellini's *Crucifixion* in 1970. I was assisted by Gaston Palewski, a collector and political figure and a great friend of Italy, where he had been the French ambassador and had retained his connections. He helped me negotiate with the heirs with regard to several pictures. We had been given a choice between the Bellini, two magnificent ceilings by Tiepolo, and a very beautiful *Madonna* by Foppa (Piero della Francesca was not in the lot put up for sale). After hesitating over a Tiepolo, which we needed — the Louvre still does not own any of his large compositions — I chose Bellini, who was also poorly represented at the museum.

Several years later, in 1977, another opportunity arose. One of Contini-Bonacossi's paintings, legally exported from Italy, had been brought to my attention in New York by Federico Zeri: the *Portrait of Malatesta* by Piero della Francesca! The painting belonged to Stanley Moss, a cultivated New York dealer and writer. I knew this painting, which had been shown at a 1954 exhibition in Florence and published by Longhi, and was well aware of its importance. Still, two or three specialists had cast doubt on it, so I had to remain cautious. After lengthily examining it in New York, I consulted several historians after Zeri, notably Charles Sterling, Kenneth Clark, John Pope-Hennessy, and André Chastel, who confirmed my belief that this would be a major acquisition.

The painting was bought for roughly ten million francs. Since we didn't have that kind of money at hand right then, we asked Prime Minister Raymond Barre for a special credit; learning that Piero della Francesca was one of the large gaps in the Louvre's collection, Barre seemed favorably disposed. Several weeks had passed between my trip to New York and our verbal agreement to buy the painting. In the middle of the night, I received a phone call from Moss, who until then had been extremely patient, asking me for a final decision right away. The Director of the Musées de France called Matignon palace, but Barre had just left for China. Panic! We finally reached the Prime Minister in his airplane, and he gave his final consent. I saw Barre twenty years later and reminded him of the episode, which he remembered perfectly. Which proves that, now and then, a little nudge from the powers that be is indispensable.

Too soon afterward, a mere few months, the other great gap in our fifteenth-century Italian collection, Masaccio, was offered to us via a very charming individual, Andrei Czeskanovieski, an expatriate Polish aristocrat and a great connoisseur. He had managed the Heim Gallery in London and later opened his own gallery. Against all hope, this patriot

thought that Poland, which at the time was still Soviet, would regain its independence. He had amassed a collection of artworks and historical artifacts that, when the moment finally came, he gave to the Royal Palace in Warsaw. Knowing that Masaccio was missing from the Louvre, he served as a pro bono middleman between us and a Polish noblewoman, Madame Lanckoronska, whose father had assembled an admirable collection in Vienna at the turn of the century, notably of Italian primitives. This collection was presumed destroyed during the war. An important work of Uccello's, *Saint George and the Dragon*, and some frescos by Domenichino had been sold to the National Gallery in London, but these were thought to be the only survivors. One of my graduate students, who needed to study a Simone Martini in the collection, wrote to Madame Lanckoronska in Rome, where she ran the Polish Library; she had remained highly evasive about the fate of the collection. As it turned out, the works were being kept hidden in Switzerland, also awaiting Polish independence. Since 1999, they have formed the core of an extraordinary collection of primitives, given by Madame Lanskoronska to Wavel Castle in Warsaw.

The Masaccio, a *Saint Andrew*, was part of the great dismembered polyptych from Pisa. We were offered first look. Unfortunately, I wasn't able to repeat the same "score" as with the Piero, and couldn't raise the ten million needed in time. The painting was bought by the Getty. I greatly regretted losing it, especially since the conditions were ideal: an owner who wanted the painting to come to the Louvre, and an intermediary who was making a gesture of friendship between France and Poland.

On the subject of regrets, the paintings that came to the Louvre under my tenure are known and have illustrated our catalogues. Those we coveted in vain, on the other hand, are not, and illustrate only our hopes.

My most painful regret is surely Velázquez. Of all the major

artists, he no doubt represents the largest gap in the Louvre's collections. There are a number of Velázquez paintings in our holdings, but none of them is one hundred percent certain. And to think that several of his masterpieces were in the Spanish gallery of the Louvre under Louis-Philippe, before being—the Republic was so virtuous—returned to the Orléans family in 1848! Those paintings had served as a reference for Courbet and other French painters.

The National Gallery in London owns several masterworks by Velázquez, one of which, the *Rokeby Venus*, possibly the most beautiful nude in all of painting, was supposed to have been acquired by the Louvre in 1906—the archives even contain an invoice for a shipping case from London. Did the National Gallery renege? There are also superb Velázquezes in Aspley House in London, which were part of the spoils that Joseph Bonaparte brought back to France and that the Spanish gave England as a gift. The infamous "exchange" of 1940 that I mentioned earlier brought to the Louvre a *Portrait of Marie-Anne*, a studio work rather than the original version we had thought it to be.

We followed a number of trails over the years: A very handsome *Study of a Woman*, which a broker showed me in great secret in a room at the Waldorf Astoria in New York, but its attribution couldn't be ascertained. An important youthful portrait that Emmanuel de Margerie, our ambassador in Madrid, hoped to be able to bring out of Spain (the Prado had another version), but in vain. A version of a genre scene from the artist's Seville period, which seemed to us better than the officially recognized one, but in too poor a condition.

In 1971 one of the last great Velázquezes still in private hands, *Juan de Pareja*, owned by the Earl of Radnor in Longford Castle, was about to go up for sale. Aware of the opportunity, I went to the London sale carrying the equivalent of thirteen million francs, which at the time was a considerable amount

of money, slightly higher than most of the funds raised for other purchases. I was feeling fairly confident. Several persons in the auction room would not have failed to recognize me, so I had decided against bidding myself. Instead, I had asked a friend, William Mostyn Owen, a manager at Christie's who had been one of Berenson's last assistants, to bid for me at the auctioneers' table, without specifying how high I could go so as not to influence the sale. We had agreed on a signal: I'd put on my glasses and remove them if my limit was passed. It was only a few seconds before I took them off: the painting went for over thirty million, more than twice what I had at my disposal! Wildenstein ultimately bought it for the Metropolitan Museum.

After all these missed occasions, here's a success story: the acquisition by the Paintings Department of another great lack, Turner, in 1967. His paintings are rare. Watercolors occasionally come up for sale, but seldom his oils, since he left his holdings to the Tate Gallery and most of the other great Turners were bought by American museums or the Mellon Foundation. One day, the question arose at customs of whether or not to let a Turner go from the famous Groult collection. Camille Groult had made his fortune in the large mills. His collection of eighteenth-century French and English painting included works by Watteau — we bought two of them — Fragonard, many British portraits, and several Turners — a little too much Turner, in fact. There was a famous story about this: Whistler, who could be rather scathing, had been asked by Groult to come see his collection, especially his Turners. He looked through the paintings one after the other and exclaimed, "Ah, what a beautiful collection! One of these paintings must be by Turner . . ." And when Groult asked which one: "Ah," said Whistler with a vague gesture, "who knows . . ." The painting we acquired is magnificent, as if unfinished, bathed in a golden fog. The work was restored at

the Tate, as Turner used a very complicated technique with several different mediums, and only the English conservators know its secrets. It remains the sole Turner in the Louvre. It would be perfect if one day we were to find—excuse me, if *they* were to find—a Turner à la Claude Lorrain.

I can't mention all our acquisitions. Over twenty years, there have been hundreds. I've mentioned examples of failures or regrets to demonstrate that it's not a simple matter. But I remain proud of what we did accomplish, and every enrichment made after my departure is a delight for me.

As for general acquisition policy, in many cases purchases depend on the chance occurrence of a sale, a curator's sudden infatuation at the dealer's, or the need to make a decision in customs. What counts in those cases is the quality of the work, even if we already have works by that artist at the Louvre. Moreover, this is true of other kinds of acquisitions. We can never have too many paintings by Lotto or Raphael, the Le Nain brothers or Champaigne, Rubens or de Jordaens, Pieter de Hooch or Hals, Watteau or Fragonard, Courbet or Corot—to cite, in no particular order, artists by whom important new works entered the Louvre in my time.

Still, we did have, in addition to the list of great "gaps" I've already mentioned, a second list of groups, tendencies, or schools that were poorly or not at all represented, and by whom we were looking for examples: Mannerism in general; Baroque movements from the Seicento—Lombards, Genoese, Neapolitans, which were less abundant at the Louvre than were the classicists of Bologna and Rome, favored by the French amateurs of the Ancien Régime; certain aspects of the eighteenth century and more generally of the nineteenth outside of France—works by the British, Germans, or Scandinavians—to demonstrate that the richness and variety of European creation did not all originate in Paris, as people too easily thought. Several acquisitions in these areas

opened a path to such a realization, which was largely developed by my successors and illustrated by several exhibitions.

In addition, we hoped to put more of an accent on small-format works, sketches, first drafts in which the artist sometimes expresses the freshness of his inspiration better than in the finished work. The Louvre is a rather official museum — except for the nineteenth century, mainly thanks to collectors who contributed gallery, church, and Salon paintings; except for Tiepolo, Rubens, and the eighteenth-century French, we have too few *bozzetti* or *modelli*. Hence the enthusiastic welcome given the Schlageter-Kaufmann gift.

As I've said, acquisition decisions are made in common, but each curator has his or her favorites: in my case, the Sienese. I've been fortunate enough to bring to the Louvre important works by Guido da Siena, Ugolino, Pietro Lorenzetti, Lippo Memmi, Pietro di Giovanni Ambrosi, and by the one I've baptized the Master of the Rebel Angels, who certainly could be Simone Martini. But for one of the Sienese painters closest to my heart, the charming Sassetta, of whom the Louvre owns six paintings, fate decreed that only one work should come in under my tenure, and the least important one at that. The three large panels of the Sansepolcro polyptych, recognized as such by Sylvie Béguin, had been acquired in 1956; and the two predella panels from the same polyptych came in, one (thanks to the Amis du Louvre) in 1965, just before my arrival at the department, and the other, identified by Dominique Thiébaut in 1988, just after my departure.

I mentioned the Société des Amis du Louvre (Friends of the Louvre). Since its creation, it has played a fundamental role as a true network of support, an accompaniment to our own efforts at enriching the collections. But its interventions are very specific. We do not ask it to help with paintings that could be acquired by other means. The board is composed essentially of genuine art lovers, less interested in "official"

paintings or works that excite scholars than in rarities, cabinet works, and beautiful pieces of painting, and I'm glad. I've always enjoyed excellent relations with the successive board presidents. I shared a kind of complicity with Jacques Dupont, who had been part of Jamot's team and was an excellent art historian — some people regretted that he hadn't been picked as René Huyghe's successor — as well as a great lover of art. I can cite an example of the work done by the Amis of the Louvre, which isn't bound by the same strictures as official channels: the purchase at public auction in London of one of those grand portraits of English gentlemen during their "grand tour" of Europe, painted in Rome by Pompeo Batoni. They also intervened in delicate private negotiations or helped secure the support of the national museum board by contributing to costly acquisitions. The president who succeeded Dupont, Raoul Ergmann, a fine collector, was no less effective or well disposed. After him came François Puaux, who had been our ambassador in Rome. These days, with Marc Fumaroli as president, I approach the deliberations from the other side of the fence. But I still tend to side with the "lawyers" — the curators — rather than with the "jury" or the "judges."

The sumptuous exhibition organized for the Amis du Louvre's centennial in 1997 brilliantly demonstrated just how much the Louvre owes them. The society became much more democratic as of 1989, as the number of visitors increased. So much the better: keeping in touch with its aficionados is one of the conditions of museum life.

During my tenure in the Paintings Department, there were several pieces of business that received widespread attention in the press. The first concerned Poussin's *Olympus and Marsyas*. Returning one day in 1968 from his ritual visits to the Drouot auction house, Pierre Rosenberg asked me to go back with

him to look at a painting attributed to the school of Carracci, which he thought was by Poussin. Convinced that he must be right, I asked for authorization for a preemption, which was exercised at the sale the following day. We had several days in which to confirm or relinquish the purchase. As the department felt that the attribution seemed quite likely and the painting was interesting, we confirmed. Several weeks later, we had a visit from the auctioneer and the consulting expert, who informed me that the former owners were dismayed to learn in the press that the Louvre had bought a Poussin (whereas the painting had been offered under a less advantageous attribution) and were asking compensation for the shortfall in income they had suffered. The auctioneer said that they had in fact made an error—he used a stronger term—and that they'd call in their insurance. Thus began an episode that lasted for twenty years. After a long series of trials, articles, debates, theses, and legal appeals, the canvas was returned in 1988 to its former owners, because of an error in the characterization of the object sold. You can't dispute the court's ruling, but the entire affair left us with a bitter taste in our mouths. One of the arguments frequently advanced was that the "powers that be" had greater resources at their disposal than the private parties, of whom they took advantage. What resources? Rosenberg's eye, and that's it. We had preempted the work over a prominent dealer, who had certainly recognized that the work was by Poussin, and who, without our intervention, would have kept the painting for a while, then sold it to an American museum without the former owners ever being the wiser. It's the usual game of the art market. The savviest dealers discover misidentified works, study them, and if their intuition is borne out, resell them at market value. Here, it was as if they were blaming a functionary for putting his talent in the service of the national patrimony!

There was a second Poussin affair of a very different

nature. In 1944 Paul Jamot's niece, Thérèse Bertin-Mourot, had bought at Drouot a *Holy Family*, which she thought was an original work by Poussin. Another example of the same composition, published by Anthony Blunt, belonged to the National Gallery in Washington. Bertin-Mourot, a good art historian and feisty personality, had not been able to get any Poussin specialist to authenticate her painting, except for Jacques Thuillier. She invited Thuillier, Rosenberg, and me to view it in an effort to convince us. I still remember her greeting us in the foyer of her small apartment in the sixteenth arrondissement: white hair hanging down to her shoulders, she began by warning us that she was like an ermine — which none of us wished to challenge or put to the test — then showed us into the living room where the painting was hanging. She allowed us to study it for several minutes, long enough for the three of us to be persuaded that it was the original. Then suddenly, shutting the window drapes, she said, "You see, the painting still stands up; a copy does not stand up in the dark." I confess that the three of us left without waiting to hear more. Some time passed. Thuillier, who never let eccentrics frighten him, checked in now and then to make sure she hadn't destroyed the painting, as she had hinted, should the entire world not recognize that hers was the only original and the canvas in Washington a copy. (Poussin is one of the few painters who we know for sure never made two identical versions of the same composition, except in his youth.) Then one day we learned that the painting had been exported illegally by a relative of Mlle Bertin-Mourot and offered to the Cleveland Museum of Art. The museum's director, who was a friend, alerted us. He was notified by Hubert Landais, the director of the Musées de France, that the work had left France illegitimately, but he went ahead and bought the painting anyway, for which he was morally condemned (with fine hypocrisy) by his American

counterparts. After long discussions, a kind of compromise was reached: *Holy Family on the Steps* was sent by Cleveland to the Louvre on loan.

The third example is the most serious: the matter of Suzanne de Canson's Murillo. The story is incredibly complicated and perfectly sordid. At the heart of the affair is a poor woman swindled by crooks, who would die a victim of evil deeds. In brief: in 1975 we had seen a handsome *Portrait of a Gentleman* by Murillo at the shop of a Paris dealer, who gave us the name of the owner, a certain Baron Landevoisin. At the time, we had other projects to think about and I didn't follow up with a purchase offer, but I had kept a photo of the work in the files. In 1981 the department's interest in Murillo having been revived because of a planned exhibition, I took out the photo. We decided at a department meeting to reinitiate the purchase offer. I asked Pierre Rosenberg, who generally handled the department's acquisitions correspondence, to have the dealer put us in touch with the owner of the work. But the owner turned out to be no longer Baron Landevoisin, but a certain Suzanne de Canson, whose address he gave us. Our letter to her went unanswered, and we concluded that she was not interested in selling. Several years later, the painting came up for auction at Christie's in London; it had therefore left France illegally in a clear case of customs violation. A compromise accepted by the customs authorities and Christie's allowed us to negotiate the sale with the titular owner, the heir to a Mme Chappuis of Geneva, for the sum of five million francs. In reality, as we learned long afterward, the seller, with accomplices, had misappropriated the inheritance of Suzanne de Canson, which included several works of art from her father, an antiques dealer. The latter's family launched a legal investigation that, after a long trial, ended in stiff penalties for the guilty parties in 1991. Suzanne de Canson herself died in complete poverty in 1986. Another

series of legal battles finally confirmed the Louvre's full possession of the Murillo in 2001.

But during the trial, the mud from this horrible incident would spatter on us. People accused the department of having willfully ignored the painting's dubious provenance. The letter that Rosenberg had sent to Mme de Canson—which, I repeat, was never answered—supposedly gave proof that we knew she owned the work. Rosenberg was indicted for "receiving stolen goods" in 1988. As head of the department at the time of the incident and because I had been more involved in it than he, I tried in vain to have myself indicted as well. The whole thing is now just a bad memory, as the entire distasteful matter was finally dismissed in 1990. At least one could take this as an homage to our omniscience, in that we supposedly know everything about the history of every work of art!

It is generally said that relations between art dealers and curators in France have become much more open, and this is true. As I mentioned earlier, we are aware of how useful these relations can be. When I started out, we were a bit more reticent in that regard, but we were wrong. As far as I'm concerned—and I know it's the same for colleagues of my generation or later—I never saw the shadow of a bribe! The situation of academics might be different. A university professor in Italy, for instance, has every right to give expert opinions or write captions for a dealer, and few pass up the chance. There have been some murky cases, notably in the United States, where certain curators have such tight relations with the art market that we could suspect them of profiting from purchases made on behalf of their museum.

Relationships with dealers are indispensable when we consider, as is the case with the Louvre, that a fundamental part of a curator's mission is to enrich the patrimony. I therefore

maintained excellent relations with numerous dealers, all the more so in that the best of them are also passionate about painting, often quite learned, and a pleasure to view paintings with, independent of any commercial transactions.

There is, of course, the slightly ambiguous case of the house of Wildenstein. An international presence, the Wildenstein firm occupied an important position in France before the war. Georges Wildenstein, heir and son of the founder, Nathan, had become, with Joseph Duveen, one of the two or three greatest painting dealers in the world; unlike Duveen, he was also interested in modern painting. He held marvelous exhibitions in his gallery on Rue La Boétie and published the *Gazette des beaux-arts* and some very erudite books. He had become a friend of the head of Fine Arts, Georges Huisman, and participated in certain official events. With the passing of the Vichy laws, the family had to flee to the United States, where the firm was already well established. When they returned after the war, the political situation had changed, and their business was no longer headquartered in France. But Georges Wildenstein brought the prestigious *Gazette des beaux-arts* back to Paris, after maintaining its publication in New York, in addition to publishing the weekly *Arts* and relaunching his publication of scholarly catalogues raisonnés.

I had met him at his office in New York, in circumstances that were rather striking. In early 1957 Charles Sterling had asked me to write the Italian entries for an exhibition of the Lehman collection. I had gone with him to visit the gallery, just as Wildenstein was showing Robert Lehman some superb paintings, notably some extremely rare French primitives — which the gallery probably still owns. For a young man like me, the magnetic current between this great international dealer and a collector of Lehman's stature was extraordinary.

Some say that my appointment to the Paintings Department

in 1966 could not have pleased Wildenstein's son, Daniel. I
have no reason to believe this. It's true that Philippe Huisman,
Georges Huisman's son, who worked for Wildenstein in
Paris, had written a violent excoriation of my 1965 exhibi-
tion; but perhaps he was sincerely offended by it. In 1967 he
graciously stepped in to help us buy a very rare painting,
identified by Sterling as a work by Jean de Beaumetz that had
been in the charter house of Champmol. We went to Lyon
together. The painting belonged to the famous Chalandon
collection, which normally we could not see, and I had to
view the work in an anonymous hotel room. Huisman then
informed me that Mr. Wildenstein was waiving his commis-
sion for this transaction, which was very decent of him.

The Georges de La Tour affair had created some ill feeling
between the Louvre and the Wildensteins.[6] Malraux, as is
well known, had even opposed President de Gaulle's ratifica-
tion of Georges Wildenstein's election to the Académie des
Beaux-Arts. The dealer died shortly afterward, but Daniel
Wildenstein was elected later on.

My second opportunity to meet the head of the house-
hold — who by now was Daniel — was under the sign of ambi-
guity, we could even say of comedy. The story is a bit long,
but it explains the distance between our two "houses."

I was on friendly terms with a very good curator after the
war, Jacqueline Pruvost-Auzas, who directed the Orléans
museum and had completely turned it around. She was also in
charge of the Musée Girodet in Montargis. To prepare a
Girodet exhibition, she had made contact with the painter's
descendants, the Becquerel family, who kept some of the
works in a country house near Montargis, which she had
brought me to visit. There were indeed some very handsome
drawings, sketches, and paintings by Girodet, and several
older paintings as well. I remember my emotion, after being
welcomed by an old retired colonel, at seeing at the foot of

the stairs the little *Allegory of Victory* by Le Nain, in which a timid young girl, naked and wearing a helmet, tramples a woman-serpent in the countryside around Laon. The painting was signed, but the attribution would have been clear regardless. I immediately told the old gentleman that his painting was charming and important and that it might interest the Louvre; he answered that he had no intention of parting with it. I asked him simply to let us know if his family ever decided to sell it. Several years later, the Colonel died, and Pruvost, whom I'd asked to keep an eye on the Le Nain on our behalf, attended the funeral. She saw the heir, a nephew just in from Morocco, and hinted that the Louvre might be interested in certain paintings in the inheritance. Months passed, then one day she told me that the heir in question had sold the Le Nain. He no doubt felt a bit sheepish about it, since he came to see me at the Louvre. He confirmed the sale, but refused to tell me the buyer's name when I said I wanted to get in touch with him. "Is it Mr. Wildenstein?" I asked, knowing that Wildenstein would certainly be interested in a work of such rarity and quality. Although he answered in the negative, I understood that I wasn't far off the mark, and by a kind of intuition, I said the name — which he didn't deny — of an intermediary, an expert in Paris who tipped Wildenstein off whenever an interesting painting surfaced. I met with the expert, who claimed not to be fully aware of the situation, but would look into it. He called me back, saying Daniel Wildenstein had agreed to see me. I preferred not to make my first visit to Rue La Boétie alone, so Jacques Dupont, president of the Amis du Louvre, came with me. The meeting was exceedingly brief: Wildenstein simply told us he would look around, that he would do everything possible to locate the painting — which I'm sure was right in the next room. There was a large share of burlesque in all this: he obviously knew that I knew. He invited us back not long afterward to

announce that he had found the painting in question, which he then showed us. The little *Victory* delighted Dupont, who declared himself ready to put the Amis' resources behind purchasing it. Wildenstein had the good grace to join in this act of generosity, adding that his father had made him swear never to sell a painting to the Louvre. The matter should have ended there, the only thing remaining being for us to express our gratitude to our host.

But — as in a boulevard comedy, when just as you're leaving someone pipes up with "By the way, I forgot to mention ..." followed by the crucial bit of information — Wildenstein told me, naturally in the friendliest way possible, that he was interested in a painting located in Dijon, the *Portrait of Mr. Blauw* by David. The portrait, a masterpiece of the artist's revolutionary period, had been given to the Dijon museum by the Blauw family heirs. Wildenstein led me to understand that he had been in contact with certain of these heirs, who wanted to take back the donation, and that the painting was therefore liable to go back into the private domain. I expressed my keen regret and my hope that it would remain with Dijon. But I obviously never said to him, and Dupont can confirm this, that I would authorize the painting to leave if it ever became an issue. He suggested exactly the opposite to anyone who cared to listen, and the painting was finally bought by the National Gallery in London in 1984. Naturally, an informed dealer like Wildenstein knew that London, which before the war had bought a masterpiece by Ingres, did not own any paintings by David, and that this was an evident gap for the museum. He therefore knew that it was the best positioned to make the acquisition and that, from a political viewpoint — which is what happened — no one would oppose the export of a masterpiece of French painting to a museum of that importance. Well played, no?

This story illustrates the fact that relations between cura-

tors and dealers necessarily have limits. What does a dealer want? To find the most interesting work of art possible, take it out of France (officially, if he is honest), and sell it under the best possible conditions to a foreign museum or collector — although fortunately, French collectors with money are now interested in old paintings, unlike thirty years ago. This is normal. What does the French curator want? To avoid having the national patrimony be diminished and to try to enrich his museum by negotiating with the dealer. Also normal. But desirable as it might be, this ideal is necessarily limited by the underlying antagonism between perfectly legitimate but conflicting goals.

In any case, nothing is possible without a minimum of mutual trust, and what I'm about to relate is a good illustration of this. Among the young French dealers after the war, the most brilliant was certainly François Heim, the son of Georges Heim-Gairac, whose eye and erudition had put him in the forefront of his field, rivaled only by Cailleux for the interest of his installations and the scholarly quality of his exhibition catalogues. We were on good terms and made several deals together. Unfortunately, the incident involving Fragonard's *The Bolt* compromised our subsequent relations. One day, while I was visiting him with Pierre Rosenberg and Jacques Foucart, Heim announced that he had just discovered *The Bolt*; the painting was known through sketches, engravings, copies, and drawings, but the original had never been identified. He showed it to us. It was obviously a painting for us. We brought it to the Louvre, verified its quality, and bought it thanks to a private contribution granted by then-Minister of Finance Valéry Giscard d'Estaing (this was in 1974). Delighted with our purchase, we began to study its history. We knew that several years earlier, a *Bolt* had gone on public auction in Versailles. Heim had assured me that this wasn't ours, but another version. But looking at the complete

file on the work, photos included, we had to face the facts: it was indeed the same painting, which had just been a bit "tarted up," either at the time of the Versailles sale or before. I was obviously very unhappy, as this put us in a difficult position. When presenting the painting to the curators' committee and to the national museum board, I could easily have told the truth: that the painting had been up for auction several years before and that a dealer had been smart enough to identify it, making a legitimate profit from his astuteness. But Heim had chosen to muddy the waters, and it was a shame.

Among the dealers whom I saw fairly regularly, there were a number of Englishmen, some of them of the old school, like Clifford Duits, Herbert Bier, or Jack Baer at Hazlitt, who always had beautiful Italian sketches and was among the first to appreciate early nineteenth-century Italian landscapes by Frenchmen. Edward Spielman, one of the most demanding and competent dealers when it came to Dutch painting, had sold us two works by rare painters who were missing from our collection, Saenredam and Ambrosius Bosschaert.

Julius Weitzner, whom I liked enormously, was of Austrian origin. Now living in London, he was one of those dealers who accumulated everything, loved painting from every period, and enjoyed both curators and amateurs. You always found interesting paintings at Julius's. They were never masterpieces of the first water, but we nonetheless bought from him a very handsome predella by Beccafumi that came from an important Sienese altarpiece. At Colnaghi, which has since changed hands several times, I met the old Jim Byam Shaw, one of the finest drawings specialists of his day. In a drawer, he kept, for small and penniless art lovers like us, some beautiful drawings taken from a book. Then younger dealers came on the scene, such as Clovis Whitfield, trained at the Courtauld, and Patrick Matthiesen, who organized some first-rate exhibitions, notably on the primitives.

The frequency of our trips to London was due to various factors: the incomparable richness of the museums, research at the Witt Library, the interest of exhibitions, in some cases the organization of our own exhibitions in London, and last but not least, making the rounds of dealers and auction houses. We often went as a group in the late 1960s and 1970s, so much so that one dealer jokingly called us "the French rugby team"! We stayed at the Eros Hotel, an inexpensive place with nothing to put our virtue at risk—the Eros was the one in Picadilly Circus—that had the merit of being close to the galleries we visited.

France also boasted some excellent dealers in old paintings, among them Jean Cailleux, a great connoisseur of the French and Venetian eighteenth century, who followed in his father's footsteps. In my time, we acquired several works from the Cailleux collection (some given as gifts), such as a handsome portrait by Charles-Antoine Coypel or, stepping out of the strict specialty of the gallery, the portrait of a singer by Claude Vignon, which at first we thought was by Fragonard because of its liveliness. We often went to see Cailleux, for the simple pleasure of looking at beautiful paintings. The tradition has continued with his daughter Marianne Roland-Michel, a well-known art historian. On the Right Bank, we are always glad to rummage through the boxes of drawings and prints at our friends the Proutés', when new works come in.

I could cite many other dealers, such as Curt Bénédict, an erudite specialist in French seventeenth-century still lifes, or Jean Néger, who came into possession of the splendid painting by Lodovico Carracci that I mentioned earlier, *The Flagellation of Christ*. He also owned a work by Juan de Borgoña, a very rare painter, that the department later acquired from his widow. And then there was Benito Pardo and sons, and the other Italians in Paris: Moratilla, Baroni and his sons.

Alongside the great learned dealers with prosperous busi-

nesses, we also liked the more informal dealers, in whose shops you could find all kinds of items by chance. One such dealer is Marcus behind the Hôtel Drouot: no major paintings, but some interesting canvases for provincial museums. Another one with an excellent "eye" is André Cabanel, from whom the Rennes museum bought a highly rare still life by Baugin.

Outside of France (apart from the British dealers, who at the time were the most numerous and best stocked), we were in contact with Peter Nathan in Zurich. Thanks to him, we were able to bring a very important work into the Louvre, Caspar David Friedrich's *Tree with Crows*, in 1975. As I said, we wanted to represent the great foreign nineteenth-century artists who were missing from the Louvre. Friedrich's work is not abundant, and most of it is in German museums, apart from a very handsome grouping in Saint Petersburg and one or two canvases in Winterthur. The artist wasn't forgotten, but he didn't have his rightful place and was not represented in museums of other countries. One reason for the scarcity of Friedrich's work is that several important paintings had burned before the war, victims of a fire during an exhibition in Germany. Nathan also acted as intermediary when we were looking for a Klimt for the Musée d'Orsay.

Even though the Louvre has never bought from her, I also loved paying visits to Marianne Feilchenfeldt, the widow of Cassirer's assistant in the famous Berlin gallery. The Cassirers and the Feilchenfeldts had had to flee Nazi Germany. Marianne Feilchenfeldt, a photographer by trade, settled in Zurich, where she opened a gallery with a certain number of pieces from the old shop. With great instincts, she then set about buying nineteenth-century paintings, mainly Impressionists. Every time I visited, she showed me first-rate works. The tall, handsome, intelligent woman incarnated the great European culture from before the war. We bought a

painting from her for the Avignon museum, a panel by the Master of St. Sebastian from a polyptych, another panel of which was already at the Musée Calvet. Many paintings from her gallery could easily have gone to the Musée d'Orsay, but unfortunately the price was beyond our means. She owned, for example, a superb sketch of the last version of Cézanne's *Bathers*, which her son still has.

Naturally, given my job, I also had occasion to visit a large number of private collections and to frequent many collectors, from the young colleague who was thrilled to find a beautiful drawing at the flea market to the nouveau riche collectors of Milan (who generally were quite well informed) and Los Angeles, crazy about their Cézannes (one of whom told me ingenuously, exhibiting an admittedly beautiful *Apples*, "It's the most beautiful Cézanne I know!"), and on to the heirs of famous family-owned galleries.

In this latter context, my fondest memory concerns a guided tour of Houghton Hall conducted by Lady Cholmondeley, who had inherited from the castle of Robert Walpole and from the collection of her brother, Sir Philip Sassoon, with Jean-Baptiste Oudry's *White Duck* (1753). After taking us on a long and well-informed visit, she offered my friend Chapman and me a drink, sitting beneath the portrait of her that Sargent had painted around 1913. I could not help but admire the grace of this lady who still felt obliged to personally do the honors to what she had received more than sixty years earlier!

Still in the aristocratic register: after my appointment to the Paintings Department, it was my job to present acquisitions projects to the national museum board, generally the second Wednesday morning of every month; the curators' committee would meet each preceding Thursday. One of the board members was the Viscount Charles de Noailles,

famous for his patronage of modern art before the war (including Buñuel and Dalí's film *L'Age d'or* and the Mallet-Stevens villa in Hyères) and his enlightened passion for gardens. He was a close friend of Roseline Bacou. After one of the board meetings, he invited me to lunch to introduce me to Mme de Noailles and said that I might be interested in some "pretty pictures" he had at his home on Place des Etats-Unis. He was a master of understatement. The few "pretty pictures" were a fabulous collection in which works by Rubens, Goya, Watteau, and Géricault were hung next to Picasso, Ernst, and Dalí. After lunch, Marie-Laure de Noailles gave me a tour of the house, the ballroom with its ceiling by Solimena, the large white salon done in shagreen by Jean-Michel Franck, the gallery-dining room, including some ludicrous little nonsequiturs that placed a kitsch gadget next to a master painting. She, in fact, made me a present of one such gadget: a cardboard bauble decorated with the *Mona Lisa*. My head spinning from this peculiar form of humor, as well as her extensive knowledge, I returned to the Louvre. Shortly afterward, I received a phone call from Carmen Tessier, who wrote the gossip column for *France-Soir*, asking if I had indeed received a *Mona Lisa* from Marie-Laure and if I would agree to have the tidbit published in her column. I answered yes to the first question, and obviously no to the second. Marie-Laure, out of pure kindness, had meant to give me some publicity. After that, I went back fairly often for lunch at Place des Etats-Unis, surprised each time by her intellectual vivacity, and sometimes by some slightly disconcerting whims. Decreeing one day that painting restorations at the Louvre were badly done, she offered, with a straight face, to handle them herself, as she had a particular technique for treating varnish. After her death, the viscount invited Roseline and me, as if to apologize for the fact that his wife had left nothing to the Louvre. He asked us to choose whatever painting

and drawing we wanted from the part of the collection that came from his side of the family; the rest would go to his daughters. One couldn't be more elegant. Roseline chose a magnificent drawing by Prud'hon and I a beautiful seascape by Willem van de Velde. I later saw the viscount again at the Pompadour pavilion in Fontainebleau, where his daughter Nathalie was living. Since the large Burne-Jones that had once graced the staircase at Place des Etats-Unis did not really fit at Fontainebleau, she kindly decided to give us this masterwork for the future Musée d'Orsay.

Personally, rather than being a collector per se, I'm an accumulator, mainly of books and records. I've bought many 33s, some of which have never been reissued on CD, especially live bootleg recordings of opera performances in the fifties and sixties on minuscule record labels. You could find them at Buongiovanni in Bologna and in a small shop in New York near Washington Square that had all of Donizetti's *Marias* (Stuart, Padilla, Rudenz), Bellini, and the "serious" Rossinis, which were only starting to emerge from oblivion, sometimes sung by Callas's "twin," Leyla Gencer. The Callas recordings have since been reissued, but not the others. I am submerged in stacks of records and cassettes that I know I'll never listen to: a book can be leafed through, a painting quickly revisited, but an opera lasts for two and a half hours — at least!

In any collector, there is a share of mania that is irrational in nature. Some great art historians and curators have never felt the need to own works, while others could not live without them. Some might have held back, fearing they would be suspected of owning pieces that belong in a museum, or of using their knowledge for personal gain. This scruple has fortunately lived on — one is honest or one isn't! Many curators and art historians are scroungers, most often with limited resources, since they usually live on their salaries and possi-

bly some book royalties. In my case, I have a few good seventeenth-century paintings found at the flea market or at provincial antiques dealers'. Along with the few contemporary works bought when I was a student, to which Soulages added a *Square*, a polyptych panel, when I left the museum, my "collection" is quite modest and hardly indicative of my taste for old art: otherwise I'd have Sienese paintings with gilded backgrounds! I nonetheless managed to assemble a handful of nineteenth-century drawings, responding to the Italian primitives, generally by Ingresque artists such as Eugène Amaury-Duval, Victor Orsel, and Paul Delaroche.

It can be the same for art historians. Longhi was a true collector, by chance, or rather following the wanderings of his research and discoveries. His collection stretched from the Bolognese primitives to Caravaggio himself and the Caravaggesques, as well as to Reni and Morandi, who was a personal friend. He had much less money than Berenson. Was Berenson a true collector? Yes, at first, but he soon stopped buying. A young Lithuanian who arrived poor in the United States, then a character out of Henry James, he built himself a persona. When he made his fortune, he built his image: the large Florentine villa, luxury and work, ritual tea, vast library, hand-picked masterpieces on the walls: Sassetta, Domenico Veneziano.

We have to make a separate case for Sir Denis Mahon, whose collection was built to illustrate the resurrection of seventeenth-century Bolognese art, which he had partly brought about. Greatly beloved of the Classical and Romantic figures of the time (such as Stendhal), the school had been eclipsed in the early twentieth century by the rediscovery of Caravaggism, which was seen as a more modern tendency in painting. Voss and Longhi had always defended these two complementary tendencies in seventeenth-century painting, but it was through the efforts of Cesare Gnudi, the superin-

tendent of Bologna, that this rehabilitation really took off. Mahon had been smart enough to acquire works by Il Guercino, Guido Reni, and the Carraccis before practically anyone else was interested. He immediately gave his support to Gnudi, then to Andrea Emiliani, who were relaunching these artists via large-scale exhibitions. Mahon is now over ninety years old, with the falsely fragile look of an old English bachelor and very funny in his way of speaking. His formidable collection of Italian "baroque" (i.e., classical) paintings, which I saw at his home in London, will go to English museums and to the Pinacoteca in Bologna. It demonstrates the power of militant connoisseurship.

Douglas Cooper, another forceful British personality, was also both a refined collector (Picasso, Gris, Léger, Braque, Klee) and a methodical and demanding art historian. He had been closely associated with the Courtauld. While many twentieth-century specialists worked essentially as critics, he also wrote as a historian. A man who could be excessively cutting verbally, who courted disputes, even fistfights, he had created for himself a physique *à la* W. C. Fields, but he could also be very charming. It was the latter aspect that I knew (which fortunately excluded neither bitchiness nor humor), particularly one day when he invited Roseline Bacou and me to his castle in Castille, in the Languedoc, where he had installed his collection. In the dining room, some improvised cutouts by Picasso bore witness to the artist's recent visit.

Among collectors, there is a race apart, that of art lovers, dealers, or brokers who keep the "cream of the crop" for themselves. Some intend these works to go to the community. This was the case for certain large Paris dealers after the war, and I have had occasion to orient their generosity toward the museum that best suited their wishes.

One of these was Pierre Granville, a friend and collector of contemporary artists such as de Staël, Vieira da Silva, and

Lapicque, and a great admirer of nineteenth-century painting and drawing, who wrote excellent articles on the art market for *Le Monde*. Inspired by Jacques Thuillier, he gave his collection to the Dijon museum. Thuillier, Pierre Rosenberg, and I would regularly go to his home to see and eventually help choose what he should donate.

The same thing happened with Henri Baderou, another connoisseur, who had been part of the group around Focillon. A friend before the war to Sterling, Vergnet, and Jacques Combes, he had hesitated between museums and the art business; he finally became a very great dealer in drawings, with an exceptional eye. We helped him direct his collection toward Rouen, where Olga Popovitch was delighted to receive it. We spent entire afternoons making wonderful discoveries and selecting works for the gift. It was a superb ensemble of drawings from all periods and of paintings, with some rare works, including some by artists not well represented at the Louvre—one painting by Paulus Bor and a number by Gabriel de Saint-Aubin.

Same for the great Avignon antiques dealer Marcel Puech. Entering his shop one day and looking at the few paintings on display, I asked the owner if he had any others. No doubt seeing that I looked professional, he offered to show me his private collection one floor up. And there, I was stupefied by the quality of the furniture, decorative objects (notably French silver work), old paintings, and drawings that were there by the hundreds, unearthed in the countryside with the infallible instinct of a great antiquarian. After many twists and turns, visits from Louvre curators to whom I'd recommended him, advice from Sylvie Béguin and Roseline Bacou, and efforts by curators from the Musée Calvet, Puech finally donated his collection to the Calvet, a donation that was enriched after his death by some more works.

Pierre Rosenberg could speak better than I about Jacques

Petithory. This great Parisian dealer left his collection of old drawings, bronzes, and terra-cottas to the Bayonne museum. In fact, thanks to the painter Léon Bonnat, the museum already owned a first-rate collection of drawings. This new bequest made it, alongside Chantilly and Lille, the richest outside of Paris.

Among the most charming collectors were Vitale Bloch, an art historian of rare finesse, and Mathias Polakovits. The latter had been a journalist for *Paris-Match*, had for a time frequented the jet set, and finally devoted his too-short life to his passion for French drawings. He bequeathed everything to the Ecole Nationale des Beaux-Arts, judiciously complementing an already considerable collection.

President A. P. de Mirimonde maintained the grand tradition of councilors and presidents of the Court of Auditors. A man with close ties to the museums, as well as a fine and original scholarly mind (his research in musical iconography is still the primary reference), he left his collection of seventeenth- and eighteenth-century paintings to the Gray and Tours museums.

Other collectors who stand out include Lucien Salavin, the chocolate manufacturer, who little by little built himself a precious collection of Italian primitives. Longhi often went to visit him and published some of his discovered treasures. He left part of his fortune to the Fondation de France, but allowed us to choose some ten works for the Louvre, including a small Fra Angelico.

I might mention a few other true amateurs who themselves chose, one by one, the works of their collections: an industrialist from the north of France, Jean Riechers, passionate about French still lifes, several of which entered the Louvre by *dation* in 1982; and, to be sure, Pierre Lévy, to whom the Musée de Troyes owes its rich selection of sumptuous Fauve paintings.

London was full of self-taught art lovers, capable of making unexpected finds at Christie's or Sotheby's. For example, Efraim Shapiro, a White Russian émigré who was not a dealer and who worked as Russian correspondent for the BBC. He had stored away a collection of this and that, with good instincts, buying Caravaggesque paintings or Flemish and Dutch late Mannerists at a time when they went for practically nothing. His studio looked like a glory-hole straight out of *Cousin Pons*. He finally bequeathed part of his collection to the Hermitage, well before 1989.

My most remarkable encounter with a collector had to be with Dr. Gustav Rau. I knew nothing about him when he asked to meet me at the Louvre one day in 1983. A tall German gentleman walked into my office, austere and somewhat ceremonious, speaking carefully chosen French. He complimented me on a dictionary of painting I'd edited for Larousse and asked if I'd agree to oversee the catalogue of his collection. And he showed me photographs of the works he owned. I remember my stupefaction at seeing dozens of paintings that I knew perfectly well — such as Fragonard's *Duc d'Harcourt*, a series of large decorative paintings by Tiepolo that I had admired at Hallsborough in London, a famous Filippo Lippi, Klimt's *Sunflowers*, and others — as well as some that I had never seen before by Sweerts or Pissarro. There were hundreds in all, bespeaking both a very catholic taste, from the primitives to Bonnard, and an exceptional sure-footedness. Dr. Rau told me that he intended to install his collection in Marseilles and was building a museum toward that end. He wanted me to assemble a team of curators to write the new museum's collection catalogue. Having obtained permission from the director of the Musées de France (since the initiative, although in the public interest, emanated from a private foundation), I accepted the offer. I asked that the catalogue authors be paid for their work, but that mine be unremunerated.

Dr. Rau was an extraordinary individual who had lived a life straight out of a novel. Heir to a huge automobile concern in Stuttgart, he had sold it off whole to devote his life and fortune to two causes: medicine and art—in both cases, to the benefit of those who needed it. At more than forty years of age, he had earned a medical degree, then built a hospital in Zaire, which he ran. During the weeks he spent in Europe, he bought sculptures and paintings to constitute a public museum. A Francophile—he had fled the Nazis during the war—he had chosen Marseilles as the site, but not a fashionable neighborhood. Two paintings illustrated his attachment to the city and what it represented on both sides of the Mediterranean: Cézanne's *View of L'Estaque* and Corot's *Portrait of an Algerian Woman*, which is surely, in its dignity and grandeur, one of the most beautiful images ever painted of a Muslim woman.

At that point began an adventure that lasted several years and still leaves me feeling somewhat bitter. Nearly all the department's curators and archivists, along with others from the Sculpture Department, eagerly set to work, making visits to Switzerland to study the objects for the catalogue. I myself made the trip several times with Dr. Rau and his faithful assistant, Robert Clémentz, and also to Marseilles. The doctor had obtained a concession from the City of Marseilles for a large plot of land on which to build his museum, even helping the city build a police headquarters next door. Edmonde Charles-Roux, wife of the mayor, Gaston Defferre, had checked with me about the importance of the collection. The museum was built: rather banal architecturally, but with large, well-lit, and climate-controlled exhibition spaces. Each time he came to Europe, the doctor called to see how the catalogue was progressing, telling me of his latest acquisitions, which were always remarkable, and also about the dire situation of his African friends. In fact, he had to put more effort into

feeding them — he regularly had milk brought in from the Netherlands — than into treating them.

And then one day he came to see me, looking very pale, and announced that he had to give up his Marseilles project. What had happened? A reversal of fortune that forced him to concentrate his efforts exclusively on the hospital? Serious health problems that forced him to leave Zaire, which was then being consumed by a bloody civil war? Disappointment, or worse, because the City of Marseilles had shown scant gratitude? He didn't say. By the terms of the agreement, he had to hand over the building to the city, which turned it into a contemporary art museum. As for myself, he understood that I couldn't put my name to the publication of a private collection, and in any case certain portions of it were to be sold off.

His health was in fact seriously compromised. I didn't see him again for quite some time, which saddened me, as this man, admirable for his physical courage, driven by uncommon moral rigor and generosity, was very odd but rather endearing. I don't know if it was the way his blue eyes blazed when he deplored the corruption of an African despot, or the way they could suddenly be moved by the tenderness with which Gainsborough painted his mother or by the sad, veiled gaze of the elderly Degas in his final self-portrait.

In 1997, having sensed my regret over the Marseilles debacle, he had the elegance to let me choose from among three or four paintings for the Louvre. I selected a magnificent and swirling sketch by the Austrian Maulbertsch.

He died in 2002, after a painful period of legal and medical difficulties. But if all goes well and his wishes are respected, his work will live on in two ways. He in fact bequeathed his estate to UNICEF and planned for a selection of his best paintings to someday be on display at the Musée du Luxembourg in Paris. Earlier, the Luxembourg organized an

exhibition of his collection that met with considerable success, and that no doubt brought him his last joy in life.

The best curators admire collectors — true ones — because they share the same hunger, speak the same language about the works, love to talk about their discoveries with other aficionados. And also, let's not be hypocritical, because the trust, even the friendship, that grows between the two often leads to the generous gesture that enriches museums.

Collectors are what give museums their personality and color, allowing them to be more than just miniature Louvres. Take Bordeaux or Marseilles, for example. These two cities have excellent museums, but when it comes to older works, you don't find the variety and savor that give such character to Aix-en-Provence, Nantes, or Montpellier, which are true collector's museums. In Aix, it's the Bourguignon de Fabregoules collection, the Granet collection, and an anonymous donation that allowed Mondrian, Klee, Giacometti, and Morandi to hang alongside Robert Campin and Ingres. In Nantes, the Cacault collection ranges from gilded-background paintings to Georges de La Tour. In Montpellier, the Bruyas collections display Delacroix, Courbet, and Fabre alongside David and the Italians, and the Valedau collection shows the Flemish and Dutch.

In the early 1970s, the Paintings Department inaugurated a new kind of exhibition, the "dossier" show. Before getting to this, let's recall that the department works hand-in-hand with the Réunion des Musées Nationaux in organizing exhibitions of old paintings in Paris, contributing scholarly expertise, helping choose the works, participating in negotiations to obtain loans, writing the catalogue, and being involved in the exhibition design.

For my part, after I was appointed to the Louvre, I could no longer assume these tasks for every exhibition, and I cer-

tainly didn't have time anymore to write an entire catalogue. The department curators were most often their own masters, without my having to watch over them.[7] We had a well-established tradition to follow: generally speaking, our mission was to celebrate (often coinciding somewhat arbitrarily with a birth anniversary) the great French painters who had not yet been the subject of a major retrospective. In the period when I was in charge, we mounted exhibitions on Ingres (Petit Palais, 1967), Théodore Rousseau (Louvre, 1967), Millet (Grand Palais, 1972), Corot (Orangerie, 1975), and Courbet (1977),[8] which traveled to Rome and the Royal Academy in London; the series has continued into recent years with Géricault, Prud'hon, and Chassériau. Exhibitions of old paintings, such as by La Tour in 1972 and the Le Nain brothers in 1979, often responded to the need to rehabilitate or newly situate an artist who was little known to the public.

In the exhibitions for which I was the lead curator, my role varied quite a bit, depending on whether it was organized within the Paintings Department in the strict sense, in collaboration with the Graphic Arts Department, or with outside specialists. I'd like to stress this last point: our work with academics. One of the long-standing debates on the practice of art history in France centers on the separation between university professors and museum curators. We were among those who tried to narrow that schism by inviting French and foreign colleagues from outside the museum world to join us; we hoped to end this artificial opposition between two complementary professions. As such, we asked a number of academics, such as Jacques Thuillier, Antoine Schnapper, Marc Fumaroli, and Alain Roy, to collaborate on various shows. For the 1972 Millet exhibition, we approached the American academic Robert Herbert, while another American academic, Janet Cox-Rearick, compiled the dossier on the François I collection that same year.

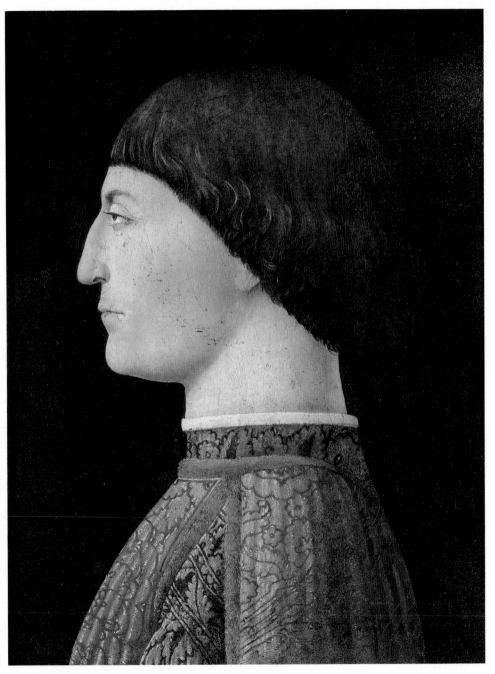

Piero della Francesca (1416–1492)
Portrait of Sigismondo Malatesta, c. 1440
Oil on wood, 17¹/₄ × 13¹/₂ in.
Musée du Louvre, Paris
See pages 130–31 and 146

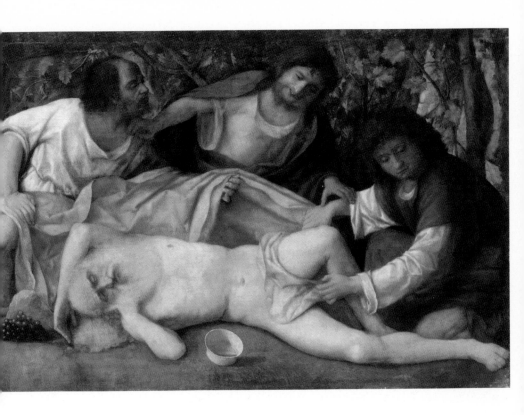

ABOVE:
Giovanni Bellini (1430–1516)
The Drunkenness of Noah, c. 1515
Oil on canvas, 40½ × 61¾ in.
Musée des Beaux-Arts, Besançon
See page 59

LEFT:
The Musée du Petit Palais, Avignon
See pages 200–3

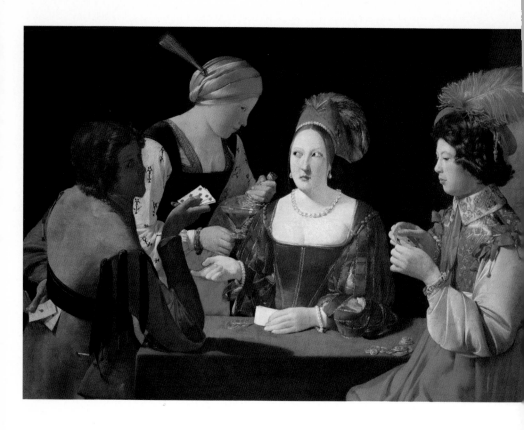

ABOVE:
Georges de La Tour (1593–1652)
The Cheat, c.1625
Oil on canvas, 41½ × 57½ in.
Musée du Louvre, Paris
See page 135

RIGHT:
Jan Vermeer (1632–1675)
The Astronomer, 1688
Oil on canvas, 20 × 17½ in.
Musée du Louvre, Paris
See page 141

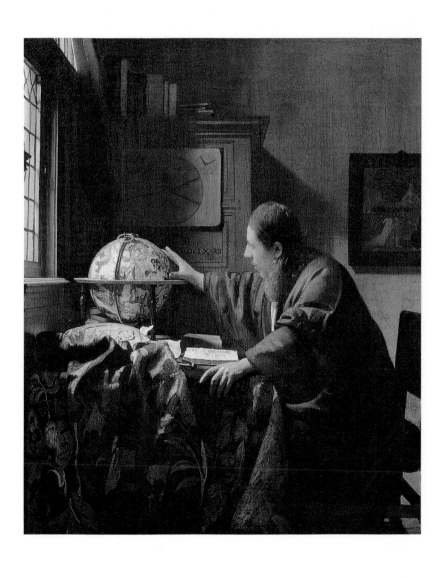

ABOVE:
Caspar David Friedrich (1774–1840)
Tree with Crows, 1st quarter of the 19th century
Oil on canvas, 23¼ × 29¼ in.
Musée du Louvre, Paris
See page 164

LEFT:
Jean Honoré Fragonard (1732–1806)
The Bolt, c. 1778
Oil on canvas, 28½ × 36½ in.
Musée du Louvre, Paris
See pages 161–622

Musée du Louvre, Paris
Cour Napoléon with pyramid designed
by I. M. Pei

These were all fairly classical exhibitions. But we also put together dossier shows. At first, these were in response to a pedagogical need. We paid close attention to what the Scandinavians and Americans were doing, as they had proved quite advanced when it came to opening their collections to different audiences. In our visits to American museums, for example, we were struck by the fact that at noon you might be able to enjoy a small piano or choral recital in the cloister (nearly every American museum has one). More than in France, we saw groups of students making sketches or listening to a talk. And little by little, the same educational need began to be felt in French museums. The educational service of the Musées de France already offered gallery tours and lectures, but the 1980s saw a marked increase in the search for new audiences, as well as heightened demand on the audiences' part.

One of the things we saw in American museums was a "picture of the month," which was on special display for several weeks. We decided to expand the idea by moving beyond its purely pedagogical function, in other words by trying to attract both specialists and general visitors. We established a program, with some changes to the format and catalogue over the years, whose object was to approach a work or group of works and study it from every possible angle. Initially, we called upon specialists who could dissect everything concerning the subject, explaining the results clearly, using photographic montages if the originals weren't available. We called this kind of exhibition a "dossier exhibition," although it took us a while to come up with the term.

The first dossier show, in 1971, centered on Ingres's *Turkish Bath*. Compiled by Hélène Toussaint, it was used as a test case. Our intent was to examine the work from all sides, and to explain how it had been conceived by the artist, based on visual and written source materials, preparatory sketches, and

different versions of the composition (we had come across a photo of the painting in an earlier state, in a square format). Long hidden away, *Turkish Bath* had been discovered only at the beginning of the century, and was admired by Matisse, Picasso, and many other artists in their wake. We went to see Man Ray to ask if he would lend us his photograph *Violon d'Ingres*, the famous nude in rear view. He was by then a grumpy old man, but glad all the same to lend his photo to the Louvre. We had assembled works by Picasso and even set up a contraption by Rauschenberg that made an image of *Turkish Bath* spin in circles. Certain critics have praised recent shows for finally bringing modern art into the Louvre. I agree, but I also have to laugh: we were already doing it in 1971! In the exhibitions that called for it, of course; never systematically or gratuitously for the simple pleasure of showing modern art. In addition, nearly every such exhibition included a presentation by the conservation laboratory, showing their often spectacular findings about the work in question.

A long series of dossier shows followed, based either on a work or group of works by a single artist (Fouquet, Holbein) or school,[9] or on a collection[10], or a dispersed decorative ensemble, such as the Cabinet de l'Amour at the Hôtel Lambert or the Studiolo of Isabella d'Este.[11]

We also thought it would be interesting to include a thematic series, as well as a technical one.[12] I personally handled two of these, with the help of Claudie Ressort. The exhibition *Copies, Replicas, Pastiches* (1973) gave us a chance to differentiate and illustrate the meanings of these terms via selected works. For many people, if a painting is not by the hand of so-and-so, it is a fake. This is false: a fake is a fabrication meant to deceive. Scholarship has taken an interest in the subject, and today we know much more about the work and personality of twentieth-century Italian forgers, such as Ioni. I wanted to show clearly the different categories, ranging from

false attribution to "real fakes"—modern forgeries that we can generally recognize by their style and iconographic errors or by their physical appearance—as well as replicas, copies, pastiches (sometimes made by great artists in their own right), and paintings "in the manner of." Artists like Luca Giordano and Sébastien Bourdon, although they painted works "in the manner of" another master, did not create fakes. This could even lead us to interpretations of older works by modern artists—Picasso's *Women of Algiers* would be just one example. *Copies, Replicas, Pastiches* helped clarify these notions even on a semantic level, while allowing us to explain to the public the concrete work done by the conservators. These questions had always greatly interested André Chastel, who devoted an entire issue of *Revue de l'art* to them in 1973. The other exhibition I curated in 1978 explored the evolution of the Italian altarpiece from the thirteenth to the fifteenth centuries, mainly with works from the Louvre, the Musée des Arts Décoratifs, and certain Parisian collections.

Later, in 1990, I returned to the subject of altarpieces for the exhibition *Polyptychs*, which largely surpassed the limitations of a dossier show and featured numerous loans from abroad. I took a keen interest in curating it. The show developed the intellectual (as opposed to merely formal or technical) theme of multiple images, from the earliest polyptychs in the fourteenth century up to Baroque altarpieces, Symbolist triptychs, and modern research into fragmentation and compositional rearrangements. For the twentieth century, I was seconded by Patrice Hergott. I had gone to see Ellsworth Kelly in New York to choose three canvases for a grouping, the hanging of which he regulated down to the last centimeter. In the same vein, I had asked Soulages to choose one of his monumental polyptychs. We showed that this kind of image in several pieces had been more or less abandoned during the Renaissance in favor of unified composition, but that

even in the sixteenth century certain great artists, such as Titian, continued to create large altarpieces as in the Middle Ages for their traditionalist clients. We also noted how the same phenomenon persisted into the seventeenth century, notably in Rubens, and in certain works of furniture, such as cabinets, on which the various small paintings depicted a single story. Abandoned later in the eighteenth century, the practice returned with the nineteenth-century revivals by the pre-Raphaelites, Nazarenes, and especially Symbolists. We presented masterworks that stretched all the way into the modern age, such as Max Beckmann's *Departure*, the triptych he had painted before leaving Europe, one of the masterpieces at MoMA, and later work by Jasper Johns and Germans such as Markus Lüpertz.

Let me come back for a moment to the dossier shows to recall a somewhat forgotten episode: the brief existence of the "experimental museum" that we set up in the Palais de Tokyo, which lasted from 1978 to 1985. The Musée d'Art Moderne had been emptied of its collections, which were transferred to the Pompidou Center, but was still in "working order." I had suggested using it to organize, at little expense, interdepartmental presentations of works from the Louvre and the future Musée d'Orsay in the form of dossier shows or thematic installations. Other museums also participated in the project, which was meant to be frankly pedagogical and allowed us to try out different displays, to involve students and interns, and to show collections that weren't on display — the Louvre's Islamic collection, or works destined for the Musée d'Orsay, for example — on a variety of themes (basketry, grisaille, ceramics from the Islamic East, and so on). We mounted about twenty such shows. Unfortunately, stimulating as they were, they did not attract large audiences, and the Palais de Tokyo was later used for other purposes. But for those who were involved in them, they remain a fine memory.

In 1971 Pierre Rosenberg and I organized the exhibition *Venice in the Eighteenth Century*, using works in French collections, including several private collections at the Louvre. To be honest, the exhibition did not alter anyone's image of the eighteenth century, but it did show several little-known works. It was mounted at the Orangerie, the usual setting for such events: a charming space, magnificently overlooking Place de la Concorde, with ideally proportioned rooms that we had to modify when the famous Walter-Guillaume donation occupied the locale. My former boss Jean Vergnet-Ruiz, who had helped mount exhibitions at the Orangerie before the war, told me that when he walked out of the place, he was so imbued with what he had just seen that he viewed the outside world through the eyes of the painter he was leaving: he saw the Paris of Corot or Hubert Robert . . .

The following year, 1972, remains the year of the great Paris exhibitions, *Millet* and *Georges de La Tour*. The La Tour show was mainly the work of Jacques Thuillier and Rosenberg, but, as I suggested earlier, it was a great pleasure for me to participate in it as well. We saw very clearly the impact that such an exhibition could have. And the interest hasn't waned, since Jean-Pierre Cuzin and Rosenberg organized a new La Tour show in 1997, which met with the same public success.

Francis Haskell has demonstrated the link between the 1934 exhibition *French Realist Painters* and the period in which it was held, which witnessed a retreat of abstract tendencies and the rebirth, in France and abroad, of representational painting, such as by Balthus, Derain, and others less famous. The emergence of this realist tendency corresponded to a moment when the "French tradition" was seeking itself through painting that wasn't exactly avant-garde but wasn't totally academic either. Haskell has analyzed the political context surrounding other large exhibitions of the time, such as the

Italian show of 1935, which coincided with a rapprochement with Mussolini's Italy; it was a kind of grand demonstration of Italian propaganda, not to mention the occasion for an incredible abundance of masterpieces to come to Paris. The political impact of the 1934 exhibition isn't negligible, either, since that renaissance of "home-grown" French tradition would later be recuperated by Vichy—as well as, to some degree, by promoters of Socialist realism. Haskell derived these ideas, which deserve further study, from the fact that chance alone does not explain the organization and the success or failure of large exhibitions. Taking each case individually and avoiding generalities, he juxtaposed these exhibitions with the production of contemporary artists and various publications of the time. In the same way, the 1972 exhibition coincided with a new resurgence of representation. I'm not claiming that it played a determinant role in this regard, but it did fit into a certain current. I was able to show the exhibition to two artists who were both passionate about its subject. One was Dalí, who came with a very sour-faced Gala. He only played the clown in front of an audience; here, he looked at the paintings with great attention and precision. The other was Balthus, who had always admired La Tour—you can see it in his work.

The other big event of 1972 was the exhibition on the Fontainebleau School. It was held at the Grand Palais, which at the time was a new space for us. The exhibition spaces are a bit difficult to negotiate, and some of them have no natural light. This was less serious in the case of Fontainebleau, as our aim was to mix paintings, sculptures, and drawings, which requires artificial lighting—particularly the drawings, which make up a good portion of what remains of the Fontainebleau School. In this case, my role was more as a stage director; the real mastermind was Sylvie Béguin. She had done her earliest work on Niccolò dell'Abbate, written a book about the

school, and in fact is still working on the subject. The exhibition was spectacular, extremely rich, and allowed us to better situate the school within the international Mannerist movement; the number of unknown works was remarkable. The Italian sources of the school are plain to see, as is the importance of that art in anything having to do with decoration and ornamentation. You also realize that part of the seventeenth century in France took inspiration from it.

After organizing several exhibitions on French nineteenth-century artists, we turned to themes illustrating painting outside of France. This was no coincidence: we wanted to show the French public the wealth of creation outside our borders. In this regard, if I may say so, "chauvinism" wasn't strictly a French phenomenon. We only have to think of statements by Lionello Venturi, the great art critic and historian, who had left fascist Italy in the early 1930s and settled in Paris, where he had written several works about nineteenth-century painting. To a critic who asked him why his book mentioned only two foreign names, Goya and Turner, Venturi answered, "Ask God"—ascribing the favored status of Frenchmen in this period to the Creator.

But in the 1960s, there was a widespread movement to illustrate the importance and diversity of great European nineteenth-century artists outside of France. It seemed appropriate to revisit the century, focusing on Neoclassicism and Romanticism. The great exhibitions sponsored by the Council of Europe on Romanticism (1959) and Neoclassicism (1972) had amply demonstrated the international aspects of these movements. I had been the French curator of the neoclassical exhibition in London, under the authority of John Pope-Hennessy—frankly, not for my knowledge of the field but because I could contribute the *Demoiselles d'Avignon* of Neoclassicism, David's *The Oath of the Horatii*!

We were also very involved in the exhibition on German

Romanticism in 1976, organized with Werner Hoffman, director of the Kunsthalle in Hamburg. A charming and inventive historian, Hoffman was one of the primary forces behind the rediscovery of the nineteenth century in Europe and a new definition of Romanticism, in painting and other art forms. As the exhibition had no diplomatic agenda, we requested loans from both East and West Germany, which at the time never collaborated on common projects. When I met with the East German curators, they were distrustful at first. But their hesitations fell away when they found out that the Soviets would participate with major loans from the Hermitage. The result was ultimately quite brilliant and, to my mind, it has never been equaled since. The presentation of various tendencies in German Romantic painting had a great impact on Parisian viewers. Friedrich was there, but also many others: Kobell, Carus, Runge (a fascinating artist unknown to the French), the Nazarenes, and even the young Menzel. We showed that Romanticism across the Rhine was not only literary and musical but pictorial as well, and that it was just as important as French or English Romanticism. The sculptor David d'Angers had seen it for himself, as he had gone to Germany to paint Goethe's portrait and had met Friedrich in Dresden. He returned from his trip with some remarkable drawings that are now at the Musée d'Angers, plus a few more that the Louvre later acquired.

An exhibition devoted to the *Myth of Ossian* (1974) supplemented this vision of Romanticism, and notably showed French illustrations—by Girodet or Gérard—that derived from the Neoclassicism of David.[13] To remain in the international context, I was very happy about the acquisition of Fuseli's painting *Lady Macbeth* in 1970. The painting was in Turin, for through the talent of certain collectors, the city had developed a great taste for Symbolism in general. And it was from one of the great Turin dealers, Mario Tazzoli, that we

were able to acquire this masterpiece, characteristic of the first wave of dark Romanticism.

Unlike the German show, the exhibition on Russian Romanticism in 1976 did begin as a diplomatic initiative. It was supposed to be handed to us pre-packaged by the Russian museums, mainly the Russian Art Museum in Leningrad and the Tretiakov Gallery in Moscow. When I went to the USSR with Jean-Pierre Cuzin to negotiate the loans, we sensed that the Russians' own view of their Romanticism from the first half of the nineteenth century remained somewhat conventional. So we asked to see what was being held in reserve, and there we discovered surprising sketches, such as by Ivanov, and some delightful paintings, some of them anonymous, that added a more intimate touch to the Russians' rather official vision. This slight inflection of the original project led us in particular to put more emphasis on a painter whom I consider one of the great European artists of the period, Venetsianov. This extraordinary painter belonged to an intimist current; his work shows a strongly classical bent not unlike the Danish painters. Most of his canvases depict daily scenes of rural life in Russia, with a unique light, a completely original feeling of reality. Their simplicity is based on the rigorous use of perpendicular angles reminiscent of Balthus, or of certain primitives.

I've made numerous trips to Russia, including several to Leningrad and Moscow. In 1968, we organized a major exhibition of French Romanticism there.[14] The choice of subject corresponded to a relative weakness in the Russian collections. The Hermitage has a magnificent collection of French paintings from the seventeenth and eighteenth centuries, as well as the late nineteenth and early twentieth — the most important in the world after the Louvre — but the Neoclassical period and the beginnings of Romanticism are less well represented, despite several beautiful pieces by David and Ingres.

One could practically write a complete history of French painting based on the Hermitage, except for this period.

These exhibitions gave us the chance to make contacts with colleagues at the Hermitage and the Pushkin Museum, who were numerous, competent, and still, in the main, French-speaking. At the Hermitage, I was at first received by an old gentleman, V. Levinson Lessing, who had already been a curator before the Revolution; he spoke perfect French and was very happy to meet a Frenchman. He was at the end of his career and had known the horrible siege of Leningrad that had so traumatized the residents of that city. And I was able to meet and enter into friendly relations with a number of other curators as well, notably Irina Nemilova and Anna Iserguina, petulant, passionate about "modern" art, whose husband had been a prominent archaeologist. As a member of the Academy, he was accorded a certain number of privileges, notably a dacha, which his wife had been allowed to keep after his death. She invited me there for a Russian-style weekend that I'll never forget. It was like something out of a novel—chaos, high spirits, silver birches, vodka, snow, smoked salmon, the sea in the distance . . . and a few dissidents thrown in for good measure. One of her sisters—there were, of course, three of them—sat down at the piano, picked up some sheet music, and sang "Autumn Leaves," which she had probably never heard before. Her rendition could break your heart, with a coloration that has remained in my memory ever since.

At the Hermitage, everything was compartmentalized. I was still interested in the Italian primitives and had been able to visit the ample reserves of Italian and Spanish paintings. I found several unattributed gilded-background works. At that time, while the Hermitage boasted a number of excellent specialists in French painting and the Flemish and Dutch Schools, there were far fewer for the Italian primitives. I was

therefore able to make a number of little discoveries, which of course I shared with them.

The residents of St. Petersburg, or Leningrad, as was already true under the czars, have always been less constrained and more open to the outside world than Muscovites. Helsinki is not far away, and they are much more aware of what's going on in the world than in Moscow, which is more insular. At the time, the curators had only one chance to step outside the borders: by serving as couriers for loans to foreign exhibitions. They had the opportunity to come to Paris, London, or Italy more easily than other intellectuals.

In Moscow back then, unlike Leningrad, I was never invited to a colleague's apartment. The French enjoyed scaring themselves by saying that everything in their hotel was a trap, that there were microphones in the chandeliers, and so on. I'd be surprised if the KGB wasted much time on us.

Before I left Leningrad, a small, convivial dinner was held in my honor in a restaurant on Nevski Prospect. Maybe I had drunk a little too much vodka—in any case I was feeling sentimental—but when taking my leave of the three or four persons there, all women, I couldn't find anything better to say than, "How sad it is to think that tomorrow I'll have to be back in Paris!" Fifteen years later, I still remember that sentence, which must have sounded so cruel to them. Except for Iserguina, none ever came to Paris. It was an inadvertent lack of tact on my part, which I still regret.

I have another memory from that first trip to Leningrad: my amazement on discovering paintings by Matisse, among the most beautiful of his great period. The most "modern" paintings of the Shchukhin and Morozov collections were only beginning to emerge from storage. I was there as Iserguina was preparing, with manifest joy, to install them in the well-lit galleries on the top floor of the Winter Palace. Some of the Matisses had already been shown in Brussels in

1958, but I hadn't seen them at the time; nor had these canvases (which also included a number of Picassos) been reproduced very widely. I thus experienced them as a visual shock, partly due to the freshness of seeing them for the first time.

I felt a similar pleasure when I visited the Barnes Collection near Philadelphia. There, too, I was looking through virgin eyes. As with many, it had taken me a long time before I could get in to see it: tales were told of Cézanne and Matisse scholars who had managed to penetrate the fortress only by posing as plumbers or electricians . . . During my first visit to the United States in 1956, I had written, making sure not to mention that I worked for a French museum, to request an appointment in the coming two months. They gave me a date for four months later. I made a second attempt several years after that, by which time federal law mandated limited visits one day per week; I was the two-hundred-third person out of two hundred accepted and was turned away. A student from the foundation who brought me back to Philadelphia kindly tried to console me with nonsensical explanations. My third try was successful, and I spent several wonderful hours there, my joy coming in part, as in Russia, from the revelation of completely unknown paintings by Cézanne, Seurat, or Matisse, seen as if still in the artist's studio. But, to avoid any misunderstanding, I am not saying that only one's first view of a work is what matters; that would be absurd. Every time I go to New York, I get the same thrill from seeing Giovanni Bellini's *Saint Francis* in the Frick Collection, and I will never tire of going to Arezzo for Piero . . .

That said, here's another memory of a similar emotion: a visit to Mougins in the fall of 1973, after the death of Picasso. I was invited by Jacqueline and Paulo to Picasso's house, along with Jean Chatelain, the Director of the Musées de France; Pierre David-Weill, president of the museum board; and several of my colleagues. Dressed all in black, Jacqueline

had made herself look like a figure from *The House of Bernarda Alba*. They showed us several works that they wanted to bequeath to the French state, taken from stacks of major works that at the time were unknown or rarely seen, from every period, along with paintings by Matisse, Cézanne, or Balthus from Picasso's collection. Added to the pleasure of discovering so many magisterial canvases was the assurance — for I am still possessed by my old acquisitive demon — that these works would belong to the patrimony. As is well known, this is what came to pass, thanks to the miraculous *dation* that gave birth to the Musée Picasso.

I was also involved in an exhibition of Turner's works, organized by the British Council in 1983. I visited several English collections to help make the final selection, but the exhibition was mainly handled by the British, and it was hugely successful. I was glad: it was another chance to broaden French attitudes, which were finally taking a more European (rather than just French) view of the nineteenth century. A similar opportunity was provided the following year by the exhibition *The Golden Age of Danish Painting*.

I've mentioned several exhibitions to which I contributed in London or the Soviet Union. I also had occasion to help organize several in Japan, including one in 1974 — which we would gladly have done without — on the *Mona Lisa*. The Soviets managed to arrange to have the lady stop over in Moscow on the way back, and obviously it was a triumph.

One very good memory is the large exhibition requested by the Australians in 1980. This was not the usual "prestigious" selection of disparate masterpieces but, in the wake of Pierre Rosenberg's 1974 exhibition *From David to Delacroix*, a serious demonstration of French painting from 1760 to 1830: *The Revolutionary Decades*, between Neoclassicism and Romanticism.[15] The show was held in Sydney and Melbourne, and during my two trips to Australia, the interest of the

museums and the intellectual vitality of the Australians I met only convinced me how well-founded the project was.

Less exotic was the Villa Medicis, which Balthus had made into an artistic Mecca of Roman life. I mounted *Ingres and Italy* there with Jacques Foucart in 1968, *Courbet* with Hélène Toussaint the following year, and *Corot* in 1975. Each time, we worked on the selection of works and their display in collaboration with the "head of the household." Balthus has been written about and filmed enough in recent years for people to be familiar with his sometimes sarcastic or haughty elegance and with the breadth of his culture. But to look at a painting with him, evoke others, and talk about them endlessly ("So, you don't still believe that *Three Women of Ghent* is by David, do you?"), in that villa that he had made into one huge Balthus painting, was to discover another person altogether, funny and generous enough to make you believe you shared a true bond.

Alongside my job at the Paintings Department, I also worked as a teacher. The Louvre school has a tradition of calling on the heads of patrimonial departments, and so I was asked to teach a series of courses on the history of old painting: the Avignon School in 1965, then the Florentines of the Trecento and the Sienese School from 1966 to 1969, and after that Piero della Francesca in 1977 — my favorite painter in the entire history of painting. As always when one teaches, these courses on the fourteenth and fifteenth centuries taught me an enormous amount as well. Since its foundation, the Louvre school's mission has been to reach very different audiences: on the one hand future professionals, curators, dealers, or restorers, and on the other the general public of art lovers. I have never ignored this last category and try as much as possible to remain comprehensible to everyone. This kind of teaching differs from the university approach, since the vocation of the Louvre school is to make reference to the

museum's collections. Obviously, you can't illustrate a complete history of art based solely on works in the Louvre. But by highlighting problems relating to technique and physical condition, to style (which for my schools means attribution), to an artist's development, the influences he felt, iconography, the conditions under which paintings were commissioned, and their critical reception, we keep the work itself in the spotlight. Studying the historical and social context is necessary for artists who led studios. Matters of iconography as they pertain to certain religious orders are also crucial. But I was mainly interested in defining artistic personalities — known either by their real name or by a nickname — through analysis, which I based first and foremost on comparisons of images. If I had given these courses on Piero or the fourteenth century at the university, I would have done them differently. But in that case, I'm not sure I would have done them at all.

Imparting one's interest — and even better, one's vocation — is a joy for any teacher. A certain number of our students (generally speaking, the ones who had left the university some time before and had decided to go back to school), wrote publishable theses on painters of the fourteenth and fifteenth centuries, having traveled to do their research, met with specialists, and so on. Federico Zeri always welcomed my students and generously shared information, photos, and pointers with them.[16]

In addition to teaching, I was also asked to edit several collective publications, notably the dictionary of painting that I assembled for Larousse. I agreed to head the project in 1965, before starting in the Paintings Department; I'm not sure I would have taken on such a huge task after my appointment, but I don't regret it. Our job was to establish as complete a dictionary as possible, in the Larousse tradition. And so I decided to set our focus very wide, to include contemporary painting and anything having to do with two-dimensional

creation in color—stained-glass windows, enamels, tapestries, as well as (and this is less common) technical terms and matters concerning the history of taste, such as collectors, art historians, critics, dealers, and museums. The complete dictionary, the *Petit Larousse de la peinture*, in two compact volumes, was published only in 1979, after a more selective *Larousse des grands peintres*.

I had thought it would be best to avoid secondary sources and instead asked actual specialists for contributions. When you look over the "cast list" today, featuring more than three hundred names, you would be struck by how many of these authors have since become famous art historians. I wanted the book to be informative, like any dictionary should be, but also to have a critical touch proper to the vision of each author. The thousands of entries required a considerable amount of work, which could be managed thanks to the team at Larousse.[17] Unfortunately, the two-volume dictionary had a rather short life and has never been reprinted, except in the Italian edition, and I'm sorry about that. The articles themselves have frequently been reused in various general or thematic dictionaries and regularly updated, but the compilation of all of these entries exists only in its first version. *Peccato*.

In the 1970s I was involved in plans for a new museum, the future Pompidou Center—not in the concept, but as part of the architectural jury, under the direction of Robert Bordaz and Gaëtan Picon. Sébastien Loste, who had often helped us when he was an adviser to the Elysée Palace, had worked on developing the extremely complex program of the Center. This was the first time in the history of French museums that they analytically defined the program before starting on the architectural design. In subsequent years, when I was involved in other such projects, at Orsay or the Louvre, for instance, I always had a hard time making the future "end users" under-

stand that before demanding so many square feet of floor space, they had to determine what those square feet would be used for. It is the planner's role to say, "You want this, that, and the other, therefore you need this kind of space." In the 1990s I was associated with the project to renovate the city museums of Venice. Italian architects are excellent, but they are so used to being in charge of such projects that they don't understand the need to define everyone's various requirements before making the working drawings. We had to twist their arms a bit to get them to accept prior intervention by planners.

On the jury, I represented the classical museums. Next to me were several great architects: Oscar Niemeyer, not very talkative but with a piercing gaze; Emile Aillaud, who was exactly the opposite, a figure out of another century who wore a lavallière tie and employed poetic metaphors to express simple ideas (he was the only one to vote against the accepted design); and Philip Johnson, who had been trained by Mies van der Rohe and had gone on to create important work of his own. Johnson was a striking personality; he had played a considerable role at MoMA in introducing truly contemporary painting. I was a bit bothered by his switch from an international style to postmodernism and have never really cared for his AT&T building on Madison Avenue. I'll always prefer the Seagram Building by Mies, and even Johnson's own Four Seasons. He's a brilliant man, quick-witted, multi-faceted (somewhat like Cocteau, if I may say so), and very aware of the latest developments.

There were other strong personalities on the jury as well: Willem Sandberg, the former director of the Stedelijk Museum in Amsterdam, who was one of the great postwar museum directors for contemporary art, famous among other things for his acquisition of the Malevich collection and very open to all contemporary art; and Jean Prouvé, who chaired our group. I had a lot of respect for Prouvé, an honest

man, perfectly judicious, who acted as arbitrator and led our discussions.

It was very impressive to see the galleries of the Grand Palais filled with architect's models. Everything had been well prepared, and the experts had previously read through the files on each proposal. One model stood out fairly quickly. There were various families of designs, quite different from each other, but the Piano-Rogers design belonged to none of them. We arrived at the conclusion that it was the right one, though no doubt rather different from what President Pompidou would have wanted. The evolution of a building can be surprising. We had all supported the fine idea of a large external stairway, with that magnificent diagonal that acts as the monument's signature. But the internal spaces proved less easy to use. One of the reasons for our choice was the functional flexibility that those vast open spaces seemed to offer. It was in fact a mirage, a mark of the times for exhibition spaces: one had to escape the dictatorship of walls, doors, and passageways. Still, we soon came to realize that the supposed flexibility offered by a flat plane with no limitations other than its four external walls was ultimately a constraint. When Dominique Bozo, whose perspicacity I will always admire, took the project in hand several years later, he asked Gae Aulenti to restructure the interior spaces with real walls and real passageways, as they were needed to help orient visitors' explorations. What might work for temporary exhibitions is not necessarily ideal for permanent displays.

Anyone involved in the battles over the Pompidou Center became caught up in a whirlwind of criticism that we can hardly imagine today. The choice of building was critiqued with rare violence. Out of personal conviction and loyalty, I always considered it my job to defend it in the circles I frequented, which wasn't always an easy task. Later, after the great, innovative exhibitions by Pontus Hulten, everyone realized

how successful the Center actually was, how its international aura sheltered Paris from charges of provincialism, and how it had sparked an extraordinary momentum throughout France.

I was on the Center's acquisitions committee for some ten years, a fascinating position for me, as I saw the arrival of works by major artists that had been so lacking at the Palais de Tokyo when I was young: Mondrian, Dada, the Surrealists, and so on, as well as the great Americans, plus forms of art very foreign from the ones I had loved, notably anything having to do with conceptual art. In those meetings, I rubbed shoulders with the critic David Sylvester, the Italian collector Panza di Biumo, and Dominique de Ménil and her sister Sylvie Boissonnas, both of them ready to donate works that might be needed with utter discretion.

One individual who made an impact on me was Daniel Cordier, who was already campaigning at the time to rehabilitate the Resistance hero Jean Moulin, accused of being a Russian "mole." Passionate about contemporary painting, he had helped organize the second postwar Surrealist exhibition with Breton, championed Dubuffet, and launched a neo-figurative style of painting that was close to Surrealism. At some of the committee meetings, we enjoyed—without taking it seriously—playing devil's advocate, in which I'd praise Matisse or Marquet, while he'd promoted artists like Réquichot or Broodthaers. In reality, we both knew that I admired some of his artists, and he adored Matisse.

In some ways, Beaubourg suggests a kind of centralization that runs counter to the activities of numerous artists, who prefer to scatter their works as widely as possible. I know that some have ascribed to the museum a will to appropriate artistic creation, but personally I didn't see it that way. I believe that the state has a role to play in helping creators. The answer lies more in the fact that the Pompidou Center engendered a widespread movement, subsequently encouraged

by Jack Lang, that resulted in many centers being opened in the provinces and in an active acquisitions policy that is hardly to the artists' disadvantage. In the same way, the effect of Orsay and the Grand Louvre led many classical museums in the region to modernize. The 1970s and 1980s were a time of great decentralization, marked throughout France by the creation of contemporary art centers, whether following on Malraux's "houses of culture" or thanks to the Regional Contemporary Art Fund (FRAC) or to different organizations born of various initiatives.

At the same time, it is difficult to think of Beaubourg without recalling the tensions between government and artists that crystallized around the exhibition *60–72: Twelve Years of French Contemporary Art* at the Grand Palais. This exhibition, and the post-Pop generation in general (Support-Surface, New Realism, and so on), represented forms of expression that I understood intellectually, but that seduced me less than the previous generation had. I think this is normal. Dealers, art lovers, and critics often have difficulty accepting three successive generations of creators with the same enthusiasm, and this is no doubt my case as well. If I prefer, to cite only two names, Claude Viallat or Anselm Kiefer to other stars, it's out of fidelity to the painted object.

As for the political tensions, I didn't at all feel that the 1972 exhibition was just a prestige operation on the government's part. But I wasn't really involved in it, and I had great admiration for the person and works of François Mathey, who had conceived the exhibition at the request of the President of the Republic.

Georges and Claude Pompidou truly loved modern art: non-figurative art, lyrical abstraction, Soulages, as well as contemporary works. And the fact that the president himself pushed for this major stock-taking of French art in 1972, as well as for the creation of a "museum" that would eventually

become the Pompidou Center and for the transformation of Elysée Palace, proves it. I followed this latter point a bit more closely, since Jean Coural was assigned to redecorate the private apartments in the Elysée. In President de Gaulle's time, that meant watching over the preservation of the place, changing the furniture now and then, or simply making restorations. Georges Pompidou, on the other hand, wanted to create a contemporary "setting" in which to welcome visitors. The president and Coural agreed to hire Agam and Pierre Paulin. The extraordinary Agam salon, today transferred to the Musée d'Art Moderne, was a pictorial space, while the series of rooms and the dining room conceived by Paulin gave the impression of live-in cocoons. I use the word "cocoon" advisedly because, in the mind of Coural, an historian sensitive to the patrimony, one shouldn't destroy the old decorations but simply cover them over so that they could be restored later if need be. This is what in fact happened when Valéry Giscard d'Estaing did away with the salons and preserved only the dining room. I'm certain that this period, which in France was characterized by Olivier Mourgue, Paulin, and a few others, will get the recognition it deserves in the history of interior decoration, with these grand, warmly colored curvilinear forms, intricately arranged in the space.

In addition to my work for the Louvre, I was involved in a project that had long been close to my heart, and that had already been sketched out by Jean Vergnet-Ruiz: reuniting the Italian primitive works in the Campana collection. The dispersal of the collection in 1863 had been an abomination. We knew the story: the Marquis of Campana, head of the state-owned pawnshops in Rome, was a fervent collector. He had underwritten significant excavations in the Etruscan lands, and through these had acquired hundreds of Greek and

Roman vases and ancient sculptures. He was among the first to avidly collect Italian paintings of the thirteenth, fourteenth, and fifteenth centuries. Taking advantage of monastery closings, public auctions, and his relations with dealers, he had amassed hundreds of Italian primitive works, among which were some real masterpieces. His passion pushed him to commit some irregularities, such as pawning his own collection! There was a notorious trial. The pontifical authorities decided to put the collection up for auction. Most of the great museums were ready and waiting, and that was how the Hermitage bought a certain number of Renaissance marbles.

With Napoleon III, there were many stories involving women. If we were to tell the history of the Campana collection in *People* magazine, it would go something like this: three women were at the center of it all. The Marquise of Campana was of British origin, and her mother had "sponsored" the future Napoleon III's political exploits, notably his famous escape from the fortress of Ham. Possibly at the behest of the marquise, whose husband was in difficult straits, the emperor had found money — public funds, not his personal fortune — to acquire the remaining totality of the Campana collection: Greek vases, Etruscan, and Roman sculptures, and roughly seven hundred Italian paintings and sculptures. The whole thing was exhibited in 1862 at the Palais de l'Industrie, under the name the "Napoleon III Museum." This institution, which had obvious analogies with the Victoria and Albert Museum in London, provided artists and craftsmen with an abundance of historical models in every medium at a time when attention was being focused on the decorative arts. Despite this, the Napoleon III Museum remained open for only a few months. The Louvre authorities played a sordid role in this episode, notably the museum's director, Nieuwerkerke, a remarkable man in most other respects. He was the lover of Princess Mathilde, the second woman in

question, who must have slipped a word to her cousin, but this time to get him to close the new museum. Like the other "Louvre people," Nieuwerkerke had reacted badly to the creation of a large rival museum, which didn't even have a curator worthy of the name. Napoleon III had in fact appointed as head of his museum Sébastien Cornu, an honorable but not exactly brilliant painter, whose wife, the third woman, had been the future emperor's foster sister. The museum was dismantled in 1863, despite vigorous protests in the press: Ingres and Delacroix, for once putting aside their differences, campaigned against its dispersal.

The Louvre kept a certain number of masterpieces, notably Uccello's *The Battle of San Romano* and Cosimo Tura's *Pietà*, and a very large number of Greek vases; the rest was scattered throughout the provinces. After the Franco-Prussian War of 1870, the Louvre began sending other works to provincial museums as well.

In the scholarly circles of the late nineteenth century, interest in this unfortunate episode was revived by Salomon Reinach, certainly the strongest personality in art history and archaeology of his day, who exercised great intellectual authority. He began an in-depth study to piece together its history, while Paul Perdrizet and René Jean set about identifying and locating the works, many of which had been scattered arbitrarily—polyptychs dismantled, pendants separated, and so on. A catalogue was established. But World War I interrupted their momentum, and after the war the situation of museums was hardly propitious to this kind of undertaking.

It was only with the arrival of Jean Vergnet-Ruiz, who possessed an extensive knowledge of museum history, that the arbitrary diaspora of the Campana collection finally came to an end. The project mainly concerned the primitive paintings that formed the most coherent grouping; fortunately, most of the Greek vases had remained at the Louvre.

I joined the Inspection team at the moment when Vergnet was planning how best to proceed. In particular, he was hesitating over where to install the regrouped collection. The importance of the Musée Fesch in Ajaccio, as yet little known, had just been revealed thanks to the efforts of its young curator, Jean Leblanc, who had inventoried a collection of one thousand little- or unstudied Italian canvases, including many primitive paintings on wood from the collection of Cardinal Fesch, Napoleon's uncle. He had wisely consulted Berenson and obtained precious insights into the primitives. Installing the reconstituted Campana collection there was thus a serious possibility. Still, I'm not sorry that the final choice was Avignon.

Georges de Loÿe, curator of the Musée Calvet in Avignon, was a young curator full of enthusiasm and energy, and it was he who suggested Avignon to Vergnet. They convinced the municipal authorities to free up the archbishops' palace, which overlooked the Rhône River not far from the Palais des Papes. Built in the fourteenth and fifteenth centuries, the palace had been home to the young Giuliano della Rovere, who later became Julius II, the pope of Michelangelo and Raphael. Moreover, the presence of many Italian artists in Avignon in the fourteenth century, Simone Martini and others, and the frescoes they had left to the palace and to Notre-Dame-des-Doms, designated the city as the ideal setting for the collection.

My first task was to arrange for the return of the works, which had been spread over ninety-five museums. Some of them were true masterpieces, like the Carpaccio in Caen. One of my jobs was to engage the support of the curators, so that they would understand the national benefit of this regrouping and accept our offer to replace them with other works on deposit, more in keeping with their collections. As it happened, the Louvre was extremely generous. In the case

of general museums, such as Lyon, it seemed reasonable to replace Italian primitives with other Italian primitives. More often, however, we tried to fill gaps in other areas. For instance, since the Rouen museum already owned a handsome Impressionist collection, it seemed proper to deposit other Impressionists there. In Bordeaux, which had a longstanding love of England, we chose a handsome portrait by Reynolds. It was fascinating work.

In addition, we had to study the Campana objects once they were together again. The 1956 exhibition helped with this preparatory work: getting to know the paintings, verifying their attributions, bringing them to Paris for conservation if needed. Some were in good condition, but others had been poorly retouched or framed, or damaged over time. The rather purist taste of the 1950s inclined us toward removing the existing frames. These frames had been manufactured in Rome in the Marquis of Campana's day, often to serve as borders to fragments. We got rid of them — preserving the most interesting ones in storage — when they weren't up to standard. Today our purism might appear excessive, and no doubt someone will one day reproach us for our sobriety. Personally, I don't regret it. The Campana frames were lacking in character, having none of the neo-Gothic inventiveness that would have justified a "retro" display of the whole grouping.

This project took up twenty years of my life, from 1955 to the opening of the museum, called the Petit Palais, in 1976. First, this required a huge commitment from the city of Avignon, and Mayor Edouard Daladier and his successor, Henri Duffaut, demonstrated true determination in the face of so large a financial engagement. The state would naturally provide part of the collection and huge subsidies, but it was up to the city to restore the palace, which at the time was being used as a technical school: when I first saw it, there were still machine tools in the rooms. Fortunately, the basic

structure was in good shape. Georges de Loÿe oversaw the operations on site, and the architect André Hermant worked with us to turn it into a museum. He was a very scrupulous architect, with whom I traveled to Italy several times. I wanted at all costs to avoid period reconstruction. Some, such as Georges de Loÿe, would have preferred to recreate a fifteenth-century atmosphere using period furnishings. I was against it, first because there is very little original fifteenth- or sixteenth-century furniture still in existence, and second, because the collection was made of many fragments of church paintings that would never have been found inside a palace! We were creating a museum, not a residence. The quality of the architecture (all the rooms still had their beautiful fifteenth-century coffered ceilings) and the fact that the palace windows offered one of the most breathtaking views of any museum in the world, with the Rhône, the Saint-André abbey opposite, and the Palais des Papes on the other side, was enough to suggest the fourteenth or fifteenth century to the viewer. André Hermant perfectly understood this desire for "distance" between the works and their setting. The project was very close to his heart, but he was ultimately disappointed by the way things turned out. Progress was slow, and he was unable to see it through to the end, as he died before the museum opened.

Restoration of the building itself was assigned to an architect familiar with historical monuments, Jean Sonnier, while the interior museum design was given to an interior architect. As Hermant hadn't been able to finish the work, we called on a designer, Alain Richard, who also understood our choices. He designed the lighting and signage fixtures, the stands, cases, and a discreet and sober support for the works.

While most of the Italian grouping came from the Campana collection, the Cluny and the Louvre had also contributed other paintings of different provenance, including a

major triptych by Giovanni Massone, the fifteenth-century Ligurian painter. Painted at the request of the future Pope Julius II for Savona, the altarpiece shows the owner of the premises, Giuliano della Rovere, as a donor. In addition, several rooms on the ground floor and the former chapel were devoted to paintings and sculptures from the Middle Ages and Renaissance in Avignon, highlighting the European importance of that school. We further enriched the collection by having the city, the Calvet Foundation, and the state make important acquisitions—Bembo, Bartolomeo della Gatta, Cristofo Scacco, Giovanni di Paolo, Lippe Memmi, Bartolo di Fredi—including four small, extremely rare panels by Simone Martini, the great Sienese master, a friend of Petrarch, who lived for a time and died in Avignon. I hope this policy will be continued.

Anyone interested in the fourteenth and fifteenth centuries cannot afford to miss the Petit Palais. Campana had bought many works in Umbria, Emiglia, Romana, and the Marches (which at the time belonged to the pontifical states); there are artists in his collection that cannot be found in the larger museums, as well as beautiful series of works from the "classical" schools—Florence, Siena, Venice, and the northern countries. And of course, the galleries devoted to "local" sculpture and painting prove that Avignon was a true capital in the fourteenth and fifteenth centuries.

In my career as a curator, the Petit Palais remains one of the highlights. How could it not, when it meant reuniting that unique collection, installing it in such a beautiful setting, and making my former boss's long-standing dream come true?

4

Meetings with
Art Historians

B y the time the Petit Palais opened in Avignon, twenty years had passed since I'd finished my thesis. In those years, a number of younger art historians had made their mark in the field of Italian primitive painting. I'd like to talk about a few of them, the ones I knew best, who in a certain way were part of my "family." There was Longhi, and then came the first generation of his disciples, mainly Federico Zeri, Giuliano Briganti, Ferdinando Bologna, Francisco Arcangeli, and Raffaele Causa.

Zeri's assistance was invaluable as I was preparing the Campana catalogue. He had published Campana paintings in *Proporzione* and other journals, notably works from the Marches and Emilia-Romagna, whose importance he helped establish. While we were writing the catalogue, he gave me many stimulating ideas and helped me track down the scattered elements of this or that polyptych, and I did the same for him. I had known him when he was just starting out and

was still part of Longhi's entourage. He worked as curator at the Spada gallery and wasn't yet an independent scholar. When he and Longhi had a falling-out, he became excessively critical of his former mentor. I've heard that he called me Longhi's "little dog" in France, but we remained on excellent terms. He was delighted when I proposed making a film of him at the Louvre, with Pierre Rosenberg as interviewer; he attended the premiere with a pleasure that erased his habitual causticity. Although physically frail toward the end of his life—he was in a lot of pain and could barely walk—he still had his mental agility, presence of mind, and sense of humor. He enjoyed telling jokes that were fairly risqué and even a bit blasphemous. One of them, which I can't resist the pleasure of repeating, takes place in Jerusalem, about the year 30 A.D. On a street corner, a woman is about to be stoned to death. A handsome man of about thirty raises his hand and says, "Let he who is without sin cast the first stone." Immediately from across the street, a rock comes zipping at the poor woman. At which point, Jesus, furious, turns around and says to the Blessed Virgin, "Mother, I *asked* you to stay home!" Zeri claimed he had made the future John XXIII laugh out loud with that one.

But his success on television—even on French talk shows, he outshone the other guests—had made him into a media star who assumed different roles to excoriate Italian culture. Little by little, he shut himself inside his persona as Italy's apocalyptic doomsayer. I visited him in Mentana shortly before his death—it had been a while since I'd seen him last—and I found him rather irritating, at least at first. He had asked me to come at a quarter to twelve. Why a quarter to? I understood only later: noon was when the news came on the radio, and he wanted me there to watch him listening to it. As always in news broadcasts, a catastrophe gave him a chance to sing his old refrain: "You see? Everything in Italy is

going down the drain. There are only two good classes in this country, the aristocracy and the little people. Everything in the middle is shit." He performed this routine in public more and more often. There was also a second routine, this one reserved for guests: calling in his secretary to open the day's mail. There followed a commentary on each letter, which was humorous enough, but not exactly spontaneous. To try to connect with the real Zeri, I took out some photos of Lorenzetti paintings, and he immediately went back to being the man I knew and loved: the art historian, always on the watch, curious about everything, kind, generous, eager to help with his pertinent analogies and unexpected insights.

I first met him in Rome, in a beautiful apartment full of strange paintings with fantastic-erotic themes. Mentana is a large villa with a handsome garden and ancient bas-reliefs embedded in the walls. He believed he had found a situation comparable to I Tatti, Berenson's villa in Settignano, or even Longhi's villa in Florence. But both of these are located in places that have remained delightfully rustic, whereas the spread of urban development has turned Mentana into a sprawling, charmless suburb. During Zeri's lifetime, the French state was desperate to acquire his library and prodigious photo archive for the Villa Medicis. But he bequeathed his home to the University of Bologna, along with the library and photo collection. Eventually, the university decided to use the Mentana villa for scholastic programs — colloquia, summer classes — and moved the Zeri Foundation into an old convent in the center of Bologna. It was a good decision.

Giuliano Briganti, who taught in Siena toward the end of his career, was also one of Longhi's first students. His work centered on Mannerism, Pietro da Cortona, and many other subjects. The son of a major Roman antiques dealer, he was already writing incredibly precocious articles for *Critica d'arte* at the age of twenty-two. He had great curiosity of mind and

a personality that mixed finesse with a certain roguishness, as well as a sense of humor that was unique in Longhi's circle. During one of his visits to Paris, he, Longhi, and I had dinner together. We had just seen *The Bridge on the River Kwai*. We then took a rather tipsy walk up the Champs-Elysées, the two of them noisily imitating the croaks and other sounds of the tropical forest and looking like anything but honored representatives of the Italian university system.

Ferdinando Bologna, who is still very active today, belongs to that same first generation of Longhi students. I met him when he and Raffaele Causa were installing the Pinacoteca di Capodimonte near Naples. We always stayed on good terms, in part because he, like me—or rather, I, like him— was interested in Mediterranean issues, artistic relations among Catalonia, Valencia, Sicily, Naples, and Provence. In this field, as in many others, he was a pioneer with an independent mind, though sometimes it was a bit difficult to shake him from his first convictions.

Causa became superintendent of Naples. A man of imposing stature, bearded and stocky, he was like a viceroy in his allotted apartment in the charterhouse of San Martino, overlooking the Bay of Naples. Beneath the facade of a *grand seigneur*, he was a subtle art historian, who died too young.

Behind Longhi stood the shadow of his wife, Anna Banti, a well-known writer who edited the literary section of *Paragone*. She had been, and still was, a strikingly beautiful woman, albeit somewhat difficult. She often created huge tensions between Longhi and his students. Or so they say: she was always perfectly friendly to me, though she did once tell me with a laugh that she put up with me because she didn't see me that often! After Longhi died in 1970, the Longhi Foundation was created as a study center, awarding grants to researchers from all over the world to come work there. Ulrich Middeldorf, a great scholar who had run the

Kunsthistorisches Institute in Florence, was appointed director. Banti resented his presence in her home, and after several management crises, the foundation began to run aground, nearly losing the international character its creators had intended for it. More recently, Mina Gregori has revived the foundation's scholarly activities. Faithful among the faithful, she had worked with Longhi on a daily basis and later took over his chair at the university.

Francesco Arcangeli was one of Longhi's most endearing students. I didn't know him well but I had a lot of respect for him. A teacher in Bologna, that tormented, somber man, a friend of Morandi, was a great specialist in Bolognese art, of which he had a highly original vision.

Staying in Bologna but stepping out of Longhi's circle for a moment, I have to say a word about the most brilliant of the postwar superintendents, Cesare Gnudi. He had been a hero in the Resistance. To look at him, thin, a bit stooped, with a receding chin *à la* Rostropovich, you could hardly imagine that he had shown such physical courage and survived imprisonment in 1943. As superintendent of Bologna, he had been responsible for a large number of restorations, acquisitions, and exhibitions that renewed interest in Bolognese paintings of the fourteenth, seventeenth, and eighteenth centuries. He himself was a specialist in Italian and French Gothic sculpture, and in this field he was considered a pioneer. He was among the first to understand certain aspects of French sculpture, such as the precociousness of the rood screen in Bourges, or to suggest links between great Italian painters such as Giotto and French Gothic sculpture. The man had an unimaginably inventive wit, and was a genius at mimicry. At the end of the dinner celebrating the opening of the Carracci exhibition, he began imitating the major art historians of the time, with their exact intonations, but making them speak as if they were figures from the seventeenth century. It was irre-

sistible! He also imitated perfectly Chastel and Sylvie Béguin, whose fruity Italian accent, delightfully devoid of crisp pronunciation, was famous in Italy.

Carlo Volpe taught in Bologna up until his premature death. Longhi himself had never devoted much attention to Sienese painting, except for a few notable examples. But he pointed Volpe toward the fourteenth-century painters of that school, and Volpe revived a subject that everyone considered exhausted, notably with his writings on Pietro and Ambrogio Lorenzetti. He also conducted research into other schools, such as Rimini. Our mutual friendship was heightened by these shared predilections.

Among the figures of my generation, I've already mentioned Enrico Castelnuovo, who remained a close friend. Slightly younger in Longhi's circle was Giovanni Previtali. As with several others, I had met him in Paris, where he had come to study the critical reception given the Italian primitives. He had succeeded Mina Gregori as Longhi's assistant. Like many Italian intellectuals of the time, Previtali was a Communist. Vibrating with intelligence, ready to explode into vehement indignation at the drop of a hat (often with some justification), an exultant polemicist, he no doubt exerted a beneficial influence on the aging Longhi thanks to his stimulating mental agility. His magisterial writings on Giotto and Italian Gothic sculpture, his crucial contributions to the large and original history of Italian art that Einaudi published in 1979, the extensive influence of his teachings in Siena and Naples, his abilities as an organizer (I'm thinking of his exhibitions in Siena and the one we mounted together in Avignon in 1983) — all this marked him as a great intellectual leader. His death in 1988 was keenly felt by us all.

The chair at Siena then went to Luciano Bellosi, whom I'd known at the fine arts superintendent's office in Florence. Of all the art historians, he is the one whose thoughts and opin-

ions on the Trecento and Quattrocento matter most to me today. He has a very calm disposition, at least on the surface. If you ask him about an attribution, you shouldn't hold your breath: his opinion comes in its own good time, but when it does, you know that it's correct. His great books on Giotto, Cimabue, and *The Triumph of Death* at the Campo Santo in Pisa (Buffalmacco); his essays on sculpture and many other subjects, written with clarity and breadth of vision; and his innovative exhibitions on the great Florentines of the fifteenth century prove that in his way he has continued the grand tradition of Pietro Toesca and Longhi. He succeeded Previtali in Siena, which enjoys an all-too-uncommon partnership between the university and the Superintendence, notably when it comes to organizing splendid exhibitions. I feel at home there with Alessandro Bagnoli, Roberto Bartalini, and others. Several of the most brilliant younger scholars, such as Andrea de Marchi, got their start at this center. Another colleague in Siennese research is Max Seidel, who runs the German Institute in Florence, the "Kunst," as we all call it. Another first-rate research center, with which I'm less acquainted personally, is the Scuola Normale in Pisa, directed by Salvatore Settis, where Enrico Castelnuovo and Paola Barocchi teach. Judging from those who have passed through the school, such as Giovanni Agosti or Francesco Caglioti, or the scholarship students of the I N H A who've gone there, not to mention young researchers coming from other universities whom I don't know personally, we needn't worry about the health of art history in Italy!

I cannot name all my other Italian friends, such as Carlo Bertelli, Evelina Borea, Alessandra Bettagno, or Anna Ottina Cavina, but, stepping once more out of Longhi's circle, I'd like to at least mention Giovanni Romano, who worked at the Galleria Sabauda and now teaches in Turin. He and his team have covered virtually every aspect of the Piedmontese artis-

tic "landscape" throughout the centuries through research and exhibitions that are unequaled in almost any other region of Italy. He is also an insightful connoisseur.

A few words on my American friends interested in Italian primitives. Millard Meiss had more or less abandoned his studies on Tuscany to complete his monumental opus on late-Gothic painting in France and Franco-Flemish circles when he died in 1975. Everett Fahy, who chairs the Department of European Paintings at the Metropolitan, is among the American "Italians" who understood Longhi's message without forgoing the American tradition of rigor inspired by Offner, nor the example of open-mindedness provided by Meiss. Everett is working on the fifteenth century in Florence, while still being drawn by many other areas of interest. His generosity is legendary. A great connoisseur with a very sure eye, he gives his discoveries to anyone who needs them, without himself publishing as much as one would wish. For him, it seems, what matters is to uncover the truth—regardless of who reveals it to the world. He is perfectly capable of traveling to see an unknown fifteenth-century Florentine painting in a church in Cotentin without then demanding that *Burlington* magazine publish a long article about it by him! Certain other American art historians share his attitude, as do I. To cite three of them: Keith Christiansen and Laurence Kanter at the Met and Carl Brandon Strehlke in Philadelphia. They were brought together in 1988 for a memorable exhibition on the fifteenth-century Sienese painters in honor of John Pope-Hennessy.

Invoking this international camaraderie of Italian painting connoisseurs also puts me in mind of Eastern Europe. Despite political constraints during the dark years that prevented them from traveling freely, the art historians of those countries managed to maintain contacts with their western colleagues. During a trip to Poland in 1959, I had met a young

woman, Maria Mihalska, who had undertaken a comprehensive study of Italian primitives in Polish museums. She had to leave her country with her husband, the great medievalist Piotr Skubiszewski, to come live in France, before eventually returning to a free Poland. In September 1999 she and I viewed the superb collection of Italian primitives given to the Wavel in Krakow by Mme Lanckoronska, which I mentioned earlier, and which enriched Maria's catalogue with magnificent pieces. Our common interests led to a solid friendship. I found the same kind of professional friendship with Olga Pujmanova in Czechoslovakia, who became an excellent specialist of Italian primitives by studying fourteenth- and fifteenth-century panels in Czech museums, facing the same obstacles and displaying the same courage as her Polish colleagues.

Outside the bounds of pure connoisseurship, many other avenues of research were opened by figures like Hans Belting and Michael Baxandall. One field that recent scholarship has exploited successfully concerns relations between form and function in the composition and iconography of fourteenth- and fifteenth-century polyptychs, naturally with reference to the religious beliefs of those who commissioned them.

For my work on fifteenth-century Provence and artistic relations in the Mediterranean, I have had occasion to meet other Italian art historians, such as Fiorella Sricchia Santoro or Mauro Natale. These transnational problems have recently given rise to an ambitious exhibition in Madrid and Bruges. Speaking of Spain, when preparing the 1963 exhibition, I had been very impressed by Jose Gudiol at the Amattler Institute in Barcelona, the type of connoisseur, on both the primitives and the seventeenth century, that was fairly rare in Spain at the time.

It is difficult for me to end this overview of my "primitive" friendships without naming the three accomplices with

whom I always enjoy talking about Fouquet, Quarton, and Barthélémy d'Eyck: Nicole Reynaud, François Avril, and Dominique Thiébaut.

Now I'd like to say a few words about the great French art historian André Chastel. I did not become one of Chastel's students when he took the banner from Focillon at the Institut d'Art in 1955, but we were brought together by the 1956 exhibition at the Orangerie, for which he wrote the catalogue introduction. He invited me to join the editorial board of *Art de France* and always offered me his help. Like Focillon, he considered his role to be more than that of a simple teacher. In a certain way—and this is what his opponents and those he disappointed (and sometimes even humiliated) held against him—he set himself up as "head" of the discipline, suggesting what had to be done in order to revive art history in France—which, as I've said before, sorely needed it. He benefited from his natural authority and the influence conferred by his teachings, his books, and his regular column in *Le Monde*.

In his column, he reviewed the major domestic and foreign exhibitions of the moment. He managed, without pedantry, to analyze the show's contents, the interest or banality of its thesis, and the scholarly quality of its catalogue; in short, he inspired you to go see the exhibition when it was warranted, giving his reasons and not being afraid to criticize or express reservations. A bit like what John Russell was doing at around the same time in London and New York. A brief digression, out of order chronologically, about the latter: I had known him in London and saw him again in New York, being on friendly terms with him and his wife Rosamund Bernier, the creator of the art magazine *L'Oeil* in Paris and a highly regarded lecturer in the United States. In 1992 she would give two brilliant lectures, just for the fun of doing

them, in the auditorium at the Louvre. End of digression; I return to André Chastel as a journalist. Apart from André Fermigier, few French critics had or have Chastel's stylistic talent, intellectual agility, or gift of making you see. His best articles were marvels of thought and expression. I often traveled with him, and I've seen him compose articles during a train or plane ride in a single draft without revisions, about subjects on which he wasn't necessarily an expert. He knew how to get to the essence, to hit the target with joyful ferocity, and sometimes with a swipe of his claw.

But these articles also allowed him to play a more fundamental role. Certain great art historians have considered it their duty to reach beyond pedagogy, to influence government policy by alerting the educated public to matters affecting the national patrimony. Chastel often fought for the patrimonial cause. Not always successfully, as the destruction of the covered markets at Les Halles — a real crime — proves. On that occasion, he wrote a piece about (with a nod to the frescoes of Ambrogio Lorenzetti) acts of "good and bad government," expressing the conviction that there is such a thing as good governance of art, and that art historians can act as safety barriers.

According to him, several elements were needed to raise the level of art history in France. First he advised his students and friends to study abroad to counter the chauvinistic self-satisfaction in which the discipline had been confined since the end of the war. At the same time, he did not try to enlist anyone under his banner. Obviously, I can only speak for myself. He didn't share my affinity for the "connoisseur" approach, but he always encouraged me to follow my direction and never tried to steer me onto a different path. Maybe he knew I was beyond hope! Nor did he ever stand in the way of those who were attracted by pure historical or archival research, even though he always stressed the importance of

philology in art history. If there ever existed a Chastel "clan," the most one can say is that it was extremely diverse in its approaches, methods, publications, and demonstrations. It's no coincidence that his foreign peers and friends included Jan Bialostocki, Willibald Sauerlander, Roberto Longhi, Erwin Panofsky, Anthony Blunt, Giuseppe Fiocco, Ernst Gombrich, and Meyer Shapiro—hardly second-stringers or representative of a uniform tendency.

The end of Chastel's life was truly heroic. He knew he was doomed, but never mentioned it. Instead, he put all his energy toward finishing his magnum opus on French art, though ultimately he ran out of time. He died on a Wednesday. When I'd seen him the previous Friday, he was standing up and his skin was sallow, but he still wanted to talk about his book. It was he who answered the door for me. We sat down and he pointed to a pile of letters on the table, saying, "You see, people still write to me. They don't know I'm no longer of this world." I never saw him again.

Some people criticized the gap between the very open-minded author Chastel was and the somewhat dictatorial power broker who reportedly stood in the way of talent developing around him. In particular, they blamed him for not promoting some of his more brilliant disciples, such as Robert Klein or, to take a slightly younger example, Henri Zerner. These two did not obtain the university positions that would have allowed them to pursue a career commensurate with their abilities. Zerner, for lack of a suitable post in France, eventually went to Harvard, though he remained faithful to Chastel until the end. The conflict between Chastel and Pierre Francastel, who taught at the Ecole des Hautes Etudes, was not merely personal, the usual rivalry between two influential leaders; it was first and foremost intellectual. More painful was the dispute between Chastel and Hubert Damisch. When I talk about it now with

Damisch, he expresses a real resentment, a real feeling of exclusion. It's not my place to judge how well-founded these tensions were, as I only knew Chastel's good side. I didn't depend on him for career support. Still, we shouldn't overestimate his power in the "Establishment": as far as I know, a teacher is not appointed to the university by a single individual but elected by a professorial committee.

While I was fortunate enough to maintain friendly relations with Chastel, he nonetheless kept a certain personal distance. At the same time, there was no demagogy in his relations with students and friends, but rather a true joy, a pleasure in working side by side. His students remember the voyages and walks during which Chastel displayed the kind of good humor and enthusiasm for which Focillon had earlier been known. For myself, I'll always remember a trip with him to Budapest in 1965 for a conference on art history organized by the International Art History Committee, in which both Focillon then Chastel were active members, and which brought together specialists from all over the world. Budapest had the added attraction of being an unfamiliar city to which one could not travel easily. When we arrived, we found that several of the art historians listed on the program were absent, suddenly unavailable, or ill. In fact, the government had forbidden them from attending. Andrès Pigler, the great scholar who wrote two large volumes on seventeenth-century secular iconography that are classics to this day, was "indisposed." One who did attend was Robert Klein, Chastel's good friend and admirer, who presented an important paper on the foundations of the Renaissance. The conference itself, on international artistic relations in the fifteenth century and the Renaissance in Europe, was quite fruitful. Chastel's authority was dazzling. I read a paper on the relations between Fouquet and Naples, one of the questions surrounding the Master of the Annunciation of Aix. I took advantage of the trip to study

the Italian primitives in Budapest and Esztergom, where we were warmly welcomed by a group of nuns—despite the Socialist regime, the convent had remained church property. It was in the reserve collection of the Budapest museum that I met the young Miklos Boskovits, already an excellent specialist on the Italian Primitives, who would subsequently leave Hungary and become an Italian citizen.

Getting back to Chastel as a public figure, he had clearly delineated three or four goals that had to be pursued in order for French art history to regain its prominence. He tirelessly campaigned for them to be recognized and implemented by the public authorities, which in the end constituted a bona fide political crusade.

First, he recommended giving the Institut d'Histoire de l'Art a central role in line with what Focillon had defined before the war: not simply as a place of learning, but as a research facility built around the significant library and photo archive that Jacques Doucet had created earlier in the century. Since the war, the Doucet library had stagnated, which was one of the main reasons for discontent among French art historians. The idea of a refurbished institute endowed with vastly increased research tools seemed crucial to Chastel. This is what he proposed when Pierre Mauroy asked him to report on the Institut d'Art in 1982, to which I'll return later.

The second point was to encourage national awareness of the patrimony, the better to promote and protect it, by creating an inventory of art for the entire country. This was Chastel's great project and he devoted himself to it fully without personal ambition. His dream was to create a service analogous to what already existed in Germany and England, which went beyond the protective role of the Inspection of Historical Monuments and extended to fostering public knowledge of the entire French patrimony, region by region. I remember Chastel's tireless energy in trying to convince

Malraux to found such an institution. He was staunchly aided in this by a man he greatly admired, Julien Cain, the former administrator of the Bibliothèque Nationale. Stripped of his office under Vichy because he was Jewish, Cain had survived deportation and returned to his post after the war, infusing the library with a new spirit. He also embodied great moral authority in the cultural domain and helped Chastel give his inventory an intellectual and administrative identity.

The third goal was an independent periodical, which was created in 1968 under the title *Revue de l'art*.

The fourth point was one of Chastel's primary battles, which unfortunately he lost and which still hasn't been won as of today: teaching art history in secondary schools, in other words, creating a specific degree, like a degree in musicology, for instance. He wasn't heeded, and the professional historians are no doubt partly responsible for this, despite Chastel's good relations with Fernand Braudel. A powerful lobby of historians, which tended to consider art history a junior or even superficial branch, stood firmly in the way. On an institutional level, I'm afraid their power was detrimental to the recognized autonomy of our discipline, which had already been severely damaged by the creation of a fine arts degree.

The years 1960–80 were marked by various currents in art history. This was the period of semiological criticism, which might be considered the antithesis of "aesthetic" art criticism as practiced by Malraux or Huyghe. Naturally, none of these tendencies can claim primacy in the discourse on art. At the same time, you can't throw them all into the same pot: the great literary analyses that you find in Elie Faure, then in Malraux and Huyghe, are actually quite different from each other, in time and intent. True, these globalizing approaches often adopt an overly vehement tone. But both tendencies

have yielded magnificent pages that have given thousands of readers a taste for art.

Those who speak of "intellectual terrorism" in the humanities are perhaps missing the central point. The fact is, much of the scholarly work done to prepare for a museum exhibition is based on a variety of disciplines and documentary sources. This welcome evolution has been particularly noticeable in the past two decades. Exploration of the historical, social, and economic context of the works, its intellectual and iconographic origins, the literary environment and what we now call its reception (both the critical response and its influence on later artists), the psychological conditions under which it was created—isn't this illustrative of a form of art history that draws simultaneously upon several disciplines of the humanities, largely overspilling issues of attribution, positivist history, and technique? In short, many are practicing total art history without knowing it, or rather without admitting it. The fact remains that such research, even if directed by a single person, is often collective. Few historians are capable of compiling the dossiers, studying their contents, and coming up with a new and luminous analytical essay all by themselves. Not everyone can be Panofsky!

But I'm perfectly aware that the opposition lies elsewhere. It lies not in the sources of information, which today are diversified, but in the different intellectual systems—whether Marxism, structuralism, or psychoanalysis—through which the images are interpreted. It's with interpretation that the notion of terrorism comes in, since the slightest trace of skepticism can brand you as a Pharisee or be used to make the interpreter look like a martyr. Many of these interpretations are indeed luminous. Still, there's no denying the excesses of certain academics, notably Americans, who do more harm to this type of discourse than any platitude about some discredited "positivism." As far as I'm concerned, not every ripe fruit

in a still life is a female symbol, nor do the obelisks painted by Hubert Robert or Pannini type them as sex-obsessed.

While we're on the subject of terrorism, let me note that the condemnation of "attributionists" is beginning to wane. Attributionism cannot be equated with positivism. The process of determining attributions is clearly a matter of interpretation. There is nothing inherently positivistic in the act of attributing a painting about which little is known to Mattia Preti or Quarton. The only thing that enters into play here is one's own subjective gaze, filtered through the hazards of visual memory and historical imagination. These two methods and tendencies are totally different. Positivism mainly consists in tracking down and interpreting the clues and documents that allow you to state that a given canvas was painted on such-and-such a date, by such-and-such a painter, in certain circumstances. Even if the two approaches are complementary, they must not be confused. Chastel was able to support both of them, even though he himself practiced neither.

In Italy, Giulio Carlo Argan used to make a similar division into two separate camps. On one side he put Longhi and his followers, whom he considered politically conservative and overly focused on the uniqueness of masterpieces and questions of attribution; and on the other, Adolfo Venturi and his camp, more inclined toward general ideas and essays, and tending toward the political left. But Argan, who was strongly influenced by Marxism and had a sociological vision of art, was mistaken in thinking that the Longhi group was interested only in masterworks. On top of which, several of Longhi's followers were openly leftist. One of this group's strengths was the way they revealed new works and little-known artists, and especially how they proposed — and in this regard they were in no way backward-looking — a new, or at least renewed, historical and critical vision of Italian painting.

Over the last thirty years, French art historians have done the same for the fifteenth century, following in Charles Sterling's wake, and for the seventeenth and eighteenth centuries, owing to men like Jacques Thuillier, Pierre Rosenberg, Antoine Schnapper, and others after them. While I modestly align myself with "Longhian" art history, I still recognize the importance of other research tendencies in France. In my own field, the Italian fifteenth century, how can we deny the depth, breadth, and originality of the research done by Hubert Damisch, Georges Didi-Huberman, or Daniel Arasse?

Earlier, I mentioned some English and American art historians in my specific field. I'd like to say a few words about those in other fields, beginning with Anthony Blunt. As I said before, we met on the occasion of the French seventeenth-century exhibition in London, and I remained on friendly terms with him afterward. I often saw him in Paris—in the final days of his public life, he was on the Museum Council—or at his home in London. I also remember a lunch with his former schoolmate Ellis Waterhouse, an old-style scholar who ran the Barber Institute in Birmingham: a frugal meal in the famously ascetic kitchen of his flat, during which the two old pals indulged in a volley of private jokes that were quite amusing, but that for the most part went over my head. When the news broke in 1979 of Blunt's past activities as a Soviet spy, it floored us. Despite promises made to him, Mrs. Thatcher delivered him to the media. We, his friends in London, Paris, and Italy, called each other to express our stupor. I've already said how much the Courtauld owes him. As a director, he was both liberal and very present. His office was always open to students or colleagues, as I often had opportunity to see for myself. I knew young people who went to seek moral guidance from the former double agent. His professional and human authority explain why, despite his

unpardonable actions, most of his former students, now professors, refused to join in the witch hunt. I, and many others, sent him a short word of encouragement, and I know this touched him deeply. He buried himself in his work on the Italian Baroque, trying to forget the anguish of no longer being able to go outside.

In his public life, Blunt was a likable and simple figure, and a bit reserved, like his writing. This restraint is one of the qualities of his style. When reading his works on the seventeenth century in France, on Roman Baroque, or on art theory, you are struck by his sobriety of tone, his refusal to shine. But you also notice very quickly that he has explored every facet of the subject and made it intelligible. He is the perfect example of an art historian whose intellectual positions cannot be explained in clear-cut ideological terms. He was at once a connoisseur, an "iconologist," in that the subject remained fundamental to him (how can one study Poussin without making a detailed study of how the artist interpreted an old text or theme?), and someone who never lost sight of the technical and concrete aspects of the work.

He was the curator of the Queen's collections — I remember a visit to Buckingham Palace where, from room to room, he made sure that She was not present in the next one! In this role, in addition to his many publications, he directed remarkable campaigns to restore paintings from the royal collections, at a time when the National Gallery was being far less prudent and using highly debatable means of cleaning its canvases. His main restorer was John Brealey, one of the best I've ever known — his famous restoration of Velázquez's *Las Meninas* was admirable, as was his work at the Metropolitan, which was abruptly interrupted by illness. I also followed closely the slow and difficult resurrection of Mantegna's *Triumph of Caesar* at Hampton Court, which took place under Blunt's close supervision and is a marvel.

The second great English art historian of that generation was Kenneth Clark, who later became Sir Kenneth, then Lord Clark of Saltwood. He had been director of the National Gallery before and during the war, exhibiting in blitz-besieged London some of the gallery's masterworks, symbols of hope and continuity. He is behind several major acquisitions, such as the *Portrait of Madame Moitessier* by Ingres. He had worked with Berenson in his youth and remained a great specialist in Italian painting. He wrote the best work on Piero della Francesca after Longhi's, and his essay on Rembrandt and the Italian Renaissance is a classic. His masterwork on landscape painting, published in 1949, had won him international fame. He had a unique way of mixing together large topics, founded on a huge visual culture, and of doing it with clarity and precision. Very early on he understood the possibilities of expression and wide circulation offered by television. I met him when he was at the Louvre to shoot a sequence for one of his films on modern art that followed the famous Civilization series. The principle was the same: in Florence, on the Pont des Arts, or at a cathedral, Clark stood alone before the works or sites that illustrated great moments in Western cultural history. He had a prodigious gift for conveying the weight of history and the beauty or singularity of artworks. It was the first time that television had the means to bring into every British household, then every household worldwide, such superbly filmed images. To be honest, his success and his eminent position on so many official committees had left him a bit vainglorious. It's true that his tall stature and profile of a *condottiere*—not unlike that of Federico da Montefeltro by Piero della Francesca—gave him a naturally imperious look. Gossips said that he'd bought a medieval castle, Saltwood, to give a name to an ardently desired lordship, and he did finally become Lord Clark of Saltwood in 1969. I spent a weekend in that terribly medieval

castle, which I found rather uncomfortable but very impressive. We were alone, the Clarks and I, Lady Clark floating vaguely around, Lord Clark, loquacious and charming, preparing the meals himself.

Sir John Pope-Hennessy, the third of that great English generation, is the one whose work meant the most to me. Before the war, while still very young, he had published superb writings on the Sienese painters of the Quattrocento, and if he subsequently devoted himself mainly to the sculpture of that century (to the point of becoming its best connoisseur since Bode), he always retained his interest in Italian painting. His work at the Victoria and Albert Museum, where he made his career and eventually became director in 1967, is outstanding, illustrated notably by major acquisitions — Giovanni Pisano, Bernini, and Canova among them. I often saw and consulted with him in London, where he left the V & A to become director of the British Museum, then in New York, where he taught and chaired the Department of European Paintings at the Metropolitan beginning in 1977, and finally in Florence, to which he retired. His bearing, his inimitable, yet often imitated, accent, his authority that was at once smiling and chilling, might have been an obstacle to any attempt at cordiality. Still, the man was a faithful and attentive friend. In 1988 his young American disciples paid homage to him with an exhibition of Sienese paintings at the Metropolitan that was far more than just a tribute to a master. Our last meeting, in Florence two or three years before his death in 1994, left me with an odd feeling. It was at a party, and he easily reigned over an Italo-British gathering that was trying to prolong the atmosphere once staged by Henry James and other Anglo-Saxon writers and more recently illustrated by Harold Acton. But he seemed fragile and strangely isolated in this worldly crowd. For the first time since we'd met, we conversed in French, and I realized that he

spoke it fluently. Until then, I had thought his refusal to speak our language (my English is deplorable) was due to a fear of not having mastered it, and therefore to pride. But not at all. In that one conversation, the barriers finally fell away— but I never saw him again.

The fourth Englishman, a bit younger than the others, was Benedict Nicolson. I met him in 1956, as the very respected editor of *Burlington* magazine; he had come with his future wife, Luisa Vertova, to see the exhibition on Italian primitives. I stayed on friendly terms with him up until his sudden death in 1978. This exotic fellow was the son of Vita Sackville-West and Harold Nicolson, the mythic Bloomsbury couple, whose life together—replete with its unorthodox love affairs—had been published, based on their private papers, by their two sons. Ben's tutor had been the young Couve de Murville, and he spoke fluent French, with the very slight lisp that makes some Englishmen so charming. He was a delightful man. Physically he always looked somewhat like a vagrant; he was very tall, not always shaven or very well dressed, and, like many individuals whose heads are in the clouds, extraordinarily precise. He always seemed to be lost in a dream, when suddenly he would burst out laughing, showing that he had been following the conversation all along. I have a great admiration for the way he revamped *Burlington*, as well as for his own work, notably on European Caravaggism, which is a model of intelligent erudition and connoisseurship.

Ben was a close friend of Francis Haskell. I remember a weekend spent with him at Francis and Larissa's in Oxford: two days of syncopated drollness. Haskell was also a friend of mine, and his passing caused me great sadness. He died young, very courageously, a little like Chastel. He was supposed to come to Paris to give a lecture on Vivant-Denon, as part of his work at the time on the history of exhibitions. Then he called me to say that he wouldn't be able to attend

the conference. When I pushed him, his answer bowled me over: "No, on top of which I don't think I'll ever come again. I've had it — I only have a few weeks left." We saw each other often, even though our work took us in different directions. His books have become classics. He opened new avenues of research on the history of taste, museums, and exhibitions; on the role of arts patrons; on the reception of artworks in literature, art, and public opinion; and, more generally, on artistic revivals. In all these respects, he inspired several of the cultural programs held at the Louvre and the Institut National de l'Histoire de l'Art (on which I'll have more to say later). His work was based on a broad erudition that spanned several cultures. We can see it in the film that the Louvre made on him: his work linked him to Italy, but no less to France. His parents were both Russian; his mother had been a dancer and his father a well-known theater critic, notably for the ballet. He had gone to school at the French *lycée* in London and spoke and wrote French like a Frenchman. In his books, he expresses few personal opinions on the works themselves, since his subject is almost always the opinions of others in history. But when he did express an opinion, or when I looked at paintings with him, I became aware of his sensitivity, the intensity of his likes and dislikes, his appetite. Moreover, he and Larissa both loved opera, and that says it all.

I cannot, without getting tedious, cite all the art historians I've met throughout the world, but at the same time I can't leave off without mentioning Jennifer Montagu at the Warburg Institute, especially her acid tongue and the importance of her research on the Algardi. Nor can I neglect one of my oldest friends, Pontus Grate, a great specialist of French painting, or Robert Rosenblum in New York. His apartment near Washington Square contained a magnificent *Target*—or was it a *Flag?*—by Jasper Johns, of whom he was an early admirer. I had liked his book on pre-revolutionary French

painting enormously. Thanks to him, and, of course, to the work of Pierre Rosenberg and many other historians who have shown up the Goncourts, the eighteenth century in France is no longer reduced to three peaches by Chardin, ruins by Hubert Robert, a pair of buttocks by Fragonard, a bit of satin, and some smiles.

Finally, two figures I met in Spain: Jose Milicua, noticed by Longhi, an excellent connoisseur who published little and with whom I've unfortunately lost touch; and Alfonso Perez Sanchez. The latter had established a huge repertory of the countless seventeenth-century Italian paintings scattered throughout Spain. Professor at the University of Madrid and director (alas, for too short a time) of the Prado, he would, more than anyone else, broaden the research of Spanish art historians into Europe.

5

The Musée
d'Orsay

Much has been written about the Musée d'Orsay since its opening in December 1986. Jean Jenger detailed the stages of that vast project using blueprints, drawings, and administrative documents.[1] And a useful issue of *Débat*, edited by Pierre Nora several weeks after the inauguration, expressed both the viewpoint of those responsible and the strongly divergent reactions of a dozen personalities.[2] Therefore, I won't rewrite the history of the museum. Not having reread the different texts about the project, nor what I myself wrote about it at the time, I will rely for the present account only on my recollections.

I was involved from the start, as the Jeu de Paume was under the umbrella of the Paintings Department. At the beginning of the 1970s, several factors led us to think that the museum should change character. Following the habitual rule, by which works were transferred from the Musée du Luxembourg to the Louvre after a certain time, the genera-

tion of artists comprising the post-Impressionists and Nabis were about to join the Impressionists.

On top of which, tastes had changed. Jean Cassou's admirable 1960 exhibition at the Palais de Tokyo, *Sources of the Twentieth Century*, had shown that the liveliest research in late-nineteenth- and twentieth-century European art stretched beyond the Impressionists and post-Impressionists, to include the development of Art Nouveau and Symbolism. Moreover, it became clear that the "avant garde" was no longer limited to Paris or to painting. Finally, a movement of ideas launched by a certain number of art historians, especially Bruno Foucart, suggested that the art of the late nineteenth century, including architecture and sculpture, needed to be revisited in its entirety, and that one could not summarily dismiss a painting as second-rate simply because it wasn't Impressionist. As such, we realized that the Jeu de Paume was no longer big enough and that we had to find another space.

Another, public event occurred at around the same time: a decision to demolish the old Orsay train station, which had stopped being used as such since the war. There were plans to use the site for a large hotel. But at that point, the demolition of the Les Halles markets came indirectly into play. There had been widespread protests, including André Chastel's in *Le Monde* and editorials in other newspapers, and the entire jury of the future Pompidou Center went to see Minister of Culture Jacques Duhamel to plead its cause—unfortunately too late. Duhamel visibly regretted it, but the decision was now irrevocable. Still, sad as it was, that demolition nonetheless saved the Gare d'Orsay: it now became impossible to destroy a second Parisian landmark, one no doubt less interesting than Les Halles, but an early example of structural steel architecture that was deemed historically worthy.

So much so that, one day in 1972, as Pierre Rosenberg and I were walking on the Pont du Carrousel and saw the Orsay across the way, we had an epiphany: that was where we should

keep the Impressionists and the other artists who would join them. I went to see Jean Chatelain. As head of the Paintings Department, this was within my purview: the future of the collections was involved. I was not acting on a sudden whim, but out of professional necessity to prepare for the future. And Chatelain accepted our idea, i.e., to convince the government to use the old Orsay station—which Duhamel had already decided to preserve—to house the permanent collections from the late nineteenth century, which would include the Jeu de Paume holdings and works transferred from the modern art museum. He even agreed that we should launch a campaign to raise public support for the project. We submitted the plan to some of our colleagues, as well as to academics and journalists, to help promote the idea. Several strongly supportive articles were published that summer, notably one by Jacques Thuillier in *Le Figaro*. Finally, during one of Duhamel's visits to the Louvre that same summer to follow the reorganization of the Paintings Department, I spoke to him about Orsay. Given the support in the press, he was favorable to the initiative, but he had also expressed his interest in using the building as a center to promote products from the French provinces. Fairly pleased with myself, I said half-jokingly, "Minister, you have to choose between Cézanne and reblochon cheese." He chose Cézanne.

The Musées de France commissioned a feasibility study in 1974, sending planners to analyze how the huge structure could be turned into a museum. We also had the support of the president, Valéry Giscard d'Estaing, who adopted it as "his" pet project. Encouraged by the new head of the Musées de France, Emmanuel de Margerie, he revived the operation in 1976. The final decision to proceed came in October 1977, I believe.

The following spring, a public commission was created to direct operations until the museum was ready to open.

The first phase was led mainly by Jean-Philippe Lachenaud, who had been head of the national architecture board. The director of this new commission, Jean Jenger, was also an old hand at architectural matters. We then needed to appoint someone to oversee the scholarly aspects. This required serious thought, as establishing an intellectual program for the new museum was no easy task. Pierre Rosenberg was offered the job, but he declined. We then considered Bruno Foucart, a university professor. He had held an important post in Michel Guy's cabinet; as technical adviser, he had pushed for the designation of certain nineteenth- and twentieth-century buildings as national landmarks and was preparing a large exhibition on Viollet-le-Duc for the Grand Palais. He didn't say no, but then new circumstances intervened. Michel d'Ornano, who in 1977 had been an attentive minister of culture, was sympathetic to de Margerie's request for significant funding for the museums, through a government program that would help finance the future Musée d'Orsay. He also wanted the status of curators upgraded. At the time, curators in both national and provincial museums were making less than their university counterparts. A small administrative reform would have allowed for a substantial raise in their pay scale. To obtain this from the Ministry of Finance, the Ministry of Culture had to demonstrate that the curator's job was unique. Given this, d'Ornano's response to me, when I talked to him about the museum commission, was roughly, "I know you all think Mr. Foucart has the right qualifications for the job, but he's a university professor, and I can't very well ask for an upgrade in your salaries if we can't find a curator who can handle the project." Foucart took the news well, remaining on the administrative board and continuing to give us helpful advice, but we could no longer offer him the position.

At that point, someone mentioned my name. Naturally, I hesitated. I wasn't a specialist in the nineteenth century, but

on the other hand, I came with a dowry: the paintings des-
tined for the new museum were under my department. They
no doubt figured that, this way, the decision of which paintings
to send to Orsay could be managed more smoothly — within
the family, as it were. I finally accepted, but on several condi-
tions. First and foremost, I wanted to keep my job in the
Paintings Department of the Louvre. Second, I did not wish
to be named director of the new museum when it opened.
Finally, I expected complete trust from the director of the
Musées de France, Hubert Landais, who had succeeded de
Margerie at the end of 1977. If I accepted the position, I would
need the authority to make final decisions for all the impor-
tant matters relating to my sphere of responsibility. He agreed,
and his trust never wavered. Naturally, I kept him apprised of
all major matters, but I was in charge of my domain.

Charles Sterling, who felt that too many commitments
kept me away from research as it was, advised me against tak-
ing the job; he kept saying that the only thing that counted
and lasted was scholarly writing and published research. He
was both right and wrong. For myself, if I embarked on this
adventure, it was because I evidently preferred a more active
calling to pure research or writing.

I had already exercised similar responsibilities for the reor-
ganization of the Paintings Department, not to mention for
the Petit Palais in Avignon, which had just opened. So I didn't
consider this new function a radical job change. Moreover,
the project was entirely controlled by the public commission,
which had its own president and director. They were the ones
in charge of transforming the train station into a museum,
handling administrative and security issues, and so on.

One of my jobs, on the other hand, was to assemble a team
of curators for the new museum, which already included
Anne Distel and Sylvie Patin from the Jeu de Paume. Hélène
Adhémar also gave her full collaboration, knowing that she

wouldn't be put in charge of it: I imagine she wished she were ten years younger. Françoise Cachin, known for her exhibitions of contemporary art at the Orangerie, came over from the MNAM; her book on Gauguin had already established her reputation as an important scholar of late nineteenth-century art. Geneviève Lacambre, who was very familiar with the Musée du Luxembourg, one of the core collections of the future museum, and with Symbolist art, came from the Paintings Department.

Having been given a free hand, I was able to hire younger curators. I asked Henri Loyrette, a former intern in our department who was interested in Italian painting, to join the team as the architecture curator; he had worked with Bruno Foucart on the Viollet-le-Duc exhibition and was interested. I also asked another paintings specialist, Françoise Heilbrun, to handle photography. It was a once-in-a-lifetime chance, this freedom to assemble a team with a specialist for every medium. Anne Pingeot, who had worked with me on the exhibition of the Fontainebleau School, was put in charge of sculpture, one of the museum's strong points, and Claire Frèches, who was cataloguing the works in the Palais de Tokyo that were not going to the Pompidou Center, joined the paintings group. Marc Bascou handled decorative arts of the Second Empire and certain European countries, and Philippe Thiébaut handled Art Nouveau. Finally, there were Caroline Mathieu in architecture, Jean-Michel Nectoux for musical programs, Chantal Georgel for projects relating to history and sociocultural events, and a solid group of archivists. Once this team was constituted—a second wave would come after the opening in 1986—we remained strongly bonded for the entire preparation period.

In this preparatory phase, my job consisted mainly in establishing the museographic program, in other words, the con-

tent of the museum. We had decided that it would span all the disciplines—not only painting, sculpture, graphic arts, photography, and decorative arts, but also architecture and the non-visual arts, such as literature, music, and theater, via documentary presentations and exhibitions. The idea of an interdisciplinary program, which could not exist at the Louvre—how could it, with all the civilizations and schools represented there?—proved to be a rather original concept for French museums. By concentrating on a relatively short period, three or four generations, we could suggest the inter-action of the arts at a time when the creators themselves were actively seeking out such interactions. All of it could be done with an eye toward shedding light on artistic creation by spotlighting it from various angles.

The first task was to determine our chronological parame-ters—and here, from the start, we ran into a serious misun-derstanding. The original directive from 1978 had nonetheless been unambiguous: the museum was to be devoted to "artis-tic production in the second half of the nineteenth century and the early years of the twentieth." Despite this, for a while the title "Orsay Museum" ran neck-and-neck with the clearly inappropriate one of "Museum of the Nineteenth Century."

The problem of dates occupied much of our thought. The end point, at least for painting, was where the modern art museum picked up, in other words before Fauvism and the *Demoiselles d'Avignon*, around 1905–7, with prolongations to World War I for certain other media. But the choice of a starting point wasn't so simple. We had at first thought of a relatively late date, around 1863, the time of the Salon des Refusés and Manet's *Déjeuner sur l'herbe*. This slightly symbolic choice stressed the break between official art and the avant garde, the birth of Impressionism. But fairly quickly, we real-ized that we'd have to push back that date.

President Giscard d'Estaing, who was keenly interested in

the project, closely followed the architectural competition. Naturally, he wasn't about to become involved in the details of the program—that was our job. But he quite strongly expressed his disagreement with our first thoughts about the starting dates for the collection. After the various architectural models were presented at Elysée Palace (this must have been in May 1979), he took me to task roundly for giving television interviews about the future museum and suggesting that we would start with the Second Empire. Troubled by his remarks, I asked if he would prefer us to start in 1850. "Hardly," he replied, "since it's the museum of the nineteenth century!" Several weeks later, heading back with him and Lachenaud after one of his visits to the site, he abruptly asked me, "So where are you planning to hang Delacroix's *Liberty Leading the People?*" I answered that since the work dated from 1830, it would remain at the Louvre. "But it's a symbol of the nineteenth century. People won't understand why you don't have Delacroix's *Liberty* in a museum of the nineteenth century!" In a way, he was right: a museum devoted to the nineteenth century should include Romanticism. His demand was more than embarrassing; it set us against a major impossibility: huge as the station was, it wasn't large enough for us to present the grand paintings of the early nineteenth century. And exhibiting *Liberty Leading the People* alone made no sense. The painting called for the artist's other great canvases, as well as the entire monumental sequence by Gros, Géricault, and David, which was so coherent that it seemed impossible to cut it up. This was not some instance of "stubborn functionaries who only follow their own whims and present the true authorities with a fait accompli," as someone very graciously said to me at the time. Finally, the minister of culture, Jean-Philippe Lecat, helped us out of the jam. I showed him the Daru and Mollien galleries at the Louvre, and he saw for himself that *Liberty* belonged with the other large canvases by

Delacroix. He pled our cause to the president, and we were able to pursue our original plan.

Still, the episode led us to include Romanticism more than previously envisioned and consequently to modify our starting date of 1863. Moreover, while that date was appropriate for painting, it didn't have nearly as much relevance for the other arts, especially architecture. It became evident that the real break occurred in mid-century, not only because of the European political upheavals of 1848, but also because of the emergence of Courbet and Realism, as well as of the Pre-Raphaelites, in those same years. In the field of architecture, our choice referred back to the Crystal Palace, built in London in 1851 for the Universal Exhibition. With 1848–50, we finally had the right parameters. Giscard d'Estaing's will to integrate Romanticism ultimately proved beneficial by forcing us to revisit the question. Gae Aulenti, who was used to Italian-style bureaucracy, was amazed by the outcome of the crisis and found it admirable that an all-powerful President of the Republic, with a direct involvement in the project, should bow to the opinions of his specialists.

We decided, then, to include Romanticism, but without going all the way back to 1820. Instead, we showed later, though still very influential works, by painters from earlier in the century who were still active in the 1850s. For this reason, we deemed it important to include two or three paintings from Ingres's last period and even acquired a work from the end of his life (*Venus at Paphos*), as well as a late landscape by Paul Huet, *The Pit*, in which the final "storms" of Romanticism were still brewing. For Delacroix, without dismantling the Louvre's rich collection, we chose a few paintings from late in his life and bought the admirable sketch for *The Lion Hunt*, a dazzling canvas and a good example of the artist's pictorial "modernity."

When the new president, François Mitterrand, opened the

museum in December 1986, he invited his predecessor to the inauguration. In the Delacroix room, Giscard d'Estaing came up to me and said (a bit mischievously, I thought), "So, I thought you didn't want any Delacroix in this museum!" I had already had very pleasant personal relations with him when he was minister of finance, and he had given us crucial financial support for major acquisitions, such as Fragonard's *The Bolt* and La Tour's *The Cheat*. He understood the patrimonial importance of these large purchases, which were well beyond the budget of the national museums.

Alongside the basic concept of the new museum, we also put great thought into its workings. It was with this in mind that Lachenaud and I took a study trip to the United States in 1979 to see the most recent American museums. The new wing of the National Gallery in Washington had just opened. I had friendly relations with Carter Brown, its director—I had known him when he was a student in Paris—who had presided over the wing's construction. Brown was one of the great museum directors of our time, who transformed the vast and rather cold mausoleum that opened in 1941 into a magnificent architectural and urban ensemble, and a static gallery into a lively place of exhibitions and art historical research. During our visit, I experienced real emotion before the pointed and monumental structure erected by I. M. Pei, which fit so harmoniously into the classical urban landscape of the capital. So much so that, a few years later, when Emile Biasini asked me what I thought of Pei for the Louvre, I was already won over.

During that visit across the U.S., we looked at both the architectural aspect and the workings of the various museums: reception, cloakroom, restaurant, bookstore, educational programs, auditorium, and so on—in other words, everything that was lacking in French museums (apart from the Pompidou Center), but that the American ones had

perfected. We also went to New Orleans; Dallas, to see the new museum designed by Edward Larrabee Barnes; and Fort Worth, with its subtle building by Louis I. Kahn. I was already familiar with Kahn's first accomplishment, the Yale University Art Gallery in New Haven, which dated from the 1950s. The second museum he designed for Yale, the Mellon Center, devoted to English painting, is a masterpiece of architectural restraint, and his control of natural light is unique.

All these examples, along with the reflections and efforts of the public commission, helped define the needs of the new museum, with all the public services that were missing from the Louvre, but that we wanted to include at Orsay.

We knew that creating this new museum would be difficult, not only because of the colossal amount of work needed to transform a train station into a museum, but also because we had to assemble collections for it. Which means that we had to find sufficient funds to acquire the many works needed to illustrate so rich and diverse a period of creation. It wasn't just a matter of taking in works from the Jeu de Paume, MNAM, the Louvre, and elsewhere: some sections had to be created from zero, notably photography, objets d'art, and architecture. Fortunately, the decision was made to devote part of the public commission's budget to the purchase of art. Not enough to buy everything we dreamed of, such as the small version of Seurat's *Les Poseuses* that belonged to Heinz Berggruen (to name only one piece), but enough to do business with.

One of our first tasks was to reconstitute the core collections, notably by taking back works that had been put on deposit in other museums, then forgotten. The huge wave that had pushed the fine arts administration toward modernism in the thirties, and especially after the war, had carried

away many great canvases and sculptures. These works had once reigned glorious, then been consigned to oblivion. We didn't know, for example, where we might find Cormon's *Cain*, one of the most famous paintings of its day: it had quite simply disappeared. Geneviève Lacambre finally located it at the modern art museum, rolled up and forgotten in a corner.

We initiated large-scale exchanges with certain museums to recuperate several examples of this rejected official art, offering new deposits to our colleagues — who in general recognized the national interest of our effort, as they had for the Campana collection. To give a single example, the Lyon museum received Cézanne's *Bathers* and a Pissarro, artists who had been missing from an otherwise complete Impressionist collection, in exchange for Rodin's *Walking Man*.

As such, we were able to find significant works, such as by Dupré, Carolus-Duran, Stevens, Rosa Bonheur, Hébert, and Antigna (for the realists); many sculptures, notably by Préault, Rude, David d'Angers, Cordier, Carrier-Belleuse, and Barrias; and, of course, once-famous canvases, too quickly dismissed as academic, by Cabanel, Bouguereau, Roll, Delaunay, Lhermitte, or Gervex.

Among these forgotten works was the series *Six Continents*, monumental statues erected on the terrace of the Trocadéro palace for the Universal Exhibition of 1878 and since abandoned in a storehouse near Nantes. We restored them to their original function by placing them on the terrace of the Musée d'Orsay.

For sculpture, the collections of the Louvre and the MNAM, along with some works brought back from deposit and with new loans from the Musée de l'Opéra and the Caisse Nationale des Monuments Historiques, were enriched by important donations from artists' heirs: Meissonier, Frémiet, Guillaume, Bugatti, Joseph Bernard, and Maillol. The Rodin museum generously lent us several important works to stand

with those from the Luxembourg: the original plaster casts of *The Gates of Hell, Balzac, Ugolin,* and the remarkable *Monument to Whistler.*

This wide-ranging search was the most stimulating part of our collective preparatory effort. Since our funds weren't unlimited, we had to prioritize our acquisitions, beginning with the most egregious gaps. To give just a few examples: in sculpture and painting, we had nothing by major figures such as Camille Claudel, Munch, and Klimt, and very little by Hodler. We were able to acquire one of Camille Claudel's most striking groups (*The Age of Maturity*) from the descendants of the person who had commissioned it. We were also looking for a figure by Klimt, but works by that artist are hard to find and the ones we were offered didn't strike us as worthy. We therefore decided to acquire, thanks to Peter Nathan, a Klimt landscape (*Rose Bushes under the Trees*), a masterpiece of the genre, rather than a second-rate example of his Symbolist work. It was a matter of principle: better to own a masterpiece in a less popular vein by a great artist than a mediocre repetition of his better known manner. The same thing happened with Hodler. For lack of an available large figure or Symbolist composition, Ernest Beyeler in Basel put together a whole bouquet of landscapes for us; Françoise Cachin and I chose one (*The Point of Andey*) from among the seven or eight available. And again, for Munch, we chose to buy an exceptional landscape (*Summer Night at Aasgaardstrand*) rather than a later repetition of one of his more famous subjects. I had nonetheless dreamed of buying from a Norwegian collector one of the very beautiful versions of Munch's *Melancholy,* which at the time was worth several tens of millions of francs. I had tried to put together a deal that, I admit, was somewhat twisted, in which the work would be bought for us by a French oil conglomerate drilling in Norwegian waters, and the Norwegian government would allow the purchase and

exempt the French company from the corresponding fees owed to Norway. It wasn't a bad plan, but it didn't work. Pity. Still in the Scandinavian context, we bought in Stockholm a *Wave* by Strindberg, who at the time was still largely unknown as a painter. In Copenhagen, on the other hand, we missed buying an admirable urban scene by Hammershøi, which fortunately was compensated for later by the purchase of one of his interiors.

At the same time, of course, we continued to research the classics. I don't have room here to mention all of the many acquisitions made through purchase or donation, from Courbet's *Trout* to Renoir's *Dances*, Monet's *Déjeuner sur l'herbe* to Gauguin's sculpture *Be Mysterious*, from a group a Nabi canvases by Bonnard (including *The Croquet Game*, given by Daniel Wildenstein) to a considerable number of works by Odilon Redon, which came from his son and were brought into the museum by Roseline Bacou.

As the Luxembourg had very little by way of decorative arts, we had to make a concerted effort in this regard. Hélène Adhémar had already managed to acquire Charpentier's dining room, a typical ensemble of Parisian Art Nouveau decor. During conversations with the heads of the Musée des Arts Décoratifs, we raised the problem posed by the extensive collection of French Art Nouveau at a time when Arts Décoratifs was already being reorganized. For a time, we even considered the possibility of transferring the entire Art Nouveau collection to Orsay, but this plan was soon abandoned, as was the possibility of taking in the Gallé glass from the Musée des Arts et Métiers. To tell the truth, I'm not sorry they decided against what would have been the dismantling of several historical collections. Still, the Musée des Arts Décoratifs helped us out by lending us a complete set of Dampt woodwork, the "Knight's Chamber" from the Comtesse de Béarn, and a monumental carved door by Fourdinois.

To a greater or lesser degree, we had to exhibit the great European centers of Art Nouveau that weren't represented in the national collections. This was not out of an acquisitive spirit, but because Art Nouveau, a truly international movement, demonstrated the vivacity and fruitfulness of exchanges throughout Europe in 1900.

During our repeated trips to Brussels, Vienna, and London, we managed to buy groupings of pieces in various media, such as several English works centered on William Morris and the Arts and Crafts movement, which foreshadowed Art Nouveau and examples by the inventors of Secession in Vienna and of the Wiener Werkstätte, such as the large cartoon of a stained-glass window by Koloman Moser and furniture by Wagner, Hoffmann, Moser, and Loos. For Mackintosh, research was more delicate because his work, though well represented in many public places in Glasgow, is not very abundant. I had even gone with some dealer friends to visit small villas outside of Glasgow that still contain decorative elements by Mackintosh, but this wasn't enough. We were finally offered a beautiful bedroom, given by Michel David-Weill, thanks to whom we were also able to buy the series of the thirty-six Parliamentarians, colored unfired clay sculptures by Daumier.

We also acquired pieces by the Americans Sullivan and Wright. On the other hand, we were not able to acquire any of the very rare works by Gaudí. It was only with the Catalan exhibition *Paris-Barcelona* in 2002 that Gaudí finally entered the Orsay collection.

We also felt that our collection needed works by Horta and Van de Velde, the two great figures of Belgian Art Nouveau, to go with Serrurier-Bovy. We were fortunate enough to buy a large set of woodwork and furniture by Horta from the Aubecq hotel, which had been demolished. Like Guimard, Horta had been virtually martyred by changes in taste: the

destruction of the Maison du Peuple in Brussels and the Aubecq sadly illustrate this.

Along with the Parisian Guimard, we also made various acquisitions by the masters of the Nancy School, Majorelle and Gallé, in the different media that had made them famous. But we also had to move farther back in time toward the preceding period, the Second Empire. Several spectacular pieces gradually composed an ensemble characteristic of the period's eclectic opulence, built around the extremely Merovingian medallion by Frémiet and the Duchess of Parma's toiletry chest by Froment-Meurice.

In the domain of photography, our two specialists, Françoise Heilbrun and Philippe Néagu, had their work cut out for them. This was still the time of pioneering collectors such as André Jammes, Roger Théron, François Braive, Yvan Christ, and the Texbraun gallery, who had been smart enough to buy Charles Nègre, Nadar, Le Gary, or Le Secq early on. We managed to take in significant bodies of work on loan from the Mobilier National and the Egyptian Department of the Louvre, whose photographs had long been considered purely documentary. Naturally, we also had to look to the English, the Viennese, and the Americans, from Julia Margaret Cameron to Stieglitz. Starting with nothing, the collection, regularly enriched since the museum's opening, has finally become one of the most complete in Europe. Photograph prices were already high at the time, but not like today: the French have caught up.

My interest was not merely a matter of patrimonial duty. I truly began to love some forms of art that had been less familiar to me, particularly Art Nouveau and *viennoiseries*, which I found imaginative and stimulating.

The competence and enthusiasm of the curators had given rise to a network of favorable dealers and collectors, who were glad to help us and were often quite satisfied to see their

pioneering efforts finally being honored, where once they had been neglected or despised. For example, Alain Blondel and Yves Plantin, the rescuers of Guimard, helped us by selling or giving us many pieces to affirm the artist's presence at the Orsay, and their objects were supplemented by the generosity of Dominique de Ménil. Several years earlier, to save them from destruction, she had bought Guimard's cast models, which formed a striking formal group. She agreed to have them shipped from Houston so that she could give them to us.

Several artists' heirs also showed their generosity, including Ginette Signac for Cross and Signac, the sons of Maurice Denis, and Mlle Boutaric for Sérusier. And there were the heirs of collectors and models, such as Professor Lvov and his brother, who wanted to give us the portrait of their mother by Serov, a masterpiece of Russian "Impressionism."

On top of which, the newly founded Société des Amis du Musée d'Orsay, first led by Emmanuel de Margerie, soon proved its effectiveness through purchases, participation, or discreet interventions in certain negotiations. We know how helpful lobbies can be in creating support networks and inspiring acts of patronage.

I've always liked presenting works to the curators' committee, my colleagues, and the museum board. My father was a lawyer, and I must have inherited his need to convince. With the excellent French system of a common fund for all the national museums, each person argues in favor of his museum or department, and the final determination is arrived at via secret ballot. You can't count on votes simply out of friendship, despite what some people think. Rather, you have to demonstrate that the proposed work is the rarest and most beautiful of its kind, if it's expensive; and if it isn't, that this is a bargain not to be missed, that it is indispensable because it fills a huge gap, or else that it will notably buttress one of the museum's existing strengths. There is a certain

amount of gamesmanship involved in this rhetoric, but you have to know how to use it. If the verdict is favorable, you have to go before the national museum board. First presided over by Pierre David-Weill, then by René Huyghe, and today by Michel David-Weill, this board is composed of persons external to the museum, such as collectors, representatives of large state organizations, arts patrons, and donors. Here again, the goal is to convince, since this second vote is final.

During those years, I promoted canvases for the Paintings Department and works of all kinds for Orsay. Being less familiar with the latter, I had to study the file in depth so as to argue my case effectively; moreover, some of these forms of art were not yet recognized as important in the late 1970s. For example, when I showed some chairs by Thonet, many board members considered them merely vulgar bistro seats. They hadn't yet become a part of major art history, any more than photography had.

Here's one example of this lag in taste, which for once worked in our favor: Robert Gérard, a learned and favorably disposed board member, had inherited a superb collection of late-nineteenth-century paintings, including some famous works by Degas. One day — this was well before the decision to create the Musée d'Orsay — seeing me argue for a new "reading" of the nineteenth century, he said to me after the meeting, "I see that you're interested in this kind of painting. At home, I have a canvas that was in my family, which I don't display: *Young Girls at the Seaside* by Puvis de Chavannes." Thinking the painting academic — even though it had come from Durand-Ruel, like his Impressionists — he gave us what is now considered one of the artist's masterpieces. "You got me," he said to me a few years later, with a smile. He had realized his mistake, but in the end was pleased about the gift.

For objets d'art, I had two contradictory prejudices to overcome: one denigrated the eclecticism of the Second

Empire, which many judged ostentatiously opulent (I myself sometimes had to force it a bit!), while the other disdained the simplicity of form and sometimes the execution of certain Viennese or Scottish objects. I had to convince the board that the little metal boxes with holes designed by Moser or Hoffmann for the Wiener Werkstätte were masterpieces worthy of Benvenuto Cellini.

I nonetheless met defeat with a painting by Henry van de Velde, a multifarious genius in architecture, design, and painting. We had found a canvas by him, vermiculated, original, and significant, but to my chagrin I was clobbered by the board. The debates were always quite cordial, of course, but the vote was final and without recourse. Painful.

As I mentioned earlier, the Musée d'Orsay also offers concerts, film projections, and so on. For architecture, which we wanted to show as a permanent feature, and not only through exhibitions or drawings and documents (such as the extraordinary Eiffel papers given by his heirs), I called upon Richard Peduzzi. We admired his theater sets, which revealed his understanding of architecture. In consultation with the curators, Peduzzi designed a section built around models and decorative or structural elements taken from the rows of metal girders in the station's western pavilion — which itself constitutes a striking example of industrial architecture. Among the high points of his display are the model of the Paris Opera and the aerial view of the neighborhood surrounding it.

For the other non-visual arts, relating to literature, journalism, shows, cultural life, and society, several long-term projects were put together by Chantal Georgel, Madeleine Rebérioux, Roland Schaer, head of the cultural service, and Nicole Savy. For music, Jean-Michel Nectoux programmed concerts that evoked the period covered by Orsay. The auditorium did not allow for performances of the Tetralogy or Mahler's *Symphony of a Thousand*, but rather chamber music,

lieder, and songs. Exhibitions evoked the relations between musicians and painters or sculptors, as well as the importance of spectacle. In a way, we had to create a complementary and dynamic relationship between the permanent collections and the succession of various events in the auditorium — conferences, lecture cycles, concerts, films (including those produced by the museum) — or in the exhibition halls. The Orsay "concept" rested on that complementariness. Of course, we knew that most visitors would come mainly to walk through the museum. But we were hoping to interest the repeat visitors, and finally, through our displays, events, and publications, to recreate the richness and extraordinary diversity of those decades.

Speaking of exhibitions, the team practiced its scales, so to speak, by organizing before the museum's opening important exhibitions devoted to Charles Nègre, Mucha, Cappiello, and Spilliaert, which in each case resulted in purchases or gifts; a first selection of new acquisitions was shown at the Palais de Tokyo in the context of the short-lived "experimental museum." A brilliant pre-exhibition was also organized in early 1986 by Guy Cogeval for the Brooklyn and Dallas museums, which whetted the appetites of our American colleagues.

One remarkable aspect of the preparations for the Musée d'Orsay is that there was no conflict between the architects and the curators. On the contrary, we had to work together to envision in space, room by room, what we wanted to show, the relation between container and contents, as it were. We had to organize a tour that would espouse both the constraints of the existing structure and what the new spaces built by the architects would bring to it. The architects, for their part, had to keep in mind the nature and character of the works on display in each room. This involved an enormous amount of thought and revision on everyone's part, the

use of large scale models, numerous revisions, complete changes of mind, abandoned hypotheses, and, of course, copious discussion.

In this regard, President Mitterrand's decision in September 1981 to create the Grand Louvre had welcome consequences. For one thing, it freed up office space along the sides facing Rue de Lille and Rue de Bellechasse, which had been reserved for some administrative departments of the Musées de France. This gave us more exhibition space — for the post-Impressionists and Nabis, who at first were squeezed into the rooms with domes — and room to ensure better vertical circulation.

We sketched out a kind of storyboard with sequences, each one corresponding to a gallery or group of galleries that would illustrate a chapter of the demonstration. By mutual agreement, to avoid a stylistic jumble, we wanted, first, to give a clear chronological presentation and, second, to differentiate between the various artistic tendencies, notably distinguishing the "avant garde" from the more traditional currents. Except for certain artists who were both painters and sculptors, such as Daumier, Renoir, or Degas, we intended to present paintings, sculptures, furniture, and art objects in their own spaces, as these objects required different kinds of space and lighting.

The relations between the different arts and media would be made clear to the attentive visitor by the passage from room to room, following the prescribed itinerary, in other words, through a global view of the entire museum. In realizing this program, which was based on the contrasts from one sequence to the next, we were helped by the complexity and extreme diversity of the building's spaces. The itinerary was meant to entail sudden changes from room to room, which served and followed our intentions.

I need to step back for a moment to say a word about the

architectural competition, which the public commission launched in 1978. Of the six finalist designs, two stood out: the one by Yves Boiret, head architect for Monuments Historiques, and the one by the ACT group. The first one had many good features and was long kept under consideration. But it had the drawback, out of respect for the internal spaces of the domed halls, of pushing much of the construction necessary for the galleries toward the Rue de Lille side and overall of offering insufficient exhibition space. The ACT group, which was made up of three architects, Renaud Bardon, Pierre Colboc, and Jean-Paul Philippon, proposed to create a wide central aisle in the nave with terraces and side rooms on two levels. The architectural effect was strong, and the collections had room to spread out. This was the design I preferred, and it was the one chosen by the president.

After further discussion and examination, it became clear that we should bring in an interior architect to work with ACT on the museum layout. It was ACT itself that suggested Gae Aulenti for the job. It's true that, later on, things didn't always go so smoothly between them. Aulenti and her team, which included Italo Rota, took charge of the interior arrangement of spaces and suggested some major modifications — the idea for the towers at the back of the courtyard is hers. Her partners reworked the design extensively with her in order to present a mutually-acceptable plan.

We ourselves were able to work easily with Aulenti for several reasons. First of all, we admired how well she was able to draw formal, stylistic, and material distinctions between the new elements required by the museum and the old station architecture. In the same way, she used the existing utilitarian structures to establish the walls and ceilings of the Galerie des Hauteurs, the Galerie de Bellechasse, and the western pavilion. Everywhere there is an intelligence about the place that makes it so the new architecture, strong as it may be

(some even found it too strong), does not clash with Victor Laloux's original structure.

It's true that her relations with the architects were often tense. They certainly suffered, especially Renaud Bardon, the one who was most often on-site, from the opinionated way she maintained her positions, which we, on the other hand, found rather seductive. They respected each other, but their arguments sometimes turned into personality conflicts that Jacques Rigaud or Jean Jenger would then have to arbitrate.

Some have wondered how I, an admirer of Bauhaus and Mies van der Rohe, reacted to the theatrical, monumental, supposedly "postmodern" architecture of Orsay. The fact is, I don't consider it postmodern at all. Robert Venturi's new wing at the National Gallery of London or certain buildings by Philip Johnson are postmodern, but not Orsay. To my mind, postmodernism is characterized by a spirit of pastiche, a kind of semi-digested revivalism, or at least by its stylistic borrowings from the great Classical (or, in Bofill's case, Baroque) examples. None of this is found at Orsay.

Certain critics have also evoked the neo-Babylonian, Mussolinian aspect of the nave, as if it were shameful to create monumental spaces — especially in that huge empty area, obviously imposed by the need to provide ventilation for the railway traffic. In such a space, it is impossible for the structure to remain hidden. The fact that Aulenti, espousing the general view of the architects, should have come up with a bold, monumental interior design, which exists in clear distinction from Laloux's interior, seemed perfectly justified to us. Moreover, this interior architecture suits the monumental sculpture it contains.

Afterward, when we worked with her on the details of museum furnishings, such as stands, display cases, hanging systems, lighting, wall coverings, and so on, we truly formed a team, with all the passion that you can put into a com-

mon project. We were swayed by her knowledge, her atten-
tion to details, which she carefully sketched out for the
manufacturers.

Naturally, certain elements were less successful than oth-
ers, such as the artificial lighting in the painting galleries of
the first floor. The temporary exhibition rooms were not
entirely satisfactory and are now being reworked. And, of
course, there are some rooms that I like less than others. But
overall I find the effect strong and stimulating. For example, I
think the view from the nave is superb: I love that immense
space punctuated with sculptures and animated by the visi-
tors walking on several levels. Certainly, the structure is mon-
umental, but it invites you to discover all the hidden spaces.

The elections of May 1981 brought a new government into
power, with François Mitterrand as president and Jack Lang
as minister of culture. It has been widely said that Lang was
hostile to the Orsay project, but this is utterly untrue: in real-
ity, he supported it and followed its progress regularly. In any
case, what happened now was up to the president. The polit-
ical changes of 1981 naturally had consequences, and the
month of June was a period of anxiety, since we didn't know
what would happen.

President Mitterrand summoned me to Elysée Palace,
alone. I was very impressed by him. I had the chance to see
him several times after that, at Orsay or the Louvre, but
remained just as intimidated. "Explain to me why we need a
museum of the nineteenth century," he asked me without
preamble. I first answered that we should do away with that
misleading title, the source of many misunderstandings. He
then asked me what we wanted to call it. "Why not the Musée
d'Orsay, as it's already being known?" He smiled slightly, then
added, "Musée d'Orsay doesn't mean anything." I answered,
"Louvre, Prado, and Uffizi don't mean anything either." My

answer amused him, and he immediately ratified the change
of name, and thus of program, freeing us in one stroke from
the burden of trying to represent the entire century.

He revived the project and pursued what his predecessor
had begun. Jean-Philippe Lachenaud left the public commis-
sion, which I regretted. I have to stress that he had played a
determinant role in launching the project and getting it mov-
ing. Fortunately, Jean Jenger stayed on as director, thereby
assuring the continuity of the worksite. Jacques Rigaud was
appointed to replace Lachenaud as president, which delighted
us. I had known him when he was cabinet director for Jacques
Duhamel, the best minister of culture between Malraux
and Lang. When Duhamel became ill, he relied heavily on
Rigaud's enormous culture. Rigaud immediately took the sit-
uation in hand. President Mitterrand gave us his trust. The
project was safe.

Another important stage was marked by the arrival of
Madeleine Rebérioux. A well-known historian with a strong
personality and ties to the left, she had been a Communist
before being excluded from the party. Her area of expertise
was Jean Jaurès and the workers' movement, and she was
interested in more general cultural issues, such as the univer-
sal exhibitions. She did and still does enjoy a great prestige
among her students. She had even been offered the presi-
dency of the public commission, which she wisely refused;
instead, she accepted the job of vice-president under Rigaud,
to help determine the overall intellectual thrust of the
museum. Naturally, my own role was directly affected, and for
a moment I thought seriously about stepping down.

The beginning of this period was difficult. While
Rebérioux had an admirable historical knowledge of the
nineteenth century, she was unfamiliar with the arcana of
museum life. So it is not surprising that a marked conflict
surfaced between her and our group, given the strongly socio-

cultural inflection she meant to give the project. But I was still in charge of the collections and the program, and so I stayed. Our relative positions were respected.

As all the previous reports and studies had shown, our intent was not to create a "fine arts museum," but to construct an interdisciplinary program. Rebérioux wanted to place more visual emphasis on this interdisciplinary aspect. She repeated this recently, in a fascinating series of interviews on the History channel. When asked whether she would have liked to install a locomotive in the museum, her answer was an unequivocal yes. She believed that the image of a locomotive as emblem of industrial civilization would make a strong impression in a former train station. To us, this seemed a bit naïve.

Nevertheless, we seriously studied ways of "showing" history and societal events. Personally, I had no objection to using this type of demonstration in temporary exhibitions. I had been struck by two particularly successful shows. One, at the Montreal World's Fair in 1967, was the American Pavilion, conceived in the spirit of Pop Art, which at first had angered Washington officials. Using several symbolic objects or images, up to and including the conquest of the moon, it offered a vision of the American miracle—synthetic, playful, and finally convincing. The other exhibition, held in Berlin, more seriously explored the birth and long history of the city. It was inventive (they had set up an authentic wheat field to recall the rural origins of the place), well informed, and evocative. I also greatly admired the richness and ingenuity of the exhibits on American history at the Smithsonian Institution.

Accompanied by Paul Guimard, who was then advisor to President Mitterrand, the Orsay team (Rigaud, Rebérioux, Nora, Jenger, Aulenti, Cachin, and myself) went to Munich in 1982 to visit what was considered the model museum of history and technology. We admired it, but understood (I

did, at least) that this type of presentation was incompatible with the permanent display of artworks.

Rebérioux never intended, as has mistakenly been said, to use the museum to promote workers' rights or class struggle. She meant to suggest through images the relations between various forms of creation. If someone had suggested she set an open copy of Maupassant's nautical memoir *Afloat* next to one of Monet's lily ponds to express the relations between the different forms of Impressionism, she probably wouldn't have rejected the idea. Although, frankly, I can't really say: maybe she would have thought, as we did, that this kind of juxtaposition was more suited to illustrated books and temporary exhibitions.

On the other hand, she had a positive influence in other areas. For example, she helped show the importance of the illustrated press and posters in the nineteenth century, to which we hadn't given enough attention. Her concern with displaying history notably led to a liminary presentation of well-chosen symbols from the Second Empire and the Third Republic. She also devised a coherent set of cultural programs and made great efforts to increase public attendance. No doubt she would have liked to involve academics in planning these programs, but we felt that this mission belonged squarely to us, though naturally we had no objection to calling on outside specialists for an exhibition, colloquium, or lecture, as we often did later on.

Needless to say, our regular Tuesday meetings were a bit strained. Every week, Rigaud, Rebérioux, Léone Nora, who handled public relations, Jenger, and I, plus some of the curators or technical crew, would get together. These sessions could get fairly heated, and not always because of Rebérioux. I can't tell you how many times Rigaud was unable to contain his exasperation at some new demand from the curators I represented: some new display case or stand that hadn't been

budgeted for, a solid wall to be knocked down ... Were these the whims of spoiled children or absolute necessities? Hard to say. In any case, it was necessity that finally carried the day, thanks to a true complicity between Rigaud, Jenger, and me.

At first, relations between Rebérioux and my team were not the smoothest. During one of the first meetings she attended, with all the curators present, Rebérioux—who knew she was in hostile territory, but was courageous and accustomed to debate—ventured the term "cultural product." A voice rose in the ensuing silence: "Madame, here we speak of works of art." Obviously, it wasn't always pleasant for her. Nonetheless, she evolved in her thinking and stopped trying to impose her viewpoint systematically, and for that I respect her. We run into each other now and again at the home of mutual friends. She is still a passionate and fascinating woman, and just as militant as ever.

What we feared in such an attitude was the reduction of the artworks to the status of documents. But I should say that this is a widespread tendency among nineteenth-century specialists, no matter what their politics: they lay greater emphasis on the image than on the work of art proper, or rather they forget that a work of art is more than just an image. Any "image," whether a statue, public monument, painting, or print, can have value as a historical document, no question about it. Still, to take just one example, can we put a canvas by Courbet and an *image d'Epinal* on the same level, even though both might depict the theme of wandering in the nineteenth century? The Wandering Jew figures in both popular art and "high" painting.

We are faced here with the conjunction of two completely different tendencies. The first grants primary importance in historical research to iconography, the theme depicted, in other words, to the study of the image itself, without giving as much weight to considerations of quality or style. This is the

viewpoint of the historian, the sociologist, and the ethnologist, for whom any artistic "product" is worthy of study and can perhaps be used for historical analysis.

The second approach, adopted by many art historians over the past forty years, studies and very rightly gives pride of place to artistic forms or techniques that were once dismissed or neglected, such as realist painting or academic art.

A third approach, which is also perfectly viable, is that of art lovers and second-hand dealers, whose eclectic interests range from sketches, models, and Orientalia to rough drafts and academic paintings. These rediscoveries are often commercially motivated, and there's nothing wrong with that. A sketch by Jean-Paul Laurens that went for nothing in 1950 had become very expensive by 1985. This is just part of the perpetual fluctuations in taste and the price of art.

Appended to this is a certain nostalgia for the nineteenth century, yellowed family photos, memories recaptured from lost objects, sentiments that connect with, and sometimes inspire, some of the most erudite research on rural or industrial artifacts and their preservation.

These disparate motivations, which support a less simplistic view of what was in fact an extraordinarily diverse and multifaceted century, have led to some changes in our scale of values — which is healthy — but also to an overall equalization. Everything becomes interesting in the historian's eyes, or the sociologist's, or the dealer's, or the collector's, and thus everything risks being put on the same level. But art historians and curators cannot afford to dismiss the criterion of quality. Such qualities as style; pictorial, architectural, or decorative invention; and technical innovation (or, failing that, mastery) can never be considered secondary or extraneous. They are, obviously, the essential thing. This is why, when showing "non-Impressionist" tendencies, we have always chosen first-rate works in the given genre by the artists in question.

Many foreign artists who were not influenced by Impressionism, but might have been by Symbolism, should not be dismissed as academic or "kitsch." Take the case of Winslow Homer, who with Thomas Eakins was the most interesting American painter of the late nineteenth century. In his time, France bought one of his paintings, which is still the only major canvas of his in Europe. It's a poetic work with nothing conventional about it. In the same way, Eakins was never an academic painter, even though he studied with Gérôme and Bonnat. If you look closely at his *Portrait of Clara J. Mather*, you'll find that it is beautifully executed and unique in its expression.

In French painting under the Third Republic, good craftsmanship wasn't so much a criterion of value as the norm. Everyone was expected to be able to paint a head of hair, a hand, drapery, or a landscape skillfully. But of course, that in itself wasn't enough. In certain artists, such as Jean-Paul Laurens, we find an undeniable historical intelligence that can be likened to someone like Verdi in the same period. Reflection on historical myths is a current that runs through the entire nineteenth century in many European countries. It was through that great artistic or musical imagery that artists expressed their pride and often a call for independence, born of a strong national sentiment. Cormon's *Cain* or Detaille's *The Dream* are forceful images that strike the imagination. These works impacted on the history of the Third Republic, much like *The Payment of the Harvesters* by Lhermitte. They are also respectable works of painting that we shouldn't be too quick to consider mere blow-ups of post office calendars.

This is also true of sculpture for public monuments, which often manifest the triumph of Republican hagiography. The museum has a large number of such sculptures on display, in the form of reductions, scale models, or drafts, which at the same time act as evidence (fascinating for artists) of the tech-

nical virtuosity of many official artists, such as Frémiet, Chapu, Falguière, Duboi, or Aubé.

After the museum opened, a debate arose over "academic" art. The critic Pierre Schneider wrote, "Courbet, Manet, and Cézanne must once again fight against Gérôme and Bonnat." This was an external debate, not one that had arisen among ourselves during the planning. Our first concern had been to distinguish between the opposing tendencies. Just as we avoided mixing different media, we refused to throw different kinds of art into the same galleries; we made a physical distinction between the various parallel or contemporary movements. There was also a question of generation: Gervex or Rochegrosse painted at the end of the century, in other words, after the period when Degas had been a friend of Bonnat and Tissot, or when the young Carolus-Duran had been close to Manet, on the side of Courbet.

One of the mistakes we made — or rather, that I made — in this vein concerns the beginning of the circuit. As you begin touring the museum, to the left begins the realist current (Daumier, the Barbizon School, Courbet), which is one path that leads to Manet. To the right are the "elders," the heroes of early nineteenth-century painting, such as Ingres and his students, Huet, Delacroix and his followers, and Chassériau. After that, rightly, come Chassériau's direct successors, in other words, Puvis de Chavannes and Gustave Moreau, great innovators who have nothing academic about them, then Degas. But — and here lies the mistake — before this sequence, immediately after Chassériau, we put an eclectic room dominated by Cabanel's terrifying *Birth of Venus*, which was hung there mainly so that it would face Manet's *Olympia* at the other end of the corridor. Looking back, I regret this ambiguity, which suggests that we meant to install a sequence of "reactionary" paintings to the right (which wasn't our intention), and a "modern" sequence to the left, prefiguring

Impressionism. If they ever reorganize the galleries, my sense is that they should remove those several paintings and hang them with other paintings belonging to the academic eclecticism of the Second Empire.

On the other hand, despite the criticism we received, I still believe that *The Romans of the Decadence* is in its rightful place. The monumental ambition of this work places Couture in the tradition of the Venetians, with a tenacity that does not bespeak a mediocre artist. We hung the painting there, like a large decorative piece, in the vast space of the nave. Someone like Courbet would have been lost next to those Salon sculptures.

We were also highly criticized for the Impressionist galleries, but here again I don't agree: those glass-gabled rooms have excellent natural lighting and are well proportioned. We had decided to hang the Impressionists there from the start. We didn't yet have precise ideas before working closely on the program, sequencing, and divisions. But we knew that the only spot with good natural lighting was in what we called the Galerie des Hauteurs, a large empty space above the domes that immediately suggested itself as a gallery. It had been created behind a very tall facade masking the skylight on the side facing the Seine. We were accused of highlighting academic painting and relegating the Impressionists to the attic— which is absurd, as we were doing just the opposite. This wasn't the attic, but the open sky.

It has been said that in art history today, we are seeing a rehabilitation of minor masters and a toppling of official hierarchies. The first question is, what is meant by "minor master"? The term can be confusing. A minor master is a Dutch or Flemish painter who painted like Metsu or Teniers (who were great masters) — not quite so well as Metsu and Teniers, but more or less in the same vein and with excellent technique. You see the same thing in the eighteenth century,

which had a plethora of minor masters who were neither Chardin nor Fragonard, but who were good painters none-theless. Chaplin is not Renoir less well done!

The current tendency of some — few in number, but very vocal — to minimize Impressionism repulses me. I will never agree with them, and nothing at Orsay supports them. Recognition of painterly quality, inventiveness, and original creativity remains a fundamental aspect in both critical judg-ment and the pleasure of viewing a work. It is obvious that Manet, the Impressionists, Gauguin, van Gogh, or Cézanne instigated a complete break from academic theory and prac-tice; this is a pure commonplace. To compare Carolus-Duran with Manet might be valid for the 1860s, but it makes no sense twenty years later, when this kind of juxtaposition becomes nonsense. The Musée d'Orsay never participated in such a reactionary reversal, in this kind of perverse or self-interested revisionism, but on the contrary contributed toward reestablishing scales of value, toward restoring great creators or movements to their rightful place. I'm thinking of certain realists, of Puvis de Chavannes, of Art Nouveau, or of the best sides of Symbolism. And we also helped restore certain "images" to their place in history, and perhaps in art history. No, we can rest assured on this point: Manet and Cézanne no longer have to fight against Bonnat and Gérôme.

Moreover, from the beginning we pursued a policy of introducing the most original, independent, and anti-academic foreign artists to France. Menzel, Pelizza da Volpedo, Hammershøi, Curlionis, Medardo Rosso, and many others have justified the appropriateness of the exhibition and acquisitions policies set by Françoise Cachin and Henri Loyrette.

In 1986 we finally began installing the works in the new museum, which was also the signal for my departure from the

Musée d'Orsay. For all of us, that spring and summer were an extraordinary time: an entire team was working to create something completely new, with passion and enthusiasm, and no doubt with a kind of blissful ignorance, since we were a bit cut off from the world in that immense vessel that was Orsay.

I was helped in all respects by Henri Loyrette. The teams of curators worked from room to room with the installers, Gae Aulenti and her assistants, and the architect Renaud Piérard, who oversaw the worksite and sometimes had to act as conciliator between Aulenti and the other architects. Everything had been carefully planned out, of course. But the installation itself, the exact placement of certain objects, had not been decided down to the last detail, no matter how many preparatory models we had made. There were exhilarating moments of doubt—when we would finally see if it "worked" or not—and fatigue (I recall one Sunday afternoon when, following some remark by Aulenti, the entire sculpture team burst into tears) and even pure pleasure. I have to say that the enormous help we received from Jacques Rigaud, Jean Jenger, and the technical crews is a large part of the reason we can now look back euphorically on those months.

Still, I began to come down from my euphoria a few days before the opening, when some French journalists expressed doubts after the preview. One, for instance, made sarcastic remarks about the display of sculptures, which we had purposely put a bit off-kilter, following an excellent suggestion by Aulenti. This consisted in exhibiting small models even in large spaces, in order to break the sameness of scale and create a contrast and a dynamic relation between monumental and small formats. The journalist's comparison of the large base supporting Carpeaux's *Ugolin* with a *trampolino* did not strike us as very favorable, and it dampened our spirits somewhat ...

Fortunately, the inaugural events in the first week of December kept us going. There were opening ceremonies by

two presidents, Mitterrand and Giscard d'Estaing, then by Prime Minister Jacques Chirac, then by Minister of Culture François Léotard; receptions in honor of many directors, curators, and art historians, both French and foreign; a grand concert in the side aisle and a gala dinner; interviews, dinners among friends, farewell drinks—all in all, a rather giddy week. In the jumble of comments, there were the usual standard congratulations, but also many heartfelt compliments, especially from certain American colleagues, or intelligently nuanced remarks from friends, as well as some profound reservations about the architectural renovations and strong criticism of the space given to academic art (notably by John Rewald and Soulages), and, as always, the reactions of those who have nothing else to say or who are afraid of hurting your feelings, and who ask simply, "So, how are you holding up?"

When I left the museum on December 5, 1986, my work was done. Françoise Cachin was appointed director of the new museum, which proved to be the right choice.

For several months, Aulenti experienced the same emotions as I did. The fact is, I was ruffled by these attacks and marks of incomprehension, despite all the invigorating congratulatory messages, especially from abroad. While I intentionally avoided reading the reviews at the time, I knew what some of them said. What restored my good spirits was reading a very favorable review by a well-known feminist art critic in a serious American periodical, who noted with self-congratulatory flair that Orsay was the work of three women: Gae Aulenti, Françoise Cachin, and Madeleine Rebérioux.

I went back to the museum very seldom after the opening. And then, as of the following year, I began seeing the public's infatuation: more and more people were visiting, and many of them were going back again. It was a fact. After the normal period of curiosity inspired by the opening, and even taking into account the general attraction of Impressionism, the

museum continued to interest a wide range of visitors through the various demonstrations it offered. I finally had the feeling that the museum existed, that we had attained our goal. The public understood our choices, the variety and coherence of the historical and stylistic sequences, the necessary succession of sudden breaks—such as passing from a Degas room to rooms devoted to Garnier's Opera, then to spaces highlighting architecture, then from architecture to Impressionism—which allowed us to express the cultural and artistic effervescence of that period, one of the greatest in history. We finally felt, despite failures on our part and the sometimes justified criticisms, that the museum had acquired its own existence, and responded to what we wanted. Little by little, I felt reassured.

Three or four years after the opening, by which time I was quite removed from these polemics, I found myself in a group of American curator friends. I walked up on two who were arguing: one shouting, "I hate Orsay," and the other responding, "I love Orsay." At that point, I said to myself that the battle was won. The museum inspired pleasure, interest, and intellectual debate—exactly as we had wished.

Moreover, how can we not recognize—and I say this without any personal vanity, as it happened after my departure—that the team, via its exhibitions, colloquia, lectures, concerts, publications, films, pedagogical efforts, acquisitions, and documentation, had managed to create a powerfully lively place, the example of which is offered by few other museums in the world; a place where every aspect of the artistic creation and cultural life of that great era are individually highlighted, set against each other? Forgive me for this rather shameless declaration: it's just my way of publicly congratulating my friends.

Given that I had been working both on the preparations for Orsay and my departmental responsibilities at the Louvre, this had been a very dense period for me, but also an extraor-

dinarily rich one. I had the opportunity to work at Orsay with a competent team of curators who took a number of initiatives upon themselves. The overall direction, led by Jacques Rigaud and Jean Jenger, relieved me of the administrative responsibilities. So I never left the Paintings Department. Several moments of tension within the department, however, showed me that I had to go back there full-time, without delay. All the more so in that, right around then, the Grand Louvre project was getting underway.

6

The Grand
Louvre

I
n many people's minds, the new cultural policies fol-
lowing the May 1981 elections initiated a golden age
for museums. In fact, this golden age had begun a little
earlier. Matters were actively taken in hand by Jack
Lang when he became minister of culture, but the movement
had already been launched toward the end of the 1970s,
partly due to the effect of Beaubourg after its opening in
1976. Following a period of relative stagnation in the late
1960s, the museum world underwent a noticeable resur-
gence, encouraged by major public works projects under the
successive presidents. This revitalizing phenomenon affected
the entire nation. Several major cities understood the politi-
cal stakes of such a resurgence, in the full and noble sense of
the word. Lang and his ministry strongly supported this
movement, notably with regard to contemporary art, and
took steps that allowed regional institutions to acquire works,
organize exhibitions, commission new art for the city, and so
on. The momentum from the postwar period got a second

wind, illustrated in part by the explosion of large exhibitions in Paris.

On the international level, this boom in museums was just as marked in Germany, which in the 1960s recovered considerably from its postwar doldrums with the creation or renovation of major museums in Cologne, Stuttgart, Mönchengladbach, and Düsseldorf, as well as in Frankfurt, where several museums were built near the prestigious Staedel-Institut. Great Britain also built new museums (as in Glasgow), and Spain actively entered the mix in the 1980s.

In America, at the turn of the century, the powerful architecture of museums physically manifested their importance to their respective cities. In the Midwest, from Minneapolis to Cleveland, the museum is always the most prominent building in town, sometimes with the opera house or concert hall. But this had also been the case in France in the nineteenth century. In cities like Marseilles, Nantes, Amiens, Rouen, or Lille, the museum was once a major urban creation, which gave it monumental visibility. This political affirmation was abandoned in the first half of the twentieth century, to start up again around 1975.

The curators of my generation therefore knew a privileged period: the years 1975–95 were feast years for museums, and by that very fact, for the enrichment of the curator's role. We felt that the museum could no longer be simply a repository of the patrimony and a study center—although these should remain part of its core missions—but that it must also become a place of welcome, accessible to all kinds of new or formerly neglected audiences. And in the best of cases, it should become a place of creation, open to contemporary art, or in any event it should aim toward establishing a deeper rapport between visitors and works of art.

The 1990s brought further changes with the reevaluation of the status of curators and the founding of the Ecole (later

Institut) du Patrimoine. That said, the training of curators at the Louvre and Patrimoine schools merely codified a practice that had existed since the war (I spoke about this earlier). Its aim was to make their practical and administrative training more complete, which was necessary. It was also important that they continue to pursue and develop their own field of research. Most curators are, and should be, specialists — an opinion that sparked some lively debates. The administration, which has an increasing need for curators in the provinces, tends to prefer generalists. But a generalist, by nature, knows everything and nothing. I have always supported the position of the specialist. It is easier to become a generalist, to handle a wide variety of periods and mediums, when you know one of them deeply. Most of the excellent curators who are capable of directing museums — that is, of exerting a function that largely surpasses the competence of an expert, acquiring good management and directorial skills and the ability to make overall judgments — started out as specialists in a given period or medium. In my case, I became interested in Italian primitive painting when I was eighteen years old, and fifty-five years later I'm still interested.

For a while, I feared that the Ecole du Patrimoine would be tempted to become a management school for museums, in other words, to lay too much emphasis on teaching the administrative and communication skills that are required of a museum director. These tasks are, of course, essential, and every director has to master them and know how they work, but on condition of preserving the time necessary for personal research in his or her chosen field. Otherwise, there is a danger that the trade will reach a certain uniformity, that knowledge and practices will become standardized, and that we'll end up training excellent technicians and managers who are totally out of their depth when faced with actual works of art. But I know that this danger has now been acknowledged.

Simply put—perhaps too simply—the curator's job con-
sists of the research and scholarly work that are part of any art
historian's or archaeologist's job and of perhaps five essential
elements, in addition to a fundamental love of art; five quali-
ties, or instincts, that academics and independent researchers
don't necessarily need to have. The first of these, and the *sine
qua non*—this seems self-evident, but it isn't—is to love works
of art "physically," so to speak; to live in direct relation with
them, know how to hold them, conserve them, have them
restored, protect them, hang them, highlight them; to know
how to juxtapose them with other works or isolate them, in
order to create presentations that make them more intelligi-
ble to the viewer. Second, you must have enough knowledge
to determine which artist or school produced a given work, if
this hasn't already been done—or, more often (since you
can't know everything), which specialist you should consult
to learn the work's identity. Next, you must have the requisite
sensitivity to measure the quality of the work and the posi-
tion it should occupy in an overall presentation. After that,
you need to respect the audience, every audience, by providing
appropriate opening hours, reception areas, scholarly, peda-
gogical, and cultural accompaniment, and communications.
The management and proper functioning of the museum all
depend on these. Finally, you must possess a patrimonial
instinct. Since the early days of public museums, from genera-
tion to generation, this instinct has dictated that curators,
whatever the size and nature of their collections, have a deep-
seated desire to enlarge them. But everything I've just listed
is fairly obvious—how to become a curator in five easy lessons.

The evolution in museums naturally entails dealing with
new audiences. At the Louvre in particular, we have to manage
a large influx of tourists and, in general, distinguish between
the different categories of visitors. On one side, there are art
lovers, specialists who come to the museum no matter what.

This doesn't mean we don't have to make an effort for them, but they know what they've come to see. This kind of "baseline audience" exists for every museum in the world. There is also a very diverse public that we have to educate, or at least inform, largely at their own request. Unlike what they thought in the 1950s, our pedagogical duty does not extend merely to scholastic audiences today, but to all audiences. Finding ways of attracting and holding people who do not have a background in art history, including from underprivileged brackets, is the role of the cultural services. On top of which, the Louvre has a large potential public: residents of the Paris area who go to the theater, concerts, or major exhibitions, but not to the Louvre. We have to excite this public's curiosity. And finally, there is the basic tourist, whom we shouldn't disdain. We often say among ourselves that amid those haggard herds dragged along by recorded audio tours, there might be one whose life will be changed by the revelation of art.

Let me now turn to the year 1981 and the beginnings of the Grand Louvre project. The president's announcement in September of that year that the Ministry of Finance building was being restored to the Louvre was the realization of a great hope. This would no longer be the sea serpent that we'd been grappling with since the days of Henri Verne's great reorganization plan in the 1930s.

That said, I remember a visit that Pierre Rosenberg and I paid in 1968 to Michel Debré, who at the time was President de Gaulle's minister of finance. I imagine that we'd gone to beg funding for some acquisition, and the minister announced to us, "Gentlemen, one day you will be at home in the Finance Ministry!" The idea had thus been floating around for quite a while. Had Malraux used his power of seduction over President de Gaulle and his persuasive force over the cabinet to carry this decision? He never said so. Whatever the case,

when I was appointed to the Paintings Department in 1966, I didn't even think about it: that's how impossible it seemed.

Chastel published an article decrying the "humiliating disorder" of the "worst-maintained of all the large museums." I shared the same feeling of asphyxiation, especially for the collections that we couldn't display sufficiently, with many works in storage. The reception we offered the paying public was also disgraceful. Everything was squeezed into the entrance hall: the coatrooms, bathrooms, bookstore, gift shop, meeting areas for school groups and guided tours were all in one room. The situation was becoming intolerable. The state of storage areas has always been a matter of concern to curators; at the Louvre they were grossly insufficient. Georges Salles very accurately compared the Louvre to a theater without a backstage.

President Mitterrand's 1981 press conference left us feeling enthusiastic, as none of us had had the slightest advance notice. Hubert Landais, director of the Musées de France, told us the news. Jack Lang asked him to immediately put together a proposed organizational structure, the most urgent thing being to define what it was we wanted.

In writing about these events, I decided to approach them as an historian, rather than rely solely on my own recollections. I therefore tried to find out who had really come up with the idea. I consulted various individuals who at the time had gravitated around President Mitterrand and Lang, such as Paul Guimard and Claude Mollard, and they confirmed that Lang had been the first to speak to the president about it. Lang himself later told me he had realized, while walking by the Louvre shortly after his arrival in office, that from a cultural viewpoint the inert mass of the Ministry of Finance building was useless. He gave me a copy of the letter that he'd sent to the president early in his tenure. In it, he already used the expression "Grand Louvre" and asked the president to put the proposed reforms into practice. President Mitterrand

has also remarked on the matter, publicly evoking the role played by his old friend Louis Clayeux. A highly cultivated man, Clayeux had been the driving force behind the Maeght gallery and a friend of Miró and Giacometti. But even he admitted that the idea had been suggested to him by Lang.

President Mitterrand made the project his own, following every stage of its progress, from planning to construction. At the end of his term in office, he did not hide the fact that of all the public works projects he had initiated, the Grand Louvre was the one dearest to his heart, and no doubt the one that had given him the most satisfaction.

The two ministry officials with principal responsibility for the project, Hubert Landais and Christian Pattyn, director of patrimony, under the authority of Jack Lang, initiated a study of an overall program, beginning with a competition, for which it was necessary to assemble a planning team.

The museum's seven department heads saw this as a historic opportunity to get extra room for the Louvre, both for the collections and for the backstage areas we so badly needed.

Emile Biasini was appointed by the president in 1982 to head the project. I had met him in Malraux's time and considered him an excellent choice. With his strong personality, he quickly bonded with the project. The epithet "bulldozer" has often been applied to him, even by the president himself — justifiably when it comes to his determination and effectiveness, so long as we remember his extreme finesse and subtlety in analyzing situations. He created a structure for the initial studies in 1982 and, after presiding over the planning competition in 1983, was named president of the public commission (*établissement public*) overseeing the entire operation that fall.

In April 1983, Jérôme Dourdin's planning team was selected. I was on the competition jury, which was presided over by Biasini, and included the ministry's two project directors (Hubert Landais and Christian Pattyn); Georges Duval,

chief architect of the palace; François Mathey, director of the Musée des Arts Décoratifs; and two foreign guests, the Mexican architect Pedro Ramirez Vásquez and Philippe de Montebello, director of the Metropolitan Museum. As with the Pompidou Center, and to some extent with Orsay, the job of the planning team was to detail the needs of the Musées de France and of each individual department, and to draw up a document that could eventually be used by the architects. At this stage, however, we weren't yet concerned with architecture, but only with planning — in itself a particularly difficult task, as the sometimes conflicting needs of the old and new spaces had to be taken into account.

Dourdin's team consulted us at great length, carefully analyzing all the data provided by the departments on the one hand, and by their site reports on the other. There was a period of feeling our way around, successive refinements, and a large number of different hypotheses, repeatedly discussed with us, the "end users." For a while, there was even some thought of installing French painting in the Richelieu Wing.

Biasini understood from the outset that an operation of this magnitude — which would unavoidably give rise to strong reactions, including political ones, since the impetus had come from a Socialist government — had to have public support. He brought into the group individuals not directly associated with the operation, such as Pierre Soulages, Jacques Rigaud, Jean-Claude Grohens, and Louis Clayeux. This wasn't quite a lobby, like the association created several years later to defend the project when it was in danger, but already the beginnings of a support network, which would grow stronger over the years.

More informally, he sometimes met with friends at the home of Geneviève Picon. I've already mentioned that Biasini and Gaëtan Picon had been very close in Malraux's time, and that they had resigned from the ministry over their disagreement with Malraux's decision to appoint Landowski, rather

than Boulez, as head of Music. I attended several of these soirées. Biasini always preferred the cordiality and freedom of speech permitted by such gatherings to the administrative formality of commission meetings.

Early on, he also decided to bring into the decision-making process the heads of the Louvre's seven curatorial departments, as well as the director of the Musées de France and Irène Bizot, who ran the Réunion des Musées Nationaux. Pierre Quoniam, the former director of the Louvre, joined his team, which reinforced our cohesion. Thus a climate of trust was created, which was largely instrumental in the success of the overall project.

Naturally, an operation like the Grand Louvre could not be led by several people at once. It would have been counterproductive for the minister himself, someone in his cabinet, the director of the Musées de France, and the director in charge of Patrimony (for the portions concerning historical monuments) to be constantly interfering with one another. It was necessary that one man take the matter completely in hand—though budgetary decisions, in any case, ultimately went back to the ministry. I should add that in cases where authority has been more diffuse, as with the new Opera or the Bibliothèque Nationale, the results were much less convincing. I don't mean architecturally, but within the teams themselves.

As the man responsible for redeveloping the Aquitaine coast, Biasini had worked with architects like Michel Macary, and he was keenly interested in construction and environment issues. When the president appointed him "Mister Grand Louvre," he reviewed all the possible architects: Norman Foster; Pedro Ramirez Vásquez, designer of the admirable anthropology museum in Mexico City; James Stirling, who had built the Stuttgart museum and designed the additions to the Tate Gallery; Richard Meier; and I. M. Pei. So many great international figures. Biasini had liked Pei's two towers in

Boston, which influenced his choice. As both men have since related, Pei was fairly reticent at first: after the poor reception given his plan for La Défense, he was hardly inclined to risk a second failure in Paris.

During one of our dinners at Mme Picon's in early 1983, Biasini tested me: "What about Pei?" My response was enthusiastic, given my admiration for the new wing of the National Gallery. I said something like, "If we could get Pei, that would be fantastic." Biasini's reply was, "You'll get him." I gladly accepted the role in which he cast me: as bellwether for the reactions of the other curators, who would pick up on my signals but would also, thank God, have opinions of their own. Biasini immediately suggested Pei's name to the president and easily won his approval. Pei set to work, installing his American team, led by Yann Weymouth, in Michel Macary's architectural offices. Macary and Weymouth were my interlocutors, my permanent work companions during those years.

Pei made a minute inspection of the site. He is a thoughtful, cultivated man who notices everything. My office was located in the Flore Wing, with a window overlooking the Carrousel gardens; more than once I saw him out there, pacing back and forth alone. His design was inspired by the urban layout of Paris and the long view that stretches out to La Défense. He was an admirer of Le Nôtre. A large portion of his plan depended on relocating the Louvre's central point toward the east and north. At the same time, Dourdin's team worked with us to specify in detail the distribution of the collections throughout the old and new buildings.

In the early days of 1984, without warning, Biasini took me to Macary's studio to see the architect's model. It was a total secret; no one had yet lifted the covering sheet. I can still see it, with its scale-model pyramid in the center. Biasini looked at me for my reaction. I was at first shocked, then won over.

On the other hand, I was not present when the model was

unveiled for President Mitterrand. I also had no reason to attend the turbulent meeting of the historical monuments board in late January, but I soon heard about it. The final vote had been in favor so the design was accepted, but the violence of the preceding debate and certain reactions were horrendous for Pei, who didn't understand French very well at the time — and the interpreter didn't dare translate everything that was said! That eminently respectable man was humiliated. But from that moment on, the Louvre became the pyramid.

In the public sphere, I was particularly struck by the reactions of two personal friends. One was by André Fermigier, a free, entertaining, and imaginative mind whose writings I greatly admired. His violent and rather excessive response shocked and disturbed me, though I didn't discuss it with him at the time. The pamphlet *Paris Mystified*, published at the end of the year, was the work of three other friends: Sébastien Loste, who had helped shape the plans for the Pompidou Center; Bruno Foucart, with whom I maintained cordial relations; and Antoine Schnapper, who was and still is a close friend. I haven't read that pamphlet in about twenty years. I have a copy inscribed to me by the three authors; one of the inscriptions claimed, in so many words, that this book, composed in a spirit of friendship, was doing me a favor and that I would thank them for it when I grew up. Loste in particular thought that the plan had been thrown together haphazardly.

He was mistaken. The project had been debated at length with and among the various curators, not without disagreement — though in reality, the disagreements mainly arose from everyone having to share the same bone, each one naturally wanting to keep as much as possible for himself. So compromises had to be made. Fortunately, technical considerations dictated the logical placement of certain collections. The sculptures, because of their weight, would be installed on the ground floor, the objets d'art one flight up, and painting on

the top floor to take advantage of the natural light from the ceiling. Museographic considerations imposed certain choices, even though we had to revise some of them later on.

I had remained on good terms with Michel Guy, and his stance — strong enough for him to create an association protesting the Grand Louvre — surprised me. After the pyramid opened, shortly before his death, moreover, he publicly changed his position. What he said to me, and repeated to Biasini, was, "I waged a battle, and I now realize I was wrong." He was a man of good faith.

On the other hand, Jacques Thuillier and André Chastel supported the project. Obviously, even within the museum, opinions were divided, but the seven department heads were all in favor and said so publicly.

After the upsets caused by those first negative articles, I more or less took on the role of defense coordinator. By common accord, we decided that the seven head curators had to make their position public. We therefore published an open letter to the director of the Musées de France, stating that the head curators supported the project, pyramid and all. We especially wanted to convey that the pyramid was an integral part of the overall plan, but that it was not the only important feature of Pei's design: this was the general line we took. Afterward, we were accused of being indiscreet. But I don't see how it was indiscreet of us to support a government-sponsored initiative! As if it were being supported solely out of personal ambition, to avoid displeasing those in power and from fear of being pushed aside! When one knows how difficult it is to manipulate curators . . .

The retreat that brought us together for three days in Arcachon, in late January 1984, had fostered a climate of cooperation among the curators, the head of the Musées de France, Biasini, Pei, and their teams. We had already put in a lot of work, and Arcachon marked the end of these prepara-

tory efforts. Some final revisions were made; some new ideas developed. For example, the idea of passing beneath the Passage Richelieu to go from one courtyard to the other evolved from a discussion between Jean-René Gaborit and Pei. One of the design's strongest features was the way it opened the museum onto the city. Instead of running up against the large, black, closed wall of the Ministry of Finance, one would now be able to enter the Cour Napoléon through the museum, via the Passage Richelieu, which was no longer fenced in. The only thing was that this opening cut the ground floor in half: this was how we came upon the idea of linking the two courtyards by a passageway on the lower level, thereby creating an uninterrupted series of spaces for monumental French sculpture of the seventeenth and eighteenth centuries. Some arbitration was required now and then, but we reached fair and balanced solutions for every department with no major conflicts. The Asian antiquities curators, for example, wanted to stretch their collection all the way to the courtyard. A study of their actual needs revealed that, in the final account, they didn't require quite that much space, but that French sculptures did.

The Arcachon plan, our "Yalta Conference," was followed to the letter, with two important exceptions. First, the Islamic section was very poorly housed in the Rohan Wing; when I became director two years later, we remodeled the basements of the Richelieu Wing to give it the prominence it deserved. Second, we hadn't resolved the matter of where to put the directorial offices of the Musées de France, which were still somewhat precariously located at the Louvre.

With the displacement of the museum to the east and the main entrance to the north, Pei correctly figured that the Flore Wing would become a kind of far-flung territory too removed from the center, and thus difficult for the public to reach. He suggested we take advantage of the situation to

better display the Prints and Drawings Department and to use the space for the conservation studios, the Louvre school, and perhaps the directorial offices. Biasini, however, thought that there were two good reasons for the director's offices to leave the museum premises altogether. In practical terms, it would free up more space for the museum, notably for the offices of the Louvre directorship, which to his mind should be expanded; and in moral terms, as a consequence of the first wish, he thought the Louvre should be given its own identity, and therefore occupy the entire building. But the final decision was made only later.

After Arcachon, we continued working with the Dourdin team, then with the architects, who were now under the authority of the Etablissement Public du Grand Louvre (EPGL) and its director, Jean Lebrat. The year 1984 became rather trying, as the polemic against the pyramid swelled. At dinner gatherings, it sometimes took on frightening proportions. I had already experienced a similar climate over the Piano-Rogers plan for the Pompidou Center, but it was nothing like the violent reaction against the pyramid. When you think about it, it wasn't entirely unhealthy; it shows that the French public is interested in such cultural matters, even if it is often ill-informed or ill-intentioned.

Here's an example: In the spring of 1984, I caught a taxi for a rather long drive to Nice airport. The driver asked me what I did, and I answered, "Guess." He looked in the rearview and said, "You look like an architect." It was the best compliment he could have paid me. I told him that architecture was indeed part of my job, since I worked at the Louvre. Whereupon he literally exploded, in the way that taxi drivers do so well: "That's horrible, what you're doing up there, it's criminal," and so on. Now this man had never set foot in Paris. But the debate had taken on national proportions, at every stratum of society.

In a way, it was Jacques Chirac who saved the day. As mayor of Paris, he had asked to see what effect the pyramid would have on the space around it. One morning at dawn—this must have been in the spring of 1985—a group of us built a scale model on the site, with ropes delineating the outlines of the pyramid. And Chirac gave his assent, even though the local mayor of the first arrondissement remained opposed. This loyal stand by the mayor of Paris depoliticized the matter. From now on, one could like the pyramid without being accused of Socialist sympathies or dislike it without automatically being branded a right-winger. Things began to fall into place.

By the time the government changed in 1986, construction had gotten well underway. Ground had been broken in late 1983, and considerable work had been done to dig out the footings and basements of the building. Pierre Quoniam, himself an archaeologist, was the one who followed the progress of the excavations. I therefore heard only indirectly of the disagreements between the various persons in charge of the individual sites: Michel Fleury for the Cour Carrée and Yves de Kitsch for the Cour Napoléon. The result of these excavations for the museum, in addition to the discovery of unexpectedly interesting objects, was spectacular. Georges Duval, the architect for the historical monuments office, was, of course, in charge of restoring the older portions of the palace, but Biasini had wisely involved him in the overall operation as well, so that from the outset he was loyal to the plan, as was his successor, Guy Nicot. The way he was able to take advantage of the restoration of the medieval foundations, reusing the naked concrete for the ceilings and passageways, fit perfectly into the "Grand Louvre spirit."

It is no secret that a delay in the Richelieu site resulted from a decision by Edouard Balladur, who became minister of finance in 1986, to try to reclaim the old Ministry building,

which his predecessor had vacated to allow construction to begin. Meanwhile, the new Ministry was being built in the Bercy neighborhood. The situation became so critical that an "association to support the Grand Louvre project" was created, headed by Paul Delouvrier. Its membership included — in addition to the main curators attached to the operation and their longtime allies (Pierre Soulages, Jacques Thuillier, Dominique Bozo) — such figures as Balthus, Pierre Boulez, Pierre Boudieu, Jean-Pierre Changeux, Georges Duby, Françoise Giroud, François Jacob, Jean Leclant, Philippe Sollers, and Marc Riboud.

I met with Balladur during this time. He was unquestionably interested in patrimonial matters. Some of my colleagues and I had visited him at the beginning of 1988, after which he had allocated funds so that the minister of culture could significantly increase the curators' wages.

Not long afterward, he received me alone in his office in the Richelieu pavilion, so that I could explain the Louvre plan to him. Anxious to convince him of the project's importance, I presented, blueprints in hand, the broad lines of the renovation project and the cohesiveness of the new spaces: the Richelieu Wing, the Sully Wing, and the Denon Wing. "I understand Richelieu and Sully, who were great ministers, but who was Denon?" he asked. I answered that Denon had been the museum's director, which made him laugh. Looking over the blueprints, he said flat out that the plan was magnificent. I asked if I might be allowed to quote him on that, and he was happy to oblige. In fact, the closer it drew to the presidential elections, the more likely President Mitterrand's reelection appeared. He wanted it to be known in our circles that he was not against the Grand Louvre in principle, but that he felt he was being pushed out of his space in an inconvenient way. Then and there, he took me on a visit of the large apartments in the Ministry, where he had already begun

significant restorations of the old Napoleon III decor. "Later on, I'll also make sure you get part of the silver," he said, and he did: it was late nineteenth-century silverware used for receptions thrown by the Ministry of Finance.

Biasini had had to retire in July 1987, but had remained honorary president of the EPGL. The actual presidency went to Pierre-Yves Ligen, who had directed the Atelier Parisien d'Urbanisme. Jean Lebrat fortunately stayed on as director. After President Mitterrand's reelection in the spring of 1988, Biasini was appointed secretary of state for public works in the Rocard cabinet. And with that, the project was once again on track.

Meanwhile, Hubert Landais had been succeeded as director of the Musées de France by Olivier Chevrillon in early 1987. I had already met Chevrillon at the home of mutual friends and got along with him quite well. He had made his career in the State Council before becoming publisher of *Le Point*. Persuaded by Biasini, he had accepted the physical relocation of the Musées de France head offices to Rue des Pyramides, which occurred later under his successor, Jacques Sallois.

In addition, he restructured the directorship of the Louvre and asked if I would assume the office. I was hesitant, not least because I had always maintained that the Louvre didn't need its own director, believing that such authority could be handled by the directorship of the Musées de France. I therefore found myself in a rather paradoxical situation, to the amusement of my friends. François Léotard, the new minister of culture, officially offered me the position, nicely stressing that it would be a way of honoring the corps of curators, who were too silent and too modest. I couldn't help remarking that the latter qualifier was no doubt in spite of ourselves!

The position of Director of the Louvre had been filled, after André Parrot and Pierre Quoniam, by three admin-

istrators, André Chabaud, Jacques Mullender, and Michel Delignat-Lavaud, who had restored much order in the house and spearheaded useful reforms, but who kept stumbling over two constraints. For one, they had to defer to the directorship of the Musées de France for any decision affecting the budget; for another, and primarily, they enjoyed no hierarchical authority over the departments and, not being art historians themselves, no control over their scholarly and museographic activities. And besides, to be fair, we hadn't exactly made life easy for them!

I therefore set several conditions: I had to be able to exercise hierarchical power over the entire staff, to have as much financial autonomy as possible vis-à-vis the Musées de France, and to hire an assistant to handle the administrative chores, which were not my strong suit. And more than anything, I expected the support of my colleagues. The question of who would succeed me in the Paintings Department was simple: Pierre Rosenberg was the obvious choice. I made the rounds of the six other department heads: Roseline Bacou in Prints and Drawings, my long-standing ally; Jean-René Gaborit in Sculpture; Daniel Alcouffe in Objets d'Art; Pierre Amiet in Oriental Antiquities; Jean-Louis de Cénival in Egyptian Antiquities; and Alain Pasquier in Greek, Etruscan, and Roman Antiquities. All of them said roughly the same thing: "If there has to be one, better that it's you . . ." The situation seemed logical to them, even desirable. I was therefore appointed in September 1987.

I should stress that the director of the Musées de France was very cooperative, as was the minister of culture, who freed up the necessary funds to establish an independent administration and new services and to hire new staff. This took place in early 1988, sanctioned by Emile Biasini and with the help of the EPGL and Jean Lebrat, who became its president that year. These reforms could not have happened with-

out the trusting and complicit rapport that had long existed between us. At my side, as administrative delegate, I had Francine Mariani-Ducray, who today is director of the Musées de France, and with whom I formed a real team. We created service departments, a prerequisite if one is going to institute new policies, and worked out what the new Louvre should be.

A complete directorship was being established. It was an exciting period, during which we recruited new service managers and built a new administrative structure.[1] At the same time, we had to define specific goals — as in any large concern — for human resources, administration and finance, public relations, technical services, and architecture. It was more complicated for the cultural services, for which we had to invent an entirely new policy, to which I'll return later. For the moment, we had to lay the foundations, gain acceptance for our projects, and discuss them with the curators and service managers.

I had instituted a collegial system, which I believe is still ongoing: weekly meetings every Thursday morning with the seven curatorial department heads, in which we made decisions and took votes. Meetings with the service managers we held on Monday, and once a month a general meeting brought together all the major staff.

Having known from within, for two decades, what a department needed in order to give the best of itself, I had clearly marked the limits of my direct involvement. I felt that the departments had to have real autonomy for them to remain strong intellectual and scholarly entities. This autonomy notably manifested itself on two points: the matter of acquisitions and that of loans to other institutions. The latter might seem marginal, but in fact isn't, for loans to exhibitions involve our relations with other museums throughout the world. I continue to believe that the sculpture curator is best equipped to decide, notably with regard to the work's condi-

tion (which ultimately he is best placed to judge), whether or not a given marble should be lent to the Metropolitan—working hand in hand with the loans committee, and naturally with his colleagues and the director if more than one department is involved. Personally, as I'm kept aware of the main facts through our collegial discussions, I have never experienced this policy as a *diminutio capitis*. Second and more important: the acquisitions policy, the expression of the head curator and of the specialized curators within each department, must always be decided ultimately by the department itself. For me it was a bit of a heartbreaker, because I loved handling acquisitions, to renounce any direct say, other than for certain objects involving several departments or when I was asked. And again, the curatorial meetings kept me informed.

Naturally, all of this presupposes coordination, mutual communication, collegial discussions, and mutual trust, which was in fact the case. I remain convinced that without this autonomy, as well as direct contacts with their colleagues and the world of collectors, curators would gradually lose their taste for their jobs and the most brilliant of them would end up choosing other careers and leaving the museums. But this danger, which results from the diminished authority of curators in favor of those presumed to be more competent managers, is, as I know all too well, widespread in the museum world. This is yet another reason to weigh the long-term consequences.

Many curators—and I was one of them—are stubborn and sometimes exasperating in their whims and their indifference to the contingencies of management. But if they weren't this way, would they bring the same passion to their work, the grain of knowledge and talent that makes each of them indispensable? When I was appointed director of the Louvre, Jacques Rigaud said to me, "Well, now you're going to see what the curators are like!" I've seen. Some of the younger

ones were especially difficult to deal with. But I never held it against them: I'd much rather be surrounded by headstrong individuals than reassuring yes-men.

On the other hand, I felt that the director of the Louvre should have complete authority over general decisions concerning renovations to the museum and cultural policy. Once a general agreement has been reached among the project foremen, the EPGL, the architects, conservation, and the director's office, you can begin debating details. It was at this point, I felt, that the museum director should intervene, giving due consideration to the favorable or adverse opinions of the architect or curators. As an example, Italo Rota had been put in charge of installing the eighteenth-century French paintings on the second floor of the Cour Carrée. We had agreed on the overall design and lighting system, but we disagreed on the color of certain hanging rails. One of the proposed colors didn't appeal to me. By discussing the matter with the architect, the head curator (in this case, Pierre Rosenberg), and the conservator in charge of the galleries, I was exercising my authority appropriately. All three of them agreed with Rota. I gave in, deeming that it wasn't that important, since a color, which reflects the tastes of the time, is never definitive. Similar discussions took place concerning certain rooms on the second floor devoted to Flemish and German painting. There again, I ultimately accepted the choice of the curators in charge. But on the whole, for the dozens and dozens of rooms, designs of stands and display cases, and wall colors, everything went smoothly in a spirit of agreement.

For matters concerning museum layout and building construction, I was in my element. Obviously, I was less so in matters of administrative management and the social sphere. But I could rely confidently on the competence of Francine Mariani-Ducray, who was succeeded in 1991 by Brigitte

Joseph-Jenneney, and of the administrative and financial departments they oversaw. In the same way, I was strongly supported in understanding personnel issues by Gilles Butaud, the head of Human Resources. I had always enjoyed working with the facilities teams and was already quite familiar with some of the specialized shops: cabinetmakers, framers, painters, electricians, and so on.

On the other hand, I had had less contact with the security crew. And I had never had occasion to meet with the museum's unions. My baptism by fire came in November 1988 with a strike resulting from negotiations over new schedules for the guards. It was a difficult strike that kept the museum closed for ten days, but it ended in a satisfactory compromise. From such circumstances and other interpersonal conflicts that arose from time to time, I understood that, even with the guidance and support of my assistants and the ministry representatives, I had to have a personal involvement. I couldn't act like the sheriff who goes fishing to get some peace and quiet while the gun battle rages back in town. Oddly enough, I don't have a bad memory of these painful arm wrestling contests, those long palavers in which misunderstanding is the common tongue, those unavoidable and despicable blackmail threats, such as shutting down the pyramid. Perhaps because I also remember the moment when the crisis resolves itself, and both sides, deeming that they've gotten what they wanted, or at least enough to save face with their constituents, can smile at each other again. All this because I had slowly learned to understand and respect the most serious and reasonable of our union representatives.

The opening of the Grand Louvre was accompanied by a dynamic roster of cultural programs. Hundreds, even thousands of events were organized in the auditorium and museum galleries. This is not the place to discuss end results

or the responses we received, ranging from critical to blissfully satisfied. I'll simply sketch out some of the broad lines we followed in composing these new programs.

When I began as director, this was, in fact, one of my priorities: to define what was expected of the museum's new functions and, consequently, what programs should be launched by the cultural services and the auditorium. From the start, a room had been planned beneath the pyramid for lectures and conferences, but without a clearly defined program. In working with the architects and discussing the matter with the EPGL, we decided to create, as in Orsay, an auditorium for musical performances. Every modern museum needs a space for lectures and films. The idea of using this space for music as well made Pei reconsider the issue of acoustics.

The result seems to me one of his most perfect architectural successes. The plan — a square inscribed in a square, following a schema of geometric composition that structures all of Pei's designs for the Louvre — creates triangular breathing spaces on the side that provide a magnificent effect. Acoustic tests showed that the room worked quite well for a certain type of music. It was never our intention to offer large-scale symphonic or choral concerts, only chamber pieces.

Plainly put, we wanted to make this auditorium attractive not only to those attending a lecture on art history, but also to film and music lovers. Our idea was that such an audience, once drawn to the Louvre, would be inspired to visit the museum proper, repeatedly. The auditorium should therefore be open and inviting and offer a broad range of programs. There would be at least one program per day, in addition to a weekly "Noon at the Louvre" offering (film, concert, or lecture) — in all, some three hundred events annually.

Defining, discussing, and setting up these projects in concert with the curatorial division was part of my mission. I therefore held countless work sessions with Jean Galard, who

headed the cultural services; Guillaume Monsaingeon, who was in charge of the auditorium; and their staffs.

Each type of event required preliminary reflection. What kind of music should we offer? Should special emphasis be placed on music from the same period as the collections? That was what we had done at Orsay, following the museum's interdisciplinary approach. But at the Louvre, we didn't want to limit ourselves to medieval, Baroque, or Romantic music; we also wanted to include nineteenth-century and contemporary music, as well as music from other cultures. Our only limitation was to avoid encroaching on the late nineteenth century, which was Orsay's domain. No Fauré or Hugo Wolf festivals at the Louvre — although one might hear some Fauré alongside Schumann or Berg.

That said, so long as it was appropriate and not forced, we liked the idea of offering a musical echo to certain themes treated in the museum, which might suggest fruitful analogies. Thus, during the exhibition *Copy and Create* in 1993, we held concerts illustrating the musical theme of transcription, such as when Schönberg transposed waltzes by Johann Strauss. The program, overseen by Monique Devaux, made our auditorium one of the most celebrated Parisian chamber music halls among demanding music lovers and offered many musicians the chance to give their first Paris recital: I need only cite Thomas Hampson, Maxim Vengerov, Vadim Repin, Truls Mørk, or Thomas Quasthoff.

With a view toward associating sound and image, we also launched a series called *Classics of the Image*, taken from largely unseen archives throughout the world assembled by Christian Labrande, as well as projections of silent films, accompanied either by their original, restored scores or by new music.

The film series involved both programming existing films and producing various films of our own. Alain Jaubert had already made one on Veronese's *The Feast in the House of Levi* in

Venice, which convinced us to pursue the experiment using works in the Louvre, then in other museums: the resulting series, called "Palettes," will soon produce its fiftieth title! Another idea, related to our intent to promote art history, was a series of filmed interviews with the major representatives of the discipline: Baltrusaïtis, Sterling, Haskell, Chastel, Zeri, and Krautheimer. All of these films were made in partnership with public television stations. We then expanded this to include multimedia productions. In addition to pedagogical films for young people, I'd especially like to mention *La Ville Louvre* by Nicolas Philibert, which gives a backstage view of the museum. This film, which garnered huge public success, finally gave acknowledgment to those in the house whose work takes place behind the scenes.

Our program of existing films also evolved. Following several trials with Pasolini and Antonioni retrospectives, we decided it was wiser not to transform the auditorium into a classical cinematheque, as several of these already existed in Paris. We would, of course, show documentaries on archaeology and the arts, but we wouldn't limit it to that. Rather, we would create a series of fiction or experimental films to illustrate themes underscoring the history of the visual arts, such as the use of lighting, metamorphoses, the lives of artists, and so on.

For lectures, concurrent displays naturally suggested certain subjects or speakers, especially in the context of the "Noon at the Louvre" series. But we also wanted to create a visible intellectual structure, with thematic cycles or colloquia, either linked to exhibitions (*David, Clodion, Byzantium, Egyptomania*) or to broader subjects, such as the story of art history or museums at the time of the Louvre's opening.

Starting with the idea that the Louvre had long been the museum par excellence, we also launched a series on museums, their history and organization, which is still ongoing and

continues to take its cue from events in the world. Lectures in the auditorium or in the galleries (talks with a writer or curator, often in presence of the works themselves), discussions of current archaeological discoveries, readings of the great texts, thematic lecture series, international colloquia leading to scholarly publications — all of this constituted a large number of varied offerings that did and still do attract thousands of listeners to the Louvre, many of whom have become faithful visitors.

Since the first lecture given in 1989 by Yves Bonnefoy on the power of the image, one characteristic of these has been the intellectual and even ideological diversity of the lecturers, who belong to every tendency in art history, archaeology, and aesthetics. Even our most difficult critics, the university professors, have had the grace to acknowledge this.

I fear that the above list of accomplishments might sound a bit dogmatic, even somewhat like an electoral campaign. Too bad! And even then, I haven't mentioned all cultural services' initiatives: publications geared to a wide range of readerships, special programs for the physically disabled, and more.

In addition to these programs, planning for the new Louvre naturally involved reflection about new kinds of exhibitions. It seemed obvious to continue organizing dossier shows and to extend the principle to every department, since these shows were so tightly linked to the museum's scholarly activities. A new space in the Richelieu Wing would allow the ancient art departments, as well as Sculptures and Objets d'Art, to open their archives as well; we began, for the inauguration of the new wing in 1993, with an exhibit on Khorsabad and the discovery of the Assyrians. We followed it with exhibitions on the Bourges rood screen and on Luigi Valadier (1994).[2]

Similarly, the only way to show the public our prints and drawings collection is through temporary displays. For decades we had been mounting scholarly exhibitions of

works on paper and the Edmond de Rothschild collection, and it seemed natural to pursue this when the department was reinstalled in the Flore Wing. But Roseline Bacou and her successor, Françoise Viatte, also thought to make drawings visible to a wider audience by displaying them in the Hall Napoléon, the new reception area under the pyramid. As such, we organized exhibitions centered on methods or techniques endemic to drawing, such as *Pentimenti* in 1991. We also initiated a new series of temporary installations, for which a personality from outside the museum world would select drawings from the Louvre's permanent collection (or from other Paris museums) to illustrate and interpret a given theme.³ These have included *Memoirs of the Blind* by Jacques Derrida in 1990, *Cloud Sounds* by Peter Greenaway in 1992, and *Largesse* by Jean Starobinski in 1994.

We also planned for regular exhibitions of recent acquisitions from the seven departments. A particularly remarkable acquisition might even inspire a special grouping, such as *Da Vinci Draperies* in 1989.

All this was fairly logical. But there was still the question of whether we should hold major exhibitions in the Louvre itself, when our own curators were organizing many such exhibitions at the Grand Palais. Our response was positive, on the conditions that these exhibitions not be similar to the ones at the Grand Palais, that they have a character of their own, and that the subject matter have a clear tie to the museum. I therefore drew up a long-term program, which I submitted to my seven colleagues, and in which I tried to define a coherent strategy.

The first point stemmed from the idea that since the end of the eighteenth century, the Louvre had been the museum where people came to see the masterpieces of world art, as well as the place where young artists came to find models to copy. I had in mind the example of two great artists, Chagall

and Hajdu, both of whom had told me that, when they arrived from the East, the first thing they did when getting off the train, even before finding a hotel, was to go to the Louvre. In his fascinating book *Louvre Dialogues*, in which he interviews painters at the museum, Pierre Schneider reports a number of similar experiences. The Louvre and its collections, a great reservoir of images, have long nourished and continue to nourish artists, providing them with positive or negative examples. Cézanne once said that the Louvre should be burned down, and at the same time, that one should go there repeatedly. And there is the famous anecdote of Vollard posing interminably for his portrait by Cézanne; the artist was having trouble getting exactly the right tone for the shirt, and suddenly dropped his brushes to run over and find the solution at the Louvre . . .

We therefore proposed to exploit the subject of the Louvre itself as a source of inspiration, and more broadly the theme of revivals, relations between older art and more recent creations, through a series of exhibitions: *Polyptychs* (1990), *Copy and Create* (1993), *Egyptomania* (1994),[4] and *After the Antique*. A second, and richer, series of exhibitions grouped together major works from the Louvre into more general presentations. Most often, research involved other public French collections as well, in line with the patrimonial exploration that we had been conducting for thirty years. The first such exhibition, in 1989, in the new galleries off the Hall Napoléon, recalled the sometimes neglected importance of our Islamic collection (*Arabesques and Gardens of Paradise*). We created a similar kind of presentation for *German Sculpture of the Late Middle Ages* (1991), *Byzantium* (1992), and *From Across the Channel* (1994). *Euphronios* (1990) and *Clodion* (1992),[5] and later *Pisanello* and *Pajou*, were true monograph shows, which also drew on resources outside of France. For *The Treasure of Saint Denis* (1990), we were able to reconstitute a glorious, dispersed ensemble.[6]

I had also thought it would be interesting to occasionally study the life and works of certain great figures from the museum's history, such as Marigny or D'Angiviller. Pierre Rosenberg's exhibition *Vivant-Denon*, organized after my departure, was in answer to this wish.

In 1987, despite the delays occasioned by the Richelieu Wing, we had to prepare for the opening of the pyramid and the new spaces it covered, designed by I. M. Pei. Various books[7] have been written about the different stages of the huge underground work site in the Cour Napoléon, the archaeological digs, the unexpected discovery of the Le Vau wall, the erection of the vertical supports that gradually defined the entrance, auditorium, central aisle, service galleries, storage areas, and shopping spaces, the laying of the floor tiles, and finally the pyramid itself rising into the air.

I cannot fully describe what those two years were like for us, when preparations for the Richelieu Wing went side by side with the opening of the spaces beneath the pyramid. Putting the technical areas (storage, security posts, human traffic, and so on) into service required active coordination with the heads of the security teams. Regular meetings were held with the Louvre department heads, various members of the EPGL, and the architects. (Two of these department heads, both heavily involved in the project, sadly had to take their retirement in 1988: Pierre Amiet and Roseline Bacou, whose support and occasional warnings had been precious to me when I became director. They were replaced respectively by Annie Caubet and Françoise Viatte.) Our job was to work out a logical arrangement for the many different types of space around the Hall Napoléon and to give them some kind of visual unity. One key element of this was the use of signage and hallways. An American team under Kenneth Carbone was hired to design these in 1985.

In addition, we needed an interior architect to design and furnish the spaces in the reception area (cafeteria, bookstore, temporary exhibition spaces, et cetera) that were not directly handled by I. M. Pei. Once more, I turned to Jean Coural for guidance; he suggested Jean-Michel Wilmotte, who was hired after consultation with the EPGL. Wilmotte's classicism perfectly matched Pei's. Later in the process, his teams would join in the group of architects working on Richelieu.

We also had to create the rooms devoted to the history of the Louvre. These were realized under the direction of Pierre Quoniam, who had become a historian of the former palace. Given his fine work at Orsay, we again hired Richard Peduzzi to install these rooms, which use scale models and different kinds of art — portraits, period views of the museum, sketches of the paintings or sculptures that once decorated it — to illustrate the Louvre's long history. For the galleries housing temporary exhibitions, Wilmotte designed a modular display case, the prototype of which was built by the research studios of the Mobilier National.

The choice of the inaugural exhibition was no accident. For the opening of a transformed museum, which so strongly marked the role of the state in the Louvre's renaissance and followed upon the great public works projects undertaken by the government since the Middle Ages, I suggested, as a counterpoint, to highlight what the museum owed to the generosity of private individuals. So it was that we mounted the exhibition *Donors to the Louvre*. I was also pleased that this gave me a chance to bring together all the departments in a collective enterprise. The exhibition further gave the museum's architects and builders a chance to spread their wings, as the EPGL, having completed its mission, now handed over the new spaces to us.

One question that plagued Pei and me for over a year was what object to place under the pyramid. In his initial designs,

Pei had, in fact, envisioned placing the *Victory of Samothrace* above the central pillar, and thus directly beneath the apex of the pyramid. The project was quickly abandoned—by Pei himself, moreover—because the sight of the *Victory* at the top of the Daru stairway had become so symbolic of the Louvre. We then tried asking the curators, notably Jean-René Gaborit, to find another work for the pyramid. The column capital from the Apadana in the Palace of Darius I? Too strong and "fascistic." Pigalle's *Mercury*? Too small. *Mercury and Psyche* by Adriaen de Vries? Same problem. A sculpture group, *Diana of Anet*, had the right proportions and style, and we tried it out using a life-size model. It was almost too good: the architecture and neo-Renaissance ornamentation of the Louvre's facades, viewed through the glass of the pyramid, seemed to echo *Diana*, which because of this seemed oddly to belong to the nineteenth century. It wasn't right.

Another serious candidate was Rodin's *Thinker*, which had long sat in front of the Pantheon. But when we installed a mock-up of the famous statue, the rather handsome effect from the entrance turned ridiculously scatological when seen from below. The idea that lasted longest was Brancusi's *The Cock*, of which a plaster model, never cast by the sculptor, existed in the studio. Brancusi's heirs agreed to allow us to cast the piece in bronze. The work was splendid; its effect in that space and its symbolism promised to be striking. We had found our solution! And then, while showing the site one day to Anne d'Harnoncourt, director of the Philadelphia Museum of Art, which owns the world's best collection of Brancusi's works, and explaining our plan, I suddenly realized from her expression that we were making a grave mistake. Unlike Rodin and Maillol, Brancusi had overseen all castings of his works, and himself given them the final polishing. The plaster model contained rough spots that we would have had to decide how to erase: in short, we were in danger of betraying

the artist's intentions. Shortly afterward, during one of our meetings in New York, Pei also expressed his doubts to me. Two cautionary articles, written by two major art critics who were supporters of the Grand Louvre, Pierre Schneider in *L'Express* and John Russell in the *New York Times*, only reinforced our decision not to use the Brancusi.

Another very interesting proposal had been made by Dominique Bozo, who was then a delegate to the Visual Arts Ministry and who, I should stress, had been one of our most effective allies throughout the Grand Louvre project. His idea was to commission a work from Jean Tinguely. I went with Bozo to Tinguely's studio, where the artist set in motion a very beautiful mobile model: two large spirals, one enveloping the other, turning at different speeds and forming a striking, endless corkscrew. It would have been ideal if Pei hadn't planned for a spiral staircase right next to it. Unfortunately, the effect of redundancy would have been detrimental to both "objects." I don't know whether Tinguely was ever able to use the idea elsewhere, but it was magnificent.

After that, we considered Henri Laurens and Dubuffet, and finally paid a visit to the Picasso museum. Pei, for one of his urban designs, had used one of Picasso's small models during the artist's lifetime to create a monumental sculpture in concrete. But none of the ones we saw at the museum seemed to work, and it probably wasn't a good idea.

And after all, we finally thought, did we really need a sculpture in that space? Probably not. And this was ultimately the conclusion that Pei and I laughingly reached.

These discussions and many others over the years, or over dinner with Pei and his wife, Eileen, had given me a chance to appreciate the man's personality, his legendary delicacy, the discreet constancy of his friendship, and his sense of humor. During conferences in American museums in which we both participated, we sometimes ended up performing

two-man comedy sketches, given how the mix of our respective languages could turn into buffoonery. Another thing that bound us was our shared tastes in the field of contemporary art. It was not surprising to see, at his home in New York, some unspectacular but perfectly chosen works by Barnett Newman, Morris Louis, Kline, or Dubuffet; but the presence of a beautiful drawing by Jacques Villon proved that his affinities with French classicism were not limited to Mansart, Le Nôtre, or Gabriel.

And then one day, the enormous construction project came to an end. In March 1988, President Mitterrand and François Léotard came for a private viewing of the work site under the pyramid, which by then was almost competed, and expressed great satisfaction. Before leaving, the president took me aside and said, with true kindness in his voice, "Orsay and the Louvre — not bad for one career."

A large concert conducted by Pierre Boulez was held in the Cour Napoléon in July of that year, then the Passage Richelieu and the Cour Napoléon were officially opened in October by the President of the Republic. A plaque saying "Musée du Louvre," proudly placed on the Rue de Rivoli facade of the former Ministry of Finance, where work was about to start up again, had a symbolic value. Accompanied by Michel Rocard, the president then visited the restored medieval foundations. It was Pierre Quoniam's last outing, as he passed away soon afterward.

Finally, in March 1989 the president inaugurated the Hall Napoléon and the reception areas. That same month also marks the opening of some of the French painting galleries on the upper floor of the Cour Carrée, from the primitives to the seventeenth century. Joseph Motte, one of the architects from the first Paintings team, had again worked for the department. He had remodeled the spaces, begun but never finished under Germain Bazin, for an installation by Pierre Rosenberg and

his team[8] that unveiled a number of paintings long held in storage, such as the huge *Battles of Alexander* by Le Brun.

The opening of the Cour Napoléon and the pyramid had given rise to countless articles in the international press, which generally were quite favorable, even enthusiastic. I. M. Pei could now forget the disputes of 1984. I was present at a scene that clearly moved him: as the two of us were leaving the pyramid, he was recognized by the large crowd standing in the courtyard, who saluted him with rousing applause.

In the beginning of April, a large dinner was given in the Hall Napoléon, presided over by Jack Lang, which gathered the international "upper crust" of the museum world. The pyramid had become part of the Paris landscape — as certain of the project's most ferocious detractors had to admit, albeit grudgingly. If one was being honest, it was hard to deny the architectural quality and perfect stereotomy of the Hall, and not to feel the very reason for this transparent structure's existence: to give life and light to a generous welcoming area.

President Mitterrand, receiving the heads of state from the G7 nations (President Bush, Mrs. Thatcher, Chancellor Kohl, the prime ministers of Italy, Japan, and Canada) for a summit in Paris, insisted on doing honor to the space by organizing a meeting there, followed by a dinner and a visit to the Louvre's medieval collection and Salle des Caryatides[9] — which gave me the opportunity to note that the only one who showed any interest in the antique sculptures was Mrs. Thatcher, whom my English friends had called a Philistine . . .

The first exhibition, on donors, was regularly followed by others. In the auditorium, concerts, lectures, and conferences began drawing the public. A considerable work site had begun on the upper floor of the Cour Carrée for the rest of French painting — a series of thirty-nine rooms, some entirely new and designed by Italo Rota for the east wing, others simply remodeled in the south wing. There again, Pierre Rosenberg

and his curators[10] had proposed a new and balanced vision of the eighteenth and nineteenth centuries, illuminated by many little-known or recently restored works.

Just as for the seventeenth century,[11] special rooms had been set up in the paintings circuit for the Prints and Drawings Department; in this case they were for pastels.[12] These rooms were inaugurated in December 1992 by the president, who could now reach the second floor via the new monumental stairway built by Pei in the Richelieu Wing. This way, finally, one could easily reach the top floor of the palace, which at last justified our old idea of using that floor for the long history of French painting.

One result of having these new spaces was that we had to rethink the arrangement of certain departments. The Richelieu Wing directly implicated the programs of five departments and indirectly affected the other two. We needed to take a global view of the museum's collections.

As I mentioned earlier, Greek, Roman, and Etruscan Antiquities, following our plans from 1984, now extended toward the west. Egyptian Antiquities covered the entire east wing of the Cour Carrée, replacing Oriental Antiquities on the ground floor and Objets d'Art on the first floor. Oriental Antiquities kept the ground floor of the north wing of the Cour Carrée and would stretch into the Richelieu Wing, leaving one of the three courts of the old Ministry of Finance for the monumental Assyrian sculptures from Khorsabad. Succeeding Pierre Amiet, the department's team was headed by Annie Caubet, while Marthe Bernus-Taylor was in charge of the Islamic section.

For the antiquities, it soon became clear that we should group works from late Mediterranean antiquity in all three departments around the Cour Visconti. The project, which was completed for Coptic civilization in 1997, is still ongoing.

Should we envision similar regroupings for the four "modern" departments? The question was unavoidable, and entailed two basic considerations. The first was technical: was it wise to mix in the same gallery paintings, sculptures, and objets d'art from the same school? The second was, should we break apart the notion of schools, which was the traditional way of grouping paintings and sculptures? Our conclusion, which was negative for both questions, might seem conservative, but personally I don't regret it, given what the Louvre is. For painting and sculpture, in any case, to highlight coherent European movements that cross over schools (I've already mentioned this vis-à-vis Germain Bazin's installations) works well only in certain instances. I had already given the matter a lot of thought, and this helped us decide to maintain distinctions between the great national schools.

To begin French painting with the portrait of John the Good and end with Delacroix and Corot, or, in sculpture, to start with pre-Roman statuary and end up at Romanticism means to follow a linear, chronological history, with its fits and starts, its high points, and its discontinuities. This is the best way to show the succession of great moments of creation through the centuries. It is the same for Italian art, which the Louvre can display from Cimabue to Guardi, and in sculpture, though less completely, from the workshops of late Antiquity to Canova. To intercut these continuous discourses with works from other countries would no doubt be confusing for non-specialist audiences. It was one option among various possibilities; for certain other museums with less complete collections, it is more appropriate to arrange the art by pan-European sequences, rather than by schools. For the paintings of the Northern Schools, we naturally had to be more flexible, alternating Flemish, Dutch, and Germanic galleries along a continuous chronological path. The nature of the Louvre's collections more or less dictated these choices

for painting and sculpture. Objets d'art, on the other hand, required a more European demonstration.

Another large question concerned the mixing of different media in the same room. Many "people of taste" have often reproached us for the coldness of rooms devoted exclusively to sculpture or painting. There are technical reasons for this. You don't light a painting and a statue in the same way, and in a room full of paintings, sculptures are quickly relegated to the status of decorative objects. Jean-René Gaborit expressed this rather humorously when he said, "In a paintings gallery, sculpture is what you bump into when stepping back to view the canvases better"—which is not entirely false. To reduce sculpture to a purely decorative function is to diminish it. We therefore decided to keep sculptures and paintings separate. But we might also note that Objets d'Art shows paintings in some of its galleries, such as still lifes by Desportes, and murals by Chassériau are planned for the sculpture galleries.

The redeployment of the collections led to some felicitous and logical juxtapositions that had been impossible before. We were now able to offer a continuous view of collections illustrating various media in a single school across several departments. Thus, for France, one passes directly and without hiatus, simply by climbing the stairs, from sculpture to objets d'art, then to paintings of the Middle Ages and the Renaissance. In the same way, you need only climb the Daru staircase to go from Italian painting to Italian sculpture.

By refusing to break the unity of each department, we also preserved each one's strong scholarly identity, founded on the specific research proper to each medium. Is it wrong to respect professional traditions that have proven their excellence for so long, and which have been adopted by such venerable institutions as the Met and the Hermitage?

The price one pays, of course, is excessive compartmentalization and an occasional absurdity. I hope one day we can

rectify certain anomalies, such as Byzantium. Nearly every department, except Prints and Drawings, owns works of Byzantine art. Does this make sense? All the works from that great civilization should be brought together, as was the case with Islam. The situation of modern bronzes is also somewhat illogical. A bronze measuring twenty centimeters is kept in Objets d'Art, while one measuring sixty centimeters is in Sculptures. But so it goes . . .

The opening of the pyramid was not the end of construction, of course. There was still the Richelieu Wing. And so the years 1992 and 1993 were extraordinarily intense, as we passed from planning to execution. Michel Macary had taken charge of the French sculpture area on the ground floor,[13] and I. M. Pei, with the assistance of Steve Rustow, handled Oriental Antiquities around the Khorsabad courtyard and Islamic art,[14] as well as the paintings galleries on the top floor.[15] Jean-Michel Wilmotte was responsible for the layout of the first floor, which contained objets d'art from the Middle Ages and the Renaissance; he also designed a café in the Pavillon Richelieu, asking that Daniel Buren, Jean-Pierre Raynaud, and César participate in the decoration.[16] All these teams in full activity, the deployment of the security guards, the final painting tests on the walls, the progressive, sometimes spectacular arrival of the heaviest objects (after Le Brun's *Battles* in the open air of the Cour Carrée, the Khorsabad bulls came parading down Rue de Rivoli), setting up the display cases, the lighting tests, and finally, during the summer of 1993, room by room, case by case, wall by wall, the installation of many different works — all that is unforgettable.

I didn't need to become involved in the details of the installations, except, of course, on those occasions when I was seized by the itch to give my opinion — which was, I have to say, always well received and sometimes followed. And during

this time, the external construction continued: excavations beneath the Carrousel, led by Gaël de Guichen, yielded revelations about the city's defenses, the surrounding area, the Tuileries, and the kilns of Bernard Palissy. The Carrousel gardens and the Tuileries were completely remodeled and rejuvenated. The facades of the palace, with their cortege of Great Men, were restored and subtly lit.

The opening of the Richelieu Wing in November 1993 was a high point in our story. After the official inauguration by the President of the Republic, then by Prime Minister Edouard Balladur, who pronounced himself quite content with what we had done with his old ministry, the government asked us to offer free admission to the museum for two days.

At a reception at Elysée Palace, to which he'd invited representatives of all the Louvre's departments and of the EPGL, as well as some foreign curators, President Mitterrand expressed his gratitude, in words that touched everyone who had been involved in the project. He reminded us that this new inauguration had taken place two hundred years to the day after the original Muséum Central des Arts first opened its doors. The minister of culture, Jacques Toubon, gave a grand dinner in the Hall Napoléon, while the following day, the ministers of the economy and of the budget, Edouard Alphandéry and Nicolas Sarkozy, welcomed the "architects and artists" of the new Louvre to the new ministry headquarters in Bercy.

During the public opening that weekend, we had a strong sense that the museum was being accepted by the mainstream public. I heard visitors talking in the galleries: "For once, our tax money has been well spent!" The national patrimony belongs to them, in a way. Many of these visitors had never set foot in the Louvre; attracted by the media coverage of the Richelieu opening, some of them were seeing art in a museum for the first time. I even saw a couple of teenagers, obviously

brother and sister, running all over the Cour Marly, saying, "We've *got* to bring our parents to see this!"

As for my own reaction to all this, let me just mention one point about the large Marly and Puget courtyards. Certain critics suggested that these large spaces, which you can see from the street without having to enter the museum, lessen the mystery that one expects from a museum. I don't agree. The museum must no longer be what it has often been, a closed vault — as it remains for certain large American museums — with no opening onto the surrounding city. The relation between interior and exterior, between the work of art and life, on the contrary, humanizes the museum without toppling it from its pedestal.

How can I have an objective view of this? It is difficult for me to talk about my own reactions without sounding presumptuous or simpleminded. It was the same for Orsay. And I don't want to seem like I'm handing out merits or demerits to anyone. I've cited several names in these recollections, knowing that I've committed some unfair omissions. But to be completely frank, and apart from a few details (I won't say which), Richelieu corresponds to what I had dreamed of for the Louvre. And simplemindedness or presumption be damned!

In any case, the Grand Louvre operation was far from over. For me, the final stage of this huge reorganization continued the following year, in October 1994, with the opening along the Cour Lefuel of the foreign sculpture galleries, Italian sculpture on the Pavillon Mollien side and Northern European sculpture on the Lefuel side.[17] We had restored the beautiful brick and stone architecture of the old Tuileries stables from Napoleon III's time. The installation was overseen by Catherine Brizouard and François Pin.

After that, the complete overhaul and reinstallation of the Egyptian Department was prepared by Jean-Louis de Cénival. He had designed a program inspired by the department's

founder, Champollion, offering two itineraries, like a double reading of the Egyptian world: one devoted to art; the other, to ancient Egyptian civilization. The Campana galleries, with their famous series of Greek ceramics, had to be completely remodeled, preserving the original museographic decor. We also needed to reinstall, on the Cour Visconti side, the ancient Greek and Coptic rooms. All this would be inaugurated in 1997 after my departure.

Cénival passed away at around this time. I'd like to mention the help he gave me in setting up a collegial system in the museum. His gruff benevolence hid a profound moral and intellectual rigor. He often acted as my safety barrier, when I was being tempted by a particular cultural project or offer of sponsorship. When he groused off in his corner, it was never without reason. And, like me, he loved contemporary art. I remember, back when we were both students at the Ecole du Louvre, seeing a recently published book about Hartung on his shelves. As he got older, he continued to follow recent tendencies more closely than I did. He appreciated a freer design style than the ones produced by the designers we used, who were a bit classical for his taste. I can still hear him say, "I hate so-and-so, but you're right, he's the one to choose."

Now, a few words about the autonomy of institutions such as the Louvre and their system of financing. When the Louvre officially became an *établissement public* in 1992, it was an important event in the museum's history. Earlier, when the new office of Director of the Louvre was created, the museum had been classified an "external government agency." As such, we were granted a certain financial independence — though not the management of our entrance fees, which was the purview of the Réunion des Musées Nationaux — and an undeniable autonomy in administrative decisions. But this still turned out to be not enough. Nonetheless, I was hesitant at first when

several people advised me to make the museum a public institution. The example of the Pompidou Center didn't seem to fit us: when the Center was built, it separated from the national museums, largely because acquisitions of contemporary art were difficult in the unfavorable climate of the national museum board. From that point on, the Pompidou Center set its own policies, and so much the better.

But it was a different matter for the Louvre. To me, it seemed (and still seems) crucial for the museum to maintain close relations with the other national museums. This is particularly important when it comes to acquisitions, which are partly financed by a shared pool of entrance revenues; museums that get fewer visitors than the Louvre, Orsay, or Versailles are the clear beneficiaries of this system. The Musées de France had always played a regulatory role for all the national and provincial museums, and certain facilities, such as the conservation and research labs, also benefited from remaining under its overall umbrella. I was afraid that our becoming a public institution would undermine the solidarity and unity of that family of national museums, which has been a feature of the French museum system since the beginning. For us to consider such a transformation, the agreement would have to grant the Louvre significant autonomy and the right to manage its own income, but without a radical decolonization.

The directorships of the Musées de France and the RMN therefore began their mutually contradictory efforts to find a solution. Need I mention that I had no idea what kind of legal structure would satisfy both sides? In any case, it led to some fascinating sessions among *énarques** juggling texts and arguments like art historians with attributions, or rather, like opera singers performing dueling scales. Finally, they came up

*Administrators trained by the École Nationale, known by its acronym ÉNA.

with an agreement between the Musées and the RMN, as well as a statute for the institution that was approved by the ministry and that seemed viable to me.

Once I was convinced, I had to fight to convince others, so divided were the opinions. President Mitterrand himself, who had closely followed the evolution of the Louvre, was a bit reticent. I went to see Laure Adler, who was then the Elysée's chargée d'affaires for cultural matters, and showed her our plan for the Louvre as a public administrative institution. She spoke to the president about it, but he continued to have doubts. So the administrative heads of the museum and I drafted a brief, personal letter of support to supplement the official file. Adler called me to say that the file now contained this simple notation: "Yes. FM." We had won.

Our transformation into a public institution therefore became a reality at the end of 1992. The statutes respected an essential requirement: that the museum's director, who by decree had to be a trained curator, also become president of the administrative board. I had worked hard to see that this latter clause would be formally ratified at every level, including by the Fonction Publique ministry, which at first was dubious. This original formula affirmed the scholarly and administrative authority of the director over the totality of the staff. When I read this past summer in the newspapers that the Louvre needed finally to have a real director, it made me smile.

All this is not merely anecdotal. A true danger exists, owing to the financial difficulties faced by large museums with enormous operating costs (and not just in France), which leads to soliciting private resources, problems with personnel, and so on. The danger is that curators are considered incapable of mastering such administrative functions and that a managerial type is better suited to the job. As if a museum could be treated as just another business concern. It can't. It's fine if administrators have the authority to

second—and I mean second—the director, as in my case and that of my successors. But only a man or woman of the "trade," a trained art historian, who has personally handled collections, will have the necessary experience and reflexes to shape viable exhibition, publication, scholarly, and cultural policies. Isn't that obvious? And too bad if some qualify this demand as corporatist!

I should say that we avoided some of the problems inherent in integrating shops, cafés, and other ancillary spaces into the museum by keeping them in a separate area. Speaking strictly for the Louvre, we needed these shopping spaces. Providing a bookstore or a gift shop selling "derived products" seemed to be the kind of service that the public expects to find at the end of its visit. It was in the museum's own interest.

In addition, the overall Grand Louvre project planned for the construction of a large parking garage beneath the Carrousel, partly financed by the building of an independent shopping area. Designed by Michel Macary with an inverse pyramid, based on I. M. Pei's initial concept, these shopping areas—which are actually quite noble—are clearly demarcated from the museum proper. I would have preferred that the shops themselves all present a more "cultural" image, or at least reflect the Parisian vocation for luxury, which isn't entirely the case. But these shops and restaurants, the Comédie Française studio, the fashion stores, Virgin Records, certain displays—all this, they tell me, could be useful or enjoyable for the Louvre's visitors. And conversely, we can hope that some shoppers will in turn be drawn to the museum!

The problem of private funding is a different matter, and was an issue well before the Grand Louvre came into existence. Museums have long had recourse to corporate sponsorship to finance certain exhibitions, gallery installations, restorations of major works, and, of course, acquisitions. Haven't they always benefited from private initiatives linked

to the museum's activities, such as the Amis du Louvre over the past one hundred years? To bring private enterprise into public cultural undertakings is not merely a way of helping the budget. After me, Pierre Rosenberg has developed this aspect of profit-sharing, in the best sense of the word.

When the huge space under the pyramid opened, we agreed that on Tuesdays, the Louvre's closing day, we would make it available to companies that wanted to host receptions there. Which is fine, so long as the festivities are not held in the museum proper. This is a fundamental difference from certain British or American museums that have no qualms about organizing such events in the galleries themselves, despite the dangers they pose to the works' safety. We have always refused to do this, except for occasional cocktail receptions (to honor a donor, for instance) on the staircase landings.

Of course, we mustn't be naïve: there is a risk involved in bringing private funding into public cultural institutions. On this score, the museum director, if he's not just a manager concerned only with profit margins, can determine how far he can go in soliciting external funds and when to walk away if the other party's demands are excessive. Completely independent and disinterested patrons are a rare breed. And so much the better if what they do in the Louvre, and for the Louvre, gets media attention and reflects well on them.

In that regard, I was horrified by a planned law in Italy that entailed turning over the management of museums to private companies. It's an awful idea, and it could happen in France as well, so we must remain extremely vigilant. When a millionaire like François Pinault wants to build a museum on Ile Seguin, or such-and-such a corporation decides to create a foundation in the provinces, we should do everything we can to support them, that's a given. But handing over the management of museums or public monuments to private enterprises seeking above all to make money can lead to disaster.

Sadly, there is no shortage of examples. The museum's vocation cannot be to bring the public in at any price. The Louvre will never be profitable; it can't. It will never be able to do without state help, and so much the better. Long live Colbert!

On a slightly different subject, our transformation into a public institution modified our relations somewhat with the Réunion des Musées Nationaux. And while I'm on the subject, I'd like to tip my hat to the RMN. For the Grand Louvre, it was the RMN that created the bookstore, which is now the richest and liveliest in Paris when it comes to art history, with opulent, seductive displays. But let's step back in time a bit and away from the Louvre. Today we tend to forget the role this rather unique organization played in the years 1970–90, in making Paris the focal point of the best exhibitions in the world, largely due to the know-how of its heads, Hubert Landais and Irène Bizot, and their staffs. These exhibitions attracted a large number of visitors, while treating topics that were often complex and innovative and producing catalogues that constituted original works of scholarship. There existed an international network of comradeship throughout the museums that placed Paris—thanks to a dynamic interplay of exchanges and mutual favors—at the origin, or at least in the circuit, of most of the major exhibitions. This is also due to the efforts and influence of the Pompidou Center and to the activities of the Paris public museums.

Over the past several years, this trend has slowed somewhat, owing to the worldwide financial crisis. But there are still, in Paris and in the provinces (this latter point is a welcome new development), some superb and worthwhile exhibitions of traditional and contemporary art. The danger is that museums will begin forgoing certain subjects with less obvious audience appeal than van Gogh, Tutankhamen, or Vermeer.

Some people say that the triumphant era of the great museums is reaching an end. But a word of caution: there are not

only mega-museums, mammoths like the Louvre, the Met, or the Hermitage. I believe, rather tritely, that culture responds to a profound need of humankind; that museums must do everything in their power to satisfy this need; and that it will never wane.

Before leaving the museum world, I wanted to mount one final exhibition, one close to my heart. The difficulties involved in transporting wood panels encouraged me to step a bit outside my usual field of research, the fourteenth and fifteenth centuries. For several years, I had been interested in Venice and Titian. I had done some work on Giovanni Bellini and had even hoped to write a monograph about him.

With great generosity, the national museum board agreed to underwrite an operation that promised to be labor-intensive and costly, given the size and nature of the paintings required by the subject. For my part, totally without shame, I intended to borrow against my credit, in almost the banking sense. Taking advantage of my relations with museum directors and curators throughout the world, I said to them flatly, "This is my swansong exhibition, so you can't refuse to lend me such-and-such a work." I also explained that my selections were motivated not by some megalomaniacal whim, but by a desire to illustrate as completely as possible one of the greatest periods in all of European painting.

Let me open a parenthesis here to say a word about the mafia constituted by museum directors and curators more or less throughout the world. This loose "association" bears no relation to administrative or diplomatic networks or to social hierarchies, but rests on a kind of moral complicity. During a trip to the United States, Jacques Rigaud told me he was struck by that kind of international club, the equivalent of which didn't seem to exist in any other profession. This complicity, which is always personal—there are many directors or

curators with whom my relations have remained simply professional — relies on shared traditions, on personal connections, and above all on a certain conception of the trade, which only becomes stronger when we feel it is endangered.

In the course of these memoirs, I've had occasion to cite various members of this association. But there are many others, from Philippe de Montebello at the Met to Jean Boggs in Ottawa, from Mikhail Piotrovski in Saint Petersburg to John Walsh at the Getty, from Shoji Takashina in Tokyo to Hermann Fillitz in Vienna, from Annamaria Petrioli Tofani at the Uffizi to Bill Rubin at MoMA, from Eric Schleier in Berlin to Neil MacGregor in London. Neil is the biggest Francophile of any Scotsman I've met, with an exquisite touch of Gallophobia that adds spice to his weakness. And here, just a word to nuance my own Anglomania, concerning my feelings about the National Gallery, no doubt the most perfect museum in the world when it comes to paintings. Every time I go there, I immerse myself in canvases, and then, after two hours of pure joy, my old demons resurface. I can't help being bothered by the thought that they have eight Velázquezes, the most moving of the late Claude Lorrains, and four works by Philips Koninck! Then I console myself by remembering that the Louvre surpasses them in Mantegna and Fra Angelico and that they have too much Moroni. When I once remarked to Neil that I was sorry they didn't have any Simone Martini, by whom the Louvre owns a masterpiece, he countered that the absence of Duccio at the Louvre (the National Gallery owns four) was no less painful to him . . .

Getting back to the Venice exhibition: thanks both to the efforts of Irène Bizot, who acted informally as the general secretary of our "club," and to my good relations with the fine arts superintendent in Venice, Giovanna Nepi Scirè, who was co-curating the exhibition with me, the results of my attempts to sway my colleagues was more than I'd hoped. Despite sev-

eral perfectly justified refusals (the Titians in Edinburgh) and several dashed hopes (Giorgione's *Judith* at the Hermitage), as well as the absence of works, notably by Giorgione, that we hadn't requested because of their extreme rarity, we were able to assemble a wide range of Venetian paintings and drawings from the early years of the Cinquecento through the years 1570–80.

Our aim was to present the century, one of the richest in the history of painting, by shedding a particular light on it. Without being academic or systematic, we showed how, over three generations, pictorial creation in Venice had reflected the rise of Titian, who was active from around 1505 until his death in 1576 — even through certain rejections of his example, such as by Lorenzo Lotto. The presentation, for which I'd asked Richard Peduzzi to design a sober and inviting setting, began with Giovanni Bellini's *The Drunkenness of Noah*, which had concluded my first exhibition in 1956. It was another way, albeit a bit self-reflective, for me to be moved by the circularity of fate.

We then followed, from gallery to gallery, some of the salient developments of that art and that innovative poetic inspiration, which would nourish European painters for centuries: the birth of Arcadic landscape in painting, drawing, and etchings; the advent of sentimental portraits; the influence of Giorgione and Titian on the *terra ferma* painters (Savoldo, Cariani, Romanino, or Dosso Dossi); the countercurrents (Lotto, Pordenone); the attraction of Mannerism; the erotic vein in Tintoretto and Veronese in the wake of Titian's poesie; and the tragic dimension in the late Jacopo Bassano, which shares an equal freedom of form with the late Titian.

I had assembled a committee to help select works and write the catalogue, recruiting major specialists of the sixteenth century in Venice, notably Alessandro Ballarin, Konrad Oberhuber, and Roger Rearick. Giorgione remains particu-

larly controversial in scholarly circles and no doubt always will. To each his Giorgione. As the curator in charge of the Giorgione sequences and to the early years of his students Titian and Sebastiano del Piombo, Alessandro Ballarin attributed to Giorgione paintings that other art historians refused to recognize. This direct presentation of the works would now allow specialists to take a more informed stance, even if opinion remained divided about certain portraits. On the other hand, those who attribute the Louvre's *Concert Champetre* to the young Titian (and their numbers are increasing), and those who credit Sebastiano del Piombo with the remarkable *Judgment of Solomon*, could only feel reinforced in their convictions. It was the same for the drawings: in attributing to Giorgione several drawings often credited to Campagnola, Konrad Oberhuber did not expect unanimous consent; but the comparison of those magnificent pieces allowed visitors to form their own judgments. I decided to let each curator be responsible for his or her own attributions, which were justified in the catalogue by some excessively lengthy arguments. Such gatherings provide a unique occasion for direct comparisons, and this was indeed such a case.

But of course, the exhibition was not intended strictly to fuel scholarly debate. Overall, it was enjoyed by a very broad audience, which was given a once-in-a-lifetime chance to see works whose lyricism and pictorial splendor could be appreciated by all, culminating in the final Titians, one of the most dazzling summits in all of artistic creation—a little, if you'll pardon the emphasis, like Beethoven's last quartets.

The reviews in the international press were nothing short of spectacular. One couldn't ask for a better article than the one Robert Hughes published in *Time* magazine. The only exception was a rather sour piece in *Le Monde*, proving, if proof were needed, that they had never managed to replace André Chastel.

The Grand Louvre

In 1994, in accordance with administrative regulations, I had to leave office and take my retirement. I had asked, somewhat hypocritically, that my departure be a simple affair. I would have liked to follow (and should have followed) the example of Jean-Louis de Cénival, who refused the slightest testimonial or farewell toast when he retired. On his last day, I saw him from a distance, without him seeing me, hang his key on the board for the final time and walk out of the Louvre alone, after forty years in the Egyptian Department.

As for myself, not a stoic by nature and taking advantage of a long eclipse in my sense of humor, I let myself by enveloped by the kindness that inspired all the ceremonies thrown in my honor. I was, I have to admit, deeply touched at the time, even a bit giddy. Only afterward did I stop to realize how much thought and planning had gone into making these events a success.

First, a surprise concert — and it really was a surprise for me — was given in the auditorium on October 1, with major performers who had played there before, such as Shlomo Mintz, Gérard Caussé, Itamar Golan, and Matt Heimovitz. The hall was filled with friends who had come from all over, even from abroad. The program notably included Schubert's great quintet for two cellos, the most tense and emotional of his works. It was enough to make me lose my composure.

On that occasion, I was presented with a charming book, *Music at the Louvre*, an homage by all the Louvre's curators, who had each written a text on an object in their department with a musical character.

After a very pleasant lunch hosted by Jacques Toubon at the ministry, a large reception in the Hall Napoléon on October 25 brought together all of the Louvre staff. It was impressive, and very warm, both in the tone of the speeches made and in the general atmosphere. I received a very

thoughtful gift, a cabinetmaker's "masterwork" from the nineteenth century showing a spiral staircase, in echo of the one I. M. Pei had designed, and in itself the kind of curious object that I adore.

The next day, in the Salon Carré, they gave me a highly scholarly and beautifully published book of essays by my friends, all on subjects concerning French and Italian primitives or on the ways these painters had been seen or interpreted in the nineteenth and twentieth centuries. It was difficult to accept so many tokens of friendship.

After my departure, I avoided returning to the Louvre for a while. No doubt out of discretion, but especially to spare myself the embarrassed encouragements of those who feel obligated to say things like, "Now you can do what you want!" or, "Now you can finally get back to writing!" No, there is nothing encouraging about retirement, at least not for me. Pierre Rosenberg was preparing to take office. I had sincerely hoped he would succeed me and that he would be replaced in the Paintings Department by Jean-Pierre Cuzin. Everything was as it should be.

7

After 1994:
Lavori
in Corso

After leaving the museum, I didn't wish to prolong
my career by performing "customer service" for
the Louvre in the form of lectures throughout the
world, from one Alliance Française to another.
The day after my departure, on October 28, 1994, to be pre-
cise, I settled into a very pleasant country cottage, a kind of
dacha in the Tuileries gardens, which would become head-
quarters of a small association that prefigured the Institut
National de l'Histoire de l'Art (INHA). That May, in fact,
Prime Minister Edouard Balladur had asked me to take charge
of planning the institute and to draft a report defining its
intellectual content and scholarly programs, the partners it
would bring together, its administrative status, its budget, and
its proposed installation in the old Bibliothèque National
building. In drawing up this report, I was joined by Philippe
Sénéchal, an art historian who taught at the University of
Paris, and Alain Seban from the Council of State.[1]

The plan for such an institute went back a long way. I've already mentioned how inadequate we felt the research tools were in the field of art history in France, even as major foreign institutes (such as the Courtauld, the Warburg, the German institutes in Munich, Florence, and Rome, and the institute in The Hague) were being modernized, and others were being created in Washington and Los Angeles.

Various plans for such an institute in France had been elaborated over the previous twenty-five years. In 1973 Jean Coural had discussed the possibility with President Pompidou, who had been keenly interested in such a project, proposed at that time by Jacques Thuillier; but the president's death put an end to that hope. The matter seemed to gain renewed momentum when André Chastel, in a report delivered to Prime Minister Pierre Mauroy in 1983, clearly defined the outlines of such an institute, which would provide both research tools (library and archives) and instruction. Unfortunately, this report was never acted on, partly for lack of a place to house the new organization: several possible sites had been suggested, including the Grand Palais, but none had been accepted. Three years later, at Antoine Schnapper's initiative, an exploratory committee had made a comparative study of the various existing institutes, but again nothing came of it.

The matter was revived seriously in 1989 by Jack Lang, who at the time was minister of both national education and culture. During a conference in Strasbourg that September that brought together art historians from around the world, he officially announced the creation of the institute, to the satisfaction of the international community. This time, there were concrete plans: the institute would occupy some of the space freed up by the transfer of volumes from the old Bibliothèque Nationale site on Rue de Richelieu to the library's new building near Tolbiac. Lang had assigned Pierre

Encrevé and Françoise Benhamou to draw up precise studies on the institute and the art libraries, which were delivered in October 1992. Everything seemed to be on track at last. But alas, the establishment's statute was not ratified by the Council of State at the beginning of 1993.

Nonetheless, the study wasn't abandoned. Assigned to fine-tune the organization of the Bibliothèque Nationale and its two sites, Philippe Bélaval created a space in the Rue de Richelieu building for the future INHA in a June 1993 report addressed to the new minister of culture, Jacques Toubon.

My mission thus aimed at determining the future institute's operational nature and requirements. I handed in a first report in April 1995. I'll dispense with the discussions and episodes that followed, then with my new assignment in October to refine the project.

The proposal, which naturally drew upon many of the considerations raised in previous reports, was in fact fairly simple. It called for, first, a library that would bring together the great Parisian holdings — the Jacques Doucet art and archaeology library, the central library of Musées Nationaux, the library of the Ecole Nationale des Beaux-Arts, and the library of the Ecole des Chartes; second, the creation of an archive, including a photo collection and databases; third, a consortium that would gather all the advanced studies in art history in Paris and the outlying areas, which were currently spread over a number of universities, as well as research centers, scholarly societies, and periodicals. The Ecole Nationale du Patrimoine and the Ecole Nationale des Chartes would be moved to this site. Each organization would maintain its independence, without the risk of being absorbed into the whole, but in a context that would allow for shared contacts and initiatives, if desired. An *établissement public* would assume the management of the institute.

Perfecting the project had necessitated countless meetings

with my team, as one can imagine, especially with the heads of the four libraries.[2] We benefited from the technical support of the E P G L planning team, opportunely placed at our disposal to help study the site.[3]

We were well received at the Bibliothèque Nationale by the president of the library, Jean Favier, and the general director, Philippe Bélaval, who took us around the various departments of the large building. The study was to include a proposal of how these departments and the future institute might share areas freed up by the moving of the books to Tolbiac. We also wanted to discuss some joint scholarly projects with our Bibliothèque colleagues. Our arrival, which I rather naively hoped would be peaceful and even welcome, did not inspire the same enthusiasm on everyone's part. Certain colleagues, notably in the Prints Department, understood full well that the research conducted at the INHA would dovetail with much of their own work and that the presence of a large art library would be beneficial. But everyone naturally feared that our installation in Rue de Richelieu would decrease the space available to them. Did we behave like occupiers in conquered territory? I don't believe so. These tensions were no doubt inevitable, even though, I hasten to add, they were never expressed in a discourteous manner. Anxiety over the departure of the books and periodicals and the fear of seeing the old building shut down could only provoke feelings of unease, even distrust, among the department members. An interministerial arbitration in 1996 reserved the Labrouste room for the INHA library, not for reasons of prestige but out of practical considerations, as none of the departments would ever need that much space. The liveliness of recent discussions on the subject, and on the division of space in general, even after I stopped attending these meetings, shows that these concerns have not subsided. And yet, with the distance I can take from it today, I am per-

suaded, and the directorship of the Bibliothèque Nationale will someday recognize this, that the arrival of the INHA is what helped save their house from the very stagnation they dreaded.

Others needed to be convinced as well. The Louvre's curators were not overjoyed to see the central library of the Musées Nationaux transferred to Rue de Richelieu. They knew that I had supported gathering the various libraries in this place—it was one of the cornerstones of the project—when I was director of the Louvre, and at the time had reproached me for it, sometimes vehemently. I had allocated funds to create special departmental libraries, which I believe my successors have continued. I would wager that in four or five years, when they can take full advantage of all the documentary resources offered by the new library on Rue de Richelieu, notably the free access, the curators will see it as purely beneficial. The very principle of the institute, moreover, implied the museum and library curators' active participation in its activities, leading to more frequent exchanges between the curatorial and professorial communities.

The university professors constituted a third front. We eventually won the trust of the art historians, university professors, researchers, and curators, over the course of their annual meetings.[4] But we were treated first to a real insurrection, complete with petitions and complaints, which turned out to be based on a misunderstanding. A poorly worded document had led them to believe that the twentieth century was not included in the research programs, which would have been absurd. It had always been understood that the field of research would be very broad. Several meetings with university representatives clarified the situation on this and other points, such as the participation of the provincial universities, museums, and research centers, as well as the institute's international role.

Officially accepted at the ministerial level in April 1996, the project then became subject to the vagaries of political change and, to further complicate matters, of three ministries, Education, Research, and Culture, whose enthusiasm for the project waxed and waned depending on the ministers and their respective advisers. Not all had the determination of Pierre Encrevé, Catherine Trautmann's adviser, who was particularly familiar with the project. But I should note that these prevarications were not politically motivated. The project finally worked its way through the various cabinets and ultimately resulted in the creation of the Institut National d'Histoire de l'Art in July 2001 with Alain Schnapp as president.

I had effectively passed the torch to Schnapp in 1999. A professor at the University of Paris and an internationally-known archaeologist, he was one of those rare individuals who enjoyed the trust of all his colleagues. We had approached him knowing that he was free from any spirit of personal ambition or intellectual hegemony. After more delays owing to budgetary restrictions, as well as to some temporary misunderstandings within the ministries, he finally opened the teaching and research facilities of the Institut at the end of 2003 and is working on grouping the libraries in the Labrouste room of the Bibliothèque Nationale.

I had participated in developing several research programs, each under the guidance of a scholarly adviser.[5] Today, I have gladly reentered the ranks by taking part in one of these programs as a researcher.

So let's be optimistic. The INHA, as we dreamed about it in André Chastel's day, is already asserting its identity. Even before settling into its definitive home, it is defining a rich and coherent scholarly program. Thanks to the presence and activities of researchers from both the universities and museums, and of the students, some fifty of them, that Alain

Schnapp has brought over, a truly international research foyer is beginning to take shape. Conferences and exhibitions in the provinces are being organized jointly by the museums and the universities. Last year, it took only a rumor that the project might be canceled for institutes and research centers the world over to come to its support. It was the kind of thing that erased any trace of retrospective doubt or impatience.

The question everyone asked when I retired was whether I would start writing again. The truth is, during my years at Orsay and the Grand Louvre, I wrote a lot. Or rather, I turned out a large number of articles, prefaces, and essays to try to explain or comment on what we were doing.

Still, I never abandoned my work on the Sienese painters or the French and Italian primitives. I wrote several articles on Pietro or Ambrogio Lorenzetti and, over the past few years, other essays and contributions to international conferences on these painters, as well as on Simone Martini or Fouquet. I am encouraged by my Sienese friends at the university and in the superintendence, who gladly include me in their activities. In 2003, for example, I helped prepare the Duccio exhibition that was held that fall in Siena.

I also plan to write a history of Sienese painting focusing on the great period from 1290 to 1350, with Duccio, Martini, and their pupils, the Lorenzettis, and several others — a book that will discuss the relations among artists, the links between painting, sculpture, and precious objects (notably pieces imported from France and Northern Europe), and the network of civil and religious patrons. The book will include — and this is the part that really excites me — a catalogue of all the works by these artists in museum collections with arguments supporting the attributions. My friends laugh that I'll never finish such a huge undertaking. It's up to me to prove them wrong.

I have always enjoyed working on a team and so have been involved in several collective publishing projects, such as guest-editing the *Revue de l'art*, alone or with Antoine Schnapper, or acting as general editor for two large volumes on *The Art and Spirit of Paris*, recently published by Abbeville Press in New York and Editions du Seuil in Paris.

I had met Georges Duby as he was making a series of television films about cathedrals. We had friends in common, such as Soulages and Jean-Michel Meurice. I was also able to appreciate his interest in the intelligent spreading of knowledge. He had put his intellectual authority and imagination in the service of a true cause: the creation of a public television station devoted to cultural matters. This was that channel called La Sept, then Arte. I would myself be associated with the development of Arte, on a more modest level, by serving on the consulting committee that helped choose its programs.

Duby had come up with the idea of a huge history of European art for Editions du Seuil and had begun working on the first collaborative volume, devoted to the Middle Ages. He first approached me as a possible contributor, and then, seeing how much the subject interested me, realized I could contribute more than just my writing; and so he invited me to co-edit the series with him. We began by organizing the first volumes, on the Renaissance and the eighteenth century, and by choosing the authors together. This new collection means to mix general history and art history, each illuminating the other. It will also include a series of more specific texts, which will highlight certain key points of architectural, art, or "cultural" history. After Duby's death, Philippe Sénéchal and I continued on in the same spirit. A subsequent volume, on the seventeenth century, was published in 1999.

Returning for a moment to the INHA, I have also joined in one of its long-term programs: establishing a complete repertoire of Italian paintings conserved in France, whether

in museums, churches, or various public institutions. This research is part of an INHA program on the history of taste. Indeed, our ultimate goal is to establish when, why, and by whom these works were appreciated, imported, and collected in France. In the end, the results of this research, when cross-referenced with all the information gathered by other INHA researchers on collectors, will be the basis of an in-depth historical, sociological, and economic analysis. In the meantime, we are setting up a useful resource for specialists of Italian painting, in both database and printed form—a bit like the census Federico Zeri and Burton Fredericksen drew up twenty years ago for the Italian paintings in American collections.

For the primitives, I kept many notes dating from the time when I worked in the Inspections office. At the end of my road, I'm coming full circle with what I was doing at the beginning of my career, except that my notecards, which I used to stuff into shoe boxes, are now entered into a computer. And there's another difference, this one significant: when I gather up my piles of photos to go chasing after attributions or information from specialists, our positions have been reversed. Today, the ones who know, the ones I'm going to consult, are much younger than I. Now it's their turn.

———

Four Mentors

The following essays
were written by Michel Laclotte
in homage to his mentors.

Jean Vergnet-Ruiz, 1896–1972

———

Correggio, Stendhal, Venice, *The Marriage at Cana:* he savored such creative summits with a profound sensuality and an enlightened sense of true greatness. But as he had no trace of intellectual snobbery, he also recognized the aristocratic right to bestow pleasure in Gilbert and Sullivan or in some carousel horse from San Francisco. Of all his lessons, this was surely among the most precious. It prescribes an eagerness to taste new things, a refusal to reject any dish *a priori*, a constant receptivity in one's appetite — in short, curiosity and tolerance. Of course, such an attitude does not mean systematic eclecticism. He had (and his friends could cite many examples) violent dislikes, which might be perfectly unjustified but were no less irreversible! The willingness to taste an unfamiliar sauce doesn't mean you'll necessarily end up liking it . . .

His preference was for a simple, exact style. How many times did he protest the overuse of needlessly formal language? "Why," he said over and over, "say 'to select' when you

can say 'to choose'?" There was nothing pedantic in his insistence on good writing, only a love of naturalness and a respect for true traditions. Hence the manner he sometimes adopted, the pleasant whiffs of archaism that scent his writings, and a few innocent idiosyncrasies of pronunciation.

In his best writings (letters and postcards to friends, portraits sketched for his own pleasure, and sometimes even business correspondence, in which he displayed a wicked insolence that was all the more succulent in that he maintained the requisite courtesy of tone), his rightness, vigor, and verve were inimitable, their scathing humor worthy of Léon Daudet. His precise, lively prose perfectly mirrored the clarity and joyfulness of his daily comportment, his distrust of lyrical flights — he looked to painting, music, and nature to move him emotionally, rather than to stylistic fancy — and, more than anything, of pseudo-philosophical abstractions. Often he warned us against the wordplay characteristic of a certain brand of French art history, the unrecognized bastard child of Focillon (whom he respected), weighted down with biblical parabolas, cosmic panoramas, and vague approximations.

In his youth, he had been a friend of Aragon and had known Breton and Eluard. Through them he had frequented Surrealist circles, savoring, as he did in Apollinaire, Max Jacob, or Poulenc, how irony can lend a note of tenderness to the most ludicrous mysteries.

However much he could by predilection take pleasure in the art of the past, he understood that his primary task, opening the provincial museums to the life of our times, obliged him to revise his views of modern art. He therefore encouraged, with his habitual honesty, liberalism, and curiosity, any impulse that would bring contemporary creation into these museums. We know how hard he worked to allow his friends Georges Grammont and George Besson to donate, as they wished, their admirable collections to Besançon and Saint-Tropez, respectively.

No one was more convinced than he that provincial museums needed to "modernize" their displays in order to speak to today's world. But he often protested, not always successfully, against the massive tendency to hide away works deemed irrelevant to this world—when taste is such a mutable thing—and against the purifying frenzy that, under the guise of "modernization," destroyed or defaced so many nineteenth-century decors. It takes more than stripping a cornice or hanging rail of its frills, or slapping a coat of white or "cream" paint on the walls, to turn a gallery into a place of delectation. He understood this well before almost anyone else, battling in the name of history and imagination against the tide of stylistic uniformity, the pretext for so much vandalism. His friends recall his imprecations, upon entering a church he had loved before its renovation, when he discovered the combined misdeeds of Roman-Jansenist "purity" (which had come back into vogue since the war) and the new liturgies: "They've done it again," he grumbled in dismay, "gone and stuck a kitchen table in the transept crossing."

Whether denouncing an unfounded attribution, engineering an opportune purchase, harmoniously arranging a display case, or writing a catalogue preface, his culture and taste were always in evidence. But more than that was needed to accomplish the task he had been assigned, and this is where he proved incomparable. For this "curious fellow," to use an eighteenth-century term with its connotations of elegant and fickle-minded amateurism, also had a logical mind that was quick, wide-ranging, and far-sighted. He was able, after a single visit, to define a museum's true and hitherto unrecognized "vocation," which would structure its reorganization; to conceive massive projects, such as regrouping the Campana collection in Avignon or D'Angiviller's commissions (which he dreamed of reuniting and which we'll perhaps undertake someday); or to manage restorations, deposits, exchanges,

and exhibitions—in short, to imagine and apply a new policy on the national scale.

Why not say it? The breadth of such a program, its indisputable successes, and the network of fertile friendships he established throughout France must have filled some people with envy. His rectitude, his disdain for courtesan compromise, no doubt some lapses in tact, a few witticisms complacently repeated—all this encourages backbiting and gossip. From that point on he ran up against countless petty persecutions. He suffered from them, no doubt more than he let on, but he never gave in.

People criticized him for his Manichean partiality, and there was undeniably some truth to this. But with the passage of time, we can stand back and wonder if he was really so mistaken in his distinctions between "good" and "bad angels." Those provincial curators whom he befriended, those he championed, helped, liked, as well as those he helped but didn't necessarily like (how often did he counter our ill will by saying, "No, trust me, he has many fine qualities . . .")—haven't they proven to be, with precious few exceptions, our most competent colleagues?

For fear of indulging in a simpleminded hagiography that his sense of humor would have derided, and bearing in mind the extreme modesty he imposed on himself in his relations with even his closest friends (no doubt the flip side of a sensibility that could easily be moved to emotion), I feel somewhat embarrassed to mention his generosity. It is nonetheless up to me, more than to the others whose careers he launched, as he launched mine, to pay tribute to his attentive and discreet tact, the gruff warmth of his affection, his lack of self-interest, his self-effacement in the team's effort at the moment of success, and, in a word, his goodness.

Published in Jean Vergnet-Ruiz 1896–1972: Souvenirs, notes personnelles et témoignages *(Paris: Les Presses Artistiques, 1972)*

Charles Sterling, 1901–1991

Struck in the heart by the recent loss of his wife, Charles Sterling died on January 9, 1991. Three days before he passed away, he had the final joy of holding in his hands, just off the presses, the second and last volume of his monumental *Medieval Painting in Paris*. Thus ended a long career, at the height of its creative activity.

He was born in Warsaw in 1901. After studying in Poland and England, he continued his training in Paris (1925–28) and chose to make France his home, becoming a citizen in 1934. Like some of the best historians of his generation (Jurgis Baltrusaïtis) or the following one (Louis Grodecki, André Chastel), he was strongly influenced by Henri Focillon, whom he considered his mentor. He joined the Paintings Department of the Louvre in 1929 and stayed there until 1961, apart from the war years which he spent in New York, where he was welcomed by the Metropolitan Museum. From 1969 to 1972, he taught at the Institute of Fine Arts at New York University, while maintaining close ties with his colleagues at the Louvre, who were eager to benefit from his opinions. It was to the Paintings Department that he bequeathed his library and incomparable photographic archive.

After some initial research for his own interest into sixteenth-century Dutch landscapes, he concentrated his efforts on French painting. Participating in the scholarly activities of the Paintings Department under Paul Jamot, then under René Huyghe, he wrote or collaborated on several of the catalogues that accompanied the remarkable exhibitions organized in Paris before the war — exhibitions such as *Degas* in 1931, *Chassériau* in 1933, *Italian Art* in 1935, *Cézanne* in 1936, *Rubens and His Times* in 1936, and *Masterpieces of French Art*

in 1937. As such, he contributed significantly toward making exhibition catalogues into first-hand reference works. This period of his career was dominated by the exhibition on the seventeenth-century realist painters (1934), which completely transformed our view of French painting of that century by shedding light on Georges de La Tour and many other major artists. The catalogue for this exhibition has since become a legendary model.

While maintaining his interest in the seventeenth century in France—let me at least cite his article on the Blanchards from 1961 and his participation in the *Seicento Europeo* exhibition in Rome (1956) and in the Poussin exhibition of 1960—he undertook an in-depth study of the "French primitives" in 1937 that constitutes his magnum opus. Two synthetic works (1938, 1942) and countless writings and articles on the artistic centers (Provence, Burgundy, Auvergne, Picardy, Savoie, Paris) or figures (Quarton, Beaumetz, Changenet, Lieferinxe, Perréal) that he had identified, constitute a corpus on the French fourteenth and fifteenth centuries comparable to what Berenson and Friedländer had accomplished for the Italian and Flemish primitives. It is on the level of those great pioneers that we must situate Sterling in the historiography of our time.

In a filmed interview produced by the Louvre in 1989, so moving today and so precious for preserving his memory, he defined himself, with the touch of wit that his aversion to ostentation dictated, as a "hunter in the darkness of the Middle Ages." Indeed, his aim was to prepare unknown or ill-explored terrains (certain historians even deny the existence of a French "school" of medieval painting) and to set in their rightful place, from both a historical and critical standpoint, the creators and currents that define or participate in a given spirit and a style—in other words, to create, without neglecting the classic texts, a new field in art history.

There was no theoretical or methodological *a priori* in his research. Rather, he employed a variety of investigative or demonstrative methods, including direct, sensual knowledge of a work, enriched by his experiences as a curator at the Louvre and the Metropolitan Museum, which allowed him to bring from the shadows a host of unknown canvases; the punctilious erudition of the cataloguer, archivist, and historian of political, economic, and social facts; and reference to an inexhaustible set of "paragon" images (he was, not surprisingly, a friend of Roberto Longhi's), which led him in his publications to juxtapose significant details that proved the pertinence of his assertions. His colleagues and students in Paris and New York will always remember those dazzling evenings, in his apartment on Avenue d'Iéna, his house in Breval, or his office at New York University, where he "tested" his theories by clearly demonstrating them through photographic comparisons.

He was a lawyer eager to convince and a writer with a clear and evocative command of language in the tradition of Focillon. "Painting should not be talked about, it should be shown," he would say. True, but he was also admirable when it came to talking about painting, as witnessed by his masterful study of still lifes that appeared after the memorable 1952 exhibition at the Orangerie.

His interests were not limited to French painting, of course: one need only consult the bibliography published in the 1975 *festschrift, Études d'art français offerts à Charles Sterling*. Preparing for the Pelican History of Art a synthetic work on fifteenth-century European painting (apart from Italy and Great Britain), a text mainly written by him but sadly still unpublished, he widened his field of research to other schools. In the studies he published on certain Flemish (Van Eyck, Christus), Spanish (J. de Borgona, J. de Nalda), Portuguese (N. Goncalves), German (Moser, Multscher), or Piedmontese

painters, he applied the same rigor and displayed the same imagination in the reconstruction of historical truth.

Published in Burlington, *April 1991*

Roberto Longhi, 1890–1970

To begin with, I must admit being impressed by the monumental solemnity of this prestigious setting, in which we are gathered to honor Roberto Longhi.* Impressed, and obviously moved, but also a bit ill at ease, so little can I reconcile my personal memories of Longhi with any notion of pomp, ceremony, or official trappings. I can almost imagine him hidden in one of the historic paintings hanging above our heads — paintings very different from the kind he liked — hidden and watching us, a cigarette in his lips, with his wicked and mocking eye. He was an extraordinary actor, as we all know. I therefore imagine him, as I often saw him during one of his terribly accurate and irresistibly droll parodies, imitating me in my pompous role as official panegyrist. The amused wink he sends me across the years is not only a reminder of the personal affection that bound us, but also a broader warning, which is part of the lesson he taught us in his lifetime. This lesson concerned the indispensable and often beneficial need to exercise our own independent judgment, which dissects and denounces anything artificial, fabricated, or dictated by mere appearance. Ironic humor is one of the weapons that most effectively unmasks pontificating vanity, snobbery, or social and (especially) intellectual arrogance, and we all know how good he was at using it.

*This homage was delivered on May 9, 1991, in the Hall of the Five Hundred at the Palazzo Vecchio, Florence.

But irony is not only a critical tool, something one trots out in a debate to expose the weakness of an argument or the absurdity of a pose. The gift of irony, the ability to analyze the humor in a thing seen, is also a valuable method that he sometimes employed in his own artistic analyses. Those who were fortunate enough to visit a museum or exhibition in his company or to sift with him through endless piles of photographs, remember how he could spot in a canvas the ludicrous detail that betrays a stylistic incoherence or paints it over in ignorant restoration. And how often did he notice (but this time in a positive and sympathetic spirit), and make us notice, the unexpected and ingenious humor of a composition or agreement of colors, the entertaining discovery that might emerge in a narrative interpretation, which were sometimes the result of great artists — Bonnard, Lorenzo Lotto, his beloved fourteenth-century Bolognese — defying the conventions of their time? In fact, if I am trying to elevate Longhi's magisterial gift for irony to the status of a lesson, it's because it is part and parcel of a much broader and more complete critical faculty, one based on his independence of judgment and his freedom in choosing the means to express that judgment.

Independence, freedom of expression: Longhi's views and writings were imbued with these until the very end, with no trace of ossification or academicism. Now that his complete works have been published (even if some notes still remain to be deciphered); now that anthologies, theses, and books have been written on him and his works, he has passed into posterity, and is therefore untouchable, indisputable.

This is why it is important to recall — and I'd like to stress this point, as the younger generations are increasingly unaware of it — that this critic, this historian, this writer who today is so highly praised and seen by everyone as one of the two or three greatest art historians of the twentieth century, and even by some — myself included — as *the* greatest, was

highly controversial during his own lifetime. Controversial, disputed, even insulted. He was the opposite of what we call in France, to designate those university dons collapsing under the weight of their academic honors, a "mandarin." Of course, to be frank, his wit and talent as a polemicist and pamphleteer left behind a number of casualties precisely among those mandarins.

Moreover, he vigorously defended the cause of "good government" versus "poor government," which inevitably brought down on his head the active hostility of those in power. It is therefore no surprise that his campaigns and his dazzling personality should arouse ferocious jealousies and lasting enmity, even affecting some of his former students, who often — this needs to be mentioned, as it is too easily forgotten — suffered in their university careers because of their attachment to the master.

But the main reason Longhi was so disputed lies not so much in his taste for provocation and polemics or in the combative aspect of his activities. Any polemicist knows that this is the price he must pay. No, the reason he was so unpopular is essentially the novelty of what bothered his enemies — the word is not too strong, as I knew people who denied the value of his entire opus. It was, quite simply, the radical originality of his views as a critic and historian. We cannot comprehend these rejections and reservations without likening them to the passions stirred by avant-garde tendencies in fields other than art history. I'm thinking, of course, of the visual artists themselves, the "rejected" revolutionaries of the late nineteenth and early twentieth centuries — the comparison is self-evident, and we know that in his youth Longhi already favored Cézanne, the Impressionists, and the Futurists over the accepted art of his day — but also of independent creators such as Le Corbusier, who was admired in his lifetime by a select circle but vilified by the mainstream; or of certain mis-

understood scientists or inventors. Longhi belongs to that race of innovators who are disputed during their lifetimes, but whom posterity puts in their rightful place, the leading place, in their chosen field.

This is not the context—and it would take far more than the allotted time—to discuss all the ways in which Longhi was an original. I would like simply to highlight a few notable traits that set him apart from his contemporaries and that characterize his singularity.

First and foremost was the breadth of his interests, his curiosity. Let us be clear: when I speak of curiosity, I don't simply mean his ability to appreciate Picasso *and* Titian, Seurat *and* Giovanni da Milano. Any sensitive critic or art lover can do that. What was new in his approach was how he broadened the field of firsthand scholarly research, what you would call philological research, to encompass the totality of Italian painting, from the thirteenth to the eighteenth century. Before him, Cavalcaselle, Berenson, Adolfo Venturi, and Toesca, to name only the greatest, had limited their field of study to all or part of the Renaissance, the fourteenth, fifteenth, and sixteenth centuries, while the few specialists of the sixteenth and seventeenth, such as Hermann Voss, did not treat the preceding centuries.

In this regard, Longhi opened a path that today is widely followed by art historians, who lightly skip from one century to another in their attributions. Longhi's lesson on this score is important: it's over the long haul that the constant characteristics of a style or spirit can be measured. He clearly demonstrated this vis-à-vis the Lombard School, which stretched from the fourteenth to the eighteenth centuries, even though its composition as a school was less classical than with the schools of Venice or Florence, for example. This is also what allowed us to recognize revivals, breaks, gaps in inspiration, and true stylistic revolutions.

The breadth of his vision was both chronological and geographical. To study Italian painting, one also has to study, as a connoisseur and a discoverer of unknown works, all of European painting. Of course, in the 1920s there were some experts who could identify *both* an unknown Velázquez *and* a Rubens, or even a Ter Brugghen. What Longhi contributed in addition to this, and no doubt at the time he was among the very few, was the ability to integrate such discoveries into a completely new, overall historical and critical viewpoint. This was the case, for instance, in his studies on the European Caravaggesque movement or on the eighteenth century in Italy and Spain. It was also the case when he suggested that the work of Fouquet, Quarton, or Jaime Huguet fit into a Mediterranean current that included the Tuscany of Domenico Veneziano or Piero and the *mezzogiorno* of Antonello, and that we cannot fully understand any of these artists if we don't know the others. All these ideas, which clearly surpass widely held notions on Italianism in northern Europe during the Renaissance, today seem self-evident and generally accepted. But they weren't so when Longhi first posited them.

By thus widening the boundaries of study, Longhi acted as a conqueror, an explorer, a discoverer, with the share of temerity, gamesmanship, and risk-taking that such an adventure entails. That Longhi was something of an "adventurer" (with all the quotation marks the term requires, to avoid pejorative connotations), there is no doubt. It is part of his dazzling singularity. He took risks; he proposed surprising, even shocking, attributions, sometimes amid a flurry of new propositions, such as in his explosive notes to *Fatti di Masolino e di Masaccio*; he exalted artists who until then were considered obscure or else committed the blasphemy of pointing out weaknesses and limitations in undisputed artists; and he distinguished, from one individual to another, one school to another, previously unsuspected relationships that wove a

convincing historical fabric. As such, he ultimately built a new history of Italian painting that was noticeably different, in many essential respects, from the one everyone recognized fifty or sixty years ago.

Now that time has passed, and that his complete works give us a panoramic view of his innovative proposals, of that history of Italian painting that he composed from 1910 to 1970, how can we not be amazed by the breadth and solidity of his corpus, which remains just as fresh and stimulating as ever? This corpus was not elaborated in a methodical and rational fashion, like the work of Max Friedländer, Richard Offner, or even Berenson, but built in fits and starts, dictated by his discoveries about six centuries of painting, with no logic or constancy in the form or order of his publications. But today, the internal coherence of his corpus is plainly visible, and its general design, its architecture, is superbly reestablished.

In this immense production, there are certainly — it would be absurd and vain to deny it — some attributions that have had to be rejected or that remain problematic, some debatable chronologies and questionable value judgments. The fact remains that this portion of Longhi's work is much smaller than for other great art historians of his century. And it has often been said, and I will repeat it again, that even his errors are interesting.

I have neither the time nor the pretension today to recap the history of Italian painting as Longhi the Conqueror mapped it out when he broadened the limits of the known world. He discovered and revealed unexplored or forgotten lands, such as the Caravaggesque continent, the islands of Bolognese and Umbrian Gothic, the river that flows from Borgo Sansepolcro to Venice. He put order into territories that had already been explored but lay fallow, such as Ferrara, or had been so worked over and plowed that the original design had been lost, as was the case with Giotto-ism,

Tuscany of the first Renaissance, or Venice. Never fear: I'll stop here with my heavy-handed metaphors and simply say that Longhi's contribution led to a phenomenal recalibration of our knowledge about entire centuries. Thanks to him, for example, we now consider that the technical know-how of the fourteenth-century Tuscans, which earned them countless commissions and the near-exclusive admiration of nineteenth-century collectors, doesn't always match the visual and expressive innovations of the Bolognese, the Umbrians, the Giotto-esque "dissidents," or the ablest of the "Padani." Thanks to him, we can measure the importance of Lombardy (already affirmed by his mentor Pietro Toesca for the Trecento and early Quattrocento), which remains a source, a ferment of innovations from the fifteenth to the eighteenth centuries, in the face of the official and universally acknowledged predominance of Florence, Rome, Bologna, and Venice. Thanks to him, we understand that the so-called Baroque centuries were not only the time of Pietro da Cortona and Tiepolo, but also of Cerano and Baschenis, Ghislandi and Crespi, Ceruti and Traversi. Thanks to him, we see that two painters — Piero della Francesca and Caravaggio — stand in the midst of their respective eras like axes, central figures, while everything else falls into place around them.

In drawing this new, more accurate, more complete, and more balanced map of Italian painting, Longhi was largely seconded as of 1940 by his students and friends at *Proporzioni* and *Paragone*. He set them on paths that he blazed through the wilderness, and later they themselves engineered new conquests of their own. This needs to be mentioned here, for another of Longhi's great merits is that he gathered around him some of the most gifted young art historians of his day, who have now become mentors in their own right.

Eager as he was to restore little-known figures to their rightful place, Longhi still did not ignore the recognized sum-

mits. Sometimes this meant giving an irreverent nudge to the
base on which the statue rested, causing it to totter a bit—
Raphael and Leonardo were two targets of his passing annoy-
ance; and sometimes his ill humor was deeper and more last-
ing, as in the case of Tintoretto and Tiepolo. Much more
numerous, of course, were the cases of great artists whom he
took almost entirely in hand, although this did not always
lead to a revision of their place in the scale of established
values. Think of Giotto and Masaccio, Bellini, Giorgione,
and Titian, or Correggio. Or else there were cases of once-
prominent painters who had now been forgotten, or rather
obscured by the wave of retroactive "modernity" that he
himself had helped set in motion. I'm thinking of artists
like Beato Angelico, Carpaccio, the Carracci, or Veronese,
whom he held firmly above the flood tides among the great
innovators.

At the same time, he vigorously refused to look at an older
work through "modern" eyes. In other words, he might use
Piero della Francesca to explain Cézanne, but not vice versa.
And he kept his distance from the often exclusively literary
enthusiasms for so-called precursors of contemporary art.
For him, Cambiaso did not prefigure Cubism or Surrealism
any more than Paolo Uccello did, even if it was the Cubist
painters and Surrealist writers who most appreciated and
rehabilitated these artists.

In writing "his" history of Italian painting, according to his
own scale of values, Longhi highlighted his personal favorites,
if only through some of his silences. These favorites address
what we might call, for lack of a better term, pictorial truth,
or else the painting of reality, of what we see. Which made
him even less receptive to what he considered the artifice of
Mannerism, grand Baroque decors, and Neoclassicism.
While on the subject, I can't help wondering what he would
have thought of the huge David exhibition in 1989, in which

the great neoclassical painter clearly emerged as the last of the Caravaggisti.

These days, should we adopt all of Longhi's views, his predilections and rejections, blindly and without exception? Of course not. As I said at the beginning, Longhi's primary lesson was one of independence and critical freedom with respect to "authorities." With regard to him as well, it would be ridiculous and counter to the spirit he inculcated in us to promote some dogma of infallibility.

So it was that none of us felt guilty at not reserving for Pietro Longhi or Antoniazzo Romano — who were nonetheless excellent painters — the same indulgent tenderness that Longhi had for them. None of us hesitated, if such was his taste, to admire the grand opera of the Scuola di San Rocco or the chamber music of Lega or Fattori.

I said earlier that one of the most original features of Longhi's corpus was his expansion of the chronological and geographical territory he covered in his research. Since then, the field has been still more widely explored, enlarged, cultivated. This is a good thing. Research should deepen and progress, but on one essential condition: that the highlighting of new works and artists be subjected to the criterion of quality. The statement might seem naively banal and self-evident, but it is motivated by a slightly alarmist observation. Over the past twenty years, we have seen a multiplication of monographic or patrimonial exhibitions, with sumptuously produced catalogues, notably thanks to the intelligent generosity of Italian business concerns. How can we not welcome this? Because of it, indisputable masterworks and truly remarkable discoveries have been honored. But it is not certain that all the works thus revived are equally deserving. How many small provincial masters have been hoisted far too high, supported by regional pride or the merchandising needs of the art market and overvalued by the magic of smartly chosen

photographic details? A current tendency in art history, one that is very potent and widespread, consists in putting everything on the same level in egalitarian fashion, on the principle that "everything is interesting" for analytical (which usually means iconographic or technical) study. As such, we are given useful information on the practices of studios, the mechanisms of commissions, the religious or social motivations implied by the subject of the work and its interpretation. I won't deny the sociological and historical interest of this research, which is obvious and largely demonstrated by works of the first rank.

By the same token, however, such research cannot give a complete picture of artistic creation if it rejects or neglects any stylistic analysis, in other words, if it does not include a properly qualitative appreciation of the work in question. And this is where we encounter Longhi's fundamental lesson, which is still relevant today and to my mind constitutes a necessary warning: the accent he put throughout his writings on quality, on what distinguishes one work from another (based on a motivated critical appreciation, and not just a simple impressionistic glance), on the "value" of the individual, concrete work, which does not look like anything else. We must never forget this lesson, which provides an antidote, or at least a counterweight, to certain recent tendencies in art history that too readily use the work as a sociological or psychological "document," an "image" whose physical nature is ultimately irrelevant.

To discern the quality of a work is first to determine and define its "identity." And here we touch on the problem of attribution, which is central when speaking of Longhi. He was certainly not the only one to play this sport, on which, after all, the historical classification of artworks has been based for more than two centuries. And yet, it is his name that most often comes up when discussing this operation, the process of

calling up a name, through visual associations in memory, that gives a hitherto anonymous or misidentified work a provisional or definitive identification. It was in this domain, owing to the breadth of his knowledge and the dazzling sureness of his diagnostics, that Longhi truly demonstrated his powers as an enlightener. *Paragone*: the magazine's title is clear. Art history is all about comparison. Hence the infinite but intelligent game of juxtapositions that allows you to identify the author of a work, possibly this work's place in a larger ensemble (such as a polyptych), and its place in the artist's career. In this light, the concrete analysis of a work of art correctly situated among other comparable works, becomes a foundation of knowledge.

As you know, it was on the basis of several remarkable attributions that Longhi completely revamped our knowledge of certain great masters. I'll cite in this regard only two or three significant examples: Domenico Veneziano's *The Adoration of the Magi* in Berlin, or the *Altarpiece of Saint Vincent Ferrer* in the church of San Zanipolo and *The Drunkenness of Noah* in Besançon, which illuminated the career of Giovanni Bellini from beginning to end.

Nevertheless, attributionism was put on trial and mocked. People poked fun at frequent changes in the attributions of famous paintings, which threw doubt on the possibility of ever discovering the truth. They made facile comparisons between connoisseurship and sleight of hand, even charlatanism. As far as French critics and historians are concerned, many of whom participated in those smear campaigns three decades ago, I can assure you that not one of them would have been capable of distinguishing a sixteenth-century painting from an eighteenth-century painting! Much more serious and well-founded were the critiques leveled against those who were content, in publication after publication, merely to assemble "expert opinions" or catalogue entries. We

all agree that art history demands more than those exercises, useful, brilliant, and accurate as they may be; but this is no reason to pillory "attributionism" as such. The point is (and here again, Longhi's lesson remains invigorating), attributions were simply a means for him — an indispensable one, based on his unique faculties and connoisseur's eye, but nothing more.

Once practiced and digested, so to speak, attributions will naturally be integrated into a complex analysis and hopefully confirmed by documentary proof. One example of this (and I could cite many others) was when Longhi rediscovered, at San Domenico Maggiore in Naples, Titian's *Annunciation*, which had lost its identification but which was in fact signed and abundantly cited in period documents.

A final word on attributions, which will allow me to underscore Longhi's generosity by recalling the exceptionally liberal way he bestowed them. He was not like the greedy inventor who keeps his discoveries for himself, I can attest to that. I hope you'll allow me to relate a personal anecdote. It was over thirty-five years ago, not very far from where we are gathered this evening, in a café on Piazza della Signoria. Horribly intimidated but encouraged by my friend Luisa Marcucci, I telephoned Longhi, whom I admired passionately but didn't know personally, and asked if we could make an appointment. He agreed to see me the next day. I had brought with me files containing hundreds of photos of Italian primitives in provincial museums, for which I was preparing a catalogue. He knew a good number of the paintings and had published several himself, but many more remained unpublished. In several hours, which are among the most memorable of my life, he baptized most of these strangers and gave them to me under the names he had devised for them. From then on, whenever he visited Paris or I went to Florence, he renewed his gift with further attributions, just as important and freely bestowed.

Longhi's youthful influences have been carefully studied: his master Pietro Toesca; his admiration for Berenson; his reading of Adolf Hildebrand and Conrad Fiedler on one side, and of the poets Laforgue, Fromentin, and Baudelaire on the other; and of course, the relations between his thought and the aesthetics of Benedetto Croce. All of this had an impact on him, as did his frequent reference to the great Italian and French critical and art historical texts, from Vasari and Boschini to Caylus and Fénéon. He made explicit mention of them in his foreword to the first issue of *Paragone*.

Clearly, however, his work defies classification. The enemy of abstraction in all its forms, he himself never published any truly "theoretical" texts, apart from above-mentioned foreword, which, without indulging in excessive conceptualization, expresses the need to reconcile critical analysis with historical vision. It was on the foundation of this dual and complementary viewpoint that he built and balanced his entire corpus, defining historical time and space by reconstructing a figurative culture—whether an era, group, or school.

We all know his famous quip from 1913 about Mattia Preti: "And now, a little biography, chronology, and documentation: he was born in 1613 and died in 1699." This is, of course, a youthful pirouette, a provocative joke that shouldn't mislead us. The fact is, he completely avoided the pure formalism that the study and practice of contemporary art encouraged in the 1920s. At the time, everyone recited the legendary statement by Maurice Denis: "Remember that a painting, before being a horse in battle, a female nude, or a given anecdote, is essentially a flat surface covered with colors assembled in a certain order."

Instead—but without ever resorting to heavy-handed erudition—he imbued his discourse with psychological, historical, and social asides that recreated the vitality and dynamism

of a particular culture, and the human substance of its art. No historian, whether writing about politics or about the mentality of Ferrara in the Quattrocento or Rome in 1600, can know his subject perfectly without having read Longhi's *Officina ferrarese* and his writings on the Caravaggisti. Longhi's historical imagination, fired by a culture's visual productions and further nourished by his readings of period documents, had a singular ability to capture the moral tone of a time and place.

Longhi suffered from the terrorism of intellectual fashion. He kept a joking distance from it, with the sense of irony that we all know well. He was sometimes blamed for ignoring the fundamental contributions of the Viennese and Panofsky, on which a good portion of Anglo-Saxon art history still rests, along with certain more recent tendencies in France, such as those related to structuralism. In reality, it is not at all certain that he ignored iconology quite so completely. But he chose to practice it differently: not by basing his work on written or figurative documents, and still less by attempting to reconstitute "thematic" structures, as they do today, but by analyzing the deep narrative meaning of the work from within, in other words, from the viewpoint of the painter, the all-powerful creator or adapter of themes, in relation to his other creations or those of his contemporaries.

One anecdote illustrates this point: More than twenty-five years ago, a large and very impressive fifteenth-century Flemish painting was offered to the Louvre for acquisition. The Paintings Department declined on the advice of an American specialist: he had refuted an initial attribution to the Master of Flémalle on the pretext that the iconography — it portrayed the Holy Family with Joseph and the Virgin sitting side by side on a bench — could only be from the very end of the fifteenth century, and not from the Master of Flémalle's era. He buttressed his opinion by citing Panofsky. Convinced that the work did in fact date from the great Flemish period

and not from a later revival and that it belonged in the Louvre, Pierre Rosenberg and I, who at the time had virtually no authority in the Paintings Department, labored in vain to persuade the head curators to make the purchase. We showed the painting to Longhi. He got very excited on seeing it, recognizing along with us the hand of a master from the great period, very near the time of the Master of Flémalle. When we told him about the American's objections, he retorted, "All that proves is that the Master of Flémalle hadn't read Panofsky!" — thereby recognizing that great creators have the right to invent new iconographic themes for themselves, new stories. The tale doesn't end too badly, since the painting, which came from a convent, is today hanging in the museum of the Puy cathedral. In it, one can see a youthful work, painted around 1435, by one of the greatest masters of the fifteenth century, the Master of King René, also known as the Master of the Coeur d'Amour Epris, also known as Barthelemy van Eyck, when he was working closely with the Master of Flémalle. By refusing to follow a monolithic conceptual system, and especially to create a new one that he could impose on his disciples, Longhi provided a tonic example of freedom and suppleness in interpreting sensory data, as well as in the means of expressing such interpretations in writing.

Still, is it appropriate speak of a lesson? Probably not, for Longhi's writing is inimitable, and those who have tried to copy or pastiche it have failed, often becoming painfully embroiled in mannerisms. Longhi's art, his talent as a writer, is clearly one of the main features that distinguishes him from the other prominent critics and art historians of his day, and that now makes him part of Italian literary history, on a par with poets and novelists.

Even the form he gives his writings proves his refusal of convention. Only one of his books, *Piero della Francesca*, truly

fits into the tradition of classical art monographs. His other major works are based on exhibitions (such as *Ferrara* in 1933, the Giotto exhibition of 1937, or the Venetian panorama of 1945) and contain the fundamental rethinkings, ferment of ideas, and previously unknown works that we came to expect of him, in an original form that freely blends discursive prose with meticulous commentary. He showed the same suppleness in his magazine's articles, which range from light "notes" that say everything in a mere few pages to long articles bristling with source references, like *Fatti di Masolino e di Masaccio.* This is another lesson in fantasy and freedom that shows him liberating himself from academic shackles, which today have so constricted scholarly publishing.

In speaking about Longhi's style and use of language, it is difficult for a foreigner like myself to fully highlight all its subtleties. Having once tried to translate a text of his into French, the one on Stefano Fiorentino, I know how complex, rich, and difficult his writings can be, which sadly limits their spread into foreign languages.

Longhi loved literature, ancient and modern, and especially French literature, which he knew like a specialist. He applied the same passion for language and words to his own writings, with a gift for literary inventiveness that has been studied by several prominent critics, and was even the subject of careful linguistic analysis. I won't presume to repeat what has already been said of the famous "verbal equivalents" he practiced, diversifying them with each subject broached, nor of the successive manners he adopted in the course of his career, which became increasingly classical and simplified. What *is* worth recalling, as it relates to lessons that remain valid, is that this verbal creation offers far more than just virtuosity. It is entirely put in the service of a definable intellectual goal: to make the reader see and appreciate works of art through the medium of words. He was fond of repeating

Corneille's famous remark to the marquise: "You will be considered beautiful only to the extent that I have said so."

There is, then, nothing artificial or fabricated in his discourse, no matter what tone, vocabulary, rhythm, or tempo he adopted to "adhere" to the subject, varying them from text to text. There is, on the other hand, a warm and persuasive ease that infiltrates, surprises, provokes, and finally seduces the reader, inspiring him to look at the work both in its real — i.e., historical — context and in the truth of today, as if it were a fresh painting, one just out of the artist's studio, or perhaps still in it.

Longhi's exceptional power to make the past *current*, to harmoniously and synthetically combine critical and historical viewpoints, no doubt constitutes one of the most original traits of what we have to call his genius. As is his ability to translate into words the "value" of the artwork. Such power and ability are by nature unique and inimitable — this goes without saying. What remains is his work, his books, present, invigorating, still current, convincing us with every page that while a painting is "never isolated, always related to something," it is first and foremost a concrete work, the fruit of a specific human effort that we must know how to savor directly and sensually.

It is on this note of sensual pleasure, which reflects his lesson that the *study* of painting must begin with a *love* of painting, that I will conclude this homage to our mentor — a very dim echo of what he brought to us and what he has left for us.

Published in Paragone, *November 1991*

André Chastel, 1912–1990

My remarks here will be personal, but they apply to all those who consider themselves students of André Chastel (even if they never attended his lectures) and who today form, over two generations, a large portion of the French art historical community.

I'll begin in the early 1950s, a time when — let's be honest — academic art history in France was too often confined in timid provincialism, removed from the living sources of information. Emile Mâle had retired; Henri Focillon had died in the United States, and in France his disciples, Jurgis Baltrusaïtis, Charles Sterling, Louis Grodecki, and André Chastel among them, still had no truly public forum. And yet, even before he took over the chair of modern art history at the University of Paris in 1955, Chastel appeared to the young people of the time as their rightful mentor.

What he offered us were teachings whose tone and resonant intelligence were completely new, teachings that illuminated the art of the past through well-chosen references to current events or to other disciplines. With him, we held discussions and visited sites. And then there was the example of his first books, from masterworks of lucid erudition, such as *Art and Humanism in Florence*, to introductory overviews such as his little handbook on Italian art, so accurate and insightful that it remains unequaled. He offered us a second wind, a new momentum, in short, a will to emerge from the isolationism of French art history at the time.

He showed us many different paths. To open the windows and look elsewhere naturally meant traveling, getting to know the art and architecture of our time, and above all finding out about the places where the most interesting research was being developed. I must cite at least a few of the study centers

he recommended, and to which he had the closest ties: the one founded at Yale by Focillon, developed by his American disciples, and frequented by a succession of French "Focillon fellows" in an uninterrupted chain; those in other great American universities, such as New York University, Princeton, and Harvard, where the influence of the great émigrés, such as Panofsky or Walter Friedländer, had sparked the birth of an original and already powerful school; nearer to us, in London, the Warburg Institute, the Courtauld Institute, and the Witt Library, incomparable centers for research, documents, and exchanges; and finally, the German institutes in Florence and Rome, as well as the magnetic presence of Roberto Longhi.

It was with these groups and individuals and with others met later in various parts of Europe that French art historians should maintain a dialogue: that was Chastel's first lesson. And let's not forget that what today seems self-evident and necessary was not always seen as such in the house-bound and ill-equipped France of 1950. One couldn't express such open-mindedness without ruffling a few feathers, even arousing some hostility. The fact that Chastel was refuted by some of his colleagues (whom we of course considered backward or jealous); that his articles in *Le Monde* often hit home and set people's nerves on edge; that he was a friend of Nicolas de Staël and other artists or writers then considered avant-garde — needless to say, all this was fine with us.

Though he pointed out new sources of information and areas of research, Chastel never pushed us in a particular direction. No teacher was ever more liberal than he, and I can attest to this in the name of all his students and friends. His aim was not to recruit but rather to explore the best in each person, while leaving him free to make his own choice of specialties, research topics, and methods.

With an inspiring energy that reinforced his authority, he

encouraged his students to cultivate their preferences: archival research for some, formal analysis, connoisseurship, or iconological interpretation for others. And all the while, he warned us strenuously against the fallacious imbalance occasioned by the exclusive use of a single analytical method. These recommendations reflect not a "doctrine"— Chastel would have none of that—but a profound conviction: that the object under study could be fully grasped only from several different angles and that the discipline by its very nature imposed such a plurality.

This tolerance, this absence of methodological or ideological dogmatism, meant that Chastel's writings and teachings —at the Ecole Pratique des Hautes Etudes, the Institut d'Art et d'Archéologie, and the Collège de France—created not a school or intellectual clique, but a family that encompassed the entire range of academic art historians, independent scholars, critics, and museum curators. Though their interests and aims varied widely, they all recognized in each other a common bond—just as, before the war, "Focillon's students" could all recognize one another.

I cannot, of course, speak in detail about Chastel's own scholarly work, his many books and articles, his work at the Académie des Inscriptions et Belles-Lettres, the periodicals he founded and edited (*Art de France*, the *Revue de l'art*), the conferences and seminars he organized. The importance and seriousness of the tributes that appeared after his death— from the greatest art historians in Italy (not surprising, as he was honored in his elective land as a great national figure), Germany, Great Britain, and the United States—prove that, in the judgment of his peers, his work put him in the top rank of art historians of our time, and that its reach was universal.

It would be presumptuous of me to analyze the components of this work or gauge its influence. I would nonetheless like to highlight briefly two or three traits that help define

Chastel's fields of study and particular manner. The first thing that impelled him was his wide range of interests. Always with the principle massif in view—the Italian and French Renaissance and humanism that stood at the center of his research—there were so many evocative side-trips, notably toward architecture and contemporary art, and all the way to his final, anxious, fascinated exploration of French art, which proved to be his last journey.

Among the traits characteristic of his approach, one in particular bespeaks the total freedom of his views, his rejection of any fixed system or exclusive method. This trait might seem minor, but it is in fact revelatory and singular: it was his way of discerning, in a painting, archival document, or printed text (and here I must stress the importance he placed in the great founding texts of art history, such as Vasari's *Lives of the Artists*) —his way of discerning the one detail that can furnish the key to an interpretation. As he pieced together these observations with the adroitness of a virtuoso, little by little he built an edifice that is logical and persuasive. His *Chronicle of Italian Renaissance Painting* is assembled in this way: by stitching together seemingly disparate articles — I'm thinking of the collections called *Image in the Mirror* and *Fables, Forms, and Figures*—he ended up composing coherent and perfectly homogenous works.

Anyone familiar with his writings knows that one term flows repeatedly from his pen: *articulation*. One of the constant goals of his research was in fact to bring out the articulations that link or, conversely, that differentiate artistic facts. Hence the importance he granted fractures (*The Sack of Rome*), upheavals (*Crisis of the Renaissance*), phenomena of disruption and continuity, of the rejection or absorption of outside influences—one of the major themes of his book on French art. These articulations stretched not only across time and space, but also from one medium to another. He identified

the formal signs that proved the interconnections among the various arts, keeping in mind the importance of ornamentation in transmitting figurative languages.

In the end, the architecture of his most subtly elaborated books can be likened to that of the altarpieces he examined so attentively, in which the various compartments and panels compose a visually unified whole. We see this in his last work, a monumental synthesis of French art on which he was still working three days before his death. I would like to quote a passage from it, in which he defines the ambition of Focillon, but which in fact perfectly illustrates his own ambition toward the end of his career: "This 'symphonic' concept of art history, and of history in general, which in constant counterpoint juxtaposes decorative media and the high arts, latent currents and prominent styles, is the only methodology that avoids abusive fragmentation and the artificial isolation of the component parts, thereby preserving the human factor in research."

We could not speak of his written corpus without evoking the perfection of his style: a light and supple way of suggesting the preferable hypothesis; an unerring sense of the *mot juste* that accurately characterizes the artist or work under discussion; the tone that blends gravity with emotion (though always with restraint), and scathing irony when necessary, as well as a wicked wit — the same wit that illuminated his conversation even in his final, desperate days. Behind so much mastery, elegance, and freedom, we can sense an immense aesthetic culture, both ancient and modern, and on top of that, a worship of great literature.

Publications, teachings, an international scholarly influence sanctioned by the rarest honors: Chastel's work does not stop there, though this alone would ensure his place among the great minds of our century. His work also includes a series of battles, campaigns, pleas, acts of courage and obstinacy. We all remember his articles for *Le Monde*, in which he could inspire

his reader, as no one has since, to see an exhibition or monument, become better acquainted with a book or personality. And those who remember these invitations recall that he could also, when necessary, alert us to a threat or iniquity. Chastel conducted these battles, publicly from his tribunal in the press or privately in exhausting meetings with the powers that be, but always with the same goal in mind: to protect our artistic patrimony and to improve the resources for art historical research in a country — ours — that was severely underdeveloped in this regard. Needless to say, there was no self-interest in this activism, but rather a generous and sustained will, despite rebuffs and resistance, to provide the tools that other countries enjoyed and that we lacked. For those who followed his efforts over more than thirty-five years, it is important to note this.

Without him, and the support he was able to win from Malraux, would the general inventory of French monuments exist? Would the long-standing art historical research conducted at the Farnese palace be complemented by new research undertaken at the Villa Médicis? Without him, would the Comité Français de l'Histoire de l'Art, long stagnant and divided, have regrouped, uniting French art historians of all stripes in activities that were ultimately quite fruitful? And would France have its current standing in the international community, as represented by the Comité International de l'Histoire de l'Art? Finally, and especially, without the indisputable force of his personal authority, would the Institut National de l'Histoire de l'Art, which he first conceived and worked so hard to achieve, have been created, and would it now stand as an effective means of grouping and catalyzing the energies of its members toward a true national resurgence of our discipline?

Certainly, this mission, these actions in the public interest, these exhortations to "good government" (to use the title of

the fresco by Ambrogio Lorenzetti that he loved) encoun-
tered their share of failures. Despite all his efforts, France still
does not offer a degree in art history, which means that young
people in this country do not receive significant training in
the field and therefore remain ignorant and uncaring of their
national artistic heritage. Despite the campaigns he bravely
led, the Baltard markets at Les Halles were demolished, as
the Cluny abbey had been in the previous century. It is there-
fore up to us, to the youngest among us, to pursue his life's
work, what we might call Chastel's "grand design": to institute
art history in France. For the battle he engaged has not yet
been won.

May he thus serve as an example, as a model to those who
believe that a work of art must be studied in order to be
understood, to be loved, and to be saved. May his books con-
tinue to transmit his thought, to enrich the knowledge and
imagination of generations to come. And may his friends
suddenly think of him when admiring an architectural tour
de force, a simple archway, or an unusual staircase, or when
discovering in a painting a detail that would have interested
or amused him: a hidden self-portrait, a fly, a reflection, a fig
leaf in twilight . . .

May his memory forever color our vision of the monu-
ments and sites we enjoyed in his company. In that case, we
will not have lost him completely.

*Homage delivered on October 16, 1990, at the church of Saint-Roch in
Paris and published in the journal* Monuments et mémoires, *1991*

NOTES

3. In the Paintings Department of the Louvre

1. In addition to specialist curators for each school, the team supervising the museum construction projects included Claudie Ressort and, after 1973, Jean-Pierre Cuzin.

2. Coordination with architects and engineers of artificial illumination of the Grande Galerie, which was especially difficult to plan and carry out, was overseen by Jeannine Baticle.

3. At that time the chief curators were, for Oriental Antiquities, André Parrot, replaced by Pierre Amiet in 1968; for Egyptian Antiquities, Jacques Vandier, succeeded by Christiane Desroches-Noblecourt in 1973, then by Jean-Louis de Cénival beginning in 1981; for Greek, Etruscan, and Roman Antiquities, Pierre Devambez; to be followed in succession by Noël Duval (1972), François Villard (1976), and Alain Pasquier (1983). Maurice Sérullaz was chief curator of the Department of Graphic Arts, Roseline Bacou replacing him in 1984; the head of the Department of Objets d'Art, Hubert Landais, was at the same time adjunct to the director of the Musées de France; he devoted himself entirely to that task, and Pierre Verlet took over as head of the department in 1968, followed by Francis Salet in 1973, Léon de Groer in 1979, and finally Daniel Alcouffe in 1981. In the Department of Sculpture, the chief curator was Pierre Pradel, then Jacques Thirion (1972), Victor Beyer (1976), and Jean-René Gaborit (1978).

4. To simplify greatly, since each had other fields of interest, one might indicate that Sylvie Béguin was occupied mainly with the Renaissance in France and Italy, Jeannine Baticle with Spanish painting, Pierre Rosenberg with the 17th and 18th centuries in France and Italy, Jacques Foucart with the Northern European schools, Marie-Thérèse de Forges with the French 19th century, and Geneviève Lacambre with the second half of the 19th century and specifically the paintings formerly in the Luxembourg. Coming afterward, during the 1970s, were Jean-Pierre Cuzin, a specialist in the French 17th and 18th centuries; Arnauld Brejon de Lavergnée, for the 17th and 18th centuries in Italy (he would be named director of the Musée de Lille in 1987); Marie-Catherine Sahut, a specialist in the French 18th century who would devote herself to research on frames and cartels; Dominique Thiébaut, who worked on the French and Italian primitives; Élisabeth Foucart-Walter, a specialist on the German schools responsible generally for paintings deposited outside the Louvre; and Sylvain Laveissière, a specialist in the French 17th century and the beginning of the 19th. The other researchers, attachés, and document specialists included Claudie Ressort, on the Spanish primitives, and Hélène Toussaint,

mainly charged to assist me for exhibitions on the French 19th century and on preparation of the catalogue. A researcher at CNRS assigned to the department, Nicole Reynaud had worked with Charles Sterling and was engaged with the German, Flemish, and French primitives, as well as the preparation of catalogues. A third generation of curators would enter before I left the department, beginning with Cécile Scailliérez. Supplementing all the permanent curators was a continued flow of interns, who included, at the beginning of their careers, Dominique Bozo, Françoise Cachin, José Frèches, and Henri Loyrette.

5. The Service de Documentation was directed by Sylvie Béguin, then, beginning in 1972, by Jaques Foucart, assisted by Isabelle Compin, who was specifically responsible for research in preparation for establishing catalogues and undertaking inventories. Many French and foreign interns worked there alongside researchers, benefiting from an array of responsibilities. These included Jacques Vilain, Claire Constans, Jean-Hubert Martin, Georges Vigne, Françoise Heilbrun, and Marie-Claude Chaudonneret.

6. The export of Georges de La Tour's *La Bonne Aventure*, which came to light when it was learned that the Metropolitan Museum of Art had acquired it in 1960 from the Wildenstein Gallery, caused a public outcry, and André Malraux was made to answer an oral interrogation about it in the Chamber of Deputies.

7. Among the principal exhibitions organized by the department's curators during my time (or ones that they took an active part in), besides those that I have already mentioned and omitting the "dossiers," one must at least mention those of Pierre Rosenberg (*De David à Delacroix*, 1974; *Chardin*, 1979; *Watteau*, 1984; *Fragonard*, 1987; and *Subleyras*, 1987); those of Jacques Foucart (*Puvis de Chavannes*, 1976; *Le Siècle de Rubens*, 1977; and *Les Flandrin*, 1984); of Geneviève Lacambre (*Le Musée de Luxembourg en 1874*, 1974; and *Le Symbolisme en Europe*, 1976); of Jean-Pierre Cuzin (*Raphaël et l'art français*, 1983); and of Sylvain Laveissière (*Le Classicisme français*, Dublin, 1985).

8. *Ingres* in 1987, with M. Sérullaz and P. Rosenberg (catalogue by H. Naef, D. Ternois, L. Duclaux, and J. Foucart); *Théodore Rousseau* in 1967 (catalogue by H. Toussaint); *Millet* in 1972 (catalogue by R. Herbert); *Hommage à Corot* in 1976 (catalogue by H. Toussaint for the paintings); and *Courbet* in 1977 (catalogue by H. Toussaint).

9. The "dossiers" organized during my tenure around a single work or a group of works in the Louvre were the following: *Le Bain turc d'Ingres*, 1971 (H. Toussaint); *Autoportraits de Courbet*, 1973 (M.-T. de Forges); *La Mort de Germanicus du musée de Minneapolis, du Poussin*, 1974 (P. Rosenberg); *Les Primitifs de Cologne*, 1974 (N. Reynaud); *La Diseuse de bonne aventure de Caravage*, 1977 (J.-P. Cuzin); *Le Portrait de Malatesta de Piero della Francesco*, 1978 (M. Laclotte); *L'Enlèvement de Sabines de Poussin*, 1978 (A. Arikha); *Fouquet*, 1981 (N. Reynaud); *Le XVIe Siècle florentin*, 1982 (S. Béguin); *La Liberté de Delacroix*, 1982 (H. Toussaint); *Murillo*, 1983 (Cl. Ressort); *Holbein*, 1985 (É. Foucart-Walter); *Andrea Solario*, 1985 (S. Béguin); and La Justice et la Vengeance de Prud'hon, 1986 (S. Laveissière).

Notes

10. The "dossiers" that examined certain aspects of the collections or of the museum were the following: *La Collection de François I^{er}*, 1972 (J. Cox-Rearick); *Le XVII^e Siècle flamand au Louvre*, 1977 (A. Roy); *Le Louvre d'Hubert Robert*, 1979 (M.-C. Sahut); *La Galerie espagnole de Louis-Philippe*, 1981 (J. Baticle and Cl. Ressort); and *Ajaccio, musée Fesch. Les Primitifs italiens*, 1987 (D. Thiébaut). To mark the publication of new catalogues, dossiers were mounted in 1979, 1981, and 1987.

11. *Le Cabinet de l'Amour de l'hôtel Lambert*, 1972 (J.-P. Babelon, G. de Lastic, P. Rosenberg, A. Schnapper); and *Le Studiolo d'Isabelle d'Este*, 1975 (S. Béguin).

12. *Technique de la peinture, l'atelier*, 1976 (J. Baticle and P. Georgel).

13. The exhibition *Ossian* was organized in 1974 with W. Hofmann in Paris and Hambourg, with a catalogue edited by H. Hohl and H. Toussaint.

14. Moscow and Leningrad, 1968 (catalogue by H. Toussaint).

15. *The Revolutionary Decades, 1760–1830*, Sydney and Melbourne, 1980 (catalogue by A. Sérullaz, H. Toussaint, and J. Vilain).

16. Among the theses accepted at the École du Louvre on Sienese subjects and supervised by me, I want to at least mention those of Mag Pellieux on Andrea Vanni (1973), by Judith de Botton and Denise Boucher de Lapparent on Bulgarini, Niccoló di Ser Sozzo, Luca di Tomme, and Bartolo di Fredi (1976), by Bianca Polton on Pietro di Giovanni Ambrosi (1988), and the work of Marianne Lonjon on the altarpieces of Simone Martini and his studio (1988).

17. The editorial team at Larousse was led by Monique Le Noan-Vizioz, with Marcel-André Stalter for the twentieth century. They were joined by Claire Marchandise for the painstaking distillation of the *Petit Larousse de la peinture*.

5. The Musée d'Orsay

1. J. Jenger, *Orsay, de la gare au musée* (Milan and Paris, 1986).
2. *Le Débat*, no. 44 (March–May, 1987).

6. The Grand Louvre

1. The administrative heads were Jean Galard for the Service Culturel; Guillaume Monsaingeon for the auditorium (Paul Salmona succeeded him in 1992); Christophe Monin for communication; Philippe Botte and Alain Boissonnet as successive directors of technical and logistic services, with Christophe Clément directing those relating to museum construction work. Gilles Butaud was responsible for human resources and became adjunct general administrator. The organizational chart of the museum obviously included other services no less important to the life of the museum — notably security, reception, and legal and financial services — as well as fire prevention.

2. *De Khorsabad à Paris*, 1993 (E. Fontan); *Le Jubé de Bourges*, 1994 (J.-R. Gaborit); *Luigi Valadier*, 1994 (A. González-Palacios).

3. The choices were guided by the curators of drawing, especially Régis Michel.

4. *Copier créer* in 1993 (J.-P. Cuzin); and *Egyptomania* in 1994 (J.-M. Humbert, M. Pantazzi, Ch. Ziegler).

5. *Arabesques et jardins de paradis*, 1991 (M. Bernus-Taylor); *Sculptures allemandes de la fin du Moyen Âge*, 1991 (S. Guillot de Suduiraut); *Byzance*, 1992 (J. Durand); *D'outre-Manche*, 1994 (O. Meslay); *Euphronios*, 1990 (A. Pasquier and M. Denoyelle); *Clodion*, 1992 (G. Scherf).

6. *Le Trésor de Saint-Denis*, 1990 (D. Gaborit-Chopin).

7. É. Biasini, J. Lebrat, D. Bezombes, J.-M. Vincent, *Le Grand Louvre: Métamorphoses d'un musée 1981–1993* (Milan-Paris, 1989); M. Bezombes, ed. *Le Grand Louvre: Histoire d'un projet* (Paris, 1994); F. de Gravelaine, *Le Grand Louvre: De la Pyramide à la Orangerie* (Paris, 1999).

8. Dominique Thiébaut for the primitives and Cécile Scailliérez for the 16th century, Jean-Pierre Cuzin for the 17th century.

9. The Salle des Caryatides had been restored under the authority of the EPGL and renovated by the department (Alain Pasquier and Françoise Gaultier).

10. Marie-Catherine Sahut for the 18th century and Sylvain Laveissière for the 19th century.

11. With hangings of drawings and cartoons by Le Brun, rotated regularly.

12. The presentation of pastels and miniatures of the 18th century on the second floor of the Cour Carrée, in the famous "couloir des poules," was supervised, respectively, by Jean-François Méjanes and Pierrette Jean-Richard.

13. Under the authority of Jean-René Gaborit, Françoise Baron focused on the Middle Ages, Geneviève Bresc on the 16th and 17th centuries, Guilhem Scherf on the 18th century, and Isabelle Leroy-Jay Lemaistre on the 19th century.

14. The Oriental department's move into the Richelieu Wing was prepared by Pierre Amiet and Annie Caubet with Dominique Beyer. Annie Caubet's team comprised Béatrice André-Salvini, Agnès Benoit, Françoise Demange, and Élizabeth Fontan. For her part, Marthe Bernus-Taylor laid out the Islamic section. The galleries of the department on the Cour Carrée side had been remodeled with the help of Agence Pylône, before being redone much later thanks to the Sackler Foundation.

15. Overseen by Pierre Rosenberg, the installation of German paintings was undertaken by Élizabeth Foucart-Walter and that of the Flemish and Dutch schools by Jacques Foucart, with Philippe Lorentz for the Netherlandish primitives. The French primitives and the French 16th century were taken in hand, respectively, by Dominique Thiébaut and Cécile Scailliérez and the 17th by Sylvain Laveissière.

16. On the first floor of the Richelieu Wing, taken over by the Department of Objets d'Art, the teams comprised, assisting Daniel Alcouffe, Amaury Lefébure, and Jannic Durand; and with Danielle Gaborit-Chopin, Élizabeth Taburet-

Notes

Delahaye, Pierre Ennès, Gérard Mabille, Sophie Baratte, and Anne Dion-Tenenbaum for the salons of Napoleon III.

17. Italy was the responsibility of Jean-René Gaborit and Sophie Guillot de Suduiraut took charge of the Northern European schools.

7. After 1994: Lavori in corso

1. For the subsequent stages of the study, we benefited from the assistance of two other administrators, Jean-François Chougnet, then Jacques-Henri Stahl.
2. To study the problems associated with the library, the team, coordinated by Serge Bouffanges, comprised Jean-Luc Gautier-Gentès (Bibliothèque d'Art et d'Archéologie–Jacques Doucet), succeeded by Françoise Lemelle, Isabelle le Masne de Chermont (Bibliothèque de l'École Nationale des Chartes), and Annie Jacques (Bibliothèque de l'École Nationale Supérieure des Beaux-Arts).
3. For the initial planning of the Richelieu and Colbert sites, studies were conducted by the EPGL under the authority of Jean-Claude Dumont, by Laurence Descubes and Véronique Minnereau, assisted by Dominique Bezombes.
4. The CFHA (Comité français d'histoire de l'art) and the APHAU (Association des professeurs d'histoire de l'art des universités) meet in a general assembly in January of each year.
5. Without discussing the research programs undertaken in association with other bodies, following various formulas, the programs specific to INHA concern the following subjects: "Historiography of art in France" (coordinated by Philippe Sénéchal), "History of taste in France" (Ph. Sénéchal), "Archives of contemporary art" (Pierre Wat); and certain aspects of the following themes: "History of architecture" (Alice Thomine), "Relationships between the visual arts, music, and the performing arts" (Jean-Michel Nectoux), and "Relationships between the visual arts and the cinema" (Irène Bessières).

INDEX

Index

Index

Index